AFRO MODERN

JOURNEYS THROUGH THE BLACK ATLANTIC

Tate Liverpool

AFRO MODERN
JOURNEYS THROUGH THE BLACK ATLANTIC

Edited by Tanya Barson & Peter Gorschlüter

WITH CONTRIBUTIONS BY

Petrine Archer, Tanya Barson, Roberto Conduru, Huey Copeland,
Manthia Diawara, Courtney J. Martin and Kobena Mercer

First published 2010 by order of the Tate Trustees
by Tate Liverpool
Albert Dock, Liverpool L3 4BB
in association with
Tate Publishing, a division of Tate Enterprises Ltd,
Millbank, London SW1P 4RG
www.tate.org.uk/publishing

on the occasion of the exhibition

Afro Modern
Journeys through the Black Atlantic

at Tate Liverpool
29 January until 25 April 2010

Supported by

With additional funding from Tate International Council,
Tate Liverpool Members, The Granada Foundation, The Embassy
of the United States in London and The Romanian Cultural
Institute in London

British Library Cataloguing in Publication Data
A catalogue record for this book is available from the British Library

ISBN 978-1-85437-923-8

Distributed in the United States and Canada by
Harry N. Abrams, Inc., New York

Library of Congress Cataloging in Publication Data
Library of Congress Control Number: 2009943195

Designed by LewisHallam
Printed by Westerham Press

Front cover: Wangechi Mutu, *You were always on my mind* 2007 (detail)
Back flap: Lorna Simpson, *Photo Booth* 2008 (detail)

*Measurements of artworks are given in millimetres,
height before width.*

CONTENTS

FOREWORD

Over the past two decades Tate Liverpool has developed an ambitious international programme which reflects a diverse and global approach. Some of our exhibitions and displays have engaged with issues of black history and identity, notions of cultural migration and the legacy of the Atlantic slave trade with direct references to Liverpool and British history. *Afro Modern: Journeys through the Black Atlantic* continues this important exploration of artistic practice and cultural legacy and demonstrates Tate Liverpool's continued commitment to delivering a diverse programme and to generating debate.

Afro Modern: Journeys through the Black Atlantic takes its inspiration from Paul Gilroy's seminal book *The Black Atlantic: Modernity and Double Consciousness* (1993). The exhibition explores the impact of different black cultures from around the Atlantic on art from the early twentieth century to the present and features over 140 works by more than 60 artists. It reflects on the notion of the Atlantic Ocean as a 'continent in negative', a network of cultures connecting Africa, North and South America, the Caribbean and Europe, and traces the real and imagined routes taken across the Atlantic from 1909 to today. By placing in juxtaposition the work of a range of artists, it opens up an alternative transatlantic reading of modernism and its impact on contemporary culture.

When Paul Gilroy came to Tate Liverpool in early 2009 for a seminar arranged as part of the preparation for the exhibition, he challenged us to consider Liverpool as a capital of the Black Atlantic. Indeed, Liverpool's location as a gateway to the Atlantic, and the history and legacy of its involvement in slavery, makes this exploration of Black Atlantic culture pertinent to the city and Gallery. We would like to express our deepest gratitude to Paul Gilroy for inspiring this exhibition and for his willingness to discuss the curatorial concept with us.

The exhibition was conceived by Tanya Barson, now Curator of International Art at Tate Modern, during her time as Curator at Tate Liverpool. It is curated by Tanya Barson and Peter Gorschlüter, Head of Exhibitions and Displays at Tate Liverpool. We would like to thank Tanya for her compelling curatorial concept and the extensive research undertaken, involving discussions with numerous scholars, artists and curators, to whom we would also like to express our sincere gratitude. It has been an enormous challenge to curate and organise an exhibition of such ambition, and we would like to thank both Tanya and Peter for their extraordinary collaboration on this project and the related publication. Further we would like to thank Paul Goodwin, Curator of Cross-Cultural Programmes at Tate Britain, who contributed to the process as Consultant Curator and co-organised, with Tate Liverpool's Public Programme Curator Caitlin Page, the Critical Forum conference to accompany the exhibition.

This publication gathers essays and interviews by key writers, respected curators and artists in the field of Black Atlantic studies and practice. We would like to thank Petrine Archer, Roberto Conduru, Huey Copeland, Thelma Golden and Glenn Ligon, Manthia Diawara and Édouard Glissant, Courtney J. Martin and Kobena Mercer for their inspiring contributions. Dmitri Van Den Bersselaar was invaluable in editing the chronology published in the appendix of this book, and has also collaborated with Peter Gorschlüter on setting up a Black Atlantic online resource as a partnership between the University of Liverpool's School of History and Tate Liverpool. We are grateful to Philip Lewis, Ian Malone, Jemima Pyne and Helen Tookey for producing this volume.

The exhibition includes iconic works, many of them rarely or never before presented in the UK, alongside major works of contemporary art. We would like to express our sincerest gratitude to all the institutional and private collections for generously loaning their work, as well as to the collaborating artists for their contributions. As ever, we would like to express our thanks to Tate Liverpool's Exhibitions Department, in particular to our Assistant Curator Darren Pih, Registrar Wendy Lothian, and Art Handling Managers Ken Simons and Barry Bentley, who have once again worked with tireless efficiency and skill to make this exhibition possible. Our Curatorial Interns Maryam Ohadi-Hamadani, Gabriela Cala-Lesina and Joao Philippe Reid have been enormously helpful throughout the exhibition planning process and supported the production of this publication with great commitment and meticulousness.

The exhibition would not have been possible without the support of Liverpool City Council and additional funding from Tate International Council, Tate Liverpool Members, The Granada Foundation, The Embassy of the United States in London and The Romanian Cultural Institute in London. We are grateful for their generous support.

Afro Modern: Journeys through the Black Atlantic introduces new and challenging narratives in our perception of modernism and modernity through the twentieth century. When developing the exhibition, it became clear that Tate Liverpool could not hope to examine in depth all aspects of the Black Atlantic theme, nor present works by all the related artists. Therefore we initiated a series of collaborations to enhance and expand the focus of the project, partnering with numerous institutions and academic bodies in Liverpool and beyond, including the Bluecoat, FACT (Foundation for Art and Creative Technology), International Slavery Museum, Kuumba Imani Millennium Centre, Metal, Liverpool Philharmonic Hall, Walker Art Gallery, the University of Liverpool and others. The resulting city-wide programme Liverpool and the Black Atlantic shows once more the legacy of a collaborative approach within the cultural sector in Liverpool in the wake of its year as European Capital of Culture.

CHRISTOPH GRUNENBERG
Director
Tate Liverpool

ANDREA NIXON
Executive Director
Tate Liverpool

INTRODUCTION: MODERNISM AND THE BLACK ATLANTIC

TANYA BARSON

Whenever a fleet of ships gave chase to slave ships, it was easiest just to lighten the boat by throwing cargo overboard, weighing it down with balls and chains... Navigating the green splendour of the sea...still brings to mind, coming to light like seaweed, these lowest depths, these deeps, with their punctuation of scarcely corroded balls... the entire ocean, the entire sea gently collapsing in the end into the pleasures of sand, makes one vast beginning, but a beginning whose time is marked by these balls and chains gone green... Relation is not made up of things that are foreign but of shared knowledge. This experience of the abyss can now be said to be the best element of exchange.

ÉDOUARD GLISSANT[1]

Our existence today is marked by a tenebrous sense of survival, living on the borderlines of the 'present', for which there seems to be no proper name other than the current and controversial shiftiness of the prefix 'post': postmodernism, postcolonialism, postfeminism...

HOMI K. BHABHA[2]

To Homi K. Bhabha's list of terms carrying the prefix 'post-' we can now add 'post-black', indicating the continuing 'shiftiness' of meaning and ongoing attempts to define new registers of cultural expression that supersede those of yesterday. Robert Farris Thompson first proposed 'post-black' as a term that aimed to expose the restrictions of postmodernity in a 1991 essay titled 'Afro-Modernism', in which he suggested 'a retelling of Modernism to show how it predicts [that] the triumph of the current sequences would reveal that "the Other" is your neighbour – that black and Modernist cultures were inseparable long ago', which in itself echoes Frank Bowling's even earlier assertion that 'the black soul, if there can be such a thing, belongs in Modernism'.[3] Both authors highlight a problem that concerns a much broader field within visual modernism, and one taken up by Paul Gilroy's book *The Black Atlantic: Modernity and Double Consciousness* (1993), and that is that there are different spaces and temporalities at work throughout the Atlantic realm that produce new periodisations of the modern and postmodern, as well as new formulations of modernism in art.[4]

This exhibition aims to address the shifting spaces, temporalities and formulations of modernism as it relates to black cultures and the black diaspora through

Édouard Glissant
Table of the Diaspora
from **Caribbean Discourse** 1989

8

the last century. In this, it also concerns a changing politics impacting on artistic expression at key instances when dominant or hegemonic modes of modernism can be seen to be challenged by alternative versions. In this sense, the exhibition is indebted to a great deal of work that has been done previously in defining a multiplicity of modernisms, rather than one single, core narrative.[5]

Paul Gilroy's concept of the Black Atlantic describes a counterculture to European modernity and modernism, to the project of the Enlightenment and its concomitant rationalism, historical progress and scientific reason. His thesis argues against essentialist versions of racial identity and racial nationalisms, in favour of a shared, though heterogeneous, culture that joins diverse communities in North and South America, the Caribbean, Europe and Africa. He proposes that the Atlantic be treated as 'one single, complex unit of analysis' which could 'produce an explicitly transnational and intercultural perspective'.[6] This perspective recognises the value of specific and divergent local or regional developments within culture, while relating them to a metaculture – described by Gilroy as a network or rhizome. In such an analysis what becomes important are the real and metaphorical journeys (both enforced and voluntary) that constitute this network across the Atlantic. Within it, the slave journeys of the Middle Passage take on a pre-eminent and foundational position. They are the origin of the racial terror and dislocation shared by black communities throughout the Atlantic, but are also the root of a productive syncretism that Gilroy aims to wrest from what has otherwise been cast as wholly negative, perpetuating a limiting sense of victimhood, cultural exclusion and inferiority. Gilroy argues that a number of different moments of connectedness might emerge from this network that, overall, build up a complex picture of cultural exchange and continuity.[7] This does not impose an all-encompassing and totalising homogeneity on what he calls 'black Atlantic expressive culture', but rather proposes a subtle analysis that, instead of foregrounding difference, takes into account aspects of sameness that nevertheless surface in diverse and complex ways and in different contexts as 'the changing same'.[8] Gilroy's text aims to highlight both the paradoxes and

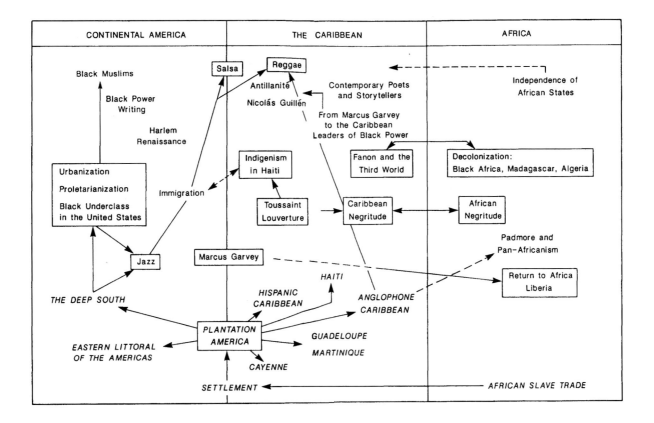

overlooked narratives of modernity, and to argue that racialised reason, terror and slavery were internal to the project of modernity. One of the central themes that Gilroy delineates is that of 'double consciousness'; drawn from the writings of W.E.B. Du Bois, this concept describes the split subjectivity and race-conciousness that Du Bois observes as inherent to the experience of being an African-American, an awareness of existing simultaneously both within and outside the dominant culture. This double consciousness, Gilroy argues, is one of the defining characteristics of Black Atlantic expressive culture.

Gilroy's concept of a 'Black Atlantic' has important implications for the study of art.[9] Importantly, his book prefigured many of the debates around the transnational, the intercultural and globalisation that have taken place since it was published. Gilroy's text can also be related to other, prior conceptual framings of these issues, such as Édouard Glissant's notion of *antillanité* (or Caribbeanness), though this latter presents both a case for a more specifically regional convergence of a greater multiplicity of cultures highlighting difference, and an emphasis on mutability, in which fragmentation, adaptation and synchronicity all play a part in the dynamics of relation. Glissant's 'Table of the Diaspora' maps complex, non-linear and somewhat chaotic associations within a network encompassing continental America, the Caribbean and Africa.[10] This diagram manifests Glissant's sense of the formlessness of cross-cultural relation or the 'true shapelessness of historical diversity' around the Atlantic and thus the complexity of its cultural and aesthetic effects.

BLACK ATLANTIC AVANT-GARDES

Any discussion of the Black Atlantic and modernism must necessarily address the appropriation by the European avant-garde of the forms of African art. From the initial pre-war engagement of Dada, Fauvism, Cubism and Expressionism, to the interwar years, characterised by a hyperbolic craze for black culture and the Surrealists' fascination with ethnography, this was a fundamental and persisting feature of the emergence of avant-garde modernism in the first half of the twentieth century. The story of this relationship is usually told without recourse to other movements that occurred more or less simultaneously outside Europe, or in relation to the European context through the agency of individual artists, writers and performers who traversed the Atlantic. There are, for example, significant links between Europe and the Harlem Renaissance in the United States and, similarly between European 'primitivism' and Brazilian modernism through artists such as Tarsila do Amaral and Lasar Segall.

African art had come to the attention of artists such as Matisse and Picasso in the first decade of the twentieth century, and Dada artists had incorporated it into their assault on the cultural establishment and status quo. However, as Petrine Archer argues in her book *Negrophilia: Avant-Garde Paris and Black Culture in the 1920s*, the arts of Africa were utilised more comprehensively in the period immediately after the First World War, when the full-blown craze for African art and black culture, epitomised by figures such as Nancy Cunard, was seen as providing a means for a renewal of European society and culture.[11] Into this 1920s' context came artists such as Aaron Douglas, Palmer Hayden, Lois Maliou Jones and James Van Der Zee, and performers such as Josephine Baker and Paul Robeson, who aimed to participate within and contribute to modernism and who could all to varying degrees be described as (in James Baldwin's phrase) 'trans-Atlantic commuters'.[12] Robert Farris Thompson has highlighted how such participation took many forms, one of which was 'New Negro' fashion: 'the zoot suit – cubism as apparel, the wearing of satiric dozens as dress – was an early example of Africa staring back, of Africa remaking Europe and America'.[13] Equally, the work of these artists remade European and American modernism. Thus, the way that black practitioners of modernism negotiated this territory sheds light on the subsequent development of Black Atlantic aesthetics. The act of appropriation by the European avant-gardes laid the seeds for counter-appropriations.

Aaron Douglas is, perhaps, the foundational artist of Black Atlantic modernism. While Douglas engaged briefly and belatedly with pre-war avant-garde styles, as in his

Aaron Douglas
Into Bondage 1936
Corcoran Gallery of Art, Washington DC

Birds in Flight 1927, he quickly rejected this brand of Cubist-Futurist modernism. As the most prominent of the artists who contributed to the NAACP journal The Crisis, his trajectory was more clearly one that made a transition from post-impressionism to a distinctive brand of politically engaged, socialist realist figuration that embodied founding editor W.E.B. Du Bois's concept of 'double consciousness' and addressed the contemporary predicament of African-Americans in the years following the trial of the Scottsboro Boys and the Depression. Douglas's paintings, as well as his illustrations for The Crisis, the journal Opportunity and other graphic projects, negotiate on the one hand an image of an idealised African past as a source of pride, to be recovered and made accessible in the present, and on the other hand a modernity that was contested, yet offered a focus for aspiration. Douglas's works assert the decisive contribution of African-Americans to the history of the United States – reflecting the optimism inherent within Du Boisian politics and its utopian plan for advancement, allied to Douglas's belief in the potential for equality offered at this time by Communism. This is introduced in paintings such as Aspiration 1936, where a ray and star motif refers at once to the light of Christianity, the star of emancipation and Marxist socialism.[14] Such images were only infrequently countered by paintings such as Into Bondage 1936, in which the exile of slavery is highlighted, though the terrors of the Middle Passage are not shown.[15]

Tarsila do Amaral presents a particular illustration of the contradictions inherent in any narrative of Black Atlantic modernism. She came from a highly privileged background, her family home being a sugar plantation in which the main workforce was drawn from the black population of former slaves.[16] Her fast absorption of European primitivism is evident in The Negress (La Negra) 1923, which was painted only shortly after her arrival in Paris, where she studied with Fernand Léger and befriended Blaise Cendrars. This was a short-lived though crucial stage in the development of an identifiably post-colonial modernism in two swiftly succeeding movements known as Pau Brazil and Antropofagia – theorised by her husband Oswald de Andrade in manifestos in 1925 and

1928 respectively.[17] Responding to primitivism, the couple proposed an assertion of Brazilian culture and, moreover, the conceptual transformation of modernism into a new form that countered the European model through the potent conceit of cannibalism. As Andrea Guinta has highlighted, 'few images are as successful as that of swallowing: eating the white man, devouring and digesting him. That which will nourish is selected and the negative parts are discarded. The swallowing metaphor was radically developed by the Brazilian avant-garde. Marked as an inaugural fact, it was also felt to be the start of a history that even required a new date-system, a chronological mark to vindicate the value of anthropofagy.'[18] That Tarsila's later painting Anthropofagia 1929 so clearly shares compositional elements with the earlier The Negress indicates how this transition was made directly through the surpassing of European primitivism. Thus she developed a mode of modernism that represented, for the first time, a perspective drawn from a society emerging from colonialism and discovering the potentiality of its cultural syncretism, as in Hill of the Shanty Town (Moro da Favela) 1924.[19]

MAYA DEREN: THE LIVING GODS OF HAITI

Maya Deren's Haitian project began as an investigation into dance, emerging from her ongoing collaborative relationship with the pioneering African-American choreographer Katherine Dunham, who had conducted anthropological studies of the African-influenced dance of the wider Caribbean before focusing on Haiti. Deren's aim was to present Haitian dance as just that – 'purely' dance. Moreover, it was to be an exercise in creative filmmaking, beyond the commercial or documentary domains, bringing an avant-garde approach to bear on her material to create what she conceived of as a 'film-poem'. This testifies to her background and involvement in Surrealist circles, as well as the tendency within that movement towards blurring the boundaries between the aesthetic and the ethnographic.

Modernism and the Black Atlantic

As Deren's project progressed, it deviated from her original plan. She made repeated visits to the island, becoming progressively more engaged with ceremonies, which appealed to her Surrealist interest in alternative realms of reality, than with dance. The film escalated in length and, on her death, she left hours of unedited footage, the project incomplete.[20] Nevertheless, Deren's film stands as an important cultural record, while illustrating the messy boundaries between European modernism and disciplines such as ethnography. Moreover, it also registers her engagement with new forms of ethnography, as exemplified by her proximity to the pioneers of visual anthropology Gregory Bateson and Margaret Mead. From both Deren's footage and her 1953 book, the source of the film's title, it is evident that the focus of her interest was the complex nature of Haitian ceremonies, the survivals from diverse African cultures which, in the Caribbean, had mixed to become a new cultural and religious form, highlighting cultural transmission, synthesis and invention in the face of rupture and dislocation.[21]

Through the twentieth century Haiti, the scene of the first successful slave rebellion and independent black republic outside Africa, was sustained as a locus of sorts

Tarsila do Amaral
The Negress 1923

within the Black Atlantic, a contested site symbolically and geopolitically.[22] C.L.R. James' anti-colonial history of Haiti, The Black Jacobins, published in 1938, was written as part of the fight to end colonialism in Africa, connecting the persecution of Africans in Africa, during the Middle Passage, in the United States, and in the Caribbean.[23] The following year saw the appearance of Aimé Césaire's Notebook of a Return to My Native Land in Volontés, the first and principal text of the Négritude movement, which took inspiration from Haiti, but developed in the context of Surrealism and the meeting of African and Caribbean intellectuals in Paris. It aimed to break away from European models and the stifling hegemony of early twentieth-century avant-gardism, and established a new agenda for Black Atlantic and African artists working in relation to, yet formulating their own versions of, modernism.

BLACK ORPHEUS: NÉGRITUDE, CREOLISATION, NATURAL SYNTHESIS [24]

Aimé Césaire inaugurated Négritude as an act of cultural and linguistic appropriation, reclaiming the pejorative term nègre and combining it with defiant references to the revolution in Haiti and to African roots to reverse its usage. Equally importantly, literary Négritude became an exercise in linguistic mutability and in neologism, language in the constant process of being made. The efforts of artists to give visual form to the potentialities of Négritude were often inconsistent. Nevertheless, important visual manifestations were produced that constitute a challenge to canonical versions of modernism. Most prominent and successful of the Négritude artists was Wifredo Lam, who effected a powerful subversion of the language of 'assimilation' and 'affinity' within European modernism in his paintings; African art motifs mediated by Cubist and Surrealist 'primitivism' are redeployed and combined with references to Afro-Caribbean culture. As Andrea Guinta has commented,

European modernity's appropriation of 'primitive' formal structures as food for a self-centred discourse was imitated and disarticulated as an operative system in Lam's work after his return to Cuba. He made the mechanisms of the centre evident, repeated them and charged them with a new meaning… Thus it was discovered that what, in the European discourse, was a horizon of desires or the object of a laboratory experiment, in the Caribbean was the latent everyday, hidden and suppressed since the Conquest and slavery.[25]

Or as put, succinctly, by Gerardo Mosquera, Lam raises the question of 'who eats whom?'[26] While Lam has in the past been called the 'painter of Négritude', his work can be seen to extend beyond Négritude's limitations, going beyond its association with a narrow politics or philosophy, to embrace the broader political and cultural basis of creolisation or antillanité.[27] Thus he can be seen as a product of the specific conditions of the Caribbean,[28] while his work marks the expression of an African presence in the Americas, as Guinta declares: 'Lam is a protagonist of the modern construction of Afro-American visuality'.[29] Moreover, he has also been identified as a 'post-modern modernist' who effects another challenge to the periodisations of the modern and postmodern within Black Atlantic modernism.[30] Like Lam, the sculptor and fellow Cuban Agustín Cárdenas lies at the fault line between Négritude and its subsequent surpassing. In Glissant's writing Cardenas embodies Caribbean-ness, the archipelago that is a 'land of converging cultures, race of many ideas'.[31] Both Lam and Cardenas encountered in their journeys within and around the Caribbean a sense of a shared intersection of cultures and races in which Africa featured prominently.

African versions of Négritude followed a very different path to those in the Caribbean. Under Leopold Senghor in Senegal, the Négritude of the École de Dakar became the official aesthetic, strongly linked to the road to independent nationhood, but marked by the opposition between the work and positions of Papa Ibra Tall, an advocate of Négritude and the use of African subject matter, and those of Iba N'Diaye, who promoted technique

over concepts of 'authenticity' and 'Africanness'.[32] Even though N'Diaye drew his subjects from Africa, his technique remained resolutely School of Paris. In contrast to the starkly oppositional formulations created in Senegal, in Nigeria a different kind of aesthetic was developed. As a consequence of the return of slaves from Brazil in the mid-nineteenth century, cultural syncretism already existed within the country and its culture. Artistic exchange between Nigeria, Europe and the USA (through the conventions of training in Europe, and artists including Aaron Douglas and Jacob Lawrence visiting or teaching in Nigeria) also fed into a complex situation of aesthetic polyphony. The most succinct expression of this situation was the movement called Natural Synthesis; the manifesto, written in 1960 by artist Uche Okeke, called for a fusion of tradition and modernity but emphasised the *contemporaneity* of African culture and society, and called for an independent spirit to meet it. Nigeria, Okeke wrote,

> needs a virile school of art with a new philosophy for the new age – our renaissance period. Whether our African writers call the new realization Negritude or our politicians talk about the 'African Personality,' they both stand for the awareness and yearning for freedom of black people all over the world. Contemporary Nigerian artists could, and should, champion the cause of this movement... The key word is *synthesis*, and I am often tempted to describe it as *natural synthesis*, for it should be unconscious, not forced.[33]

He openly declared himself against both a slavish reliance on European modernism and a misguided deference to African traditions, stating, 'I disagree with those who live in Africa and ape European artists. Future generations of Africans will scorn their efforts. Our new society calls for a synthesis of old and new, of functional art and art for its own sake... Western art today is generally in confusion... It is equally futile copying our old art heritages, for they stand for our old order. Culture lives by change'.[34] Okeke's *Ana Mmuo* 1961 embodies this sense of purpose, synthesising Africa and modernity, *uli* line and a syntactical

modernism, formulating an abstract language that epitomized contemporary Africa.

Négritude in Brazil arose at the onset of a volatile period within the history of the nation, with a military coup ushering in a succession of authoritarian regimes. Against this backdrop, Rubem Valentim's paintings crossed the aesthetic boundaries drawn between the Brazilian modernism of Concrete and Neo-Concrete art, and Brazil's culture and religions of African origin. This was a significant act of trespass since at the time such religions were the subject of repression.[35] Thus his works manifest Hélio Oiticica's assertion that in Brazil 'purity is a myth'. Oiticica's provocative statement referred to both the suppressed nature of Brazil's social make-up and the subversive potential of art to challenge the versions of modernism emanating from Europe and the USA, a project that was to reach its culmination in the counter-cultural movement known as Tropicalia. Meanwhile, as Paulo Herkenhoff has commented, 'Valentim led Brazilian art to a new symbolic level and a new ethical plane... Xangô's double axe, which cuts from both sides, is the metaphor for an art conceived within Western constructivist modernity and genuinely incorporates Brazil's African roots.'[36] Moreover, he continues, 'in lieu of experiencing the nostalgia of Africa, [Valentim] seeks the contemporariness of the Afro-Brazilian present'.[37] It should come as no surprise, then, that Valentim's works found significant exposure in Africa, where they were exhibited at the First World Festival of Black Arts in 1966 in Dakar, a festival conceived by Senghor as a celebration of Négritude and contemporary optimism in the African Independence movements. Oiticica's own work, particularly his 'fireball' *B03 Box Bolide 03 'African' and 'Addendum'* 1963, aimed at a similar unification of abstract-constructive language with an acknowledgement of the importance, as well as the potentially incendiary significance, of Africa within Brazilian culture. Such works complicate the narrative of Brazilian modernism and the ways in which it took up the challenge of transforming Eurocentric modernism.

DISSIDENT IDENTITIES: RADICALISM, RESISTANCE AND MARGINALITY

The counter-cultural politics of the Civil Rights and Black Power movements form the background for a greater political engagement in art around issues of racial politics, identity and visibility, and the development of strategies that involved diverse manifestations of institutional critique. The anti-dictatorship stance of artists, musicians and activists in Brazil provided a parallel context, though one that prompted more clandestine operations, or else necessitated exile in London or New York. Thus political activism and radicalism, street-based performances, interventions and improvisations, often allied to carnival, and other strategies of marginal resistance located outside institutional structures, proliferated in diverse locations from the late 1960s onwards. Black Atlantic art became less about the trans-national relationships traversing the Atlantic than about the specific social and political implications of the legacies of slavery, segregation and oppression within societies such as the United States and Brazil.

Norman Lewis's delicate Abstract Expressionist compositions of the 1940s and 1950s gave way in the early 1960s to paintings composed of stark chromatic contrasts and equally stark political subjects that embodied an oppositional sense of what it was to be an African-American.[38] Lewis was a committed participant in the Civil Rights movement throughout his life, but this shift in his work coincided precisely with the increasing prominence of the movement and the foundation of Spiral in 1963, a group dedicated to furthering the movement's aims through the visual arts. In paintings such as *American Totem* 1960, hooded Ku Klux Klan figures merge to form a totemic, or missile-like, form, while *Redneck Birth* 1961 exemplifies Lewis's fusion of abstraction with the scenes of Klan congregations, parades and mobs that would occupy him for the next decade. These allusive compositions do not make a return to the overt politics of his 1930s' socialist realist paintings; instead, they present a subtly politicised abstraction. Romare Bearden, a close

associate of Lewis's, was also becoming involved with the Civil Rights movement by the early 1960s, at precisely the moment when, abandoning abstract painting, he developed his most distinctive productions – socially engaged collages in which scenes from the history and experience of African-Americans were orchestrated in a deliberately rudimentary play of newspaper and magazine cuttings.[39] His composite arrangements employ the glossy materials of consumerist modernity to critique modernist primitivism and effect a simultaneous reappropriation of African art in an echo of Lam's strategy of counter-appropriation. Here, however, African sculptures are sliced and reassembled, sampled and redeployed, forging a new language based on a disjunctive mix of forms and sources. In other works Bearden focused on the nude, using pornographic magazines as a starting-point. These works function as reflections on Gauguin, Picasso and Matisse, though subverted again through the origin of their material sources, that make explicit the nature of the male gaze. Hinting – perhaps inadvertently – at the complexities of gender relations within the black community, these works nevertheless bring to mind the contemporary slogan 'Black is Beautiful' and mark the political use of the nude as a symbol of black pride; for Judith Wilson, Bearden's nudes 'recuperate the black female body, wresting it from the clutches of white purveyors of erotic fantasies about exotic Others, and reposition it in relation to black vernacular culture.'[40]

More radical practices are embodied, quite literally, in the work of David Hammons and Adrian Piper. Piper's early work *Food for the Spirit* 1971, according to Lorraine O'Grady, might be considered 'the catalytic moment for the black subjective nude' suggesting a more complete recuperation of the female nude than that presented by Bearden, since this work designates the body more specifically as a site of black female subjectivity, and addresses the traditional aesthetic unworthiness or invisibility of the black female nude by offering 'a paradigm for the willingness to look, to get past embarassment and retrieve the mutilated body.'[41] Hammons's practice, which combines aspects of Duchamp, Dada and Arte Povera with Outsider or Folk art, is one of inventive evasiveness; his critique of

the institutions of art consists, more often than not, of ignoring them. He prefers instead to operate in the domain of the street or, more specifically, the neighbourhood (Harlem), making ephemeral, often unannounced, art for those who stumble across it, or else surfacing in diverse and unexpected locations in street performances and alternative venues. Hammons's is an art rooted in the materials and realities of street, neighbourhood and other marginal spaces, and of African-American life, undermining the commercial value of art by using humble substances or discarded items. Hammons's early sculpture *The Door (Admissions Office)* 1969 belongs to a series of body prints, in which he used his own body, often in combination with unconventional materials such as margarine or grease and pigment rather than ink or paint. The sculpture, in which the print represents a body pressed up forcefully against the glass pane, appears to refer quite clearly to the systematic exclusion of African-Americans from the privileges of white society, including education and employment, not solely through racial segregation, but as a much more widespread and persistent situation.[42] Kellie Jones has described how for Hammons, 'Charles White, whose socially committed work was for and about African Americans and their struggles, and the climate of Black Power and black cultural nationalism of the late 1960s, were certainly influences'.[43] Hammons's work manifests a sophisticated negotiation of modernities and modernisms in relation to the persisting double consciousness of being black in America.

There are a number of artists whose careers raise pertinent, yet often overlooked or evaded, questions about the relationships between modernism, its subversion, and the communities of the black diaspora within the Black Atlantic, as well as the position of the artist as both marginal and hero.[44] Brazilian artist Hélio Oiticica's engagement with the marginalised, predominantly black communities of Rio's *favelas* has often been oversimplified, particularly in terms of the problem of appearing to speak for others, the level to which Oiticica became truly immersed in or participated within those communities, the degree to which this has become mythologised in relation to his career and persona, and, moreover, as Michael

Asbury has pointed out, the extent to which 'the exotic nature of the favela, its attractiveness and repulsiveness, could ... become tamed via the figure of Oiticica'.[45] Oiticica's series of *parangolés* or capes were created in close collaboration with his friends among the inhabitants of the *favelas*; they were produced to be worn within carnival-inspired gatherings, the first one staged at the Museum of Modern Art in Rio in 1965 with dancers from Mangueira, the largest of Rio's *favelas*. The invasion of the museum by poor inhabitants from the city's margins proved too much for the museum authorities and the dancers were thrown out. This event, and the *parangolé* series, manifested a significant development in Oiticica's work, and achieved a position of avant-garde dissidence in relation to Brazil's governing elite and art establishment, as well as effecting a challenge to the parameters of modernist practice in the form of both an interrogation of modernist formalism as well as institutional critique through the example of the officially marginalised Afro-Brazilian culture. However, the nature of Oiticica's relationship with the *favela*

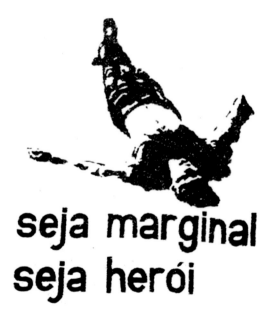

Hélio Oiticica 1937–1980
Be a Marginal, Be a Hero 1967

communities, and the balance between collaboration and representation, should not be accepted uncritically, but rather treated with circumspection.

Residing outside the art world and on the margins of society, Arthur Bispo do Rosario made works drawing upon the Afro-Brazilian imaginary, using found objects and detritus, or elaborate embroidery. The fact that he committed himself to a psychiatric hospital in 1939, and remained there until his death fifty years later, has quite reasonably resulted in his being viewed as an outsider figure.[46] Nevertheless, he left behind a substantial body of work that reveals an idiosyncratic awareness of art and its institutions, and of the works of a range of artists. Bispo's assemblage of found objects, *Macumba*, is a shrine dedicated to Lemanjá, the Candomblé goddess of the sea and mother of the waters derived from the Yoruba *orisha* Yemaya, while his *Exu's Cape* stands as a counterpoint to Oiticica's *parangolés*.[46]

Jean-Michel Basquiat's movement from the margins to the mainstream raised the issue once again of the extent to which black artists were able effectively to control their own agency and participation within cultural modernities, rather than continuing to be viewed as 'other' and remaining the subject of tokenism. Again, we seem to return to the question of who eats whom. Thus while Basquiat began his career as a graffiti artist, creating 'tags' captured in photographs by Peter Moore, the small scale and unannounced gestures of his work make knowing references to the history of modernism's anti-art practices. By the time he came to paint *Native Carrying Some Guns, Bibles, Amorites on Safari* 1982 he had been embraced by New York's art scene and had achieved a level of fame and recognition unprecedented for an African-American artist. Yet this work offers a multi-layered reflection on identity politics and postcolonialism; while it critiques the history of Western colonialism, it does not attempt to recuperate racial identity in any simplistic sense but, as bell hooks has observed, 'graphically evokes images of incomplete blackness'.[48] In its epigraph, it also epitomises Basquiat's anti-materialist stance, whereby he attacked the tendency of the art establishment to co-opt cultural opposition.

Hélio Oiticica
B 03 Box Bólide 03 "African" and **"Addendum"** 1963

RECONSTRUCTING THE MIDDLE PASSAGE: DIASPORA AND MEMORY

In recent years, contemporary artists have repeatedly examined a series of interrelated themes that are also crucial to Gilroy's concept of a Black Atlantic; they approach the terrors of the Middle Passage and the experience of diaspora and dislocation from culture and history, through the strategy of representing historical narratives (in the absence of adequate records) by imaginative recovery. The image of the Middle Passage and the slave ship become central motifs or ciphers of the Black Atlantic, located, as they are, outside national boundaries. Gilroy defines the ship as a chronotope, a spatio-temporal matrix which can be considered not only as the mobile means by which the different points of the Atlantic world became joined but also as a 'cultural and political unit'.[49] As Gilroy states,

> I have settled on the image of ships in motion across the spaces between Europe, America, Africa, and the Caribbean as a central organising symbol for this enterprise and as my starting point. The image of the ship – a living micro-cultural, micro-political system in motion – is especially important for historical and theoretical reasons… Ships immediately focus attention on the middle passage, on the various projects for redemptive return to an African homeland, on the circulation of ideas and activists as well as the movement of key cultural and political artefacts: tracts, books, gramophone records, and choirs.[50]

Édouard Glissant, in his *Poetics of Relation*, has also written of the Middle Passage as a foundational experience, though he describes it as an abyss. He too emphasises that it 'projects a reverse image of all that has been left behind,

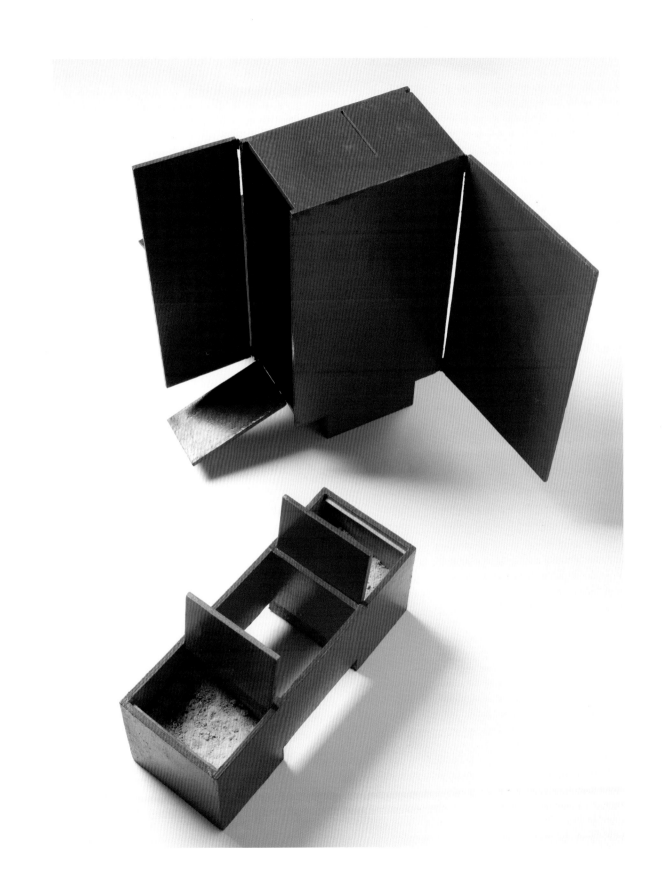

not to be regained for generations except – more and more threadbare – in the blue savannahs of memory or imagination'.[51] He describes the Atlantic as a 'land-sea', upon which a relation, though not a unity, is formed: 'Peoples do not live on exception. Relation is not made up of things that are foreign but of shared knowledge. This experience of the abyss can now be said to be the best element of exchange.'[52] So, the communities that formed among diverse island nations as a result of slavery also find themselves crucial to these imaginative retrievals of history. Consequently, Renée Cox enacts the life of Nanny of the Maroons, the rebellious leader of Jamaica's maroon community, in her series of black and white photographs, while Ellen Gallagher's painting *Bird in Hand* 2007 makes the figure of the black sailor, drawn from the population of former slaves in the Cape Verde islands, its central motif of Black Atlantic mobility. Gallagher's work also evokes an alternative Atlantic cartography of the Middle Passage through the underwater world of Drexciya, the home of souls thrown overboard during the transatlantic journey, suggesting the desire for a kind of utopia or return to an African homeland.

In Keith Piper's *Go West Young Man* 1987 the artist brings together multiple histories of migration from slavery to post-war immigration, while Isaac Julien's *Western Union Series No.1 (Cast No Shadow)* 2007 addresses more recent migrations and trafficking from Africa to Europe, although through an image that also harks back to the historical departure of slaves from western Africa as well as quoting subtly Douglas's painting *Into Bondage*. From the slave ships of the Middle Passage to warships crewed by black sailors, post-war immigrant vessels such as the *Empire Windrush* and the latter-day migrations and human trafficking from North Africa and across the Caribbean, the ship has become a potent symbol of transnational dislocation, global inequity and violence in contemporary art.

EXHIBITING BODIES: RACISM, RATIONALISM AND PSEUDO-SCIENCE

Early twentieth-century ethnographic Surrealism produced a complex iconography that sought to challenge and undermine, but which also often reinforced, the tradition of Western scientific rationalism and its dubious assumptions and prejudices that framed the West's relation to 'otherness'. Surrealism both highlighted and adapted the specific pseudo-scientific languages on which such a discourse was based. It was often the black female body that provided the most extreme embodiment of 'otherness', both for the proponents of 'rational' science and for Surrealism.[53] As O'Grady has commented, 'it is the African female who, by virtue of colour and feature and the extreme metaphors of enslavement, is at the outermost reaches of "otherness"' and yet, she continues, 'the black female's body needs less to be rescued from the masculine "gaze" than to be sprung from a historic script surrounding her with signification while at the same time, and not paradoxically, it erases her completely.'[54] Since the 1980s, a number of women artists have investigated the representation of the black female body and its framing through devices such as ethnographic and classificatory photography, tourist postcards and other seemingly 'documentary' forms and conventions, as well as pornography, as a way to explore wider issues of gender, race and inequality. Focusing on these examples of the performance of identity and re-presentation of the female body, on contemporary responses to the explicit objectification of the black female body during colonialism through instances of transportation and exhibition for amusement's sake (most notably perhaps the case of Sarah Bartmann, who became known as the Hottentot Venus), this section of the exhibition highlights a key argument within Gilroy's book: that the project of modernity was dependent upon and effectively produced the terrors of slavery as part and parcel of its own formation and continuance.[55] But this group of works also addresses aspects of gender politics and notions of visibility that are absent from Gilroy's text.

In a photographic self-portrait Tracey Rose pays tribute to Bartmann, who is recuperated and transformed into a symbol of black female struggle; the work can also be read as a commentary on the complexities of the (self-)presentation of the black female body within modernism, referring back to figures such as Josephine Baker and her willingness to appear nude or in exaggerated poses, and at the same time also owing a debt to Adrian Piper's forceful performance of the 'subjective black nude'. In her work, Candice Breitz has explored the abuses and ambivalences of (pseudo-)ethnographic imagery in relation to globalised multiculturalism and the commodification of ethnicity that reached a particular height during the 1980s and early 1990s, as well as the context of a specific period in the post-apartheid history of South Africa where the use of the black body by white artists was itself a contentious issue. Appropriating postcards of women in 'typical' tribal settings in her Ghost Series 1994–96, she altered them by masking the women's bodies in brilliant white correction fluid and then re-photographed the images, as Octavio Zaya has commented, 'not only in order to highlight the phantasmagoric nature that already pervades them – in the elision or erasure of the subjectivity of the women in the image – but, more significantly, to exacerbate the laws of appropriation that categorize these presences as exotic and primitive fetishized absences'.[56] Wangechi Mutu's works deliberately recall the workings of Surrealist collage (particularly the work of Hannah Hoch), creating a confluence between ethnographic photo-essays and postcards, similar to those used by Breitz, and cuttings from fashion magazines, medical journals, wildlife and pornographic magazines, in works that comment on and subvert notions of beauty within popular culture as well as in Surrealist magazines.

Carrie Mae Weems' photographic work A Negroid Type / You Became a Scientific Profile / An Anthropological Debate / & A Photographic Subject 1995–96 interrogates the attitudes underlying the early development of the discipline of ethnography, and the deprival of subjectivity within photographic representation as it was deployed during the nineteenth and early twentieth century. Coco Fusco's

video performance with the Mexican artist Guillermo Gomez-Peña, The Couple in the Cage: A Guantianaui Odyssey 1993, also refers back into the historical past, to the transportation for spectacle and amusement, as well as the objectifying gaze, in order to highlight ongoing exclusions. Fusco's work plays on complex notions of colonial desire, entrapment, exile and display, and the historical exclusion of black subjectivities from modernity. Ana Mendieta's performative work and Marta Maria Pérez Bravo's photographs foreground the female body, this time in relation to the practice of Afro-Cuban religions such as Santería and Candomblé. Pérez Bravo's works employ an anachronistic photographic style combined with a deliberately jarring assertiveness and the foregrounding of frequently submerged cultural forms which have often been seen as outside or beyond modernism.

In Sonia Boyce's From Tarzan to Rambo: English Born 'Native' Considers her Relationship to the Constructed/Self Image and her Roots in Reconstruction 1987 the artist questions the relationship between her own 'self-image' and the one offered by a predominantly white society through the mass media and Hollywood; 'blackface' or 'golliwog' images are included as indictments of the widespread dissemination of racially prejudiced imagery and black stereotypes. The repeated portraits and wide-eyed expression of the artist refer to the perverse representation in Hollywood films of black religious practices such as trance, which is central to Haitian voodoo. At the same time, for Boyce, Tarzan and Rambo represent a crisis of white identity which necessitates the construction of an 'other'. Concepts of nationhood and belonging are also addressed and questioned in the work and its analytical title. Thus, this section of the exhibition makes clear the complicity of rational science and racialised reason in the racism that underpinned slavery, which reverberates in the dissemination of imagery within Surrealism, Hollywood film, advertising and other forms of mass media.

FROM POSTMODERN TO POST-BLACK: APPROPRIATION, BLACK HUMOUR AND DOUBLE NEGATIVES

As in silent film, Kara Walker's 8 Possible Beginnings or: The Creation of African-America, a Moving Picture by Kara E. Walker 2005 is divided into chapters, each detailing the history of black experience in America, including the initial crossing, in which bodies are thrown off a slave ship in the Middle Passage, and then swallowed by a Motherland rising out of the sea, only to be digested, excreted and reborn as King Cotton in the New World. Walker's shadow-play images recover the atrocities and the bestialities of humanity exemplified by racial slavery, their double-negative aiming to effect a moral ellipse. Like Walker's film, which is both an ellipse and a beginning, an embarkation, the exhibition ends on a conceptual starting point. It marks a transition between generations, from the identity art of the 1990s to the 'post-black' art of today. This final section examines the tactics used by contemporary artists to explore the profound complexities and ambivalences within black diasporic subjectivity. These tactics include appropriation, the use of black vernacular and popular culture, the practices of sampling, recycling and accumulation – embodying what Gilroy calls the 'polyphonic qualities of black cultural expression' – and, often allied to this, the use of negative and racist images and/or black humour and laughter to undermine racism but also to re-examine the attitudes and aspirations of black politics, particularly of the 1960s and 1970s.[57]

Chris Ofili's works draw on a wide range of black vernacular sources that are combined with references drawn from the history of Eurocentric and Black Atlantic modernisms, from Matisse and Kandinsky to Douglas and Bearden. In Double Captain Shit and the Legend of the Black Stars 1997 Captain Shit is a symbol of black superstardom, though couched in ambivalence and self-directed parody, while the collaged black stars refer to the many untold stories of fame in black history. The apparently pejorative and racist imagery contained within the images of Ofili or Walker is, like the lyrics of rap music, a latter-day equivalent to the 'satiric' practice known as the 'dirty dozens' recorded in the novels of Richard Wright.

Another aspect of this deep ambivalence is the practice of masking and/or doubling. The image of split or fractured subjectivity persists. Alongside the artists that exemplify this set of tendencies, including Glenn Ligon, Ellen Gallagher, Walker and Ofili, is David Hammons, whose work continues to be a reference point, and those whose work signals both a debt and a departure and who have been associated with the term 'post-black', including Adam Pendleton. Thelma Golden and Glenn Ligon's application of the term 'post-black' to a younger generation of artists 'who were adamant about not being labelled as "black" artists, though their work was steeped, in fact deeply interested, in redefining complex notions of blackness' can be brought to bear here.[58]

Ligon's investigation of the social, linguistic and political construction of race is encapsulated in his text paintings Gold Nobody Knew Me #1 and Gold When Black Wasn't Beautiful #1 2007. They incorporate jokes employing profane language and racial epithets taken from routines addressing racism, black culture and politics by stand-up comic Richard Pryor. The gags used highlight the discrepancy between the imagined and real Africa and the myth of black unity, and explode notions of racial harmony and pride. Ligon has commented that 'Pryor's genius is that his jokes ain't funny in any conventional sense. He makes you laugh, but you are laughing at incredibly painful and charged topics... Pryor is an archive... his routines are a catalogue of working-class black life... He spares no one – not even himself.'[59]

Adam Pendleton's work, such as his Black Dada 2008 and System of Display 2008–9 series, is concerned with language as an open structure, and alludes in a deliberately disjunctive manner to early twentieth-century modernism though the filter of conceptual art practices, the black arts movement and experimental poetry. System of Display combines references to diverse Black Atlantic modernisms and modernities, from a Dada performance through the display of Picasso's work and African art in the first Documenta exhibition in 1955 to a photographic studio in Nigeria or the Independence movement in

Ghana. He interrogates the notion of history and the archive and its assumed veracity, fixity and chronological integrity. As Pendleton's Black Dada manifesto states, 'Black Dada is a way to talk about the future while talking about the past. It is our present moment.'[60]

Examining modernism through the lens of the concept of a Black Atlantic does not furnish a comprehensive history any more than do canonical narratives of modernism. However, it does foreground different protagonists and highlights different contributions, problematising conventional accounts and making for a more complex field of study, as well as intimating further routes of investigation and relationships of exclusion and inclusion to be resolved. Gilroy's questioning of the temporality of modernity, the division between the modern and the postmodern, proposes a longer-standing strategy of syncretism and polyphony. Thus, simultaneous to Eurocentric versions of modernism, artists such as Tarsila do Amaral, Wifredo Lam, Uche Okeke and

Romare Bearden were creating challenging models which pre-empt and prefigure what would later be termed postmodernity. One way in which the concept of the Black Atlantic could be useful is to see how it enables a sense of connectedness to arise among different manifestations that could be said to share conceptual problems and find equivalent though unrelated solutions; thus the Brazilian anthropophagist notion of cannibalising Eurocentric modernism can be compared with Lam's commandeering of 'primitivism', effecting, as Andrea Guinta has called it, an 'appropriation of appropriation'.[61] Considering the ways in which other divergent modernisms – ones that developed, in contrast, from within hegemonic cultural bases – relate to these examples can also illuminate their special place within newly expanded histories of modernism. Thus, Gilroy's concept of a Black Atlantic can be used to establish a transnational and transhistorical revision of the story of modernism.

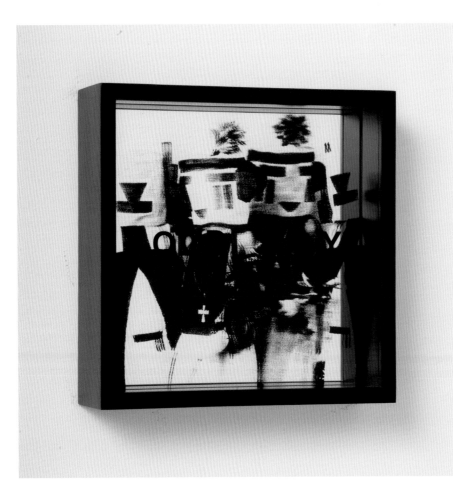

Adam Pendleton
System of Display, ODIY (Modernity/Dada dancers, Zurich, 1918) 2008–9

1 Édouard Glissant, *Poetics of Relation*, translated by Betsy Wing, Ann Arbor, University of Michigan Press, 1997, pp. 6–8.

2 Homi K. Bhabha, *The Location of Culture*, London and New York, Routledge, 1994, p. 1.

3 Robert Farris Thompson, 'Afro-Modernism', *Artforum*, Sept. 1991, pp. 91–94. Farris Thompson, however, was using the term to critique postmodernity, Bhabha's borderline of the present, and to ask 'Can anything really be post-now?'; but also to argue for the preservation of race-consciousness in art in order to redress the omissions from the history of modernism. Thus he asks '[why] use the word "post-Modern" when it may also mean "post-black"?' (p. 91). Farris Thompson's argument for a rewriting of modernism and its temporalities, and his emphasis on the impact of blackness on modernism, holds even if one does not accept his dismissal of either 'postmodern' or 'post-black'. Thelma Golden and Glenn Ligon's deployment of the term 'post-black' is very different, and more subtle, and is discussed below as well as in the conversation they had with Huey Copeland, also published in this volume. Frank Bowling quoted by Kobena Mercer in 'Black Atlantic Abstraction: Aubrey Williams and Frank Bowling', in Kobena Mercer (ed.), *Discrepant Abstraction*, London, Institute of International Visual Arts, 2006, p. 203.

4 Paul Gilroy, *The Black Atlantic: Modernity and Double Consciousness*, London and New York, Verso, 1993.

5 For instance, exhibitions in the UK alone such as *The Thin Black Line*, ICA, London, 1985; *The Other Story: Afro-Asian Artists in Post-War Britain*, Hayward Gallery, London, 1989; *Mirage: Enigmas of Race, Difference and Desire*, ICA, London, 1993; *Rhapsodies in Black: Art of the Harlem Renaissance*, Hayward Gallery, London, 1997; as well as elsewhere, including *The Short Century: Independence and Liberation Movements in Africa 1945–1994*, Museum Villa Stuck, Munich, 2001; and numerous publications, for instance the series of books edited by Kobena Mercer for the Institute for International Visual Arts, London, have made important contributions to this discourse.

6 Gilroy, *The Black Atlantic*, p. 15.

7 This comes out most clearly in his use of the motif of the ship as chronotope, which is discussed below.

8 Gilroy, *The Black Atlantic*, p. 106.

9 This is not the first time that Paul Gilroy's book has been taken as the starting point for an exhibition. An important exhibition titled *Der Black Atlantic* was organised by the Haus der Kulturen der Welt, Berlin, in 2004, and featured the work of Isaac Julien, Keith Piper, Lisl Ponger and Tim Sharpe, Jean-Paul Bourelly and Ismael Ivo. Gilroy's book has been both influential and controversial, though he does point out that 'Black Atlantic culture is ... massive and its history so little known', and that in his book he has 'scarcely done more than put down some preliminary markers for more detailed future investigations. My concerns are heuristic and my conclusions are strictly provisional. There are also many obvious omissions'; Gilroy, *The Black Atlantic*, p. xi. Lucy Evans has recently provided an invaluable summary of the critical reception of Gilroy's text in 'The Black Atlantic: Exploring Gilroy's Legacy', *Atlantic Studies*, 6.2, Aug. 2009, pp. 255–68; in addition, Walter Goebel and Saskia Schabio (eds.), *Beyond the Black Atlantic: Relocating Modernism and Technology*, London, Routledge, 2006, provides a collection of detailed responses; for a more critical stance, see David Scott, *Refashioning Futures: Criticism after Postcoloniality*, Princeton, Princeton University Press, 1999.

10 'Appendix: Table of the Diaspora', in Édouard Glissant, *Caribbean Discourse: Selected Essays*, translated and introduction by J. Michael Dash, Charlottesville, Caraf Books, University Press of Virginia, 1989, pp. 258–59, and Dash, p. xxix.

11 Petrine Archer-Straw, *Negrophilia: Avant-Garde Paris and Black Culture in the 1920s*, London, Thames & Hudson, 2000, p. 9.

12 James Baldwin, 'James Baldwin Breaks His Silence', in Fred L. Stanley and Louis H. Pratt (eds.), *Conversations with James Baldwin*, University Press of Mississippi, Jackson, 1989, p.60. For an in depth discussion of the relationship of black artists and performers to modernism and some of the problems that qualified their participation, see Archer-Straw's *Negrophilia*, ibid., and Jeffrey Stewart's essay 'Paul Robeson and the Problem of Modernism' in *Rhapsodies in Black*, op cit., pp.90–101. For African-American artists and writers in Europe see *Explorations in the City of Light: African American Artists in Paris 1945–1965*, The Studio Museum in Harlem, New York, 1996

13 Farris Thompson, 'Afro-Modernism', p. 92.

14 Susan Earle (ed.), *Aaron Douglas: African American Modernist*, New Haven and London, Yale University Press, 2007, p. 107.

15 This lack within Douglas's stylised use of silhouette was taken up and its optimism forcefully subverted by Kara Walker.

16 Slavery was not abolished until 1888 in Brazil, the last nation in the Western hemisphere to abolish it; thus Tarsila's experience was of the immediate aftermath of slavery.

17 Dawn Ades, *Art in Latin America: The Modern Era, 1820–1980*, London, Hayward Gallery, 1989, p. 133.

18 Andrea Guinta, 'Strategies of Modernity in Latin America', in Gerardo Mosquera (ed.), *Beyond the Fantastic: Contemporary Art Criticism from Latin America*, Cambridge, MA, MIT Press, 1995, p. 55.

19 Ades, *Art in Latin America*, pp. 133–134. It is for this reason that the strategies delineated by Antropofagia were later to prove such an important basis for the *Tropicalia* countercultural movement of the 1960s and 1970s, which foregrounded Brazil's hybridity and its Afro-Brazilian heritage.

20 The film was only assembled posthumously in 1977, at which point its rather traditional, ethnographically toned voice-over reading extracts from Deren's book was also applied.

21 Such Vodun gods and ceremonies recorded by Deren remain an important source of inspiration for the visual arts of the Caribbean, surfacing in the work of numerous artists, from Wifredo Lam and Agustín Cárdenas to Marta Maria Pérez Bravo, Ana Mendieta and Tania Bruguera.

22 It was occupied by US forces between 1915 and 1934.

23 C.L.R. James, *The Black Jacobins*, London, Penguin Books, 2001 [1938]. The Appendix, added in 1963 following the Cuban Revolution, argued that 'West Indians first became aware of themselves as a people in the Haitian Revolution', p. 305.

24 The title 'Black Orpheus' establishes a web of transatlantic connections: Sartre's essay 'Orphée noir' (Black Orpheus) from 1948, introducing Leopold Senghor's *Anthologie de la nouvelle poésie nègre et malgache de langue française* (and later issued independently by the Présence Africaine press) inaugurated a reflection on Négritude in literature and politics. From 1957, *Black Orpheus* also became the title for the Nigerian journal edited by Ulli Beier (who was inspired to found it by Alioune Diop's Paris-based Présence Africaine); Wole Soyinka and Es'kia Mphahlele and issued in Ibadan by the Mbari Club (which was closely associated with the Natural Synthesis movement); it contained writing by African, African-American and West Indian intellectuals and artists. Finally, *Orfeu Negro* was the title of Marcel Camus' film of 1959, which set a contemporary retelling of the myth of Orpheus within Rio de Janeiro's favelas and carnival.

25 Guinta, 'Strategies of Modernity in Latin America', p. 62.

26 Gerardo Mosquera, 'Modernism from Afro-America: Wifredo Lam', in *Beyond the Fantastic*, p. 121.

27 Robert Linsley, 'Wifredo Lam: Painter of Negritude', Art History, 11.4, Dec. 1988, pp. 527–44. Mosquera comments that Lam's work can be 'related to Negritude as conscious and neological construction of a black paradigm'; 'Wifredo Lam', p. 126.

28 Lam's work, for Mosquera, can be seen as 'a result of Cuban and Caribbean culture and as a pioneering contribution to the role of the Third World in the contemporary world'. Furthermore, 'the intercultural dialogue implicit in Lam's work is an example of the advantageous use of "ontological" diversity in the ethnogenesis of the new Latin American nationalities, of which the Caribbean is paradigmatic'; Mosquera, 'Wifredo Lam', pp. 121 and 123.

29 Guinta, 'Strategies of Modernity in Latin America', p. 63. Mosquera makes the substantial, and rather more problematic, claim that Lam was 'the first artist to offer a vision from the African element in the Americas'; 'Wifredo Lam', p. 123.

30 See Lowery Stokes Sims, 'The Post-Modern Modernism of Wifredo Lam', in Kobena Mercer (ed.), *Cosmopolitan Modernisms*, Cambridge, MA, and London, MIT Press and Institute of International Visual Arts, 2005, p. 86. Mosquera had made a similar observation, though less directly, in relation to Brazilian modernism, which he sees as 'heralding postmodernism'; 'Wifredo Lam', p. 122.

31 Glissant, 'Seven Landscapes for the Sculptures of Agustin Cardenas', in *Caribbean Discourse*, p. 241.

32 For an in-depth discussion see Elizabeth Harney, 'The Ecole de Dakar: Pan-Africanism in Paint and Textile', African Arts, 35.3, Autumn 2002, pp. 12–31 and 88–90.

33 Uche Okeke, 'Natural Synthesis', in Okwei Enwezor (ed.), *The Short Century and Liberation Movements in Africa 1945–1994*, Munich and London, Prestel, 2001, p. 453.

34 Ibid.

35 Paulo Herkenhoff, 'Constructive Congá: Rubem Valentim', in *Pincelada: Pintura e Método, Projeções da Década de 50*, São Paulo, Instituto Tomie Otake, 2006, p. 184. I would like to thank Paulo Herkenhoff for bringing his text to my attention.

36 Ibid.

37 Ibid.

38 In his youth Lewis worked for two years on ocean freighters, travelling extensively as a result, and thus is perhaps another exemplar of Black Atlantic mobility.

39 Lewis and Bearden had been fellow members of the 306 group of artists and writers during the 1930s, which also included Ralph Ellison and Jacob Lawrence.

40 Such works can be considered the antecedents of Ofili and Mutu's complicated and contentious use of collage.
Judith Wilson, 'Getting Down to Get Over: Romare Bearden's Use of Pornography and the Problem of the Black Female Body in Afro-US Art', in Feminism-Art-Theory: An Anthology 1968–2000, Blackwell Publishers Ltd, Oxford, 2001, p.274.

41 Lorraine O'Grady, 'Olympia's Maid: Reclaiming Black Female Subjectivity', online at http://lorraineogrady.com/sites/default/files/wr10 2_olympiasmaidfull.pdf, © Lorraine O'Grady, 1992, 1994, p.5–6.

42 In 1968, the year in which Hammons began his body print series, all forms of segregation were declared unconstitutional by the Supreme Court, though it was also the year in which Civil Rights leader Martin Luther King Jr was assassinated.

43 Kellie Jones, 'The Structure of Myth and the Potency of Magic', in *Rousing the Rubble*, New York, PS1 Museum, 1991, p. 16.

44 Echoing Oiticica's slogan 'Seja marginal, seja herói' or 'Be a marginal, be a hero'.

45 Michael Asbury, 'Hélio não Tinha Ginga (Hélio Couldn't Dance)', in Paula Braga (ed.), *Fios Soltos: A Arte de Hélio Oiticica (Loose Threads: The Art of Hélio Oiticica)*, São Paulo, Editora Perspectiva, 2008, p. 53. Asbury highlights the fact that the 'overwhelming emphasis on the artist's involvement with Mangueira, with Samba and the architecture, environment and culture of the favela' has led to a significant imbalance in discussions of his work.

46 This has meant that it is impossible to date Bispo's works with any accuracy.

47 Lemanjá (also known in Brazil as Yemanjá or Janaína) exists in various forms around the Black Atlantic; for instance in Haitian Vodou she is La Sirène, while in South Africa she becomes Mami Wata.

48 bell hooks, 'Altars of Sacrifice: Re-membering Basquiat – Artist Jean-Michel Basquiat', Art in America, June 1993, p. 71.

49 Gilroy, *The Black Atlantic*, pp. 16–17.

50 Ibid., p. 4.

51 Glissant, *Poetics of Relation*, p. 7.

52 Ibid., p. 8.

53 As Petrine Archer's essay in this publication demonstrates.

54 O'Grady, op cit, p. 2, p. 9.

55 Sarah Bartmann (1790–1815), or Saartjie Baartman in Afrikaans, was a Khoi-San (or Hottentot) woman from Cape Town, South Africa, who was brought to England in 1810 and displayed as a sideshow attraction in London and Paris to demonstrate the alleged anatomical distortions of the black female, particularly the size and shape of her buttocks.

56 Octavio Zaya, 'From Text to Action in the Work of Candice Breitz', in *Candice Breitz: Multiple Exposure*, Leon, MUSAC, 2007, p. 21.

57 Gilroy, *The Black Atlantic*, p. 32.

58 Thelma Golden, 'Post…', in *Freestyle*, New York, The Studio Museum in Harlem, 2001, p. 4.

59 Glenn Ligon, interviewed by Malik Gaines in *Glenn Ligon: Text Paintings 1990–2004*, Los Angeles, Regen Projects, 2004, p. 2.

60 Adam Pendleton, 'Black Dada Manifesto', quoted in *Adam Pendleton El T D K*, Berlin, Haunch of Venison, 2009, p. 26.

61 Guinta, 'Strategies of Modernity in Latin America', p. 61.

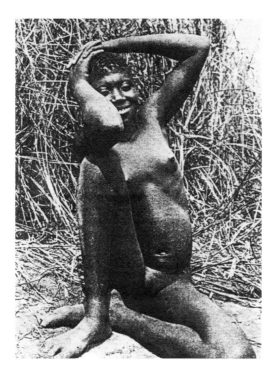 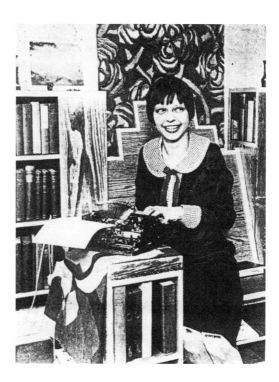

Le Paradis des Nègres
Variete Paris, 1929

NEGROPHILIA, DIASPORA, AND MOMENTS OF CRISIS

PETRINE ARCHER

How can my Muse want subject to invent,
While thou dost breathe, that pour'st into my verse
Thine own sweet argument, too excellent
For every vulgar paper to rehearse?

William Shakespeare, Sonnet 38

Under the title *Le Paradis des Nègres* or *Black Paradise*, photographs of two young women are juxtaposed in typical Surrealist fashion.[1] The first, a young woman from the Congo, is posed naked against a backdrop of the forest's long grass. Although her genitalia are available to us, we sense her shyness in the way her body angles itself away from the camera and how she raises her arm to shield herself from our intrusive gaze. By contrast, the second image shows a confident, stylishly dressed woman seated at a typewriter, surrounded by the trappings of urban life. Its caption, *The Next Year in Harlem*, completes this shocking diptych contrasting primitive existence and civilisation.[2] The viewer is asked to believe that these women are one and the same, and that the first model has somehow been transformed into the second, via the Atlantic and modernity.

That we can decode these images so easily signals the immutable nature of their provocative vocabulary; the way that a visual lexicon related to the black body and race has become engrained in our psyches; and also the fact that deconstruction has become part of our way of seeing and thinking. What is less easy to unpack is the powerful space conjoining them, which requires a move beyond Surrealist ideas of metamorphosis towards an understanding of the diaspora itself as a discursive form related to scattering, difference and multiplicity. The painful passage between the bodies of these two women leads us in many directions, all of which are valid markers of diaspora existence and identity.

It is their relationship to each other that makes our reading of these pictures so potent and disturbing. Combined, they convey the sense of awe and curiosity many Europeans felt when first confronted with the reality of black people who made their way into their cities, mainly after the First World War. In the case of these images that moment was 1929, when stage shows such as the *Black Birds* were 'all the rage' and when discharged African-American soldiers, rebelling against the prospect of returning to American segregation, opted to stay in Europe and survive by their skills in singing and dancing, and by their wits.[3] We can thank the Belgian Surrealists for having the audacity to document this moment and for employing this strategy of juxtaposition that conveys the complexity of black identity and its relationship to modernity during that time.

Published in the topical Belgian magazine *Variétés* that circulated in Paris in 1929,[4] this image formed part of a more complex photographic layout that allowed coupled photographs to relate to others.[5] The intention was probably that this image be read dialectically, presenting Surrealist ideas about beauty in a synthesised statement that pitted the African savage state against conventional bourgeois values. Today, our postmodern eyes see much more and our questions are multiple. Why are both women smiling? What is the significance of the books and abstract paintings in the background? Is the nakedness of our dusty-footed model gratuitous, and ought we to place a judgment on the smooth stockinged legs of the other? Is this a critique of the harshness of Belgian colonial rule in the Congo in contrast to that of the French?[6] Is this transformation positive or an indictment of civilisation and the modern condition? Whether binary or multivalent, past or present, our reading of these women is all the more vexed because we also know that we are being manipulated. We sense the Surrealist game that points our curiosity beyond their frames. The power of their juxtaposition rests not so much in their comparison but in what is left unsaid about the incongruity of blackness and modernity.[7]

In many ways, it is the 'distance' between our Congo and Harlem models that lies at the heart of *Afro Modern: Journeys through the Black Atlantic*, since this exhibition uses as its starting point Paul Gilroy's view that diasporic Africans' experience of trans-shipment and relocation was an entirely modern one that transformed them. Forcibly removed from Africa and re-birthed in the Atlantic on the most modern vessels, diaspora blacks were crucial to capitalist enterprise and plantation economies that relied on their labour to produce sugar, cotton, tobacco and more. The contingency of their New World lives shaped their formation of imagined communities and identities based on transposed cultural forms and a forced consciousness of race and its restrictions. In turn, these identities were fashioned in contact with, and in contrast with, other black transnational formations according to their colonial contexts and the continued mobilisation and emigration of these peoples. Gilroy tells us that the 'history of the Black Atlantic yields a course of lessons as to the instability

and mutability of identities which are always unfinished, always being remade'.[8] He further notes that, as a result of this rupture, return is impossible. Diaspora blacks can no longer trace a straight line to an African past via ritual and tradition. Instead, they must acknowledge and embrace a global citizenship that is syncretic and culturally diverse.

This history of the Black Atlantic is not about the African diaspora alone, since it was the European slave trade that set in motion this scattering of African peoples and their subsequent cultural dislocation and hybridisation. The restless migratory patterns of diaspora blacks since their removal from Africa have left their communities in constant motion, peoples of the sea, forever looping back to points of entanglement rather than to their origins. As 'black Westerners',[9] their movement into the metropolis of their long-time masters has meant that their host cultures too have absorbed and been absorbed by this process of syncretism. In this sense, Malcolm Bailey's Hold, *Separate but Equal* 1969 is poignant. Fashioned after abolitionist tract illustrations, the diagrammatic bare bones of a slave ship float against a stark glossy polymer azure sea. Deep inside the womb of this vessel, black and white bodies crouch. Although separated, both groups are equally bent low under the weight of slavery, suggesting that we are all implicated in this history of the Middle Passage and that, in turn, we must all bear the burden of its consequences.[10]

Yet this acknowledgement of a shared history is only recent, and what is ultimately disconcerting about the photograph *Le Paradis des Nègres* is that its authors are undeclared, silent, but complicit in their presentation of a diaspora identity. The image itself is telling: its fetishisation, ribald nakedness and split-screen shock value reveal how Surrealism's most radical aspirations for Africans influenced the shaping of their double identity. Our models smile as if to remind us that any project that recuperates the ambivalence of contemporary black identity in 1920s' Paris must also take account of the identity crisis of the European avant-garde in the same period.

Referencing a handful of books and articles, including Paul Gilroy's *Black Atlantic*, my own *Negrophilia*,[11] and the Surrealist journal *Documents*,[12] this essay explores how the

Malcolm Bailey
**Hold, Separate but
Equal** 1969

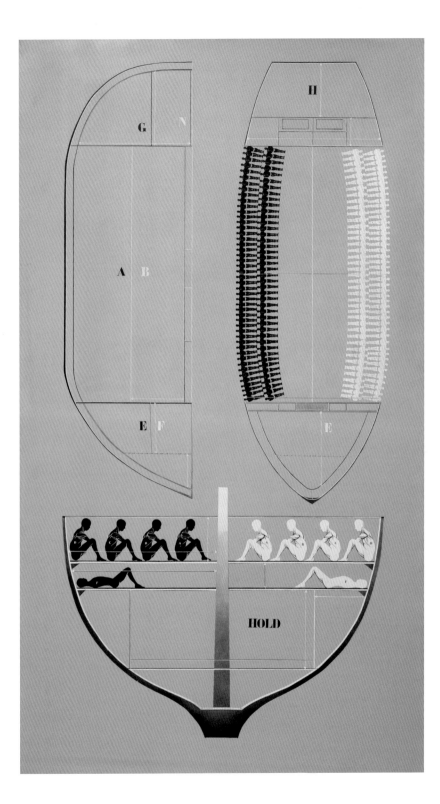

ambivalent (and multivalent) nature of the black model as muse was deployed by the Parisian vanguard to promote their ideas of the primitive, and how their fascination with African sculpture was transferred to the black body using fetishised and coded imagery that was pejorative but fashionable. Conversely, this text also considers how African-American artists such as Hayden Palmer, in their desire to be viewed as modern, responded to this vogue for blackness, painting in ways that reinforced mischaracterisations and favoured humour. Finally, I track the ways in which the racial signifiers embedded in this *genre noir*, usually ignored by art historians, are currently being undermined by contemporary artists prepared to exploit their own black bodies. By looking at the images of Paris's vanguard artists alongside contemporary artworks such as Sonia Boyce's *From Tarzan to Rambo* 1987, Chris Ofili's *Captain Shit* 1998, or Ellen Gallagher's *DeLuxe* 2004–5, we can consider the high stakes involved in exposing such racialised imagery today.

AMUSEMENT

Why 1920s' Paris should be our starting point as the city where a conjunction of creativity, racial identity, and an infatuation with difference emerged requires an understanding of its bohemian communities, their post-war anxieties and France's historical attitudes towards black people and Africa. Since the French Revolution, *liberté, égalité, fraternité* had helped to support a response to 'others' that stressed assimilation and accommodation (albeit a stifling one) within France's own sense of imperial destiny. French interest in France's colonised subjects, especially Africans, went beyond economic considerations. In addition to mainstream patronage and a colonial mission to 'improve' black people, the avant-garde's admiration and borrowing of black forms, which they called *les fetishes*, satisfied their need for a sense of the magical and spiritual that had been lost in their increasingly materialistic and mechanised society. The assimilation of black forms into the subculture of Paris was remedial and therapeutic, especially after the First World War decimated the city's youth and left its survivors disillusioned and militant.

The avant-garde's first encounters with Africa and black culture came via their admiration for African sculptures, which, as a result of colonial trade and pillaging, found their way into the hands of collectors and museums at the beginning of the new century. Initially, these *objets d'art* went under the generic labels *l'art nègre*, indicating a general ignorance about their origins, and *les fetishes*, another term suggesting their magical potency. That the fascination they exerted was a mere flirtation with 'otherness' is reflected in the cover illustration for *La Vie Parisienne* from 25 October 1919. A skimpily dressed flapper stares coyly back at a highly embellished sculpture of a life-size female form. The carving is animated, alert and fecund, while our flapper, despite her best efforts at mimicry, is – as the cover's title suggests – a 'pale imitation' of the object she admires. Her backward glance might even denote the way in which the avant-garde viewed these *objets d'art* as part of an ill-defined primitive past.

This flapper's infatuation has come to be labelled 'negrophilia', from the French *négrophilie*, a term used by avant-garde artists themselves to affirm a passion for things African that was temporary and defiant. Their love of black culture paralleled the innovations and cultural borrowing reflected in modernist art as well as the rebellious postures associated with their 'outsider' status. African objects were considered sources of divine inspiration, and by musing on them modern artists believed they could tap into new dimensions of creativity. Both these sentiments are evident in Picasso's recollection of his first encounter with *l'art nègre* after stumbling across African items in the Trocadéro. He recalled:

> Those masks weren't just pieces of sculptures like the rest, not in the least, they were magic things … those negroes were intercessors, that's a word I've known in French since then. They were against everything, against unknown threatening spirits … I kept on staring at the fetishes. Then it came to me, I too was against everything … I too felt everything was unknown, hostile! The All …[13]

Negrophilia, Diaspora, and Moments of Crisis

Man Ray's *Noire et Blanche* photographs echo this empathy and embodiment of blackness. The head of Kiki de Montparnasse is placed alongside an inanimate mask in a set of compositions that introduce Man Ray's solarisation techniques. Reversed, the mask appears white and Kiki's face is blackened. The objectification and isolation of both images and the removal of any context allows them to be viewed as equal, to trade each other's differences and enhance their similarities.

Man Ray's choice of a Baule mask also reflected the *vogue nègre* and the growing discernment of artists and collectors as their knowledge of African art increased and the collection of ethnographic objects became more fashionable.[14] The legitimisation of *l'art nègre* came out of a mutual exchange of ideas and activities between ethnographers and artists in the post-war years. An inter-disciplinary network of researchers, collectors and connoisseurs involved in the research and promotion of 'primitive' art and cultures developed between Europe and North America, including aestheticians such as Paul Guillaume, Henry Clouzot and André Level in Paris, Carl Einstein and Eckart von Sydow in Germany, Roger Fry in London and Marius de Zayas, Thomas Munro and Albert C. Barnes in New York and Philadelphia. Academic theories about origin, function and meaning merged with avant-garde Surrealist thinking that aestheticised ethnographic objects and promoted the 'primitive' as central to modern life.

After the war, this interest in *l'art nègre* was reinforced by the popularity of African-American stage revues that introduced contemporary black culture to vanguard Paris. These spectacles featured the new sound of jazz and comic skits overlain with coded conventions related to minstrelsy that had operated in white American and European cities since the nineteenth century, and had been present in Western mythology since its inspirational Greek muses fell from grace, formed a band, and became sources of amusement. Even before black people began performing for white audiences, whites blackened their own faces to provide entertainment in circuses and theatres. The black-faced banjo-playing minstrels allowed whites to laugh at their negative characteristics under the

Pale imitation from
La Vie Parisienne
25 October 1919

guise of blackness. Black people's mimicry of these acts in vaudeville and European music halls continued their roles as jesters and entertainers. Later, shows such as *La Revue nègre*, including performances by Josephine Baker with her facial contortions and goofing around, allowed whites to laugh at human frailty without having to compromise their own identities.

In many ways, the European avant-garde's adoption of negrophilia was a form of minstrelsy that allowed them to call each other 'nègriers', acquire alter egos and act out fantasies that they perceived as African. Their pranks were viewed in pathological terms, referencing malady or mental illness such as *virus noir*, *melanomania*, *l'épidémie*, *négropathie* and *la rage* that suggested a contagion but also allowed those who suffered its sickness to disclaim responsibility and divorce themselves from their normal identities. The caricature of Josephine Baker's biographer Marcel Sauvage wearing the infamous banana skirt that shot her to stardom in her revue perfectly (if crassly) captures his sense of black possession and also confirms the avant-garde's self-identification with negrophilia's madness.[15] Baker's more erotically charged and frenzied

gyrations led artists to think that they had rediscovered Baudelaire's *Vénus Noire*, an erotic black muse who could open the doorway to their inner souls.

Although it may have suited Parisians to believe that the blacks with whom they 'hung out' were authentic Africans and spiritual intercessors, this was far from the case. African-Americans eager to enter white society accentuated the more entertaining aspects of their culture by exploiting their talents and commodifying primitivist stereotypes to meet the needs of their white audiences. They found that white interest in dances such as the Charleston, the Lindy Hop, the Black Bottom and the Shimmy could earn them a significant income. Their blackness qualified them for modernity, but to participate in it they had to negotiate, straddle, distort and deny their identities and accommodate a European taste for vitality, sexual potency and Africa.

Cultural analyst Brent Hayes Edwards, discussing negrophilia and its relationship to diaspora blacks in Paris, questions its appropriateness as a theoretical construct. Although the city's negrophilia represented a passion for black culture, its preoccupations were still

Man Ray
Noire et blanche (negative)
1926

Negrophilia, Diaspora, and Moments of Crisis

those of the white avant-garde that skewed the experience of blackness. Hayes Edwards uses the term *crise nègre*, also employed by ethnographer Michel Leiris as a negative commentary on Paris's infatuation with African culture,[16] to show that the real crisis was that experienced by blacks as a result of their cultural dislocation and their inability to communicate their own sense of being modern to their white vanguard colleagues.[17] African-Americans saw their use of African idioms as a compliment to their New Negro ideals and modernity. Contemporary cultural expressions such as jazz were meant to counter racist stereotypes and position the culture of diaspora Africans as contemporary. But the white avant-garde's preoccupation with primitivism and atavistic transgression closed down this sense of modernity in favour of a black identity that was misunderstood and misrepresented. Hayes Edwards redefines *crise nègre* as 'a crisis of representation: the modernity of black performance [is] an expression [that] clashes with the mirage of a silent, distant "ethnic" primitive'. For Hayes Edwards, the ultimate crisis for African-Americans was the difficulty of articulating their very existence as part of a modern experience.

Understandably, the diaspora blacks who made a second crossing of the Atlantic to Europe viewed themselves as pioneers and as modern. Their arrival in Paris was a continuation of their journey towards self-improvement and racial equality initiated by their urban migrations to cities such as Chicago, Washington and New York a century before. After the war, Paris became the European hub for blacks from all over the diaspora, including Africa, the Antilles and America, where they discovered their commonality with each other in ways that had not been possible in the United States. Guided by thinkers such as W.E.B. Du Bois and Marcus Garvey, this intelligentsia used the city as a base for the promotion of a pan-African unity and the establishment of political movements: the Pan-African Congress was first convened in Paris in 1919. Additionally, in the arts, the transatlantic crossings of artists such as Palmer Hayden, Augusta Savage, Henry O. Tanner and Lois Mailou Jones, writers Countee Cullen and Joel Rogers, and intellectuals such as Alain Locke laid a network for cultural exchange

Marcel Sauvage
Voyages et adventure de Josephine Baker
Paris, 1932

between Europe's avant-garde and the vanguard of New York's Harlem Renaissance. In Paris's poorer quarters such as Montmartre, diaspora blacks also mingled easily with other immigrants, developing their own sense of being part of a wider diaspora that was creative and cosmopolitan.

Images of this immigrant community painted by black artists at the time are few. So it is not surprising that much has been written about Palmer Hayden's *We Four in Paris* (*Nous Quatre à Paris*) c.1930, which captures the artist and friends relaxing over a game of cards in a Montmartre café. More crucially, that discussion has been contentious because of the style of the painting. Although the card players face each other around the table, their heads are angled sharply outwards, emphasising their exaggeratedly negroid physiognomies: big lips, flared nostrils and minstrelised features. For this rare and intimate insight into immigrant life to be depicted by Hayden in a stylised and pejorative vernacular that mimics the primitivist vogue is troubling. Is this parody, or a crisis of self-representation peculiar to this moment?

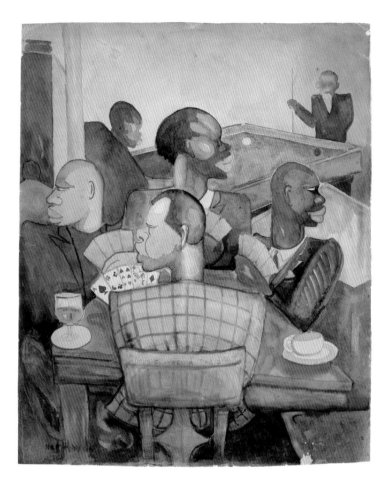

Iris Schmeisser generously views Hayden's work as 'strikingly and self-consciously ironical', although she believes that it was not actually created in 1930 but painted from memory in the artist's later illustrative style.[18] But comparison of this work with another, *Bal Jeuneuse*, from around 1927, might suggest otherwise. *Bal Jeuneuse* again features blacks in a Montmartre haunt, but this time they are creoles performing the *biguine*, a courtly dance favoured by the more 'colonial' Caribbeans. Hayden depicts these Antillians and their setting with greater sensitivity and little use of caricature. Considered alongside *Nous Quatre à Paris*, and even *Variété's Le Paradis des Nègres*, it is possible to frame another equally surreal juxtaposition that speaks of the temporal and cultural

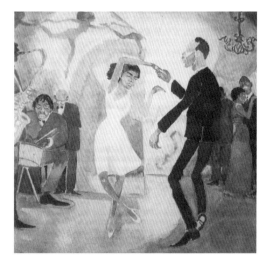

differences between the two distinct diaspora communities. Is it possible that Hayden's detailing of this club, with its old-world chandelier and swirling backdrop, is a reflection on the Antillians' colonial charm and gentility, as opposed to his jazzy comic-book-like illustration of African-Americans that negatively reflects an aberrant modernity? This disparity in Hayden's work could be read positively as an indication of the cultural diversity he encountered within the diaspora, or more negatively as a commentary on the distortions he saw reflected in his fellow African-Americans.

Although contemporaries of Hayden, such as Harlem intellectual Alain Locke, were wary of this type of racial essentialising as part of black thinking about cultural reconstruction, their French hosts' passion for l'art nègre made such distortions inevitable. As we have seen, the black vanguard relied on European ethnographic sources for their understanding of African arts, and were indebted to vogue noire for their sense of modernity. As a result, their black diaspora identities hinged on a negrophilia that misrepresented both Africa and contemporary blackness. This is the crisis embedded in depictions of black people during this time that makes images such as Nous Quatre à Paris or Le Paradis des Nègres and other Surrealist photography so troubling, and that makes a return to Surrealism in 1929, and an understanding of the rivalry and dissident discourse behind its imagery, so critical.

VULGAR PAPER

Le Paradis des Nègres appeared in the March 1929 issue of Variétés, a periodical that was not strictly a Surrealist magazine but a current affairs monthly that featured Surrealism among its other topical interests. That summer, Variétés published a special issue devoted to Surrealism titled Surrealisme 1929, edited by André Breton and featuring significant artists and writers including Freud, Eluard, Péret, Sadoul, Aragon and Mesens. Tellingly, despite its avowed intention of presenting Surrealism in all its manifestations, this special publication did not list

among its contributors the fringe group of Surrealists led by Georges Bataille, who launched their own publication, called Documents, in the same year. Bataille's part-Surrealist, part-ethnographic preoccupations would be more fully expressed in this dissident magazine, which pushed even further the subversive quality of visual essays such as Le Paradis des Nègres. Documents remastered the Surrealist art of disquiet by combining even more disparate and decontextualised images in photographic compositions that bled at their edges and silently ruptured their frames.

Art historians Fiona Bradley and Dawn Ades, offering a comparative summary of Surrealist publications from 1929, clearly nominate Documents as the most provocative, specialising in visual manipulation and strategies of subversion. They argue that 'whereas Variétés made a game, very simply decoded, of comparing or contrasting pairs of images … Documents' use of "resemblance" drew visual and thematic parallels, hilarious and shocking, that undermined categories and the search for meaning'. They also recognise the rivalry between Documents and other Surrealist publications, and Bataille's method of critiquing other magazines by rehashing their pages and re-presenting imagery in even more outrageous ways: 'Not infrequently, Documents picked the same topic as one just discussed in another magazine but wholly subverted the spirit of the original article'.[19]

So perhaps it is no accident that the fourth issue of Documents, published in September 1929, added the subject of 'variétés' to its own content and introduced the young but budding ethnographer Michel Leiris in the role of cultural analyst, commenting on current events, jazz, music-hall stars, cinema and photography, alongside art, archaeology and ethnographic issues.[20] This new feature, combined with André Schaeffer's music column Phonographie, and Bataille's 'key words', Chronique: Dictionaire, revealed Documents' developing interest in black culture and in the current popular revue Black Birds, whose subject matter was thematically interwoven into many areas of the journal.

This preoccupation also reflected the fact that all three men had become frequent visitors to nightclubs such as

Page from **Documents no. 4** 1929

Le Grand Duc, Bricktops and other black haunts in Montmartre, where they could interact with actual black people and listen to live jazz. Leiris, describing his feelings after viewing the *Black Birds* show, wistfully summarised such encounters as his *moments de crise* – sudden revelatory experiences that collapsed the real and surreal worlds, 'when the outside seems abruptly to respond to a call from within, when the exterior world opens itself and a sudden communication forms between it and our heart'.[21]

In contrast, Bataille's evaluation of black culture was less romanticised. Unlike other Surrealists, Bataille did not primitivise African-Americans. Instead, he recognised their cultural expression as modern and he theorised about it in uncompromising, realistic and critical terms. Rather than valorising the diaspora experience, he considered African-Americans equally afflicted by the scourge of white civilisation. He described their contemporary culture with its jazz, spirituals and other forms of expression as an aberrant and necessary detritus resulting from their arrested development and their diaspora existence within civilisation's wasteland. Refusing idealism, Bataille challenged most notions of Surrealism and was a controversial advocate of black culture.

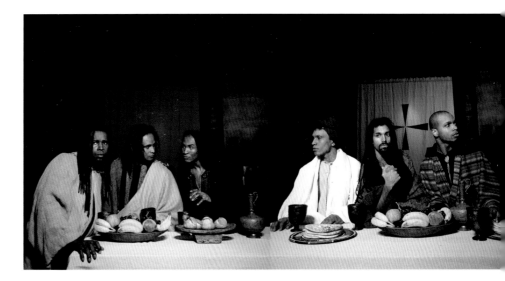

Renée Cox
Yo Mama's Last Supper 1996

Negrophilia, Diaspora, and Moments of Crisis

Subjecting black people to his concept of formlessness (l'informe), Bataille juxtaposed images and ideas in pairs, guided by resemblance and an absence of predictability or bourgeois sensibility. In this way, photographs of Bessie Love's dance troupe could be posed alongside a regimented group of African teenaged soldiers, or a young girl in Harlem could resemble a pygmy. But unlike the other Surrealists, Bataille did not contrast images for the sake of arriving at a synthesis. Instead, he worked with and between images – within the non-tangible spaces related to their meanings – to create new forms of articulation. Le Paradis des Nègres and Documents' photographic compositions related to blackness echoed the same style. Bataille understood that the relationship between the African and the African-American existence resembled an aching gap that is painful but also productive – a creative energy that emanates from both their difference and their misunderstanding. In spite of its visual crudeness, Bataille's imagery opened up a whole other way to reference the diaspora's black body, a way that inheres not so much in its form but in its signifiers. A closer reading of Bataille's juxtapositions can deepen our understanding of racial discourse and these hidden meanings.[22]

THINE OWN SWEET ARGUMENT

Beyond art history, the task of examining these constructs has been taken up by contemporary diaspora artists prepared to explore the fictions and frictions around the black body to understand what and how they signify. They have embraced the stereotypes of blackness in their own work in order to dismantle them from the inside out, using what Stuart Hall has theorised as a 'turn' – a strategy that calls for a risky journey into the morass of their origins.[23] He describes how these artists are using the black body as a moving signifier 'on which to conduct an exploration into the inner landscapes of black subjectivity', and understanding the body 'as a point of convergence for the materialization of intersecting planes of difference – the gendered body, the sexual body, the body as subject, rather than simply the object of looking and desire'.

This strategy obviously has its ironies, notably the fact that the black diaspora's postmodern artists are challenging representations of blackness using dissident Surrealism's strategies of inversion and subversion. They deploy methods similar to those of Bataille to shock

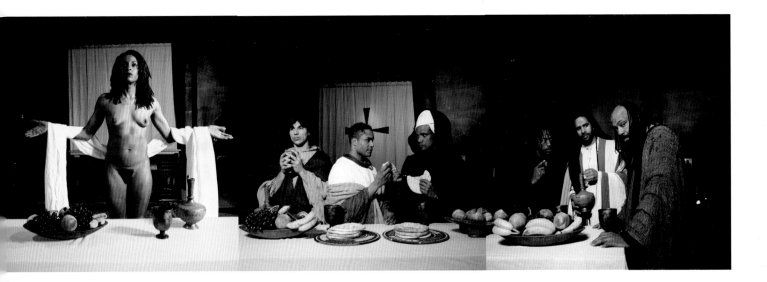

contemporary sensibilities towards new moments of crisis and recognition. Think, for instance, about the big lips, bulging eyes and golliwogs in Sonia Boyce's *Tarzan to Rambo* 1987, or consider the intersection of beautiful black bodies with flora and masks in the poignant work of Rotimi-Fani Kayode.[24] Sometimes these interventions speak to a particular 'moment' that can be healed by their re-presentation, as in Ellen Gallagher's squiggly curls and wigs for *DeLuxe* 2004–5. Sometimes the wounds of misrepresentation are still too raw, so that they register laughter as a sign of avoidance, embarrassment, disgust or self-hate, as with the elephant dung and use of parody in Chris Ofili's *Captain Shit* 1997.

In so many different ways, these diaspora artists make the very precarious return journey into the belly of the floating beast, crouching low to disembowel its fetid fictions and tease out new meanings for their work. Sometimes, like the characters in a minstrel show, they are predictable and pathetic in the way they unwittingly repeat the same abject history and racial discourse. But often that recovery is complete, so that we cannot think of one stereotype without its subversive other. Remember Aunt Jemima's tight grip on a tiny hand-grenade in Betty Saar's *Imitation of Life* 1973, or Renée Cox's Jesus standing brazenly bare-breasted in her *Yo Mama's Last Supper* 1996? Both prove it is possible to be liberated from the womb of the Middle Passage, slavery and the white shadows of worn Western parody.

The multiplicity of forms taken by these contemporary artworks and their numerous meanings show the ways in which artists of the African diaspora are filling the painful gaps once inhabited by muses, minstrels and maniacs with their own narratives and bodies of meaning. No longer the static and fixed objects of avant-garde scrutiny and desire, they are swimming in the margins, moving, morphing, re-creating and changing, changing, changing…

1 See *Variétés*, 11, 15 March 1929, between pp. 612 and 613. The translation *Black Paradise* is mine; the literal translation is 'Paradise of the Blacks', which has an even more pejorative tone.

2 I owe a debt of gratitude to Tate curator Matthew Gale, who first brought this image to my attention over twenty years ago. He has since suggested that this image may have led to the refusal of *Variétés*' distributors to handle the issue, which was later made available directly from its Brussels office: 'Presumably it was the frank pose more than her nudity that caused the difficulty, as other Congolese photos showing scarification appeared in earlier issues. Interesting that there was no direct defence, but, instead, an offer to distribute the issue directly' (letter to author, 5 October 2009).

3 Lew Leslie's *Black Birds*, with female star Florence Mills, first performed in Paris in 1927. They returned in 1929 with a new star, Adelaide Hall, and a show based on Du Bois Heyward's *Porgy* (New York, 1925), which proved a big success.

4 Although the Brussels-based *Variétés* was not a Surrealist review, it had strong ties with Surrealism and accepted contributions from the movement's Belgian and French artists. Profusely illustrated, *Variétés* featured artworks by Dufy, Picasso, Arp and Magritte, and photographs by Man Ray and Atget. The Belgian E.L.T. Mesens acted as a link between the two groups; he selected articles and did the layouts for illustrations.

5 The sequence was titled *Beautés* and included the following pairings: a modern beauty salon next to women in a palm court, titled *A quoi rêvent les dactylos?*; actress Sophie Tucker and a typist in an image titled *Chant de la Remmington*, above *Le Paradis des Nègres*; and finally *Les mélisandes, Coiffure japonaise* and *La permanente*, an Eli Lothar photograph of heat curlers approaching a woman's head (as described by Matthew Gale; letter to the author, 5 October 2009)

6 The atrocities that resulted from Belgian rule in the Congo Free State under the rule of King Leopold were well known by this time. The Surrealists' stance against colonialism and especially the atrocities in Annam, the Lebanon, Morocco and Central Africa would be formally set out in their tract *Ne Visitez Pas L'Exposition Coloniale*, Paris, 1931.

7 With these concerns related to Paris in 1929, I follow scholars such as David Scott and Stuart Hall in supporting the notion of a 'problem space' where a complex conjunction of questions creates a significant and instructive moment that informs, and is also informed by, the present. See interview between Stuart Hall and David Scott, published in *Bomb*, 90, winter 2004/5; and David Scott, *Conscripts of Modernity: The Tragedy of Colonial Enlightenment*, Durham, NC, and London, Duke University Press, 2004.

8 Paul Gilroy, *The Black Atlantic: Modernity and Double Consciousness*, Cambridge, MA, Harvard University Press, 1993, p. xi.

9 A term first employed by James Baldwin.

10 I thank my colleague and fellow teacher Cheryl Finley for this reading of how the slave ship has been used as an icon in contemporary black diaspora art. Without her scholarly work on mnemonic aesthetics my understanding would be severely limited. See Cheryl Finley *Committed to Memory: the Slave Ship Icon in the Black Atlantic Imagination*, Princeton University Press (forthcoming 2010).

11 Petrine Archer-Straw, *Negrophilia: Avant-Garde Paris and Black Culture*, London and New York: Thames & Hudson, 2000.

12 Georges Bataille, Michel Leiris and Carl Einstein (eds.), *Documents*, Paris, 1929–31.

13 This statement of 'discovery' is questionable because it was made to André Malraux some time after the event; originally published in French in Malraux, *La Tête d'obsidienne*, Paris, 1936, p. 17, and later translated into English in Malraux, *Picasso's Masks*, trans. J. Guicharnaud, Paris, 1974, pp. 1–11.

14 The new sense of an African aesthetic that many artists and collectors brought to these objects was reflected in the growing level of discernment in their selection of items for display, and the use of ethnographic details to reflect their knowledge and connoisseurship, when possible.

15 'Marcel Sauvage', in Marcel Sauvage, *Voyages et aventures de Josephine Baker*, Paris, M. Seheur, 1932. Courtesy of the Bibliothèque nationale de Paris.

16 Michel Leiris, *Afrique Noire: La création plastique*, Paris, Gallimard, 1967.

17 Brent Hayes Edwards, 'The Ethnics of Surrealism', *Transition*, 78, 1999, p. 85.

18 Iris Schmeisser, *Transatlantic Crossings between Paris and New York*, Heidelberg, Universitätsverlag Heidelberg, American Studies Monograph Series, vol. 133, 2006, p. 149.

19 Dawn Ades and Fiona Bradley, 'A Playful Surrealism', *Guardian*, 6 May 2006, 'Features and Reviews' section, p. 14.

20 The relationship between Bataille and Leiris pre-dated the former's association with the Surrealists. They met in 1924, the same year that Leiris met Bréton and joined the Surrealists. But Bataille always remained on the periphery of that group and at odds with Bréton. Together, Bataille and Leiris attended the lectures of ethnologist Marcel Mauss, and later assisted in the reorganisation of the Trocadéro under the supervision of the ethnographers Georges-Henri Rivière and Paul Rivet.

21 In his article 'Civilisation' reflecting on the *Black Birds* and *Porgy*; *Documents*, 4, 1929.

22 Despite *Documents*' recent popularity as the focus of exhibitions and critical discourse, art historians and curators have avoided tackling Bataille's peculiar heterology that allowed him to equate blackness with the aberrant and subversive. These issues of race related to this moment in art history remain relatively silent, rarely tackled or deconstructed. Although Bataille's use of the black image has been labelled 'hilarious' or 'shocking' (as by Ades and Bradley in 'A Playful Surrealism'), in general the subject has been avoided, perhaps for fear of discovering or confronting his perversity and racism. This avoidance of ethnography and primitivism as they relate to dissident Surrealism has previously been noted by Brent Hayes Edwards in his evaluation of Yve-Alain Bois and Rosalind Krauss's *Formless: A User's Guide*, New York, Zone Books, 1997. Reviewing this text, Edwards states that it 'reinstates by omission that old treacherous distinction between "high" and "primitive" art – and worse, it defers to some of those "neat boundaries" between form and content'; 'The Ethnics of Surrealism', p. 108. More specifically, Simon Baker's discussion of *Documents* and *Variétés*, in which he mentions but does not elaborate on the glaringly problematic imagery of *Le Paradis de Nègres*, underscores this type of omission. See *Undercover Surrealism*, exh. cat., Hayward Gallery, London, 2006, p. 67. My own earlier reading of Bataille in relationship to negrophilia (see *Negrophilia*, pp. 142–57) has been critical but insufficiently perceptive in teasing out his relationship to the black image. It is hoped that this essay goes some way to re-examining Bataille's agenda, especially in light of current discourse related to the black diaspora body and contemporary art.

23 Stuart Hall, 'Black Diaspora Artists in Britain: Three "Moments" in Post-war History', *History Workshop Journal*, 61.1, 2006, p. 20; 'Negotiating Caribbean Identities', *New Left Review*, 1/209, January–February 1995, p. 13.

24 Ibid., p. 20.

COSMOPOLITAN CONTACT ZONES

KOBENA MERCER

During the 1940s the imaginative epicentre of Afro-Modernism moved beyond the New York environment of Harlem and migrated towards the Caribbean contexts of Negritude. In this way, various black modernist practices that were scattered around the globe became self-consciously diasporic for the first time – artists and writers saw themselves as part of a trans-national movement in twentieth-century art and culture rather than one restricted to a national milieu. We face something of a paradox here because while the 1935–55 period has a clear-cut shape in black popular culture – from the music of Charlie Parker to the zoot suits worn by Malcolm X when he was 'Detroit Red' – the era seems more amorphous in the visual arts, being often regarded as merely a transition from Social Realism to Abstract Expressionism.

The modernist strategies of formal experimentation put into play by painters such as Jacob Lawrence, Romare Bearden and Wifredo Lam, like the inventiveness that drove Aimé Césaire's epic prose poem *Cahier d'un retour au pays natal* (1938–41), rejected naturalism and realism so as to break apart the prevailing image of 'Africa' in the West and thus open a space for new understandings of black cultural influences as a core feature of global modernity. Our ability to comprehend the trans-national networks of artistic connections that were put into place across Anglophone, Francophone and Spanish-speaking regions at mid-century, which defined major transformations in Afro-modernism, is severely compromised, however, by the linear chronology whereby art history is ordinarily laid out in terms of a narrative arc.

It is entirely fitting that the Harlem Renaissance has received the lion's share of attention in our general understanding of the historical origins of the Afro-modern – it defines the primal moment of *Ursprung* or 'origination' from which a distinctive variant in modernism emerged from a specifically African-American source. But when it is narrated as an exclusively national story, as in *Harlem Renaissance: Art of Black America* (1987), which starts with the New Negro era of 1895–1914 and moves through the 1918–29 Jazz Age before concluding with the Federal Arts Projects of the Works Progress Administration, such an ending underplays the irony whereby many signature 'Harlem' artworks were actually produced during its 'afterlife' in the early 1940s. Conversely, when it is told in trans-national terms, as in *Rhapsodies in Black: Art of the Harlem Renaissance* (1997), we see that curatorial methods based on the wider concept of diaspora give us an inter-active rather than a separatist narrative and show how artists of different ethnicities were constantly entangled in cross-cultural dialogue. Such a trans-national model also shows that, far from coming to complete closure, the impetus for black modernism simply made a lateral

move by migrating sideways towards Caribbean nations such as Haiti and Cuba or the Jamaican locale of sculptors such as Edna Manley and Ronald Moody.[1]

Whereas the struggle to reclaim an ancestral African origin for modern black identities was initially surrounded by a euphoric mood of possibility, which then gave way to scepticism, ambivalence and doubt, by the 1940s the modernist primitivist paradigm had diffused into more complex debates about the survival of hidden African traces brought into contact, fusion and synthesis with cultural forms generated by the advanced industrial civilisation of modernity. Having studied with the émigré artist George Grosz at the Art Students League in New York, and participated in discussions among the post-Harlem Renaissance cohort that formed the 306 Group, Bearden was critical of the romantically idealised version of 'Africa' evoked by earlier artists – 'to try and carry on in America where African sculpture left off would be to start on a false basis,' he wrote in 1942: 'the gap of the years, the environment and ideology is too great'.[2] While this outlook led Bearden towards the vernacular 'folkways' of the American South – a thematic focus he shared with Charles Alston, John Biggers and Elizabeth Catlett – it is revealing that in 1942 the critic Alain Locke made similar modifications to his earlier views on the 'ancestral arts'. Taking issue with 'over-simplified conceptions of culture', Locke stressed 'the general composite character of culture', and boldly declared: 'To be "Negro" in the cultural sense, then, is … to be distinctively composite'.[3]

Arguing that black cultural identities were to be understood as 'a hybrid product of Negro reaction to American cultural forms and patterns', Locke took an anti-essentialist standpoint that was echoed by Bearden, who stated: 'whatever creations the Negro has fashioned in this country have been in relation to his American environment. Culture is not a biologically inherited phenomenon … However disinherited, the Negro is part of the amalgam of American life'.[4] Once we note how 'amalgam' acts as a synonym for cross-cultural mixing, we begin to observe that many of the metaphor-concepts put into play by the postcolonial turn of the 1980s – hybridity, syncretism, creolisation – were first registered in debates of the 1940s

that saw cross-cultural exchange as a source of fresh aesthetic possibilities brought about by the global conditions of modernity. For their part, Jackson Pollock and Barnett Newman, for instance, pursued abstraction as one such possibility opened up by their artistic 'borrowings' from Native American sources. But where post-primitivist notions of the tribal, the indigenous, the folkloric and the vernacular were also put under immense political pressure by anti-colonial movements for national liberation – as symbols of cultural autonomy in the struggle for independence – one might add that the contradictory outcomes of the post-1945 period effectively shut down the critical potential of hybrid aesthetics as something that only returned in the 1980s as a result of the ground-clearing critique of modernist primitivism.

Accepting that diasporas are the product of forced migrations which separate populations from their natal origins, we find that instead of time's arrow moving in a straight line, the traumatic ruptures and breaks that characterise the Black Atlantic as a chronotopia of multiple stops and starts are offset by unexpected patterns of repetition, detour and return. Thinking of the modern art world in Mary Louise Pratt's terms as a 'contact zone' – a 'social space [..] where disparate cultures meet, clash and grapple with each other, often in highly asymmetrical conditions of domination and subordination'[5] – we can identify some key sites where a cosmopolitan model of cross-cultural translation is glimpsed in Afro-modernism's negotiations between the conflicting demands of anti-colonial nationalism, on the one hand, and the ascendent formalist narrative of metropolitan institutions of modern art, on the other.

It is vital to know that Haiti was under US military occupation between 1915 and 1934 on account of its strategic importance to American trade routes. Eugene O'Neill's play *The Emperor Jones* (1920) alluded to this quasi-colonial situation while telling the story of Henri Christophe, the sovereign of Haiti's first independent republic in 1805. When John Houseman and Orson Welles staged their all-black production of 'Voodoo *Macbeth*' in a tropical scenario that alluded to Haiti, they too expressed leftist dissent, but their allegorical critique of colonialism

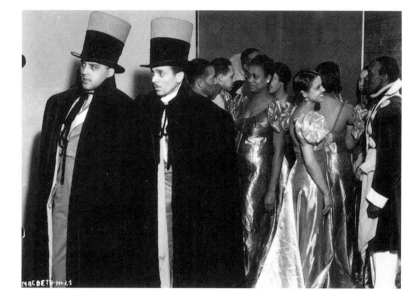

involved extreme depictions of blackness as atavistic savagery. Fully locked into the primitivist mindset of 'racial' fear and fantasy, it was exoticism that took the upper hand in these forays into the discursive space of 'Haiti' – and it was precisely the representational strategy of such 'othering' that Jacob Lawrence overturned in *Toussaint L'Ouverture* 1937–8 by telling the broader story of Haiti's 1791 insurrection. Led by a former slave who directed a twelve-year campaign against invading European troops, this revolution defeated Bonaparte's 1803 expedition long before Christophe's rise to power.

Laid out sequentially, the 40 panels create an unprecedented stylistic hybrid. Lawrence's flat planes of bold colour, and graphic simplification of figure and ground, connote a 'folk art' idiom, but by either pulling in like a close-up or pulling back to a wide-angle master-shot, as it were, he reveals a cinematic ability to alternate between the miniature and the monumental, which creates multi-perspectival viewpoints. Rather than illustrate past events in black history as though they were already widely known, Lawrence's formal innovations in pictorial narrative addressed the past genealogically so as to focus on the political relevance of the Haitian revolution to the quest

for black self-determination. In *The Migration of the Negro 1940–1* his serialised and imagistic form of story-telling took the 'Great Migration' in African-American life after the First World War as its subject-matter, but Lawrence's remarks on this work – 'I don't think in terms of history about that series. I think in terms of contemporary life. It was such a part of me that I didn't think of something outside'[6] – also illuminate the way that his critical response to the erasure of black history in American national culture led him to create a black modernist variant of 'history painting' that one scholar likens to a *Gesamtkunstwerk* or 'total artwork'.[7]

Where Lawrence acted as a genealogist of Black Atlantic counter-memory, it is significant that Trinidadian scholar and activist C.L.R. James published *The Black Jacobins* in 1938. Without conflating the disciplines of art and history, one might observe that this mutual interest in Haiti gives us a striking confirmation of the constructionist view that 'history' does not exist as such prior to the moment of being written up as a text and thereby entering the contested realm of representation. As he shuttled between Paris and London to research his book, James created a new textual genre of history-from-below. In his

preface to a new edition in 1980 he also recalled how South African activists found *The Black Jacobins* to be 'of great service' in their battle against apartheid – a vivid case of genealogy in action.[8]

NÉGRITUDE AND SURREALISM

Turning to our second contact zone, we find that Antillean and African students who met in Paris during the inter-war years similarly 'discovered' their African ancestry for the first time only by encountering images of sub-Saharan civilisation that offered an alternative to the distortions of the colonial policy of assimilation in which they were raised. When Césaire coined the term 'Négritude' in 1935 in *L'Etudiant Noir*, a journal he established with Leopold Senghor from Senegal, it gave rise to a literary movement that eventually went in different philosophical directions, but it initially acted as a rallying cry for a subjective sense of black 'authenticity' hitherto denied expression by the internalisation of a Eurocentric worldview.

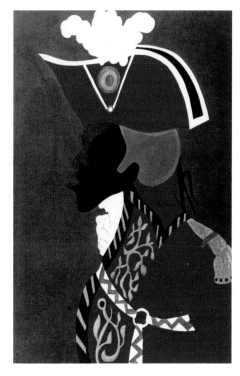

Jacob Lawrence
No 20: General Toussaint L'Ouverture from
The Life of Toussaint L'Ouverture 1937–38

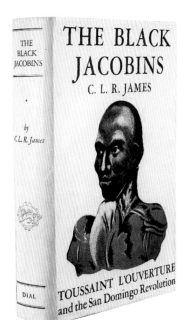

CLR James
The Black Jacobins 1938
Book jacket

Radiating outwards from the literary salon convened by Jane and Paulette Nardal, whose periodical *Revue du Monde Noir* translated Harlem Renaissance writers into French, what made Paris 'a special place for black trans-national interaction' was the way that a new kind of black internationalism arose from convergences among African anti-colonial movements.[9] In addition, 'Paris Noir' was further distinguished as a key site in the diasporic networks of Afro-modernism by the critical role played by Surrealism as a counterweight to exoticist tendencies within modernist primitivism.

Instead of valuing so-called 'negro art' on aesthetic grounds alone, critic Carl Einstein and writer Georges Bataille embraced the 'otherness' of tribal artefacts in the journal *Documents* (1929–30) as part of their political critique of colonialism. The 1931 exhibition of commodity kitsch that Louis Aragon, Paul Eluard and Yves Tanguy held to reveal 'The Truth About the Colonies' was an open riposte to the Exposition Coloniale of the same year. In short, French West Indian students sent to the metropolis to be trained as middle-class professionals not only laid claim to their 'blackness' as an empowering act of cultural affirmation, but also went back to the Caribbean with altered perceptions of the region's indigenous 'folk' cultures as a potential route towards the higher reality or sur-reality that would transform the experience of everyday life.

Whereas Senghor returned to Africa with a classicist version of Négritude, the dialogue between Surrealism and Négritude that led to a shared focus on the syncretic religions of the Caribbean is crucially important to understanding the context in which Wifredo Lam produced *The Jungle* 1943. This was the centrepiece of a new line of avant-garde enquiry into the hybrid mix of African and European elements that had fused into new combinations under colonial modernity. The contact zone in which Lam and other artists explored the Afro-Cuban religion of *lucumi*, for instance, is thus best approached in conceptual rather than simply geographical terms.

Just as Césaire returned to Martinique in 1941, Lam took flight from war-torn Paris, travelling to Marseilles where he encountered André Breton, before all three artists met in the Antilles. While Breton continued on his journey to New York, discussing Lam alongside Frida Kahlo and Robert Matta in his writings, Lam himself resided in Havana with his partner Helena Holzer from

1948 to 1952. Crossing paths in Port-au-Prince in 1945/6, where Breton wrote 'A Night in Haiti' for Lam's exhibition, both men witnessed the ritual trance states in which the devotee is possessed by the ancestral spirit evoked by the *voudun* priest. Their mutual friend, critic Pierre Mabille, wrote up what they saw.[10] Having witnessed similar rituals in Cuba, in works such as *The Murmur* 1943 Lam arrived at the enigmatic iconography of the *femme cheval* – part human, part animal – in direct reference to the liminal trance state whereby the *loa* or gods take possession of the lucumi worshipper much as a rider takes control of his horse. Lam's response to his source of inspiration had far-reaching implications.

In a world where Enlightenment beliefs in the perfectibility of humankind were being violently torn apart by the global conflagration of the Second World War, the search for a 'new man' took numerous forms. The aggregate of Egyptian and Buddhist icons among the motifs of modern industry in Aaron Douglas' *Building More Stately Mansions* 1944 evoked an ecumenical synthesis of world cultures. Ronald Moody had earlier explored similar themes in the hieratic composure of *Johanan* 1936. In 1948, Jean-Paul Sartre's essay 'Orphée Noir' ('Black Orpheus') introduced Senghor's *Anthologie de la nouvelle poésie nègre et malgache de langue française* with a dialectical schema that saw Négritude as the antithesis to colonial racism, which would eventually lead to a universalist synthesis (although Frantz Fanon argued that Sartre's vision allowed no room for cultural autonomy). Against the backdrop of this profound crisis of humanism, Lam's voyages into the contact zone of Caribbean syncretism pursued a quest for the transformation of subjectivity through the process of 'transculturation', whereby different cultural identities change their self-conception as a result of their mutual encounter. Lam's *femme cheval*, in this view, is a hybrid go-between who travels between material and spiritual worlds, and journeys from the lost African past towards the uncertain future of the West. In Lam's pictorial space of modernist transculturation, symbolic boundaries are transgressed and the ecstatic loss of self brought about by ritual trance puts the very identity of universal 'man' at risk.

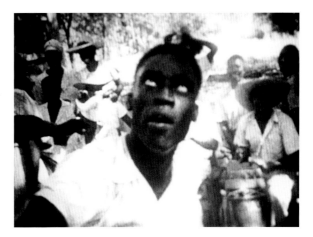

Maya Deren
Still from **Divine Horsemen** 1947–1951

Other artists who also passed through this contact zone included Zora Neale Hurston, whose *Tell My Horse* (1938) was a travelogue of her ethnographic journeys in the Caribbean, and film-maker Maya Deren, whose travels to Haiti in the 1940s resulted in *Divine Horsemen*, an avant-garde film that remained uncompleted until the 1970s. What curtailed these explorations were two post-war developments that pushed questions of hybridity to the margins of inquiry, such that they lay dormant for forty years before resurfacing with the postcolonial turn. On the one hand, Surrealism played a key role in perceptions of Caribbean life as itself a 'marvellous realism'. This later morphed into 'magical realism' in the broader Latin American context, but the critique of exoticism that Cuban novelist Alejo Carpentier expressed in 1949 was also inflected by a strident evocation of cultural 'authenticity' in his view that 'the European surrealist was condemned to paucity of vision because Surrealism was not embedded in society ... Its real domain was Latin America and the Caribbean, where magic remains part of everyday life.'[11]

If such indigenist notions of 'authenticity' were a touchstone for the nation-building process after independence in the Caribbean and West Africa, the shift away from cross-cultural experimentation was also reinforced, on the other hand, by the metropolitan institutionalisation

of modernism, which relied on a parallel criterion of 'authenticity' in classificatory distinctions between the tribal and the modern.

Faced with an 'art and culture system' that valued non-Western art forms for their 'otherness' to Western conventions,[12] black diaspora artists found themselves in a double bind: one could be included by being purely primitive and authentically 'other' to modernism, or one could assimilate to an unmarked position in abstract art, for instance, but the idea of combining elements from a mixture of sources – that is to say, being both 'Afro' and 'modern' – simply did not fit within the binary sightlines of the leading institutions of modern art that emerged in the mid-1930s and which, by the mid-1950s, had gained considerable influence.

MODERNISM AS A SCENE OF TRANSCULTURATION

The 'still life' treatment of African masks in works by Walker Evans and Norman Lewis, both made in 1935, draws attention to the ways in which white and black artists alike articulated a response, in the contact zone of the New York art world, to the 'de-contextualisation' of the tribal artefact as it entered the symbolic economy of modernity. But these shared interests had split apart by the 1950s.[13]

During the integrationist 1940s black artists were represented by commercial galleries for the first time. Lewis exhibited with Marian Willard from 1946 to 1964, Jacob Lawrence held six solo shows at Edith Halpert's Downtown Gallery between 1941 and 1953, and Bearden exhibited with Samuel Kootz Gallery as part of a group that included Adolph Gottlieb and Robert Motherwell. But when Bearden was 'dropped' in 1948 alongside other figurative artists who lost out to an incoming cohort that included Mark Rothko and Jackson Pollock, cross-cultural flows were blocked by a wall that separated 'pure' painterly abstraction from signifying elements previously associated with the primitive, the ethnic and the folkloric. William Edmonson, the first African-American to have a solo show

at the Museum of Modern Art in 1937, could fit within the institution as a self-taught 'naïve' who was visibly 'non-modern', but for Bearden, Lewis, and other African-American artists such as Hale Woodruff, it was not until the Spiral Group, which they formed in the 1960s, that they could achieve a break-out from the post-primitivist enclosure.

Regarding the second contact zone, MoMA readily purchased *The Jungle*; but in the unitary formalist narrative that saw modernism as unilinear 'progress', the institution was never sure where Lam should be placed, and for decades the painting languished by the cloakroom.[14] Re-reading Lam within a globalised conception of modernism, contemporary scholars point out that *The Jungle* alludes to two crops that were national symbols of Cuba's colonial economy.[15] In *Cuban Counterpoint: Tobacco and Sugar* (1940), Fernando Ortiz stressed the composite mix of disparate ethnicities that was specific to Cuba and the Caribbean – 'Men, economies, cultures, ambitions were all foreigners here'.[16] His deconstruction of the 'intense, complex, unbroken process of transculturation of human groups, all in a state of transition', gave emphasis to both 'the destruction of cultures and the creativity of cultural unions'.[17] This dynamic and agonistic relation of two phases, 'the loss or uprooting of a culture ("deculturation") and the creation of a new culture ("neoculturation")', is precisely how contemporary thinkers approach the question of cosmopolitanism under the universal conditions of modernity at large.[18]

In cross-cultural situations where adaptation to the 'foreign' or 'strange' is brought about coercively (as in Caribbean histories of slavery and colonisation), the resulting process of creolisation always involves two-way traffic in which, as Stuart Hall puts it, 'the colonized refashions the colonizer to some degree, even as the former is forced to take the imprint of the latter's cultural hegemony'.[19] But in the act of purposively choosing a self-questioning relationship to strangeness or foreignness, such a critically cosmopolitan outlook is one in which identity is always creatively put at risk in the uncertainties and potentialities of the cultural encounter with difference and multiplicity.

Venturing towards the African context in which Uche Okeke produced *Ana Mmuo* 1961, one might say that the formation of the Zaria Arts Society around Okeke's idea of Natural Synthesis was an extension of the exploratory interest in the combinatory logic of hybridisation and creolisation that crystallised in the 1940s. As the agency of the *uli* line, indigenous to Igbo culture, enters into a poetic dance of transculturation with the playful line associated with Paul Klee or Joan Miró in European modernism, a further hybrid variation arises. Okeke's inscriptive practice of mark-making is Afro-modern by virtue of the polyvocal sources it draws upon. With the formation of the Mbari arts group in Ibadan in 1961, this would be the location of a third contact zone in continental Africa, even though the crisis of nationhood that resulted in the Biafran civil war in Nigeria set severe limits to the possibilities that Okeke had begun to explore. In widening our understanding of the global conditions of artistic production in different moments of twentieth-century art, we realise that our overall view of the mid-century period is incomplete without taking the contributions of Afro-modernism into account, and that the factors which constrain the aesthetic potential of cross-cultural relations are still with us as unresolved questions today.

NOTES

1 Studio Museum in Harlem, *Harlem Renaissance: Art of Black America*, New York, Harry N. Abrams, 1987; Hayward Gallery, *Rhapsodies in Black: Art of the Harlem Renaissance*, London and Berkeley, CA, Hayward Gallery, Institute for International Visual Arts and University of California Press, 1997.

2 Romare Bearden, letter to Walter Quirt, 20 January 1942, quoted in Myron Schwartzman, *Romare Bearden: His Life and his Art*, New York, Abrams, 1990, p. 121.

3 Alain Locke, 'Who or What is Negro?', *Opportunity*, Feb./March 1942, reprinted in Jeffrey C. Stewart (ed.), *The Critical Temper of Alain Locke: A Selection of his Essays on Art and Culture*, New York, Garland Publishing, 1983, p. 311.

4 Romare Bearden, 'The Negro Artist's Dilemma', *Critique*, Nov. 1946, p. 19.

5 Mary Louise Pratt, *Imperial Eyes: Travel Writing and Transculturation*, London and New York, Routledge, 1992, p. 4.

6 Jacob Lawrence quoted in Carrol Green, 'Oral history interview with Jacob Lawrence, 1968 Oct 26', Washington, DC, Archives of American Art, Smithsonian Institution.

7 Sieglinde Lemke, 'Diaspora Aesthetics: Exploring the African Diaspora in the Works of Aaron Douglas, Jacob Lawrence and Jean-Michel Basquiat', in Kobena Mercer (ed.), *Exiles, Diasporas & Strangers*, London and Cambridge, MA, Institute for International Visual Arts and MIT Press, 2008, p. 133.

8 C.L.R. James, 'Preface', *The Black Jacobins: Toussaint L'Ouverture and the San Domingo Revolution*, London, Allison & Busby, 3rd edn, 1980, p. x.

9 Brent Hayes Edwards, *The Practice of Diaspora: Literature, Translation and the Rise of Black Internationalism*, Cambridge, MA, Harvard University Press, 2003, p. 11.

10 Pierre Mabille, 'The Jungle' (1945), reprinted in Michael Richardson and Krzystof Fijalkowski (eds.), *The Refusal of the Shadow: Surrealism and the Caribbean*, London, Verso, 1996.

11 Alejo Carpentier, 'The Marvellous Real in America' (1949), in Lois Zamora Parkinson and Wendy B. Faris (eds.), *Magical Realism: Theory, History, Community*, Durham, NC, Duke University Press, 1995, p. 76.

12 See James Clifford, 'On Collecting Art and Culture', in *The Predicament of Culture*, Cambridge, MA, Harvard University Press, 1988.

13 See Ann Gibson, *Abstract Expressionism: Other Politics*, New Haven and London, Yale University Press, 1997.

14 See John Yau, 'Please Wait by the Coatroom', in Russell Ferguson, Marth Gever, Trinh T. Minh-ha and Cornel West (eds.), *Out There: Marginalization and Contemporary Culture*, London and New York, New Museum and MIT, 1990.

15 See Lowery Stokes Sims, *Wifredo Lam and the International Avant-Garde, 1923–1982*, Austin, University of Texas Press, 2002.

16 Fernando Ortiz, *Cuban Counterpoint: Tobacco and Sugar*, Durham, NC, Duke University Press, 1996, p. 101.

17 Fernando Coronil, 'Introduction to the Duke University Press Edition', in ibid., p. xxvii.

18 Ibid.

19 Stuart Hall, 'Créolité and the Process of Creolization', in Okwui Enwezor, Carlos Basualdo, Ute Meta Bauer, Susanne Ghez, Sarat Maharaj, Mark Nash and Octavio Zaya (eds.), *Créolité and Creolization*, Ostfilden-Ruit, Hatje Cantz, 2003, p. 31.

Frank Bowling
Mirror 1964–66

THEY'VE ALL GOT PAINTING: FRANK BOWLING'S MODERNITY AND THE POST-1960 ATLANTIC[1]

COURTNEY J. MARTIN

And my exit from Guyana was via Captain McKenzie I was a passenger on his boat, to Trinidad. And left Guyana.

Q: *So you went from Guyana, from Georgetown?*
Georgetown.

Q: *On the Booker ship.*
The Booker ship, to Port of Spain.

Q: *To Port of Spain.*
And then I joined a French boat, the name of which I can't remember, to travel to England in May 1953.

Q: *From the Port of Spain.*
From Port of Spain.

Q: *Not from Trinidad?*
Port of Spain, Trinidad.

Q: *Of course, I beg your pardon. From Port of Spain.*[2]

Mel Gooding's life story interview with Frank Bowling

In art history, and its related areas of object study, visual culture and material culture, the first voice to explicate an oceanic connection among Africa, Europe and the Americas was Robert Farris Thompson. Thompson outlined the concept of a 'black Atlantic world', in which the traces of African visual matter had a direct outlet via the Atlantic Ocean. He coined the term 'black Atlantic visual tradition', describing 'the rise, development, and achievement of Yoruba, Kongo, Fon, Mande, and Ejagham art and philosophy fused with new elements overseas, shaping and defining the black Atlantic visual tradition'.[3] Thompson's text put forth two simultaneous and related ideas. The first is that the seeming rootlessness of the world's African descendants, and their cultural products, was predicated on the circumstances of their dispersal. Thus rootlessness (despite its numerous antecedents) was generative. The second important idea that Thompson launched was that this (African) circulation of objects, way of seeing, process of making, and visual tropes formed a continuous flow of visual matter that superseded the dominance of other traditions, namely European. In the vocabulary of the time, one might have called this a discovery of African retention in art, just as Thompson's ideas were unselfconsciously afro-centric. This is not, nor was it ever, an uncomplicated discourse, and the last several decades have not untangled its root predicaments, but it must be understood for what it was: the first attempt to name and contextualise art of the black diaspora, if not all objects in contact with the circumference of the Atlantic. Thompson places this art into art history and leads us to the other side of Picasso's appropriation of African forms, so that we understand that the contact between Europe and Africa produced the decisive moment in modern art and modernity, resulting in the idea of a connection as opposed to the one-sided sense of contact.[4] Yet this moment had almost never been narrated from the

African, much less a trans-cultural, perspective. As Thompson explained,

> the richness of detail, moral elaboration, and emblematic power that characterize the sacred art of the Yoruba in transition to Brazil, Cuba, and the United States, as sampled in this volume, is but an introduction to a wider universe of interlocking forms that will require future books fully to explore and explain.[5]

Some ten years later, Paul Gilroy's The Black Atlantic: Modernity and Double Consciousness explored another side of the Atlantic, one in which black cultural writers and thinkers gave voice to a duality born out of their special circumstances.[6] As with Thompson, Gilroy finds out that the Atlantic is constitutive. It is a powerful force that disruptively brings black writers into and out of contact with world thought and each other. Gilroy's modernity is set against tradition not simply as progress but as a clash that propels. In response to Britain's Cultural Studies terrain and the fields of African-American Studies or Black Studies in the United States, he writes from an intentionally anti-nationalist position, wherein he seeks 'to develop the suggestion that cultural historians could take the Atlantic as one single, complex unit of analysis in their discussions of the modern world and use it to produce an explicitly transnational and intercultural perspective'.[7] The Atlantic is now mined philosophically for its diasporic traces that reveal themselves to be not a shadow of the white, Western world, but its absolute. It is of note that interspaced among these examples are a few that would seem out of place, were it not for the iconography of the Atlantic. To this end, Gilroy writes that

> the idea of the black Atlantic can be used to show that there are other claims to it which can be based on the structure of the African diaspora into the western hemisphere. A concern with the Atlantic as a cultural and political system has been forced on black historiography and intellectual history by the economic and historical matrix in which plantation slavery – 'capitalism with its clothes off' – was one special moment.[8]

This is, after all, the Black Atlantic, not the dark sea.

It is of note that both of these texts emerge out of what I call the post-1968 moment. For Thompson, writing principally from the Americas and Africa, the decades following the sixties revealed deep fissures in the nation-state that had been ripped open, and were only beginning to reform in the early 1980s. Chicago, Detroit and Los Angeles still bore the wounds of their 1960s' riots, while Birmingham, Montgomery and Selma were fast becoming living memorials. By the same token, Havana, Asmara and Port-au-Prince were oft-disputed projects-in-formation over which East and West bandied.

For Gilroy, the legacy of 1968 in Europe spread the theories of social uprising and reform across the British Isles. Importantly, Britain's 1968 happened in the art schools, where students, tutors and working artists demanded reform of the curriculum and, in the process, sought to gain control of contemporary art.[9] It was a movement of object-centred populism that coincided with the after-effects of decolonisation. Throughout the 1970s and 1980s, Britain succumbed to a financial crisis, urban unrest in the form of Irish Republican Army terrorism and riots centred around black communities in all of its major cities.[10] To use a shorthand formulation, Brixton became the Bronx, making a comparative look across the ocean not only common sense but also inevitable. By the early 1990s, and the publication of The Black Atlantic, Britain now shared the American trait of a large, fluid population of foreign-born citizens. As Gilroy rightly points out, the nationalistic presumption that 'England ceaselessly gives birth to itself, seemingly from Britannia's head', had been all but destroyed by the close of the twentieth century.[11] It is from this perspective that I would argue for a view of the 1960s as a cross-Atlantic turn for the latter part of the twentieth century, wherein history rears its head in the present, particularly the visual present.

So, back to this question of modernity. Thompson assumes for his readers a modernity that brushes up against a canonical approach to art rooted in European painting and sculpture. As an art historian, he takes for granted that we understand the fine art tradition that he is writing against. Gilroy is more explicit in foregrounding a specific either/or binary, largely due to his construction of

writers and thinkers who are circulating in the frame of European modern thought and its attendant national racialised ambiguities. Throughout the text, his references to art, specifically painting and painters, are acute. The first, and most pronounced, is to J.M.W. Turner's *Slave Ship (Slavers Throwing Overboard the Dead and Dying, Typhoon Coming On)* 1840, a work that circulated through London, via John Ruskin, before being sold to America.[12] The work carries with it a narrative about a slave ship lost in a typhoon from which the ship's captain off-loads its human cargo to benefit from his insurance policy. In its time, the painting roused British feeling against the sheer cruelty of slavery. In art-historical terms, the painting's dramatic abstraction set in motion Britain's visual modernity. Here, the modern makes itself known as a violent sweep of sea and sky under the guise of a morality tale about greed, hubris and the vengeance of the natural world. Gilroy's invocation of Turner's *Slave Ship* places us firmly within a discussion of art, artists, modernity and the ways in which the slippage, or fissure, between figuration and abstraction in painting will be a defining question for the latter third of the twentieth century, at least in the work that criss-crosses the Atlantic. Knowingly or not, Gilroy hits upon a key fact of modernism: painting is the medium by which modernism in art is articulated.[13] In the late twentieth century, the values of painting become modern art; so inseparable were the two that when America's art market surpassed France's (and Britain is pushed into a derivative corner) it was largely a fact of the shift in the making of and marketing of painting to New York at the expense of Europe.[14]

Following Gilroy's model, I want to take the Atlantic as a motive force for the painter Frank Bowling. Moreover, I want to use Bowling as a model to consider the period from the sixties to the present in much the same way that Gilroy shapes the structure of modernity through individuals like W.E.B. Du Bois, Richard Wright, or the lesser known Martin Robinson Delany. In the discourse of Atlantic exchange, Bowling's early professional life charts the course of how late modern, supra-national art functioned – for a black artist. Like Gilroy, Bowling weaves together Europe, the Americas and Africa. Further, as a

writer about art, Bowling sought to define and describe a phenomenon, 'Black Art', which he intially viewed from the position of an ex-pat in New York and which he then began to write about, bringing it to the awareness of London and the rest of America. His discourse on the subject, credited or not, continued to inform the way in which artists of African descent functioned in the world of contemporary art. Like Gilroy's case-studies, Bowling lived the transnationalism (and its consequences) that he painted in and wrote about. As an artist, Frank Bowling is where both propositions (Thompson and Gilroy) of modernity and the Atlantic meet.

Born in 1936 in Bartica, Essequibo, in the then British Guiana (Guyana), Frank Bowling moved to London in the early 1950s. As a teenager, he was fascinated by the sights and sounds of the city. After completing his national service in the Royal Air Force, he entered the Regent Street Polytechnic in 1955 to study painting. In 1959, he was granted admission to the Royal College of Art. Though his name is often cited along with Aubrey Williams' as one of a generation of Caribbean artists in London, Bowling was only loosely affiliated with Caribbean art circles. He was not, for example, a member of the Caribbean Artists Movement (CAM), nor did he participate in any of CAM's exhibitions.[15] Williams, also from Guyana, was known to him through his younger brother, not as an artist contemporary.[16] Bowling, unlike Williams, was not involved in any of the Caribbean and Commonwealth exhibitions at the Commonwealth Institute or the Africa Centre, such as the well-known *Commonwealth Artists of Fame 1952–1977* show in which many other immigrants participated.[17]

Instead, Bowling's set was made up of art students from the Royal College and the Slade School of Art. Bowling's first few years in London were unremarkable, save for the fact that he circulated in a group of artists who were being pitched against the past and the present. There was the tradition of British painting that extolled figuration and there was the call of something very new outside of Britain, American abstract art. For Bowling, who was mentored by Francis Bacon and Carel Weight and educated alongside David Hockney and R.B. Kitaj,

Frank Bowling
Bowling's Variety Store 1966

London in the autumn, to complete his last year at the Royal College, New York hung like a weight around his paintings, despite his having taken an RCA travel scholarship to South America and the Caribbean after graduation in 1962. Whereas his previous work stood firmly in line with his training, new paintings such as Mirror 1963–64 staged his battle with representation and abstraction, London and New York. In the vertical, rectangular composition, three bodies in varying degrees of figuration descend a spiral staircase into a lower space that consists of several geometric partitions of colour. The painting is a double portrait of Bowling and his first wife, Paddy Kitchen (the middle figure), who, along with the staircase and a Charles Eames-type Eifel chair, are the only fully representational components in the picture. The painting's ambivalent style suggested Bowling's state. Should he stay in London, a dormant art market in which he had to contend with being excluded from significant exhibitions?[21] Or should he move to New York and join in the excitement of a robust art market, with new colleagues and a seemingly more cosmopolitan art scene? In a later conversation with fellow painter Bill Thomson, he described his decision to leave London for New York as one of need, stating, 'I left because I needed N.Y.'.[22]

The need that pushed him across the Atlantic found him altered at the other end. If Bowling had been construed as a Commonwealth immigrant in London, he was now, strangely and inexplicably, British, South American and black in New York.[23] What is significant about Bowling's decision to move to New York in 1966 is that he dropped himself squarely into abstract painting and the social politics of New York's art world. As a newcomer he pushed his quasi-South American and quasi-European perspective by experimenting in his own method of abstraction and by being both a painter and a writer. Here is Bowling in another set of circumstances by way of migration, one that posited him as a very different type of outsider than he had been in London. In New York, Bowling mixed in disparate sets, such as that of established American Pop artist Larry Rivers. One of his paintings from the year that he moved, Bowling's Variety Store 1966, references his multiple personal and formal

representation was clearly something to play with, even expand, but not to depart from completely.[18] Called by any of its names – Abstract Expressionism, New York School painting or American action painting – the abstract painting made in New York was easily reduced to two things for Bowling: a break from representation and a move away from London. Heeding this call, Bowling travelled to New York for the first time in the summer of 1961.[19]

In New York, Bowling was introduced to the aesthetic and social aspects of abstraction. The allure of the Cedar Tavern mingled with daily visits to the Museum of Modern Art, studio visits with Franz Kline, socialising with James Rosenquist and the dealer Dick Bellamy, who bought some of his work.[20] Upon Bowling's return to

perspectives. Geometrically abstract, *Bowling's Variety Store* also incorporates text in the style of American Pop art. The text, 'Bowling's Variety Store', neatly legible on the flat, planar lines of the painting's surface, references his mother's business in Guyana. It is also a word-play on the variety and scope of his own practice.

This repository of skill placed Bowling in an odd space relative to other painters. From his home in the Chelsea Hotel and his downtown studio, Bowling met established artists such as Jasper Johns through Rivers' introduction.[24] He came into contact with Norman Lewis, whose work he knew from the 1966 First World Festival of Negro Art in Dakar, where Bowling had won the grand prize. He also began to meet a younger set of black American artists, including Melvin Edwards, Daniel Johnson, Al Loving, Jack Whitten, and William T. Williams. It would be easy to configure the appearance of one of Bowling's central motifs, the map, as an outward sign of mobility. The outline of South America in a series of paintings from the late 1960s into the 1970s occurs just as Bowling is working through the full possibilities of abstraction. At first, South America appears as a stencilled outline, then morphs into an apparition before becoming the focal point of the composition. In dialogue with Barnett Newman's *Who's Afraid of Red, Yellow and Blue II* 1967, *Who's Afraid of Barney Newman?* 1968 features the map as a fragmented ghost emerging from the Newman-like colour-zip that divides the canvas from top to bottom. The loose contours of the chalky, shadowy South America outline slide up, down and between the opposing colour fields of red and green, creating a third, lower zone of depth between the divided halves. Naming Newman points to the way in which Bowling's conversations in New York were invested in a first-generation abstract formalism that melded with his friendship with Clement Greenberg and his social sphere.[25] Yet he was also in contact with New York Pop (Rivers and Rosenquist), as well as with British Pop via classmates Hockney and Derek Boshier and the critic Lawrence Alloway, who had relocated to New York. The trace register of South America points to both of these currents (abstraction and Pop) as a new space, not as a geographic locator. The map is not about his relationship to South America or Guyana *per se*; rather, South America, a continent, is a place-holder for the enormous task of bridging a stylistic divide in painting at a time when few voices outside formalism were being heard, let alone supported by museums or collectors.

Contemporary with Bowling's pursuit of a modernist painting idiom in New York, America was involved in social upheaval throughout the 1960s, whose repercussions were felt for at least another decade. Warhol, another artist whom Bowling met after settling in New York, described the era as

> one confrontation after another, till eventually every social obstacle had been confronted. I'm convinced that the attitudes behind the mass confrontations in the last part of the sixties came from these minor scuffles at the doorways to parties. The idea that anybody had the right to be anywhere and do anything, no matter who they were and how they dressed, was a big thing in the sixties.[26]

The party analogy is an appropriate one for Bowling, whose success in the art world – a Guggenheim fellowship in 1967 and a solo exhibition at the Whitney Museum of American Art in 1971 – was incongruent with his role as a witness to, and sometimes a participant in, the burgeoning issue of Black Art. It was a discourse that he moved into and out of as a black ex-pat, using his platform at *Arts Magazine* to craft the debate for a wider audience.[27] In essays such as 'New York Classicism' he introduced a nationalist agenda to the structure of art criticism, explaining that

> the term classical has been used in criticism, since the emergence of the New York School, before but, using the term as I do now, I am using it to describe the situation. Classicism, or the classical one might say, is that which the French and Paris lost. To paraphrase Gide: Classicism would seem to me so completely of the New World, America, or New York, that I would make the two synonymous – Classical and America – for it is. That the first could lay claim to exhausting American genius in its cultural search and had

romantic expressionism not succeeded in making its home also America, at least it would be in its classical art that the American genius has been most fully manifested.[28]

Implicitly he situates himself as an observer of the turn in (New World) American art. And to cite America as the New World positions him as an informed observer, if not also a member, of the Old World (Europe in general, Britain specifically). He writes a series of articles for Arts Magazine in which both British and American audiences are given a window onto New York's Black Art debate. From his outsider perspective, and with the view that art in America is intrinsically nationalist, if not parochial, Bowling describes the predicament of black artists as being neglected, through a conspiracy of art world 'guilty secrets'.[29] These secrets of a 'Black Art', Bowling argued, were a reaction (or direct action, as it were) to the 'evolutionary, revolutionary forces stretching its possibilities'.[30] Yet he was not content with the declaration of race and the fight for civil rights as a claim for a distinct aesthetic. It was an issue that he struggled with in his own writing and in his choice to participate in exhibitions that grouped artists by race, as opposed to style, medium or subject. The question that he set out to answer in May 1969 – 'Why have black artists, given their historical role in art, contributed so little to the mainstream of contemporary styles or better still, why have they contributed so little to the great body of modern or modernist art?' – became a defining point in his texts and in his relationship to the art world, both black and white. As Kellie Jones notes, Bowling's interrogation of black group shows led him back to Robert Farris Thompson, who argued for the recognition of African creativity in the Americas during his symposium lecture on the burgeoning field of Black Studies at Yale University in 1969.[31]

In 1975, heeding family pressures and secure in his New York success, Bowling returned to London. Over the next several years, he re-established his London studio and travelled back and forth to New York, where he kept a studio. If one of the aims of this essay is to see the trajectory of Bowling's work through to the present, it can be done

in two ways. After leaving New York, few of the major strides that he made institutionally bore fruit for future black artists. In many ways, the parochial dynamic of 'Americanness' that he wrote against won out, with black artists being shown in largely race- (or ethnicity-) based exhibitions and being cultivated within a discourse of identity and persona. The complicated success of Jean-Michel Basquiat in the 1980s is perhaps the best example of this. The multi-lingual and multi-referential scope of his painting was largely undervalued, set against the proposition of his singular stardom.[32]

Similarly, the work of black artists (here African, Asian, and Caribbean) in the 1970s and 1980s, like Sutapa Biswas, Zarina Bhimji, Sonia Boyce, Chila Kumari Burman, Eddie Chambers, Lubaina Himid, Claudette Johnson, Keith Piper, Donald Rodney, Marlene Smith and others forced conversations about access and aesthetics in Britain's art instituons that was then broadcast internationally. Yet, they too became engulfed in a racialized rhetoric that often ignored the objects that they made. In 1982, after Bowling was back in London, he was invited to a now well-known conference on black art, the First National Black Art Convention to Discuss the Form, Functioning and Future of Black Art, which was held in October in Wolverhampton. Though some of this history has been rehearsed in other places, what is little known is that Bowling attended the convention, thereby forming a link between his generation and theirs and mirroring, in reverse, his transit between American and British art.[33] For many Americans, the existence of black British artists in the 1980s ignited discourse about the visuality of post-coloniality, cosmopolitanism and the global economy, issues that defined late twentieth-century art and shaped its exhibition practices.

Bowling's model might also lend perspective to the way in which the contemporary art market in South Africa was 'introduced' in the 1980s, a proof less of a reframing of the race idiom (it was, on the face of it, multi-racial) than of a re-branding of a market concept. South Africa's market led to a focus on contemporary African art, both on the continent and beyond it, throughout the 1980s and 1990s. With it came the idea of a transnational African

artist, one defined by his or her mobility. In practice, this meant that an artist had access to Europe in the way that Bowling had first moved to London. The space of the transnational artist was twinned with the rise of various art markets or centres. One could be mobile only within the restricted boundary of one's market scope. After all, Bowling moved to New York for abstraction and the market that grew up around it, not unlike those who now seem to float from London to New York to Miami to Beijing. This is not a criticism of the market; rather it is a way to properly describe what we now easily codify as transnational. Interestingly, transnational's tandem term, 'post-black', first identified by Thelma Golden in 2001, is generally synonymous with American black artists who have some international renown.[34] So, for example, if Yinka Shonibare, Chris Ofili, Tracey Rose and Wangechi Mutu are transnational, then Glenn Ligon, Kara Walker, Ellen Gallagher or William Pope L. are post-black. What this list (or any other that I could have constructed) proves is nothing. A by-product of art history's preoccupation with biography and a conundrum from the nineteenth century that we cannot pry apart, race is an ineffective way of situating aesthetic practices. Bowling's pronouncement of and indictment of this truth did not affect the ways in which it continues to function. What we call transnational or post-black is what Bowling called Black Art. Neither would constitute Gilroy's and Thompson's concept of the Black Atlantic, though there are overlaps (misunder-

standings) among all of the terms. Even if unintentionally, these terms facilitate the same reductive rhetoric for black artists that formed Bowling's argument against Black Art. But, again, the problem is not the concept, it is what we do with it.

There is another way to situate Bowling in the post-1968 moment. In 2005, Bowling was elected to the Royal Academy of Art, making him the first black Royal Academician, an accolade that came later than similar accolades had for Basquiat, but not as late as they had for Norman Lewis.[35] His election followed a spate of international success for younger black artists. Chris Ofili was selected to represent Britain at the Venice Biennale in 2003, in the same year that Fred Wilson represented the United States. The prominence of these accomplishments was underscored by the way in which a black Atlanticism flowed effortlessly through each of their pavilions. Where Wilson investigated the history of a complex, multinational and multi-purpose black presence (evidenced by the inclusion of Quattrocento and Cinquecento paintings with black subjects) in *Speak of Me as I Am*, Ofili pursued a semi-futuristic utopia with a suite of five paintings inhabited by a pair of black lovers. In a pared-down sense, both artists sought to give us, their viewers, a space of contemplation outside the contemporary understanding of black subjectivity, yet within a recognition of an African-influenced aesthetic practice. That each of these, in very different ways, occurred within an expanded

Fred Wilson
Untitled 2003

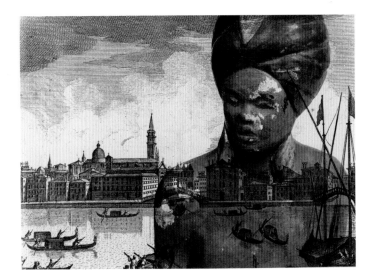

notion of painting, and its relationship to modernity, cannot be discounted. It is in this way that Bowling's intervention into criticism is retained by artists who have worked to secure more refined understandings of modernity. Bowling got this in the 60s and ushered it into his writing and practice for several years. In the interview published with his Whitney Museum exhibition, Bowling is asked by curator Richard Doty if the map of South America suggests a microcosm. To this question, Bowling answers:

> The question refers to some kind of 18th-century idea of a little (small) man in a little situation, very mechanical and small in scale; the world of black art. I don't believe, as a painter, in the idea of black art; but it's obvious the black experience is universal. The more I think about it the more I feel... yes, and no because obviously, in a way the whole idea of a microcosm, as opposed to a macrocosm, is something that I'm about in this sort of harassing situation. Yet, I felt reticent about committing myself totally to the idea; simply because over and above everything else, I feel very political about a lot of issues, and I'm certainly political about what it means to be an artist, an artist who happens to be black, as such, and I think a lot of the things which have gone down makes what I'm doing a reflection of a much wider spectrum.[36]

By any other name, that 'wider spectrum' would be the Atlantic Ocean.

NOTES

1 The title refers to Bowling's concern over Black Art in the article 'It's Not Enough to Say "Black is Beautiful"'*Art News*, 70, April 1971, p. 53. It is worth quoting him at length: 'Much of the discussion surrounding painting and sculpture by blacks seems completely concerned with notions about Black Art, not with the works themselves or their delivery. Not with a positively articulated object or set of objects. It is as though what is being said is that whatever black people do in the various areas labeled art is Art – hence Black Art. And various spokesmen make rules to govern this supposed new form of expression. Unless we accept the absurdity of such stereotypes as "they've all got rhythm...," and even if we do, can we stretch a little further to say they've all got painting? Whichever way this question is answered there are others of more immediate importance, such as: What precisely is the nature of black art? If we reply, however, tongue-in-cheek, that the precise nature of black art is that which forces itself upon our attention as a distinguishing mark of the black experience (a sort of thing, perhaps, only recognizable by black people) we are still left in the bind of trying to explain its vagaries and to make generalizations. For indeed we have not been able to detect in any kind of universal sense The Black Experience wedged-up in the flat bed between red and green: between say a red stripe and green stripe.

2 Cited in Frank Bowling, British Library Sound Archive, National Life Stories.

3 Robert Farris Thompson, *Flash of the Spirit: African and Afro-American Art and Philosophy*, New York, Vintage Books, 1983, p. xiv.

4 To be clear, Thompson does not name Picasso in *Flash of the Spirit*. He does not have to. Instead he demonstrates that African art has generally not been constituted as an active source for modernism. We, the readers, can make the connection for ourselves.

5 Thompson, *Flash of the Spirit*, p. xv.

6 Paul Gilroy, *The Black Atlantic: Modernity and Double Consciousness*, Cambridge, MA, Harvard University Press, 1993.

7 Ibid., p. 15.

8 Ibid.

9 For a longer discussion of Britain's art school conflicts in 1968, see Lisa Tickner, *Hornsey 1968: The Art School Revolution*, London, Frances Lincoln, 2008.

10 For two British perspectives on the 1970s into the 1980s, see *The Empire Strikes Back: Race and Racism in 70s Britain*, London, Centre for Contemporary Cultural Studies/Hutchinson, 1982, and Andy Beckett, *When the Lights Went Out: Britain in the Seventies*, London, Faber and Faber, 2009.

11 Gilroy, *The Black Atlantic*, p. 14.

12 Gilroy, *The Black Atlantic*, pp. 13–14. For a longer discussion of the painting's provenance, see Andrew Walker, 'From Private Sermon to Public Masterpiece: J.M.W. Turner's "The Slave Ship" in Boston, 1876–1899', *Journal of the Museum of Fine Arts, Boston*, 6, 1994, pp. 4–13. In addition to Turner, Gilroy mentions other painters. In his discussion of W.E.B. Du Bois' novel *Dark Princess*, he includes the novel's use of Kandinsky, Picasso, Matisse and Wyndham Lewis (*The Black Atlantic*, p. 141). In relation to Edward Wilmot Blyden's roots in St Thomas, he mentions Camille Pissarro, who was born in the same community as Blyden (p. 210).

13 This point is made over and over with each copy of the paperback edition of *The Black Atlantic* which features *Building More Stately Mansions* 1944, one painting from Aaron Douglas' cyclical and mural works held at Fisk University.

14 For a longer discussion of the transposition of these art markets, see Serge Guilbaut, *How New York Stole the Idea of Modern Art*, Chicago, University of Chicago Press, 1985.

15 Despite Edward Brathwaite's overtures to Bowling regarding CAM, Bowling never joined the group, owing, perhaps, to his residence in New York during the height of CAM's London activities. See letter from Edward Brathwaite to Colin Rickards, 6 February 1967, George Padmore Institute, London. For a longer

discussion of visual artists active in CAM, see Anne Walmsley, *The Caribbean Artists Movement 1966–1972: A Literary and Cultural History*, London, New Beacon Books, 1992.

16 Bowling, British Library Sound Archive, National Life Stories.

17 *Commonwealth Artists of Fame 1952–1977*, held at the Commonwealth Institute's gallery from 1 June to 3 July 1977, was a major exhibition that featured many artists who are now often linked to Bowling, including Avinash Chandra, Ben Enwonwu, Ronald Moody, Francis Newton Souza, and Williams. This tenuous tie between Bowling and these artists (equally tenuously connected as a group) came not from professional or social relationships but probably from Bowling's participation in 1989's *The Other Story: Afro-Asian Artists in Post-war Britain* at the Hayward Gallery. In the late 1950s, Bowling initiated an exhibition group of young Commonwealth artists, composed of artists from the "Old" and "New" Commonwealths. This group was not connected to the more established activities of the Commonwealth Institute.

18 Bacon's pictorial influence on Bowling was noted early in his career. In a review of the *Young Commonwealth Artists* exhibition, David Sylvester described Bowling and the other artists in the show as 'Baconians', due to their emulation of the senior painter's style. David Sylvester, 'No Baconians', *New Statesman*, 20 April 1962, p. 573.

19 Bowling made this trip with Royal College students David Hockney and Billy Apple. During the summer, he travelled west, seeing various modern architectural sites and museums. His first New York summer has been documented in several interviews, exhibition catalogues and reviews, including *Bowling at the Center for Inter-American Relations*, 28 November 1973–13 January 1974.

20 Bowling, British Library Sound Archive, National Life Stories.

21 *The New Generation: 1964* exhibition at the Whitechapel Art Gallery was the first significant group show in which Bowling was not included

alongside his Royal College friends and contemporaries Derek Boshier, David Hockney and Allen Jones.

22 'Frank Bowling and Bill Thomson: A Conversation between Two Painters', *Art International*, Dec. 1976, p. 61.

23 For example, he was eligible for a John Simon Guggenheim fellowship because he was born in British Guiana, then considered part of the fellowship's Americas remit. Yet he knew many of the British art world ex-pats from London, such as Lawrence Alloway, who related to him as a Briton. He also had a solo show in 1973 at the Center for Inter-American Relations (now the Americas Society), an exhibition space under the mandate of Latin American, Caribbean and Canadian interests. In 1969 he took part in the Whitney Annual and in 1973 their biennial, both exhibitions dedicated to showing contemporary art in the United States.

24 Interview with Frank Bowling, 25 November 2008. Bowling's first studio in New York was on Beekman Street. Later, he moved to 535 Broadway, just north of SoHo.

25 For a longer discussion of Bowling's and Greenberg's friendship, see Bowling, British Library Sound Archive, National Life Stories, and The Clement Greenberg Papers, Getty Research Institute, Los Angeles.

26 Andy Warhol and Pat Hackett, *POPism: The Warhol '60s*, New York, Harcourt Brace Jovanovich, 1980, p. 43. Warhol made this statement in relation to an anecdote about getting into the opening of the Marcel Duchamp exhibition at the Pasadena Art Museum in 1963.

27 Bowling was a correspondent for and contributor to *Arts Magazine* from 1969 to 1972, though he wrote for other periodicals before, during and after this period.

28 Frank Bowling, 'New York Classicism', *Arts Magazine*, 47, Dec. 1972/Jan. 1973, p. 63.

29 Frank Bowling, 'Discussion on Black Art', *Arts Magazine*, 43, Apr. 1969, p. 16.

30 Frank Bowling, 'Silence: People Die Crying When They Should Love', *Arts Magazine*, 45, Sept. 1970, p. 31.

31 Bowling sites Thompson in a comparison of the *African Art* exhibition at the Brooklyn Museum with the *Afro-American Art: New York and Boston* held at the Boston Museum of Fine Arts. Frank Bowling, 'The Rupture – Ancestor Worship, Revival, Confusion, or Disguise', *Arts Magazine*, 44, Summer 1970, pp. 31–34. Thompson's text, 'African Influence in the Art of the United States', is included in Armstead L. Robinson, Craig C. Foster and Donald H. Ogilvie (eds.), *Black Studies in the University: A Symposium*, New Haven, Yale University Press, 1969. Kellie Jones cites the intersection of Bowling and Thompson in 'It's Not Enough to Say "Black is Beautiful": Abstraction at the Whitney 1969–1974', in Kobena Mercer (ed.), *Discrepant Abstraction*, London, Institute of International Visual Arts/Cambridge, MA, MIT Press, 2006. Jones notes that Bowling's continued interest in Thompson's theories is demonstrated in his essay 'It's Not Enough to Say "Black is Beautiful"', pp. 53–5, 82–4.

32 Recent scholarship and exhibitions, such as the Brooklyn Museum's Basquiat exhibition in 2005, have worked to prove Basquiat's skill outside the cult of his persona.

33 Interview with Frank Bowling, November 25, 2008.

34 See Thelma Golden et al., *Freestyle*, New York, The Studio Museum in Harlem, 2001. While the term has gained currency over the decade, it has also been widely misused. Golden's original thesis is useful to return to as a corrective. There is also the term Afropolitan, a synonym of transnational. One of its earliest citations was made by Taiye Tuakli-Wosornu in *The Lip* 5, March 2005.

35 I insert Basquiat and Lewis to acknowledge that this essay, like Gilroy's multiple-subject studies, could easily have been framed around either of the two of them.

36 Exhibition brochure, *Frank Bowling*, Whitney Museum of American Art, 4 November–6 December 1971, unpaginated.

CONVERSATION WITH ÉDOUARD GLISSANT ABOARD THE QUEEN MARY II (AUGUST 2009)

MANTHIA DIAWARA

MANTHIA DIAWARA

We're travelling aboard the *Queen Mary* II, on our way to New York from Southampton. Why a ship, when it would have been easier and faster to travel on a plane?

ÉDOUARD GLISSANT

Ever since I started having heart trouble, I've been unable to take long-distance flights. And since it's eight and a half hours from Paris to Fort-de-France, I'm obliged to take the boat, and this one is pretty much the only one that makes regular trips. It's all quite ambiguous, because you'd think that a boat is a sign of comfort and ease, but in my opinion it's quite the opposite. It's a sign of catching up the time lost; the time that you cannot let slip away or run away, the times that you become caught up in things – you can't flee or run anywhere. It seems to me that on any kind of boat you can be closer to yourself, while in a plane you're really detached from yourself – you're not yourself, you're something else. And I'm saying this jokingly – and I'm not alone in this – it's not normal for a person to be suspended in the air even if man's always dreamed of being a bird. Accordingly, I take this boat regularly when I have to go to Martinique or New York.

MD I gather that crossing the Atlantic in a ship also gives you time to think about the past, the present and the future. It recalls for me not only the slave ships, but also the New World and an important landmark for the creation of the African diaspora.

ÉG That's another matter. It's also a paradox, because this is an ultra-comfortable, super-luxurious ship… and when you lean over the ship's railing, you can't stop thinking about the Africans at the bottom of the sea. It's not the same route, but you think about it just the same. It seems to me that it's another way of meditating on what's happened in the world. Christopher Columbus had left for what was called the New World and I'm the one who returned from it [laughter]. And being on this boat – well, it's not exactly revenge, which would be the stupidest thing to say – but it's a turn of events to know that my ancestors had left for the New World in terrible conditions very much unlike these. There is a return, because right from the start, the whole set-up – Africa/middle of the ocean/arrival – is an enslaving, colonialist set-up: it's the moment when the African diaspora became a forced diaspora. And the return occurs when slavery and domination disappear. That's why I said that Christopher Columbus leaves, but I'm the one who returns. I don't mean myself, Édouard Glissant. What I mean is that those who were forced to leave as slaves do not return as slaves, but as something else: a free entity, not only free but a being who has gained something in comparison to the mass of humanity. And what has this being gained?

Multiplicity. In relation to the unity of the enslaving will, we have the multiplicity of the anti-slavery will. That is what we've gained, and that is the true return.

MD A boat connotes a departure from point A and an arrival at point B – in this context, it is a departure for the Africans who are captured for the first time and pushed onto a boat. What does departure mean to you?

ÉG It's the moment when one consents not to be a single being and attempts to be many beings at the same time. In other words, for me every diaspora is the passage from unity to multiplicity. I think that's what's important in all the movements of the world, and we, the descendants, who have arrived from the other shore, would be wrong to cling fiercely to this singularity which had accepted to go out into the world. Let us not forget that Africa has been the source of all kinds of diasporas – not only the forced diaspora imposed by the West through the slave trade, but also of millions of all types of diasporas before – that have populated the world. One of Africa's vocations is to be a kind of foundational Unity which develops and trans-forms itself into a Diversity. And it seems to me that, if we don't think about that properly, we won't be able to understand what we ourselves can do, as participants in this African diaspora, to help the world to realise its true self, in other words its multiplicity, and to respect itself as such.

MD The middle of the Atlantic, just like the middle in every narrative, represents a moment of uncertainty before the moment of arrival or change, or rupture. What is the midpoint of the Atlantic for you?

ÉG First, we must think about the following. When the caravels arrived on the African coasts, the Africans had never seen a covered boat. They didn't understand this boat that wasn't open. Their politics was a politics of the open boat, not the closed one. And furthermore, when they were transported across the ocean, they didn't understand this river without a shore on both sides, so the Middle Passage was truly the unknown: no shore to their right, no shore to their left, and nothing in front of them – the complete unknown. The first chapter of my book *Poetics of Relation* describes this situation, saying that what characterises the Africans' situation in this adventure is the abyss, the abyss of the unknown, the abyss of the ocean floor, of course, but also the two non-existent shores, the unknown that lies before, the unknown country at which they will arrive; nobody knew what was awaiting these people who were already slaves.

The Africans in the New World – African-Americans, but also the Antilleans, Brazilians, etc. – escaped the abyss and carry within them the abyss's dimension. And I think the abyss's dimension is not, contrary to what one might believe, the dimension of unity, but rather the dimension of multiplicity. And we have to bring all that together, explore it so that we can see where we're going.

MD Where we're going? Are we arriving somewhere? Still, a story has a point of arrival. So what is that arrival point for us?

ÉG For me, the arrival is the moment when all the components of humanity – not just the African ones – consent to the idea that it is possible to be one and multiple at the same time; that you can be yourself and the Other; that you can be the Same and the Different. When that battle – because it is a battle, not a military but a spiritual one – when that battle is won, a great many accidents in human history will have ended, will be abolished.

MD In the Anglophone world, scholars and artists, following Paul Gilroy, have been using the concept of the Black Atlantic to attempt to give similar explanations of the condition of the people of the African diaspora. What do you think of the theory of the Black Atlantic?

ÉG I respect the work of these thinkers who are African-Americans for the most part. I think that, deep down, in the idea of the 'Black Atlantic' there is more of a persistence of that kind of unity than they would have us believe.

I think that part of the African genius – not the black race's – is multiplicity. The diaspora is exploding forth everywhere; it is not concentrated in a single area. So for me the Atlantic is a continent, not an archipelago. And we are inhabitants of an archipelago. When Africa was attacked by the colonisers, it wasn't a continent, but an archipelago. Consider that 'NATO' stands for North Atlantic Treaty Organization. I believe the arrival of the Africans within the phenomenon of slavery is not about the Atlantic, but the Caribbean. That's where they arrived: in Louisiana, the islands, Cuba, Jamaica, Martinique, and it spread from there across the new continent. And the Caribbean is the source, the origin of the plantation system that began to contain and signify the existence of the Blacks. So I'm not an Atlanticist, nor am I continental. I think that the 'archipelagisation' of the deportation of the Africans is a reality, a precious one. That is why, for all the esteem I have for the theoreticians of the Black Atlantic, I don't agree with their thesis.

MD Do you address the same critique of unity to Négritude?

ÉG Yes, but bear in mind that, historically, Négritude was an absolutely necessary movement. When Négritude intervened in the history of Black people, above all in the history of Black people in the New World, it did so to restore balance to our souls and our spirituality, something that appeared quite improbable to us, because we held ourselves in contempt, we had no consideration for ourselves, and we knew nothing of African civilisations and cultures. In other words, Négritude was utterly necessary. I have always been hesitant to subscribe to Négritude completely, because I thought that it was nonetheless a kind of general idea. Blacks are not all the same. A Black from Brazil and a Black from the United States are not the same. So we have to establish nuances, we have to bring out the specific richness of each. There's African-American richness, Brazilian richness, Martinican richness, Cuban richness, etc., and we shouldn't try to bring everything under the same uniform model.

Paradoxically, I think that in its beginnings at least, the theory of Négritude was greatly inspired by French intellect, because that intellect is generalising, given to generality, whereas the British, Anglophone intellect is empiricist and not very interested in general ideas. That's why from the start Anglophone Africans were not at all partisans of Négritude. Wole Soyinka said the most unbelievable things about Négritude when he spoke of 'tigritude' – the tiger lives his tigritude and doesn't need to proclaim it, etc. All this because even as Anglophone Africa was fighting for the rights of Black people, there wasn't a felt need for a theory of Négritude as a generalising unity that would encompass everyone. One day, a commander of a liberation army told me: 'Wherever Black people are suffering, Négritude is completely necessary. But whenever they pick up a rifle, they no longer need it.' In other words, it's a general idea that can be conceived within suffering, but when you particularise yourself by affirming the multiplicity of your being, you no longer need this general theory.

MD Was the Créolité movement an answer to the paradoxes of Négritude, or is it just another form of 'Atlanticism'?

ÉG I don't think it's an answer, no. I believe that the Créolité movement is like Négritude: it has some real justifications, namely, that a large number of the African population, in particular the Brazilians, Antilleans, Caribbeans, were formed on the basis of a mixed reality, or a will towards that reality. You can't say that the Caribbean is not mestizo. What's important is that Caribbean mestizaje is African.

Like Négritude, Créolité has a dual aspect. It's necessary because you can't deny that the Caribbean's mestizo. But you can't say that it's a Chinese or White mestizaje, because Africa and Africans have a vocation for diaspora and mestizaje. But when they mix, they don't stop being themselves. That's what nobody wants to admit. For some people, you're either Black or you're mixed, i.e., not Black. Now that's not true. In Africa, there is a need for diaspora

and multiplicity. Anyway, in Africa itself the nations and tribes mix with each other. Today, there's no such thing as a unified Peul or Senegalese people. For example, there's very intense *mestizaje* between Senegal and Mali. So this aspect of Créolité is valuable.

The other aspect, which is not valuable, is this: when you say 'Créolité' you fix its definition of being once and for all in time and place. Now I think that being is in a state of perpetual change. And what I call creolisation is the very sign of that change. In creolisation, you can change, you can be with the Other, you can change with the Other while being yourself, you are not one, you are multiple, and you are yourself. You are not lost because you are multiple. You are not broken apart because you are multiple. Créolité is unaware of this. It becomes another unity like Frenchness, Latinity, etc., etc. That is why for a long time now I have developed the idea of creolisation, which is a permanent process that supersedes historical avatars. It's difficult to admit this because we're afraid of losing ourselves. We tell ourselves: if I change, then I'll lose myself. If I take something from the Other, then my own self will disappear. We absolutely must abandon this error.

And that's why it seems to me that the history of Africans in the New World is exemplary. It's a history that takes into account the history of the world, because in this very moment the whole world is creolising itself, and there are no longer nations or races that are untouched by others. And what racists fear most of all is mixing. They don't allow for it. And that, I think, is the battle we need to wage, despite everything happening in the world, all those fundamentalisms of all shapes and sizes. I believe we are on the way to winning that battle.

MD I am fascinated by your definition of creolisation as a continuous process. Do you think that we can talk about the African diaspora in the same sense?

ÉG There was an African diaspora millions of years ago which gave birth to the various humanities, because Africa is the cradle of humankind. And there have been other diasporas out of Africa: for example, the forced diaspora brought about by slavery; and today there is also a coerced diaspora caused by poverty and destitution, emigrants and emigrations. Consequently, we can say that in the African condition there is a kind of vocation to go elsewhere. And when there is a mixture of Africa and something else – well, it's Africa that's dominant, because of that vocation, not for racial or historical reasons.

MD The word 'diaspora' was borrowed from the Jews. African-Americans have been very much inspired by the Jewish experience, be it the literal return of Jews to Israel today or the history of the Old Testament. So what are the similarities and differences?

ÉG Outside of the similarity of suffering, I don't think they resemble each other very much. It seems to me that in Jewish errantry, there has been an extraordinary suffering that may be found in the displacement of Africans towards the New World. All kinds of comparisons can be made on this point. Beyond that, there's no similarity. When the Jews made their diaspora in the world, they always preserved their cultural instruments: the Torah, the Talmud, etc. The Africans had lost everything; they had nothing, not even a song. In jazz, Black Americans had to recompose, through memory and through extraordinary suffering, the echo of what Africa had for them. Jazz came about not through a book but through a flight of memory. That's why jazz is valid for everybody, because it's a recon-struction within a distraught memory of something that had disappeared and had now been regained. It required a terrifying effort. That's why jazz at the beginning was so tragic. If you look at the faces of the great jazz musicians, they are very tragic, and that's something everyone can see. The same goes for Bob Marley and reggae: it's valid for everyone, but in the end what we have here is a fundamental difference, and we need to be aware of that.

The arts created by the Blacks of the diaspora, contrary to what's believed, are not indigenous to them; they are arts of mixture, of adjustment to situations. For example, music from, let's say, Tyrol, to take a well-known example,

is linked in the ancestral order to the use of a musical instrument from that place. What's fantastic about jazz is that there's an African music that expresses itself with an incredible beat through the piano, which is an instrument played by Beethoven and Bach. And if you think about it, the same thing applies to most of the other areas.

What's happening is that music is becoming more and more diverse. We're now beginning to understand that European liturgies, Arab music, Indian music, Japanese music are valid for everyone. But only now are they like this, because there's this amazing mixture, this incredible complexity. And because of that, it's of fundamental importance in today's world to say that everything is happening in a rhizome world, that is, roots that inter-twine, mix, and mutually assist each other. And I think that somewhere in all this is the drama of New World Blacks, whether in Brazil to the south, in the Caribbean at the centre, or in the Americas of the north, which has begun to make this multiplicity of the world comprehen-sible. That's why it's so important, and that's why I believe that the truth that is increasingly coming to light about Black reality in the New World is the truth of multiplicity, the truth of the step towards the Other. Well, it's all quite simple to summarise things in formulas. But I myself like the idea that I can change through exchanging with the Other without losing or distorting myself. It's only recently that it's been possible to believe this, and I think it's one of the truths of the present world.

MD And that's where your theory of Relation comes in.

ÉG Yes, because within Relation... now I'm going to try to say something that I hold dear on this terrain. I believe that Relation is the moment when we realise that there is a definite quantity of all the differences in the world. Just as scientists say that the universe consists of a finite quantity of atoms, and that it doesn't change – well, I say that Relation is made up of all the differences in the world and that we shouldn't forget a single one of them, even the smallest. If you forget the tiniest difference in the world, well, Relation is no longer Relation. Now, what do we do

when we believe this? We call into question, in a formal manner, the idea of the universal. The universal is a subli-mation, an abstraction that enables us to forget small differences; we drift upon the universal and forget these small differences, and Relation is wonderful because it doesn't allow us to do that. There is no such thing as a Relation made up of big differences. Relation is total; otherwise it's not Relation. So that's why I prefer the notion of Relation to the notion of the universal.

MD Definitely. Now, another question – why is it that nowadays architects, museum curators and young musicians are so interested in Édouard Glissant's work?

ÉG I can try to tell you why, and it's out of modesty, not vanity, that I say this. It's because reality has caught up with and imposed what I've been saying for twenty or thirty years now amidst general incomprehension. Forty years ago in Mexico, in a conference with Octavio Paz at the National Autonomous University of Mexico, I demanded the right to opacity. There's a basic injustice in the worldwide spread of the transparency and projection of Western thought. Why must we evaluate people on the scale of transparency of the ideas proposed by the West? I understand this, I understand that and the other – rationality. I said that as far as I'm concerned, a person has the right to be opaque. That doesn't stop me from liking that person, it doesn't stop me from working with him, hanging out with him, etc. A racist is someone who refuses what he doesn't understand. I can accept what I don't understand. Opacity is a right we must have. And the audience said: but what kind of barbarism is this? We have to understand, and if we don't, etc., etc. And I can assure you that twenty or thirty years later in the same audito-rium, in the same city, there was a meeting, and quite pleasantly I reminded them of what I had said twenty or thirty years before, and everyone in the room said, we have to demand the right to opacity at the UN. Why? Because people came to understand that what was barbaric was imposing one's own transparency on the Other. I always tell psychoanalysts: if I don't accept my own opacity for myself, I've essentially defeated myself, but I can accept

my own opacity and say: I don't know why. I don't know why, but I detest this person or like this other person. I can like this person not for any particular quality or reason, but just because I do. Does anyone know why he dislikes cauliflower or that other green vegetable…

MD Broccoli?

ÉG Everyone likes broccoli, but I hate it. But do I know why? Not at all. I accept my opacity on that level. Why wouldn't I accept it on other levels? Why wouldn't I accept the Other's opacity? Why must I absolutely understand the Other in order to live next to him and work with him? That's one of the laws of Relation. In Relation, elements don't blend just like that, don't lose themselves just like that. Each element can keep its – I won't just say its autonomy but also its essential quality, even as it accustoms itself to the essential qualities and differences of others. After thirty years, people understood that, but before, they never stopped saying how stupid it was. Then, at a certain moment, the very movement of the world enables us to understand, because after seeing on TV the aborigines of Australia, Japanese, Parisians from the hood, Inuits from Alaska, we've understood that we can't understand everything and that there are things that remain within themselves. As a result, the world catches up with this sort of reflection on its complexity, on mixture, etc., and people end up accepting the idea.

MD Beautiful. I'm thinking about a concept that's popular in Anglo-Saxon countries, not just in philosophy but especially in the definition of cultural identity: the notion of the Other. In France, it's more nuanced; you use *alterité*. The Other has become the minority – the Black, the homosexual, the Chicano, the woman, etc. What do you think of that notion of the Other?

ÉG Well, that doesn't interest me; it's so obviously false that I can't see why anybody would discuss it. I don't think that genuinely Anglo-Saxon thought would go that far. But we were talking about what's specific in the definition of the Other. Whether in the Francophone, Anglophone, Arab, Chinese, Japanese world, what's specific in the definition of the Other is that this Other is not just considered different. The Other is considered as contrary. Now, in the world, there is no contrary. The dialectic of differences is something I agree with, but not the dialectic of contraries, because the dialectic of contraries assumes that there's a truth over here, and its contrary over there. Now I don't believe there is a truth…

MD Or a model…

ÉG … or a model, yes, that's it … a luminous transcendence. I don't believe in that. I say that nothing is true and everything is alive. We've already gone over this – what that means is that nothing is absolutely true. There isn't one absolute truth, but truths. Everything is alive; everything is a Relation of differences, not contraries, but differences. Accordingly, the dialectic is not a linear approach towards that which is contrary. The dialectic is a total rhizome of what's different.

TRANSLATION BY
CHRISTOPHER WINKS

BRIDGING THE ATLANTIC AND OTHER GAPS: ARTISTIC CONNECTIONS BETWEEN BRAZIL AND AFRICA – AND BEYOND

ROBERTO CONDURU

London Snow Africa, London Hole Brazil 1998–99 consists of a pair of images captured by Milton Machado on the streets of London: a snow-covered map of Africa and a hole in the asphalt resembling the map of Brazil. Beyond questioning the political dimensions of cartography, the work provides an interesting means of access to connections between the visual arts and the question of Afro-Brazilian socio-cultural influences.[1] Its apparently literal title possesses a sonority that resonates with other meanings: difference, identification, domination. It leads us to consider how relations between Brazil and Africa are often forged by external mediators, artists not necessarily of African descent, establishing diffuse networks of meaning in the Atlantic and configuring unique images of Africa in Brazil. It also allows us to understand how, regardless of the fact that it is a constant in the process of Brazilian artistic modernisation, Afro-Brazilian hybridity is infrequently perceived and analysed, an absence that correlates with Brazilian society's more general silence regarding African descent.

Milton Machado
London Snow Africa, London Hole Brazil
1998–99

AFROMODERNITY IN BRAZIL

Afro-Brazilian influences are both inherent in and essential to the understanding of Brazilian culture. However, these connections take place in different modes and with varying degrees of intensity over time and space, certain moments and places being of particular interest to the process of artistic modernisation. One such conjunction took place between the late 1800s and the early twentieth century in the academic milieu of Rio de Janeiro, São Paulo and Bahia, within the context of the intensification of the abolitionist process, the end of slavery and the beginning of the Republican regime. Reflecting an intricate process of representation and self-representation even as they constructed images of themselves and of the other, black painters such as Estevão Silva, Antônio Firmino Monteiro, Antônio Rafael Pinto Bandeira, and the brothers João and Arthur Thimótheo da Costa navigated the genres of Western painting, avoiding Afro-Brazilian subject mattter, which was left to artists of non-African descent – such as Belmiro de Almeida, Pedro Américo, Antônio Parreiras, Rodolpho and Henrique Bernardelli – to address, albeit in predominantly deprecatory interpretations that helped to establish a marginal place for blacks in society.

Another singular moment occurred around 1910 in São Paulo, Recife and Rio de Janeiro, with early expressions of another appreciation of the African component of Brazilian culture. Instead of being regarded as negative or degenerative, a social evil to be eradicated, ethnic miscegenation became a positive cultural value – a paradigm for artistic and cultural relationships. Continual references to women and religions stand out as part of the artistic map of popular culture in Brazil. The figure of the Bahiana – whether in the guise of *mãe-de-santo*, or as an *acarajé*[2] or fruit vendor – drew the attention of Brocos, Anita Malfatti, Cecília Meireles, Oswaldo Goeldi and Cândido Portinari, among many others, and culminated in the international icon that was Carmen Miranda. The mulatta was elected as an emblem of miscegenation, and tribute was paid to her, particularly in Di Cavalcanti's pictorial elegies, which helped to transform her into a standard of Brazilian beauty, subverting Western aesthetic standards imposed by fine arts culture, on one hand, while perpetuating the sexual objectification of black women on the other. This process was criticised in a simultaneously monumental and affective mode by Tarsila do Amaral in A Negra [The Negress] 1923,[3] and by Anna Bella Geiger's Am.Lat. [Lat.Am.] 1976, in which the mulatta is included in the artist's critical vision of Latin America as part of a subservient repertoire of sexuality and mysticism.

The 1950s brought a new approach to the subject, one that was simultaneously an ethnic-cultural development of Brazilian modernism and a formal artistic response to the process of building yet another perspective on African cultural influence in Brazil, as then outlined by the Black Movement. In Bahia, Rubem Valentim began to explore possibilities for synthesis between the principles and forms of Constructivism and Afro-Brazilian religions, a mode that has continued into the present day, having spread to other regions (Rio de Janeiro, São Paulo and Minas Gerais) as a result of both aesthetic and museological initiatives by Emanoel Araújo, Ronaldo Rego and Jorge dos Anjos, countering persistent threats to – as well as the marginalisation of – these religions by contributing to their positive public visibility.

Another important development began in the late 1960s, within the countercultural flux of that time. By the 1970s, the works of Antonio Henrique Amaral, Hélio Oiticica, Lygia Clark, Lygia Pape and Regina Vater were exploring particular connections with Afro-Brazilian culture, particularly with Afro-Brazilian religions as established in Rio de Janeiro and São Paulo. During this decade, the Afro cults experienced a revival of sorts in the arts (film, music, theatre, the visual arts) and in the social sciences.[4] In the visual arts, dialogue with the Afro-Brazilian universe is easily perceptible in works by Antonio Manuel, Artur Barrio, Cildo Meireles, José Roberto Aguilar and Waltercio Caldas.

Anna Bella Geiger
Am.Lat (América Latina) 1977

Bridging the Atlantic and Other Gaps

Since the 1990s, the exchange between visual artists and Afro-Brazilianness has gained new impetus, along with another wave of connections to African and Afro-Brazilian cultures in various cultural fields, particularly within popular music; at the same time public policies have sought new modes of social inclusion for Brazil's black communities. These accomplishments do not quite constitute a specific watershed, or even an immediately discernible cluster within contemporary Brazilian artistic output. They are dialogues established by artists in certain specific works, based on their own experiences of the many heterogeneous, often sporadic Africas present in a number of Brazilian cities, dispersed across Brazilian territory.

TOURIST *MACUMBA*?

This cluster of connections has occasionally been called 'Afro-Brazilian' art, underscoring the sense of a mixture formed in Brazil; at other times it has been referred to as 'Afro-descendant' art, emphasising a supposed African purity. Yet neither label has ever referred exclusively to art produced by Africans in Brazil or by black Brazilians. In addition to Brazilian artists not of African descent, such as Milton Machado, an abundance of artists from overseas (some of whom eventually became Brazilian citizens) engaged with aspects of Afro-Brazilian culture: Spaniard Modesto Brocos y Gómez, Mexicans Henrique and Rodolpho Bernardelli, Lithuanian Lasar Segall, Argentinean Hector Julio Páride Bernabó (aka Carybé), German Karl Heinz Hansen (aka Hansen Bahia), Frenchman Pierre Verger, Portuguese Maria Helena Vieira da Silva and Cristina Lamas, and North Americans Matthew Barney and Arto Lindsay.

Based on the expression *macumba para turista* (literally, 'macumba for tourists'), which designates simulations of Afro-Brazilian religious practices for the uninitiated,[5] one might speak of 'macumba by tourists' in order to consider this group of artists. Recently, certain artistic, museological and historiographic productions have broadened the inclusive quality of this tendency: the native himself or herself might be the tourist, which leads one to reflect on the various modes of belonging triggered by works made from within and from without, for insiders or for outsiders of ethnic groups, Afro-Brazilian religions, or the Black Movement itself.

ARTIST *MACUMBA*?

Most artistic dialogue with the Afro-Brazilian universe in Brazil has focused upon Afro-Brazilian religions, dealing with their images and reinforcing the tradition of the representation of their practices that began when Brazil was a Portuguese colony. Whereas the works of Carybé and Verger are very often ethnographic in their focus on Afro-Brazilian material culture, rites and myths, Valentim's investigations explore the syntax and semantics typical of the symbols present in these religions. He refers to many religions, predominantly but not exclusively Afro-Brazilian ones, in hieratic and abstract arrangements with universalising claims. Araújo refers specifically to Candomblé, with a dynamism derived from lyrical constructivism as disseminated in Brazil and the power of the *orixá* Exu.[6] Rego approximates the formalistic-ritual structures of these religions to modalities of contemporary art (object-paintings, installations). Dos Anjos, influenced by the Neoconcretists in his 'creole constructivism', explores the tension inherent in the reversibility and opening up of geometric abstract signs.

At the same time, it is possible to observe the immediate or transformed appropriations of images from Afro-Brazilian religions as outgrowths of research conducted directly in *terreiros* (literally 'yards', but more broadly, outdoor places of worship) and disseminated in the landscape or the history of art in Brazil. Arthur Bispo do Rosário's *Macumba* is particularly noteworthy for the simultaneous self-representation and rearticulation of things and meanings in its synthetic representation of Afro-Brazilian religions through the free agency – at once raw and poetic – of multiple objects. Certain artists, however, have had considerable involvement in and experience with Afro-Brazilian religions without necessarily

having been initiated into them. Some of the finest accomplishments in this field feed off both consonances and discontinuities among art, religion and culture, between the universal and the local. Usually, such works rearticulate procedures of dematerialisation that are typical of contemporary art – performances, *instaurações*[7] and installations – towards religious practices in which rites and objects are crucially inseparable. Rituals rarely take place without the introduction or use of certain objects which, according to tradition, must be made and displayed according to specific conventions.

In Nimbo/Oxalá 2004, Ronald Duarte manifests a chemical/physical encounter with the deity Oxalá, presenting a brief and uncontrollable cloud generated by the expulsion of the entire contents of a number of fire extinguishers as an offering to the Nagô *orixá* of creation. This connection is reinforced through some of Oxalá's characteristics: the day of the performance (Friday); the colour of the smoke, which is also the predominant colour of the garments worn by the congregation (white); the temporarily formed element (a cloud) and one of its qualities (a diffuse omnipresence). In a work which doubles as an *ex voto*, the artist explores the semantic multiplicity of religions and the clandestine dissemination of their signs within Brazilian cultural codes. Similarly, without iconic representations and exploring the semantic breadth of the signs with a transitory performative intervention, Marepe realised *Pérola de água doce* [Freshwater Pearl] 2007, casting thirteen thousand freshwater pearls into São Paulo's Tietê River. On the borderline between the artistic and the religious, the performance was presented as a ritual offering to Oxum (the Afro-Brazilian deity most directly and powerfully associated with fresh water) and also as a manifesto against the pollution of the river and environmental degradation.

One might well ask whether some of art's dialogues with Afro-Brazilian religions ought not to be qualified as 'artist *macumba*': the deliberately 'exotic' exploitation of these religions in order to produce aesthetic effects. Undoubtedly, the recurrence of works linked to Afro-Brazilian religions is significant for the social

incorporation of those religions. And yet, the aestheticising of aspects of these religions is a dimension of their spectacularisation through art, which may be linked to the 'ritual hypertrophy of the Afro-Brazilian religions', due to the emphasis placed upon their market and aesthetic values.[8]

MACUMBEIRO ART?

One must distinguish between an aestheticising of religious cults, which stems from a neglect of ethical values and causes a subsequent reduction of meaning to mere appearance, and the aesthetic dimension that is intrinsic to these religions, which leads us to think about the insertion of religious objects and practices into the world of art, in what might be qualified as '*macumbeiro* art'. The work of Deoscóredes Maximiliano dos Santos, better known as Mestre Didi, present within art institutions in Brazil and abroad as early as the 1960s, bears witness to the possibility of preserving the qualities or attributes required by religion and its expansion into other domains. Although Mestre Didi's work and career herald more broadly influential and culturally inclusive transitions between the worlds of religion and art, establishing precedents for the works of Lena Martins, Wuelyton Ferreiro and Junior de Odé, these artists are still exceptions to the marginal status of Afro-Brazilian religious art within the art circuit. To come to grips with the invisibility of this artistic trend is to understand the social standing of black Brazilians and their cultural practices, which leads to a consideration of accomplishments associated with the black cause.

ARTIST ACTIVISM?

The articulation of art, politics and blackness in Brazil led to the actions of the Black Movement in the field of the arts and, consequently, to the intellectual and political militancy of Abdias do Nascimento in favour of Afro-

Marepe
Freshwater Pearl 2006

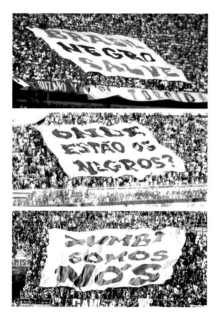

Brazilian populations.[9] Having been active in the fields of poetry and theatre, as well as in politics, when he devoted himself to the visual arts in the 1950s he strove to create a new public image for the black man, to establish a museum and disseminate knowledge regarding black art. When the military dictatorship drove him into exile in the United States and in Africa during the 1960s, Nascimento also began to paint Afro-Brazilian subjects. Although he defended Pan-Africanism in his writing, his paintings reflected an effort to achieve a positive public visibility for Afro-Brazilian culture by highlighting Yoruba myths. Araújo's case is a similar one, for he has been politically active within art's institutional field, especially as an editor of books, a curator of exhibitions and a museum director –activities that eventually culminated in the 2004 creation of São Paulo's Museu AfroBrasil, the largest and most important museological initiative dedicated to reflection on the participation of Africans and their descendants in the making of Brazil.

Artists who have sought to connect the Afro-Brazilian cause to the tradition of engaged art that denounces social exclusion, and draws attention to the plight of the socially abject, include Johann Moritz Rugendas, Lucílio de Albuquerque, Cândido Portinari, Antônio Henrique Amaral, Sebastião Salgado and Vik Muniz. Within this tendency, one must highlight Lasar Segall's critical representations of suffering or melancholy black men. *Bananal* [*Banana Plantation*] 1927 depicts the humble wisdom of elderly blacks, derived from the mixture of ancestral cultures and suffering, marginality and resistance generated by slavery, upon which is based the figure of the *preto velho*,[10] relating the political predicament of the farm worker to the Afro-Brazilian religious universe.

Today's younger artists frequently reference works by Meireles and Pape that broach racial exclusion. Meireles' *Inserções em circuitos antropológicos: Black Pente* [*Insertions into Anthropological Circuits: Black Comb*] 1971–73 speaks explicitly to the politics of exclusion in Brazil, and is introduced thus:

A project for the production and distribution of combs for blacks at cost price. In the 'Insertions into

Ideological Circuits' series, the essential fact is the observation of the existence of the circuit(s), and verbal insertion constitutes an interference in this circulatory flow; that is, it suggests an act of ideological sabotage against the established circuit. As for the 'Insertions into Anthroplogical Circuits' ('Black Comb' and 'Token'), the concept of 'insertion' is of greater consequence than that of the circuit: the purpose of the confection of the objects, elaborated analogously with those belonging to the institutional circuit, is to induce a habit and, from that point on, the possibility of characterizing a new behaviour. In the case of 'Black Pente' specifically, the project would affirm an ethnicity.[11]

Black Pente represents a good-humoured attack upon the politics of devaluation of black hairstyles, bodies and cultures that is visible in society on a daily basis, participating in an appreciation of blackness and attacking social restrictions. Recently, certain artistic actions have engaged in this struggle by means of the insertion of ludic and good-humoured messages into urban circuits and practices, tackling more general issues of the Afro-Brazilian social condition. São Paulo's Frente 3 de Fevereiro [February 3rd Front] question the racism entrenched in Brazilian society with their Ação Bandeiras [Flag Action] 2006, carried out in soccer stadiums. This collective incite crowds into action, by leading them to unfurl and read huge flags that salute the visibility and reach of Afro-Brazilian identity with emphatic slogans such as 'Brazil negro salve' ['Hail Black Brazil'], 'Onde estão os negros?' ['Where are the Blacks?'], and 'Zumbi somos nós' ['We are Zumbi'].[12]

In her parodic and subtly incisive Caixa Brasil [Brazil Box] 1968, Pape uses irony to criticise the institution of art and the myth according to which the Brazilian nation was built harmoniously by the Portuguese, indigenous peoples and Africans. Representing the ethnicities by means of locks of blond, brown and black hair, she attacks the hierarchy of races represented by Brazilian society's 'appreciation' of straight, fine, light hair over dark, thick, curly hair, along with museological practices such as fetishism, accommodation, enclosure, control and voyeurism.

Along this critical/poetic path, another way into the Afro-Brazilian universe involves the use of ethnically accented materials with more or less circumscribed cultural references. In Divisor 2 [Divider 2] 2001, made of three large glass boxes that contain salt, water and palm oil, Ayrson Heráclito goes beyond the literalness of those materials, exploring metaphorical dimensions based on their juxtaposition: water and salt are indivisible in the sea; palm oil is made from palm tree nuts, and the palm tree (Elaeis guineensis) possesses multiple meanings in Afro-Brazilian religions, while the oil of its nuts can represent human blood. The work therefore presents a concatenation of materials that refers to the Atlantic Ocean as a fulcrum for social processes based on the forced transportation of Africans to be enslaved in Brazil, from the sixteenth to the nineteenth centuries. Remaining isolated, in layers, in a process of partial and conflicting interaction, these materials allude to the impossibility of

Ayrson Heráclito
Divider 2 2001

considering the Atlantic without taking into account the stalemates of the diaspora and its consequences – the bloodless sea that was the means to so much bloodshed. Thus, they symbolise complex connections and disjunctions of persons, social groups, religions and cultures between Africa and Brazil.

Nevertheless, one might question to what degree works that focus on Afro-Brazilian themes constitute themselves as artistic activism. To be sure, such works are linked to the Brazilian present and contribute to the greater visibility of issues around blackness in Brazilian society, one result of which has been the affirmative public policies for black Brazilians which have increased in recent years. The question is not merely one of measuring whether or not art can act effectively to transform the social field beyond its own domain; it is also a matter of perceiving how political action may currently be revitalised through art.

ART + RELIGION + POLITICS +

In most artistic dialogues with Afro-Brazilian themes, religion and politics are mixed together with other matters, whether artistic or belonging to other domains, times and places, for African and Afro-Brazilian references are rarely exclusive. The work of Rosana Paulino is an example of this range of expression. Living in São Paulo, she has played a pioneering role in the recent intensification of these dialogues, with an original outlook that spans the individual and the collective, drawn from her experience as a black artist. Her work makes use of printed materials and manufactured objects and alludes to fetishes and sortilege (divination or prophesy) that may be linked – albeit not exclusively – to Afro-Brazilian religions. Consisting of images of her ancestors printed onto grigris (African charms, fetishes or amulets), *Parede de memória* [Memory Wall] 1994 is about beliefs, memory, and the transmission of knowledge and practices from generation to generation that makes possible cultural survivals within adverse contexts. In other works – which refer explicitly to politics rather than to religion – she alludes to everyday prohibitions imposed upon black women, dealing with ancient and current social constraints, as well as to limitations to her activities and expression as a black artist and woman.

Situations of micro- and macro-power are also addressed (usually with a caustic humour that is light-years away from 'political correctness') in the interventions of Alexandre Vogler, who approaches the universe of religions in Brazil with a satirical perspective. In *Tridente de Nova Iguaçu* [Nova Iguaçu Trident] 2006, he openly and provocatively inserts himself into an ongoing religious war in a region densely populated by *terreiros* and other places of worship. With critical irony, he exploits the demonising of Exu by traditional Christian religions in order to propose the *orixá* as a patron of tactical media; he does so by whitewashing a trident onto a hillside in the Vulcão mountain range, behind and above the Mirante do Cruzeiro (the name refers to the cross at the summit, a powerful religious and cultural symbol that dominates the region's landscape). Thus, he exploits the ambiguity of the sign that alludes to Neptune's mythological sceptre and to the trident of certain Afro-Brazilian Exus, defying religious intolerance as well as the political populism that attacked work and artist, destroying the former and threatening to sue the latter.

The dialogue between art and Afro-Brazilian culture has not always been tranquil. Just as the Afro-Brazilian social condition continues in large part to be an unequal and unjust one, the ways in which it is depicted often result in myth, stigma or caricature. The challenge, which is met by artists with varying degrees of success, is the attempt to attain the critical/poetic status of art in response to Afro-Brazilian culture, without producing religious art, or artistic propaganda, although occasionally establishing itself as a religiously and/or politically engaged realisation – a dynamic and risk that has affected critics and historians alike, subject as they are to condescendence and ingenuousness in the name of faith or the black cause. Nevertheless, the dialogues between art and Afro-Brazilian culture constitute a branch of contemporary art production in Brazil which art criticism and history cannot avoid considering.

Alexandre Vogler
Nova Iguaçu Trident
2005

AFRICA HERE, THERE AND BEYOND

The recurrence of religion comes as no surprise, for it is above all by the religious (whether Africans, Afro-Brazilians or otherwise) that Africa has been internalised and experienced in Brazil throughout the *terreiros* – omnipresent spaces for the preservation of African cultural values. Mestre Didi's work is the finest example of the survival of African techniques, symbols and ideologies in spite of spatial and temporal gaps. Agnaldo Manoel dos Santos represents another exceptional instance of continuity in spite of rupture. In 1966, his prize-winning work was deemed a symbol of the 'universality of Africanism, preserved through the aesthetic expression of new cultures' at the first edition of the World Festival of Black Arts in Dakar, Senegal.[13]

Within this process, direct contacts with Africa have been sporadic. In their journeys to that continent and in works that exist on the borderline between art and visual ethnography, Carybé and, above all, Verger emphasised cultural continuities on both sides of the Atlantic, the dissemination of which has had a powerful impact upon religious communities. Whereas their output generated perceptions of an African whole based on its parts, the recent work of Viga Gordilho is based on specific survivals between the African and Brazilian socio-cultural contexts, related to affirmative processes by ethnic groups in Brazil. As much a result of the scarcity of direct contact with Africa as of Africa's diffuse and pervasive presence in Brazil – never as widely considered as it could or even should be – Africa in Brazil, one might conclude, is incomplete: it is a future.

TRANSLATION BY
STEVE BERG

NOTES

1 By way of introducing his work, Milton Machado says: 'In ancient times these two portions of land – Africa and Brazil – were connected. They were parts of the Pangeas, the unified continent which was split by cataclysms that occurred in the Cambrian Period. London is where I mind the gap'. However, he was not the first – and will certainly not be the last – to have noted connections and gaps between Brazil and Africa from abroad. To be sure, these artistic connections are rarely made directly, having often been established from Europe and from the United States.

2 Translator's note: *acarajé* is a dish made from peeled black-eyed peas formed into balls and then deep-fried in *dendê* (palm oil). It is found in Nigerian and Brazilian cuisine. It is traditionally encountered in Brazil's northeastern state of Bahia, especially in the city of Salvador, often as street food. The *acarajé* are served split in half and then stuffed with spicy pastes made from shrimp, cashews, palm oil and other ingredients.

3 Tarsila painted *The Negress [A Negra]* in Paris, where she discovered Negrophilia and remembered the blacks who lived on the coffee plantation where she had been raised. She was motivated and accompanied by Blaise Cendrars with whom she (along with other artists and writers) undertook trips to Rio de Janeiro and to Minas Gerais in which they explored areas, images and practices of popular culture, the affectively distant observation of which generated her somewhat ethnographic canvases of the 1920s.

4 See Yvonne Maggie, *Guerra de orixá*, Rio de Janeiro, Jorge Zahar Editor, 2001.

5 Editor's note: *macumba* is a word of African (Bantu) origin used in Brazil to refer to rituals or religions of African origin. It often has pejorative connotations referring to superstition, witchcraft and luck-related rituals and beliefs; but when used by practitioners of these religions, it is not necessarily viewed as having negative implications.

6 In the Yoruba tradition *orishas* (*orixá* in Brazil) are spiritual manifestations of a supreme divinity. In the syncretic religions of African origin (such as Candomblé and Santeria) dedication to Orishas has been conflated with the Catholic veneration of sainthood; individual Orishas thus retain characteristics of their Catholic counterparts.

7 Translator's note: the term is a neologism. *Instauração* (meaning literally 'to set up') is the name Antonio Mourão, better known as Tunga, has given to a recurrent strategy used in his work, which consists of incorporating people from outside the art world into the work as protagonists of a sort of performance, following a ritual with objects and materials suggested by the artist; the remains of the performance make up an installation that is kept on display. The whole formed by performance + process + installation 'sets up' a world.

8 See Reginaldo Prandi, 'Hipertrofia ritual das religiões afro-brasileiras', *Novos Estudos CEBRAP*, no. 56, 2000, pp. 77–88.

9 Editor's note: born in 1914, Nascimento was a prominent leader of Brazil's black movement. He was exiled by the military dictatorship in 1968 and subsequently became very active in the international Pan-African Movement. He returned to Brazil in 1983.

10 Translator's note: the figure of the *preto velho* is linked to Saint Anthony and/or Saint Benendict and represents the spirits of old slaves who died in captivity. These are very peaceful and kind spirits who possess great wisdom about suffering, compassion, forgiveness and hope.

11 Cildo Meireles, *Cildo Meireles*, Rio de Janeiro, Funarte, 1981.

12 Editor's note: Zumbi dos Palmares (1655–95), who became a national hero, was the last leader of the Quilombo dos Palmares, a maroon (fugitive slave) republic in Alagoas. He became commander-in-chief during its defence against the Portuguese and the subsequent ongoing rebellion, but was captured and executed on 20 November – celebrated in Brazil as a day of black consciousness.

13 See Clarival do Prado Valladares, 'África Nova: a busca do universal', *Jornal do Brasil*.

POST/BLACK/ATLANTIC: A CONVERSATION WITH THELMA GOLDEN AND GLENN LIGON*

HUEY COPELAND

HUEY COPELAND

The first question I'd like to pose to you both concerns your senses of 'the Black Atlantic'. When did you first encounter the notion? How was it useful in thinking about your individual practices? What kinds of connections did the concept allow you to forge? And how has it come to frame your understanding of black culture's unfolding in the present?

GLENN LIGON

I first encountered the term in relationship to an exhibition created by David A. Bailey at the Institute of Contemporary Arts in London called *Mirage: Enigmas of Race, Difference and Desire*.[1] What was interesting about the exhibition was that it brought together a number of artists who were prominent in Britain alongside artists from the United States, myself included. In addition to the show there was a conference organised around the issues raised by the Black Atlantic, which introduced me to scholars like Paul Gilroy, Kobena Mercer, Stuart Hall, and Homi Bhabha. I realised that London was an intellectual hotbed, and being in that environment made me think about my relationship to black British cultural studies and to the work of artists like Isaac Julien and Steve McQueen.

THELMA GOLDEN

I first became acquainted with the idea of the Black Atlantic through Paul Gilroy's book *The Black Atlantic*, which allowed me to understand the historic connections between black progressive political movements in the US and in the UK; to come to a more nuanced understanding of the immigration patterns that created these similar but different communities; and to situate black cultural history in an international guise.[2] More specifically, I became very engaged with the Black Atlantic as it related to the visual arts in the same way Glenn did, through the *Mirage* exhibition and conference. For me those events opened up my world curatorially. At that point, I had been indoctrinated by multiculturalism and during the conference I discovered how parochial that indoctrination was because it looked only at the American experience, as if the experiences of other artists of African descent had happened in the past. I also met a number of the artists included in the exhibition for the first time, many of whom I have since come to work with in one way or another, allowing me to have a curatorial network that stretches around the world.

* This conversation took place on 28 September 2009 at the Studio Museum in Harlem.

HC Both of your responses resonate with my own initial encounter with Gilroy's text, particularly, as you put it, Thelma, its importance in decentralising the African-American experience within the context of academic black studies. Just as crucially, I think, *The Black Atlantic* offers a counter-hegemonic narrative of modernity that has profound ramifications for our understanding of the present. I wonder, then, how that aspect of Gilroy's formulation has offered you ways of critically interrogating prior historical moments as well as the contemporary art world, which is so often framed these days as global and dispersed?

TG I think the Black Atlantic allows us to rewrite and reflect on our own history in a more expanded way. For instance, another moment during which I spent time thinking about Gilroy's intellectual construction was in 2003 when Dr Lowery Stokes Sims, former director of the Studio Museum, curated a show called *Challenge of the Modern*.[3] In that exhibition, Dr Sims aimed to frame the history of modernism as a history of modernisms. The show focused on the literal movements and migratory patterns that *The Black Atlantic* charted, and also explored artistic movements in the Caribbean, the US, the UK, and Europe. The Black Atlantic not only allows us to push back against an amorphously understood globalism, but also to become more precise with our history. One of the things I treasure about the book is that there is an Aaron Douglas painting on the cover and also that Gilroy frames the Harlem Renaissance within a larger transnational context.

GL What's also interesting about *The Black Atlantic* is that it acknowledges that ideas don't circulate in the same way across different historical moments. For example, one could argue that Aaron Douglas's Africa was an 'Africa of the mind', whereas now there is a more substantial dialogue between artists on this side of the Atlantic and artists in Africa as well as with African artists living in the United States, which for me has produced a rethinking of what is possible. In 2002 I had a residency in Germany where I worked on a cycle of text-based paintings using

James Baldwin's essay 'Stranger in the Village'.[4] In that essay Baldwin tries to come to grips with European culture in the 1950s and his relationship to it. Not just 'I'm here to write about my self-imposed exile from America', but also 'I'm here in this particular place at a particular time. What does that mean? What do I signify here as a black person? What's a black person's relationship to this cultural legacy?' And so during my time in Berlin I was trying not just to make 'American' work in Europe, but also to consider how other people have thought about what it meant to be a black person in that cultural space. In some ways, that approach was informed by the work of the black British artists I had met through *Mirage* who were thinking more expansively about their experiences, but also more specifically.

HC That notion of specificity, particularly as it relates to Douglas's fantasised Africa versus your actual working connections with African artists, puts me in mind of one of your paintings in the exhibition, *Gold Nobody Knew Me #7* 2007, which recasts a Richard Pryor joke: 'I went to Africa. I went to the Mother land to find my roots: right? Seven hundred million black people! Not one of those motherfuckers knew me.' What I find compelling about the work is how it uses humour to pull the rug out from under the notion that anyone might have some kind of instant access to 'Africa', at the same time that it visually and conceptually demands that we think about the difficulty of translating blackness from one context to another. In that vein, I wonder if you could comment on the ways that certain iconic black figures become the ground for registering these processes of translation across the diaspora, whether in your own work on Malcolm X, or in other pieces in the exhibition such as David Hammons's *African-American Flag* 1990, or Coco Fusco's video, on the visual production of Angela Davis, *a/k/a Mrs. George Gilbert* 2004?

GL If we look at a figure like Malcolm X, we see that his message and image have been exported globally. Malcolm X has become an international figure, and during his lifetime, particularly after his pilgrimage to Mecca, he

certainly imagined himself as an internationalist. What interested me in the series of works where I gave an image of him to children to colour in was how images get made and re-made and how they read differently from generation to generation. Each generation makes the Malcolm X they need. Many of the works that are in the show deal with this notion of re-making as a way to think about the particular historic moment that we're in and what those iconic images – of, say, Marcus Garvey's red, black and green flag, or Angela Davis, or Malcolm X – were about in the moment in which they emerged.

HC Such reiterations of the past are, of course, key to all kinds of advanced black diasporic cultural practice. So I wonder how you both understand the logic of these returns, particularly in the present moment when artistic citations of the 1960s and 1970s often seem to function as ways of adding value rather than of deeply thinking through? How do historical retrievals develop a kind of force, politically and formally, that makes an intervention in our conceptions of the present?

TG History matters, particularly in the practices we're talking about, because it signals a reference point that in many ways defines identity and place, which artists then claim and deploy in their work. You are right to say that sometimes the past is used simply as a point of departure or as a way to reference something else. I do think that in many of the works included in this exhibition it is also about an extremely innovative effort not so much towards reclaiming and reflecting on the past, but moving towards writing a new history from the present moment.

HC And, I think, towards differently locating all of us on the map of culture, which is not unlike what you and Glenn aimed to do in introducing the notion of post-black in the context of your 2001 Studio Museum exhibition *Freestyle*. That term named a new generation of African-American artists, who, as you put it, 'were adamant about not being labeled as "black" artists, though their work was steeped, in fact deeply interested, in redefining complex notions of blackness'.[5] Now, I don't have to tell

y'all that since that time, post-black has been frequently mobilised and critiqued for a range of ends.[6]

TG I will take this opportunity to talk about the notion of post-black. Glenn and I have had many conversations about art and I am completely grateful to him for his willingness to help me work through ideas, because often as a curator you're doing two things at once: you are looking and seeing, but you are also trying to frame ideas. When it works the two come together, and when it doesn't it can be a big train wreck. Coming to understand the difference means working through one's ideas. Glenn is an incredibly generous spirit in that he shares information, which is another way of saying that he is not a hater. There has never been a time when Glenn has seen a young artist who he thinks is great and not shared that information with me, knowing that it could perhaps galvanise something for that artist. I say this to suggest how in my conversations with Glenn I came to formulate this concept of post-black. Glenn and I have talked a lot about his work as it relates to history and what he uses as his reference points. There is a shorthand that we have adopted over time to speak about the various works that we might be looking at, or looking away from. Post-black was an abbreviation of post-black art, which really referred to our way of talking about a particular kind of practice at a particular moment that engaged with a particular set of issues and a particular ideology. For us, in those conversations of the late 1990s, it was often a way to talk about what we thought was coming next: saying a practice was post-black art was how Glenn would tell me that 'this is an artist who has moved several steps beyond having to work out their relationship to a particular set of issues'. That working out could be a positive or a negative, a wrestling with or an ignoring of, which is why I feel it is necessary to say that post-black was not about a particular artistic strategy, but about what had happened over the last thirty years and how artists were moving beyond a place in history and to the present moment. I know that there are those who would like to think that we sat down and wrote a list of qualities and qualifications, but that was never the case. It was a way for me to take the next step curatorially,

because I felt deeply invested in a group of artists who had come of age in the 1990s who were working with a set of issues that I had been able to consider within the context of several different exhibitions. I was also looking for a way to take the Studio Museum and its then thirty-year history around these issues to the next intellectual and programmatic step. It's like we were at Lenox and I was just trying to get to 7th Avenue. I wanted to move forward by looking at a group of artists who generationally, for me, were new.

GL For me, the whole discussion of post-black art was really about a notion that there's a generation of artists younger than myself that has a different relationship to images and history than my generation or the generation before me. So the kinds of debates that Thelma and I were deeply engaged in in the era of what we might call High Multiculturalism – the question of negative and positive images, for example – were debates that they felt distant from.

TG We felt distanced too!

GL I know, but I think we still had to engage those debates in a way that a younger group of artists don't feel they have to. For them, that territory had been dealt with: 'we're in a new space. We're going to have a different relationship to these images. We're going to have a different relationship to this history. Your sacred cows are not our sacred cows.' That was really what post-black art was about for me, the perception of a shift in terms of what you might generally call responsibility, or more precisely, a narrowly defined sense of our responsibility to a certain history and to certain kinds of images. These artists' rethinking of that responsibility was very exciting and helpful for me as an artist in moving out of one way of doing things. It was like going from black-and-white TV to colour.

TG In fairness, I also found the debate around post-black somewhat fruitful, just because it allowed me to under-stand how hard it was for some people to imagine that we

could have debates in this way and to ask why we couldn't imagine that in this space at this moment, there are different ways we can understand what's happening artistically. *Freestyle* was one way to engage these ideas, but there could be others as well. I think the notion that there is some singular narrative that we all have to be a part of doesn't seem fruitful for our understanding of contemporary practices. This is something I learned from being within an international context, in which the practices can unfold individually and still be a part of larger dialogue, but are not necessarily tied to one track of ideas.

HC Thelma, your discussion raises the question of post-black's relationship to notions of internationalism, particularly within the context of the Studio Museum. Artists from various points in the diaspora were included in *Freestyle*, in part, it seems, because black cultural practitioners the world over are dealing with similar circumstances in terms of the media's production and reproduction of blackness, yet in palpably different ways. I want to ask, then, how has your thinking about the profile of the Studio Museum and its reach across the Black Atlantic shifted in the context of the post-black?

TG That is something I also need, in part, to credit to Gilroy's argument. Our mission at the Museum changed in the early 2000s, when Dr Sims was our Director and I was Deputy Director and Chief Curator. The former mission stated: 'The Studio Museum in Harlem collects, presents, preserves, and interprets works of African-American artists and artifacts of the African diaspora', which was valid at the time for an institution that was founded in 1968 in Harlem. That statement addressed the position of African-American artists at a time when the art world was still highly exclusionary, so it imagined the museum as a corrective to those exclusions. It was also an institution very much steeped in the cultural movements of the 1960s that were claiming the history of Africa as a living, breathing tool for the formation of black identity. Now, what it also meant, as you thought about the mission in a working way, was that there was a split between living, breathing African-American artists and artefacts of the

African diaspora, which suggested that Africa was our past and Afro-America was our present. The current mission states: 'The Studio Museum in Harlem is the nexus for black artists locally, nationally, and internationally, and for work that has been inspired by black culture. It is a site for the dynamic exchange of ideas about art and society.' This change was meant to acknowledge a few things. One being to recognise the global black presence in a way that created some parity to the differences in our histories, without necessarily needing to line them up with black American history, whether that meant showing artists of African descent working in the 1920s in Jamaica or artists of African descent working now in Amsterdam. The new mission, in some ways, also questioned established notions of the diaspora, which often only mark out a historical conception of the migration patterns in which we have moved. 'Locally, nationally, internationally' is about anywhere we are, which means the Studio Museum is engaged with black artists regardless of their location or nationality. Now, again, the Studio Museum grew out of a moment that looked at America through the lens of a black history, in which Harlem, Detroit, South Central Los Angeles, Chicago, Atlanta, and Washington DC were the cities in America with a large, defining black presence. At the Museum we were trying to represent a cultural phenomenon: the rebuilding and rebirth of these places that we owned, maybe not literally in financial terms, but that we owned as the places where we were. The new mission was also about breaking from that paradigm. It was about acknowledging Africa and the Caribbean and also acknowledging North America, South America, Europe, and so on. As a curator, the change allowed me to work in an institution that could show David Hammons, Adrian Piper, Isaac Julien, Edna Manley, Alma Thomas, Chris Ofili, El Anatsui, Julie Mehretu, Stan Douglas and Henry Tanner, among many others. It also allowed the institution to acknowledge the multi-cultural, multi-ethnic nature of Harlem and of black America right now, without again centralising four hundred years of African-American history as the black experience worldwide. The rewriting of the mission opened that conversation up so that we could look back at our collection and say, 'Yes,

James Van Der Zee is right here at the centre, but Seydou Keita needs to be right here too.'

HC The way in which you describe the museum's brief now seems to move away from a certain Middle Passage epistemology, while not occluding the continuing histories of violence, dispersion and resistance that remain formative to the production of the black diaspora.

GL I think it's about continuity and rupture, which is a way of thinking about the term post-black too.

HC That's also a useful way, I think, to consider the possibilities for artists of colour now. For instance, many of the practitioners included in the *Freestyle* exhibition have gone on to show with major galleries and to be included within the network of fairs and biennials, although racial limitations often persist in the discursive framing of their work. How do we think about both the continuities in the presentation of work by black artists and also the significant rupture that has occurred in terms of the opportunities available to them in the present?

GL Well, I think, as you've noted, one thing that has changed is the commercial and institutional presence of black artists. I think that for a lot of young artists there's an assumption that they will enter the market fairly quickly and that's been borne out. The question is, is that sustainable in the long term? Do these artists get the ten publications that their peers who are not black might have? Are they collected by museums over the life of their careers and not just at the beginning? That is something we'll have to see play out, but I do think that the presence of black artists has been – and maybe it's not the right word – normalised.

HC So, from post-back to normal-black?

GL But I also want to note that often there are shows where I think 'I can name a half a dozen artists of colour that should be in this exhibition', and they're not. So, I think in the art world there still is this kind of narrowness.

TG It's exclusion by self-imposed amnesia. I think for some people the exclusionary default is still satisfactory and the absence does not read as problematic because they are reinforced by a norm that has always been there. Even in this moment of more engaged dialogue about these issues within the art world and the cultural world in general, we can still think of whole groups of artists who remain on the outside. And that, for me, remains the great tragedy of this moment, because recent history has given us the opportunity to understand the range of artists working and the breadth of their work.

GL Especially when artists are taking up notions like diaspora, which has been conceived historically, and exploring them in their contemporary forms. I think, for instance, of Isaac Julien's *Small Boats* 2007, which is about migration to Europe, and not necessarily of Africans, but of all different kinds of people. Those migrations have profound resonance with notions of the African diaspora, but also with discussions around European identity. What's interesting to think about is how people have taken scholarship such as Gilroy's *The Black Atlantic* and tried to apply it to other kinds of diasporas. This is a fascinating moment in which we can see how that knowledge gets played out in contemporary artworks.

NOTES

1 Mirage: Enigmas of Race, Difference and Desire, exh. cat., Institute of Contemporary Arts/Institute of International Visual Arts, London, 1995.
2 Paul Gilroy, The Black Atlantic: Modernity and Double Consciousness, Cambridge, MA, Harvard University Press, 1993.
3 Lowery Stokes Sims, Challenge of the Modern: African-American Artists 1925–1945, Volume I, exh. cat., Studio Museum in Harlem, New York, 2003.
4 James Baldwin, 'Stranger in the Village', Harper's Magazine, Oct. 1953, pp. 42–8. For accounts of Ligon's engagement with Baldwin's text and its relation to his practice more broadly, see Thelma Golden, 'Everynight', in Glenn Ligon: Unbecoming, exh. cat., Institute of Contemporary Art/University of Pennsylvania, Philadelphia, 1997,

pp. 37–49, p. 44; as well as Huey Copeland, 'Untitled (Jackpot!)', in Glenn Ligon: Some Changes, exh. cat., Power Plant, Toronto, 2005, pp. 119–32.
5 Thelma Golden, 'Post…', in Freestyle, exh.cat., Studio Museum in Harlem, New York, 2001, p. 14.
6 Although the art historian Robert Farris Thompson used 'postblack' ten years earlier to suggest the limitations of analogous descriptive categories such as 'postmodern', it is Golden and Ligon's mobilisation of the phrase that has subsequently been taken up by academics, critics and commentators in assessing, whether positively or negatively, the current states of African-American cultural discourse. For Farris Thompson's use of postblack, see his 'Afro-Modernism', Artforum International, Sept. 1991, p. 91. While the articles, symposia and authors that in some way engage Golden and Ligon's

formulation of post-black art are too numerous to list here, several texts are worth noting that suggest how the discourse has evolved: Cathy Byrd, 'Is there a "Post-Black" Art? Investigating the Legacy of the Freestyle Show', Art Papers, Nov./Dec. 2002, pp. 35–9; Elizabeth Alexander, The Black Interior, Saint Paul, Graywolf Press, 2004; and '"Post-Black," "Post-Soul," or Hip Hop Iconography? Defining the New Aesthetics', special issue of International Review of African American Art, 20.2, 2005.

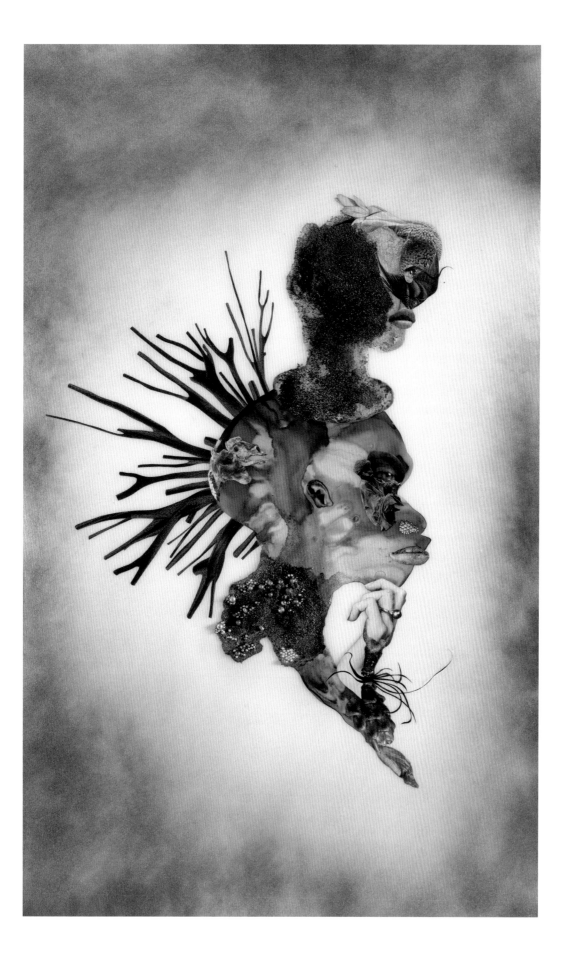

PLATES

AARON DOUGLAS
Aspiration 1936
Oil on canvas
1524 × 1524 mm
Fine Arts Museums of
San Francisco

BLACK ATLANTIC
AVANT-GARDES

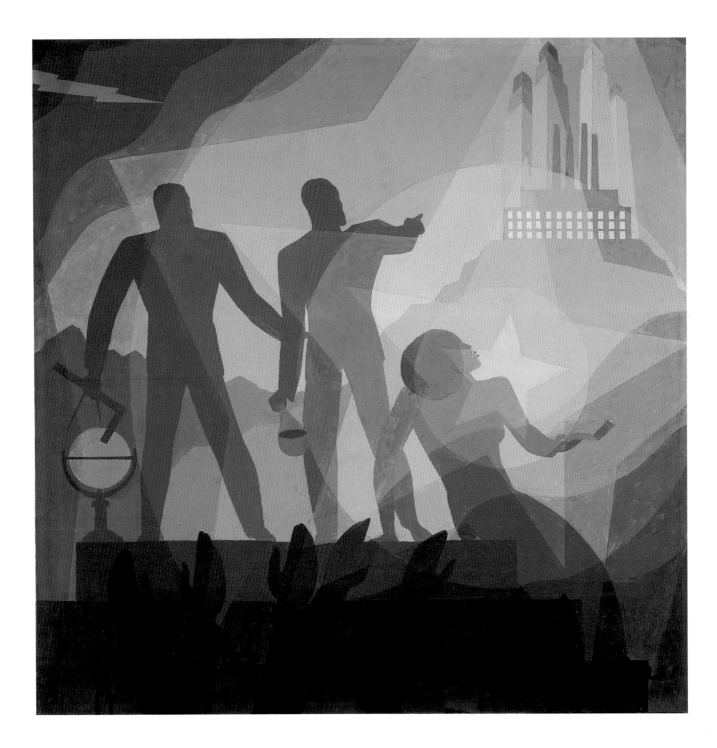

AARON DOUGLAS

Aspects of Negro Life: The Negro in an African Setting 1934
Oil on canvas
1835 × 1994 mm
Art & Artefacts Division, Schomburg Center for Research in Black Culture, The New York Public Library, Astor, Lenox and Tilden Foundations

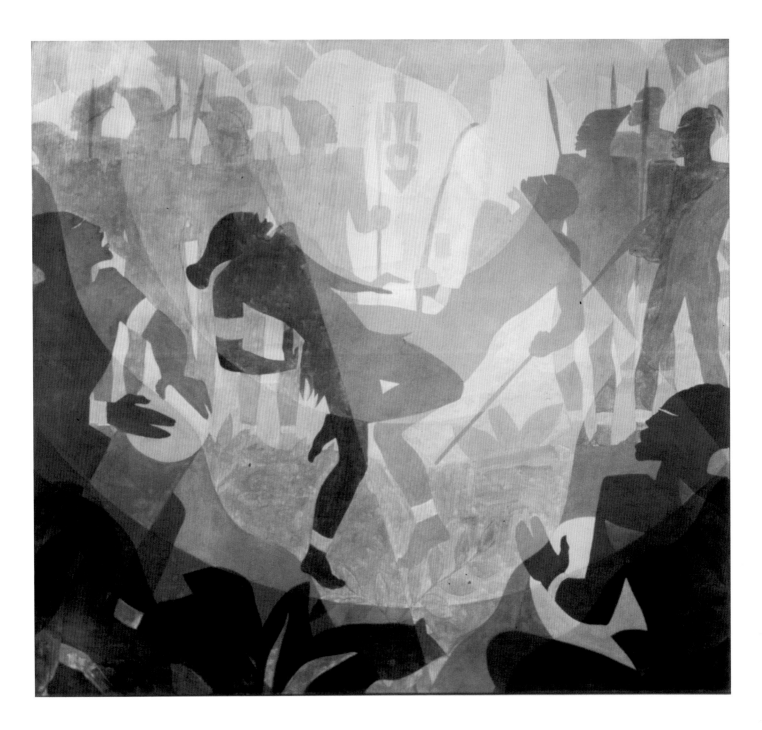

PAUL COLIN
Josephine Baker in Banana Skirt,
from **Le Tumulte Noir** 1927
Lithograph with pochoir colouring
on paper
470 × 319 mm
Victoria and Albert Museum,
London

SARGENT JOHNSON
Forever Free 1933
Wood with lacquer on cloth
914 × 292 × 241 mm
San Francisco Museum of Modern Art.
Gift of Mrs. E. D. Lederman

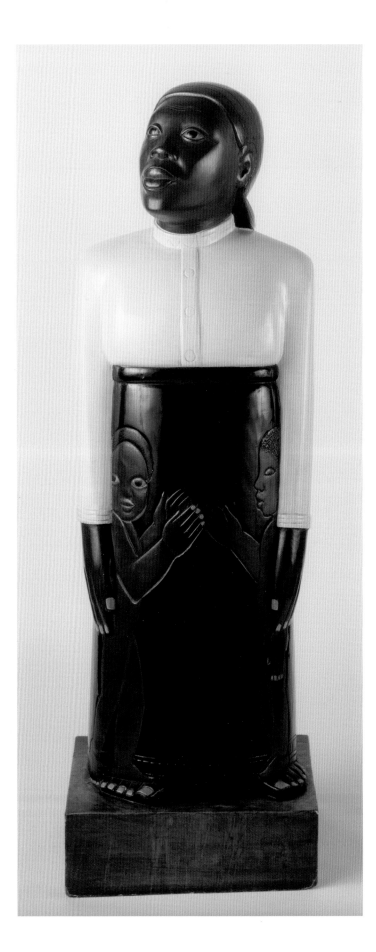

CONSTANTIN BRANCUSI
The Blonde Negress front view,
polished bronze (1926) 1926
Gelatin silver print
238 × 179 mm
Centre Pompidou, Paris
Musée national d'art moderne /
Centre de création industrielle

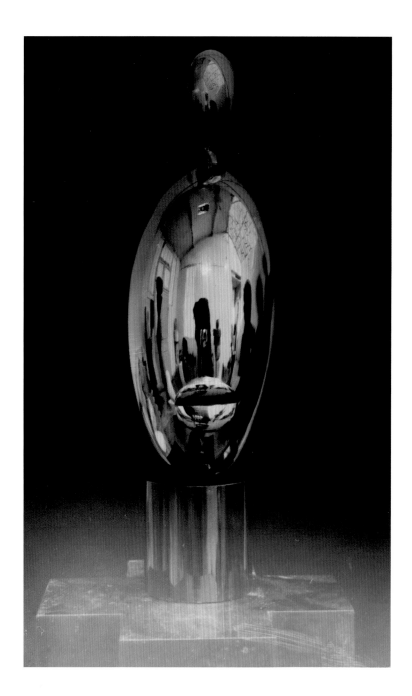

CONSTANTIN BRANCUSI
Head circa 1919–23
Wood (oak)
292 × 194 × 210 mm
Tate. Purchased 1980

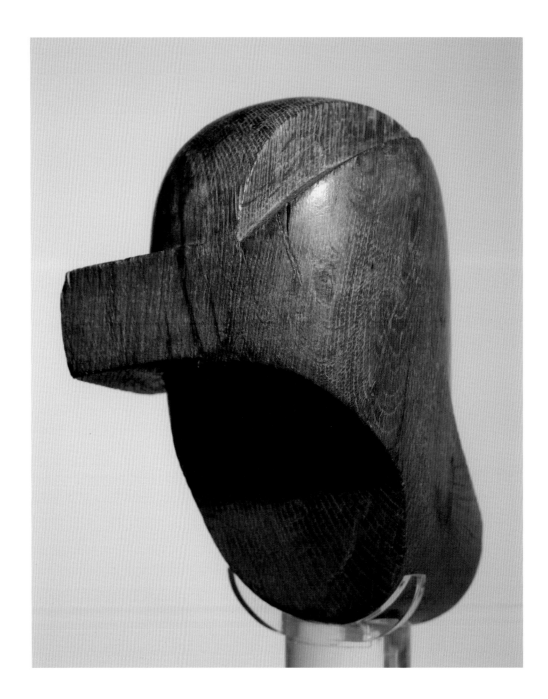

MAN RAY

Noire et Blanche 1926 (copy 1982)
Gelatin silver print
219 × 294 mm
Museo Nacional Centro de Arte
Reina Sofia, Madrid

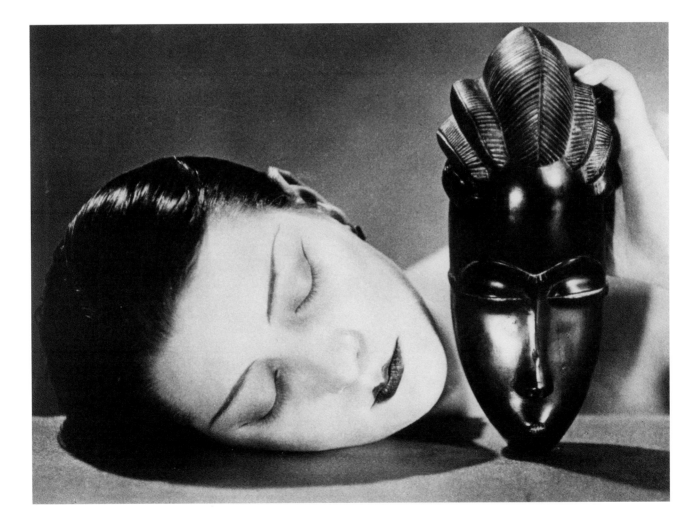

ANTHONY WYSARD
Probably Henry Crowder;
Nancy Cunard 1928
Watercolour on paper
267 × 211 mm
National Portrait Gallery, London.
Purchased 1990

CECIL BEATON
Nancy Cunard 1929
Vintage bromide print
241 × 188 mm
National Portrait Gallery, London
Given by executors of the
Estate of Eileen Hose, 1991

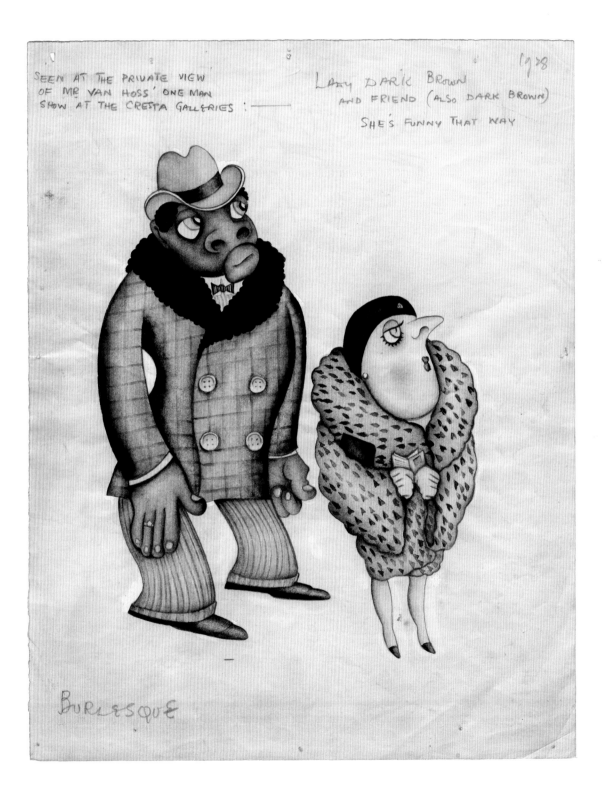

SEEN AT THE PRIVATE VIEW
OF MR VAN HOSS' ONE MAN
SHOW AT THE CRESTA GALLERIES :———

1978

LAZY DARK BROWN
AND FRIEND (ALSO DARK BROWN)
SHE'S FUNNY THAT WAY

BURLESQUE

AMEDEO MODIGLIANI
Caryatid circa 1913–4
Drawing on paper
549 × 448 mm
Tate. Purchased 1957

PABLO PICASSO
Bust of a Woman 1909
Oil on canvas
727 × 600 mm
Tate. Purchased 1949

FERNAND LÉGER
**Mise-en-scéne for the ballet of
'The Creation of the World'** 1922
Pencil on paper
210 × 270 mm
The Museum of Modern Art, New York.
Gift of John Pratt, 1949

La Création du Monde
Ballet nègre
projet de décor 22 FL

WALKER EVANS
Mask, Ivory Coast, Plate 98 from
African Negro Art 1935
Gelatin silver print
240 × 172 mm
Victoria and Albert Museum, London

NORMAN LEWIS
Dan Mask 1935
Pastel on sandpaper
459 × 317 mm
Courtesy of Michael Rosenfeld
Gallery, New York

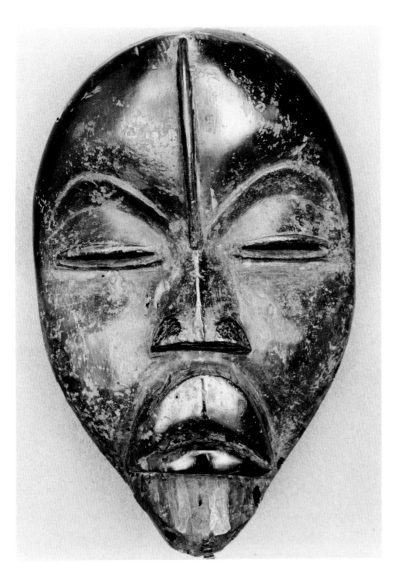

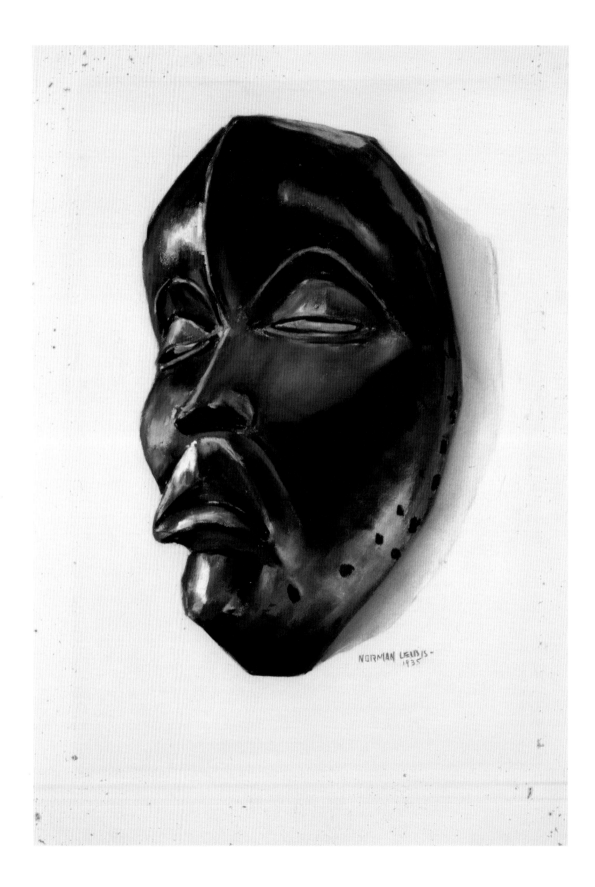

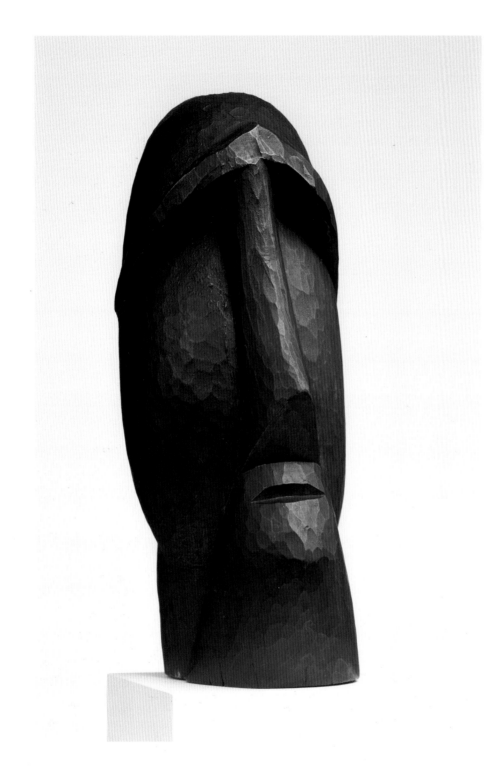

KARL SCHMIDT-ROTTLUFF
Male Head 1917
Wood
343 × 133 × 165 mm
Tate. Presented by the executors of
Dr Rosa Shapire, 1954

RONALD MOODY
Midonz 1937
Wood (elm)
720 × 380 × 445 mm
Ronald Moody Estate

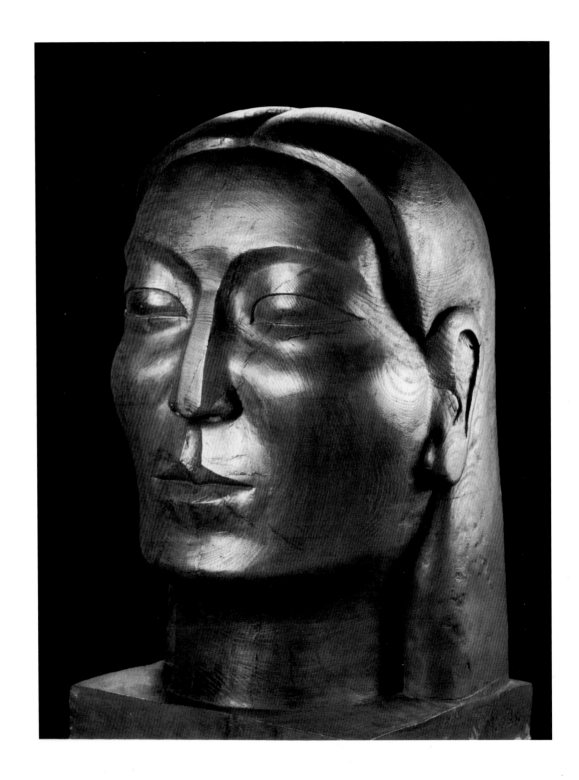

JAMES VAN DER ZEE
Garveyite Family, Harlem, from
Eighteen Photographs portfolio 1924
(printed 1974)
Gelatin silver print
379 × 318 mm
The Minneapolis Institute of Arts,
The Stanley Hawks Memorial Fund

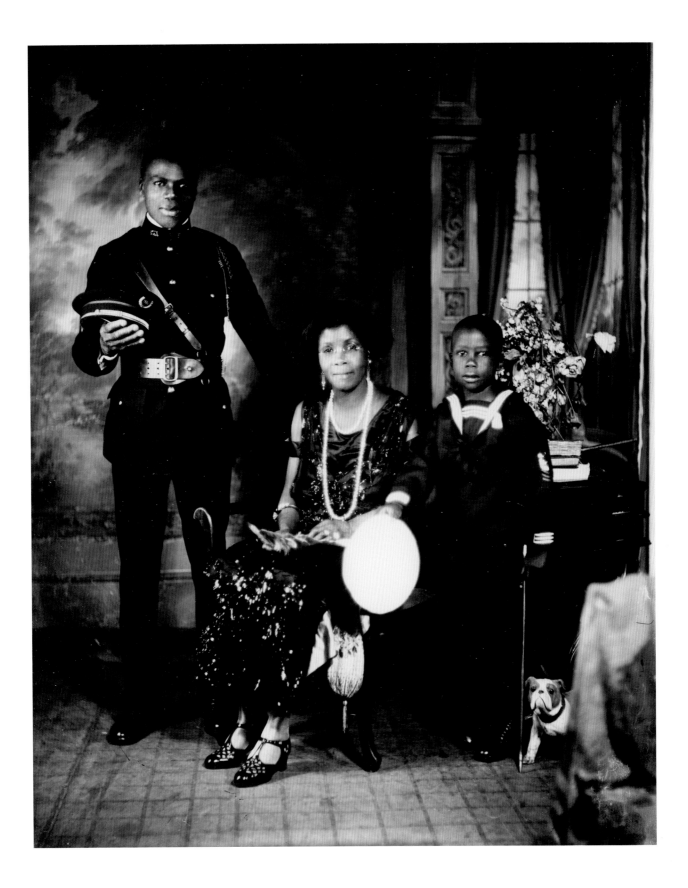

PALMER HAYDEN
Midsummer Night in Harlem 1936
Oil on canvas
635 × 762 mm
Museum of African American Art,
Los Angeles

EDWARD BURRA
Harlem 1934
Brush, ink and gouache on paper
794 × 571 mm
Tate. Purchased 1939

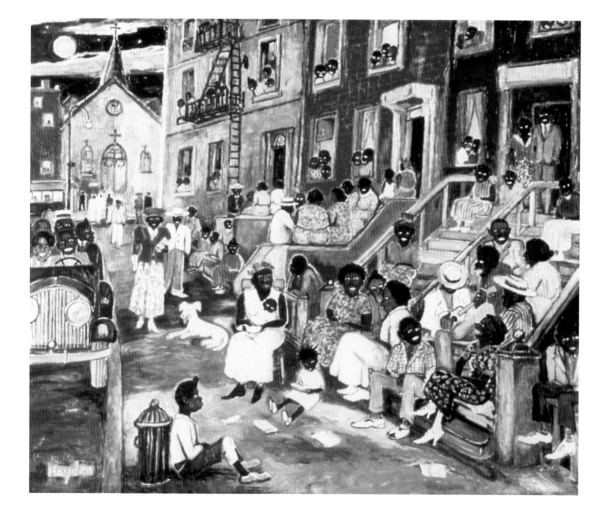

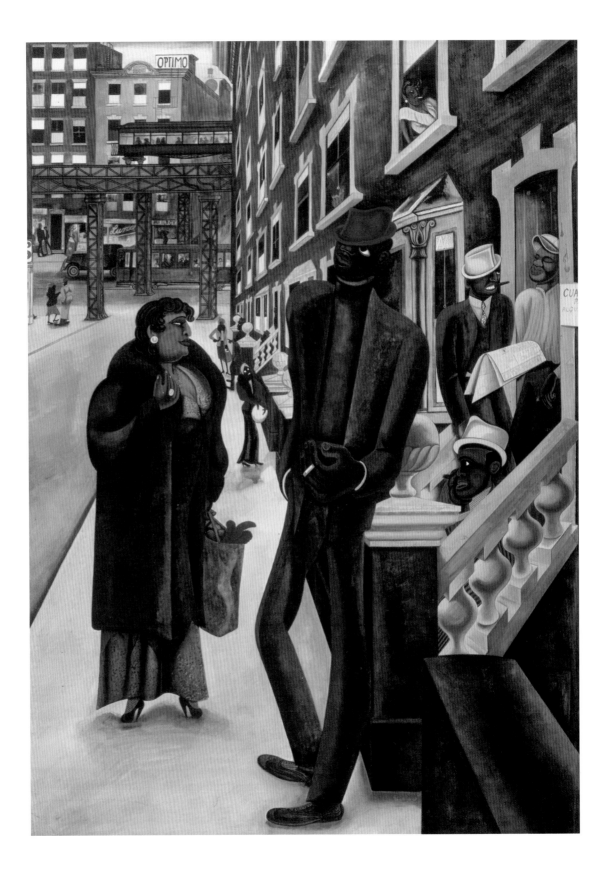

Hill of the Shantytown 1924
Oil on canvas
640 × 760 mm
Hecilda and Sergio Fadel Collection

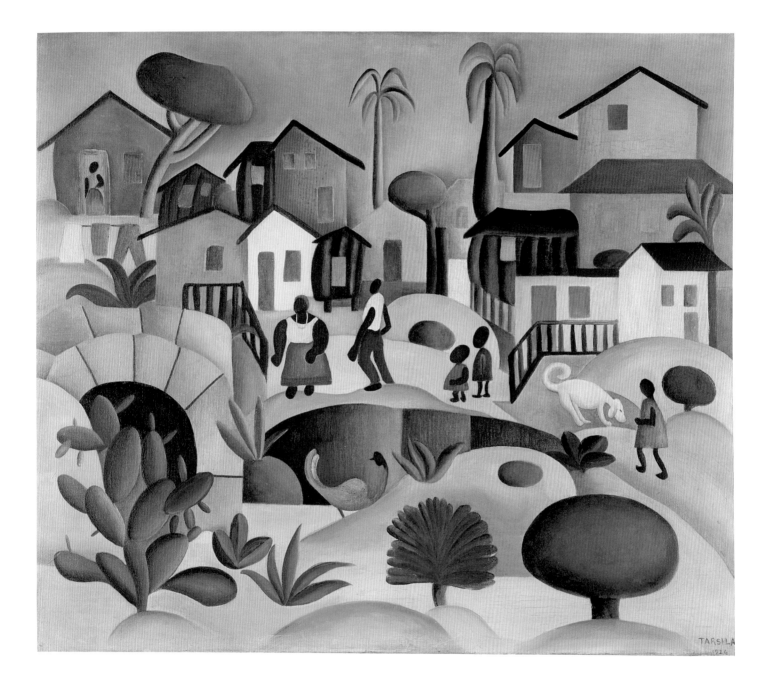

LASAR SEGALL
Banana Plantation 1927
Oil on canvas
870 × 1270 mm
Collection of the Pinacoteca
do Estado de São Paulo/Brazil.
Acquisition by the Government
of the State of São Paulo, 1928

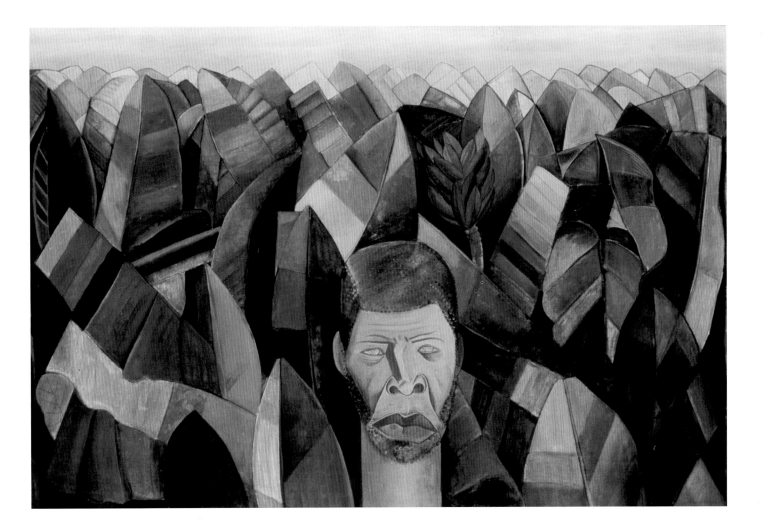

PEDRO FIGARI
Candombe 1921
Oil on canvas
730 × 1040 mm
Museo de Arte Latinoamericano de
Buenos Aires – Malba – Fundación
Costantini

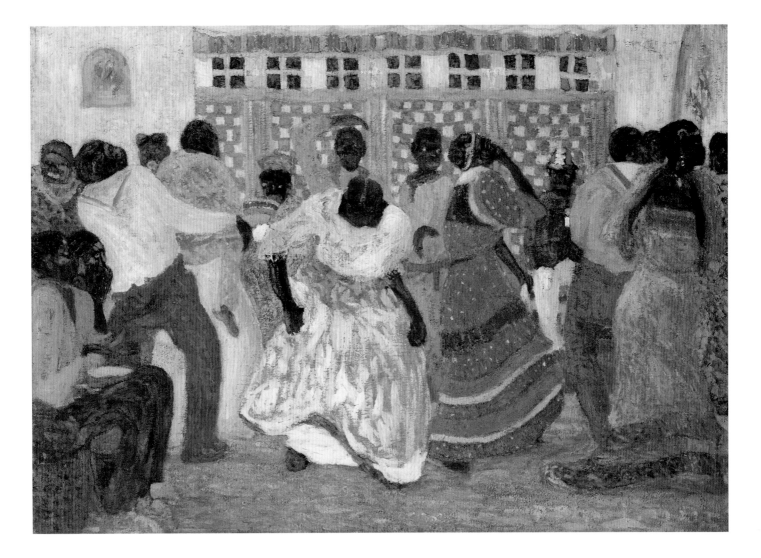

MAYA DEREN
**Divine Horsemen: The Living Gods
of Haiti** 1947–1951 (1977)
16mm film transferred to DVD,
black and white, sound, 55 minutes
Courtesy of Tavia Ito and
Pip Chodorov, Re:Voir

MAYA DEREN:
THE LIVING GODS OF HAITI

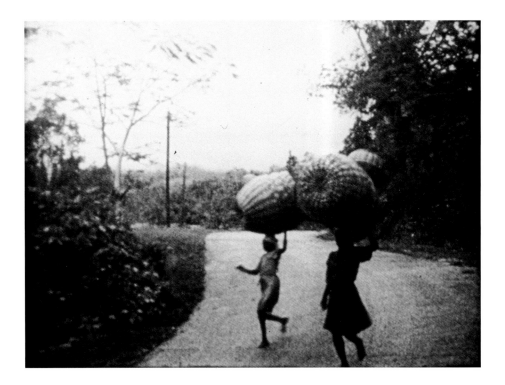

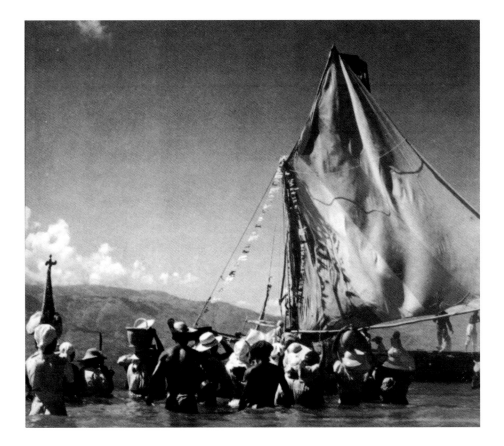

WIFREDO LAM
The Murmur 1943
Oil on paper mounted on canvas
1050 × 840 mm
Centre Pompidou, Paris
Musée national d'art moderne /
Centre de création industrielle

BLACK ORPHEUS: NEGRITUDE, CREOLIZATION, NATURAL SYNTHESIS

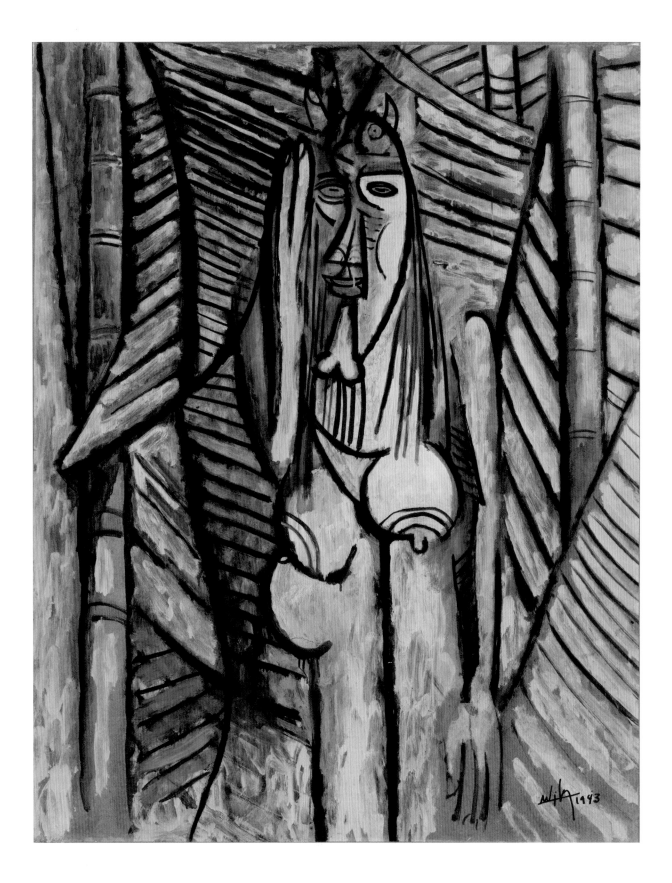

AGUSTÍN CÁRDENAS
Untitled circa 1960
Wood
3200 mm (h)
Private Collection, France
Courtesy of JGM Galerie, Paris

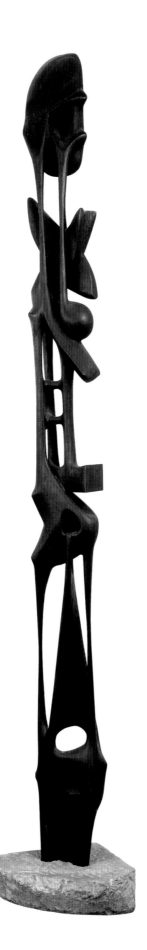

UCHE OKEKE
Ana Mmuo 1961
Oil on board
910 × 1219 mm
National Museum of African Art,
Smithsonian Institution, Gift of
Joanne B. Eicher and Cynthia,
Carolyn Ngozi, and Diana Eicher

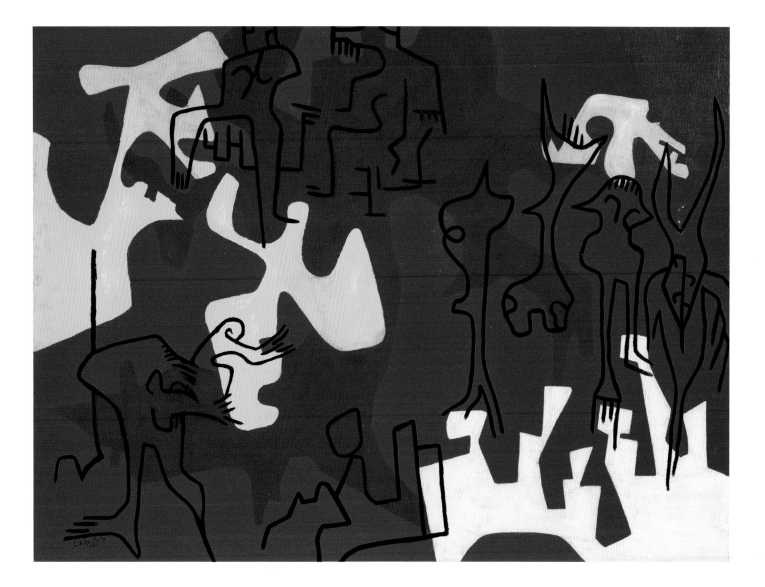

ADEBISI AKANJI
Untitled (Two Screens) circa 1966
Cement and metal
1575 × 1010 mm and 1556 × 1029 mm
National Museum of African Art,
Smithsonian Institution, Gift of
Mr. and Mrs. Waldemar A. Nielsen

MARC and EVELYNE BERNHEIM
**New Art of Africa: Cement
sculpture bas-relief by Felix Idubor,
decorates the side facade of the
new 25-story Independence House,
In Lagos, Nigeria** circa 1960–1965
Gelatin silver print
336 × 242 mm
The Minneapolis Institute of Arts,
Gift of Lora and Martin G. Weinstein

JACOB LAWRENCE
Street to Mbari 1964
Tempera, gouache and graphite
on paper
565 × 784 mm
National Gallery of Art,
Washington DC
Gift of Mr. and Mrs. James T. Dyke

AGNALDO MANOEL DOS SANTOS
Nun circa 1950s–1960s
Pau Brazil wood
1270 × 400 × 360 mm
Collection of Vilma Eid

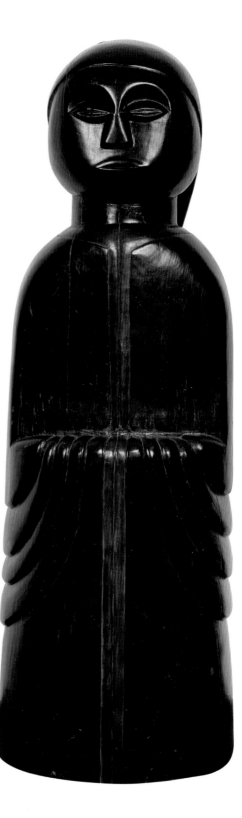

RUBEM VALENTIM
Composition 1961
Oil on canvas
400 × 300 mm
Courtesy of Galeria Berenice Arvani,
São Paulo

RUBEM VALENTIM
Painting no.11 Rome 1965
Egg tempera on canvas
1000 × 740 mm
Ricard Akagawa Collection

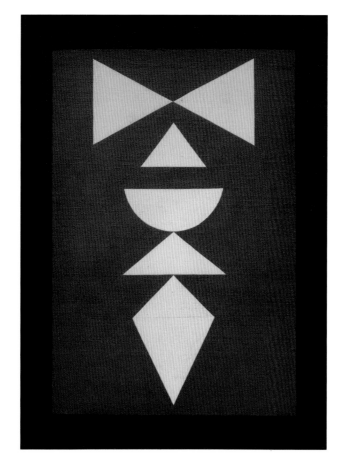

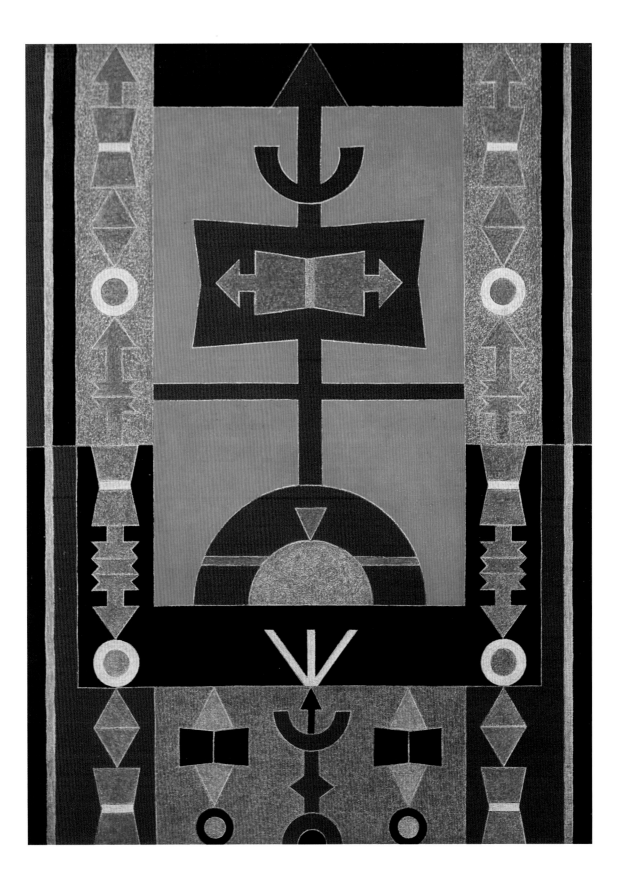

NORMAN LEWIS
American Totem 1960
Oil on canvas
1880 × 1143 × 50 mm
Collection of Ouida B. Lewis

DISSIDENT IDENTITIES: RADICALISM, RESISTANCE, AND MARGINALITY

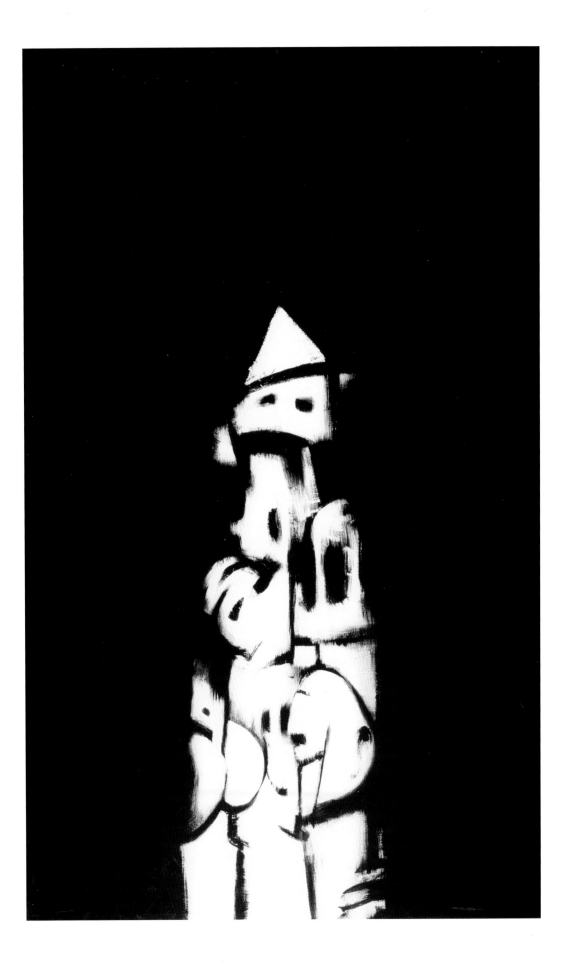

FRANK BOWLING
Who's Afraid of Barney Newman?
1968
Oil on canvas
2364 × 1295 × 27 mm
Tate. Presented by Rachel Scott 2006

GORDON PARKS
Emerging Man, Harlem 1952
Gelatin silver print
305 × 457 mm
International Center of Photography
with funds provided by the ICP
Acquisitions Committee, 2003

PIRKLE JONES
Plate glass window of the
Black Panthers Party National
Headquarters the morning it was
shattered by the bullets of two
Oakland policemen September 10,
1968
Gelatin silver print
298 × 278 mm
International Center of Photography
with funds provided by the ICP
Acquisitions Committee, 2003

ANDY WARHOL
Birmingham Race Riot from
Ten Works by Ten Painters 1964
Screenprint on paper
510 × 610 mm
Tate. Purchased 1996

CHARLES MOORE
**Birmingham, Alabama (police
dogs attack demonstrators)** 1963
(printed later)
Gelatin silver print
279 × 356 mm
Charles Moore and Howard
Greenberg Gallery, New York

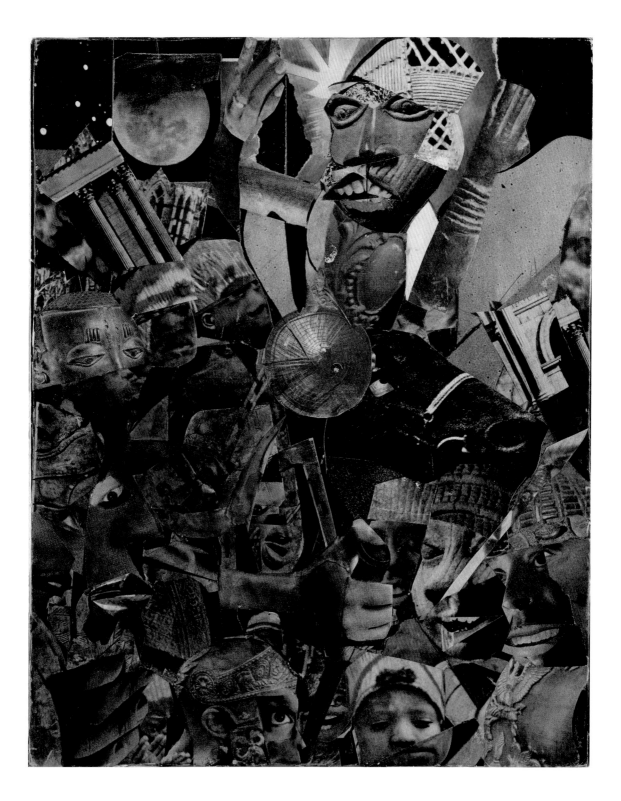

ROMARE BEARDEN
Sermons: The Walls of Jericho 1964
Photomechanical reproductions,
pencil, brush, ink and watercolour
on paper
300 × 237 mm
Hirshhorn Museum and Sculpture
Garden, Smithsonian Institution,
Washington DC, Gift of
Joseph H. Hirshhorn, 1966

ROMARE BEARDEN
Flights and Fantasy 1970
Mixed media collage with synthetic
polymer paint on Masonite
222 × 298 mm
Courtesy of Michael Rosenfeld
Gallery, New York

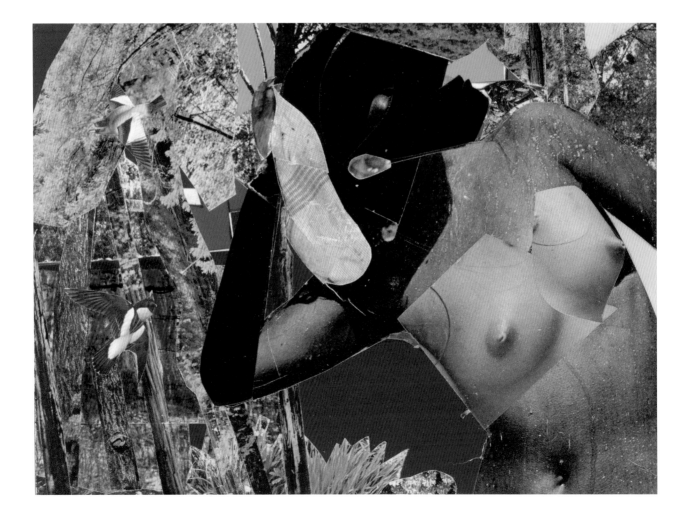

DAVID HAMMONS
The Door (Admissions Office) 1969
Wood, acrylic sheet and pigment
2007 × 1219 × 381 mm
California African American
Foundation

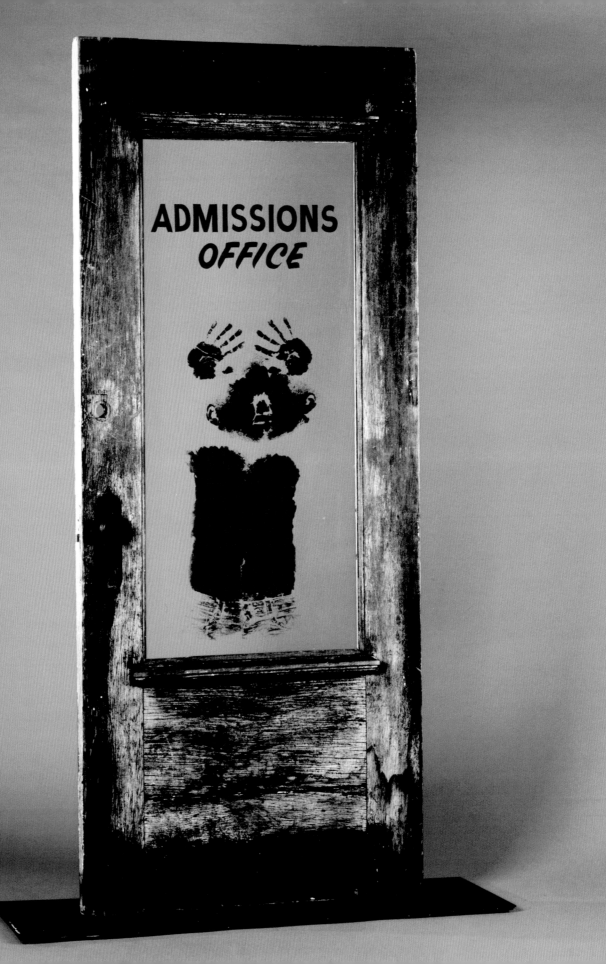

ADRIAN PIPER
**I Embody Everything You Most
Hate and Fear** 1975
Oil crayon on black and white
photograph
178 × 254 mm
Collection of Thomas Erben,
New York

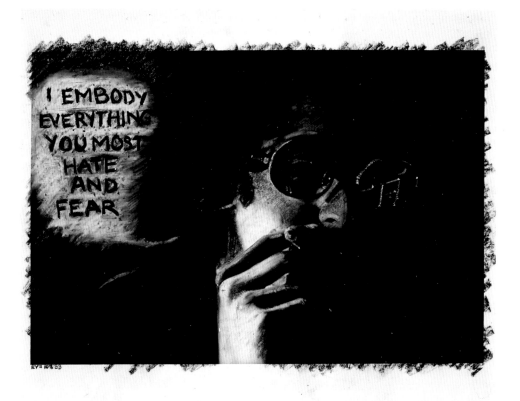

PETER MOORE
**Untitled (Jean-Michel
Basquiat/SAMO Graffiti,
New York City) 6/2/79 – B31** 1979
Gelatin silver print
254 × 203 mm
Paula Cooper Gallery and
Barbara Moore

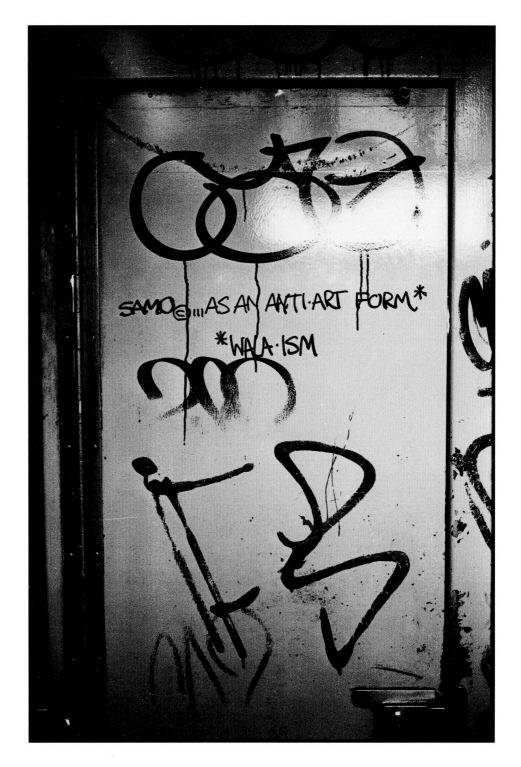

JEAN-MICHEL BASQUIAT
**Native Carrying Some Guns, Bibles,
Amorites on Safari** 1982
Acrylic and oil on paper, mounted on
canvas, and exposed wood
1828 × 1828 mm
Collection Hermes Art Trust
Courtesy of Francesco Pellizzi

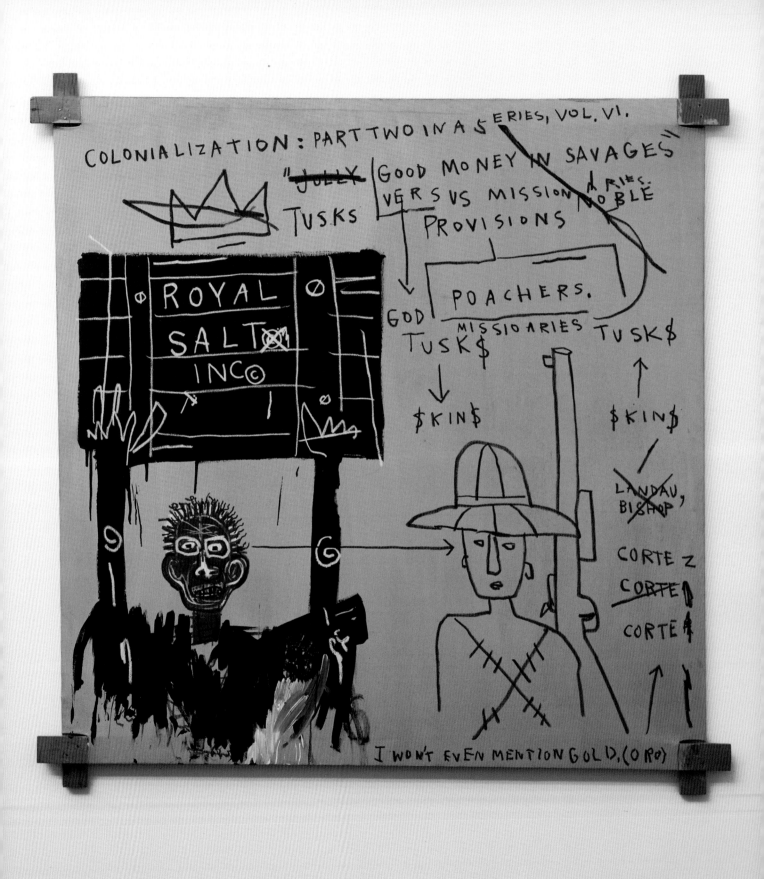

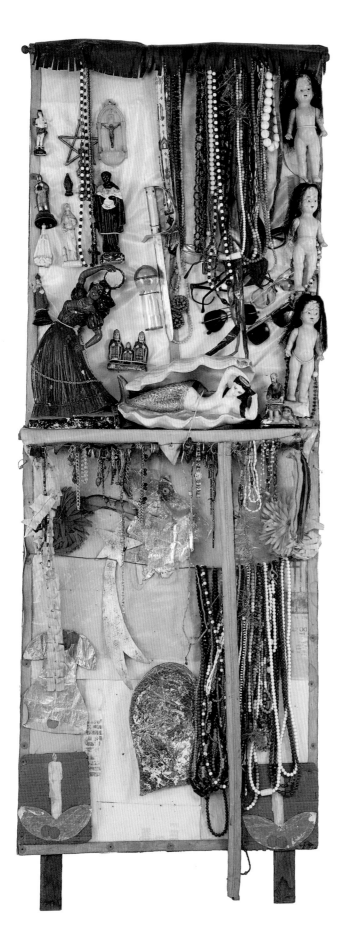

ARTHUR BISPO DO ROSARIO
Macumba n.d.
Wood, metal, cloth, plastic, thread,
nylon, glass, iron, gesso and paper
1930 × 750 × 150 mm
Collection of the Museu Arthur Bispo
do Rosário Arte Contemporânea /
Prefeitura da Cidade do Rio de Janeiro

RECONSTRUCTING THE MIDDLE PASSAGE: DIASPORA AND MEMORY

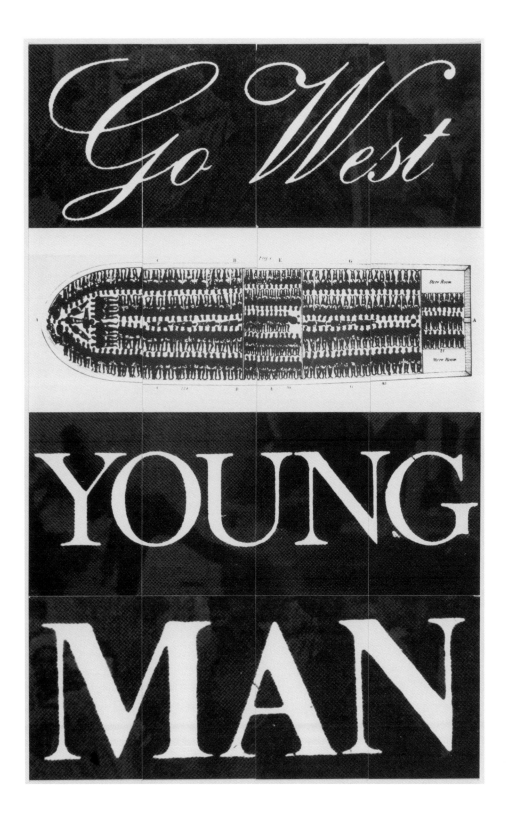

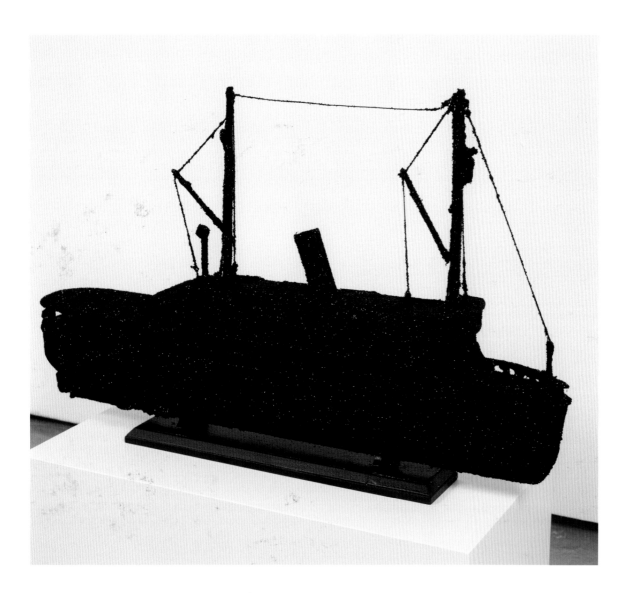

RADCLIFFE BAILEY
Garvey's Ghost 2008
Model ship and black glitter
476 × 762 × 121 mm
Courtesy of the artist and
Jack Shainman Gallery, New York

ISAAC JULIEN
**Western Union Series No. 1
(Cast No Shadow)** 2007
Duratrans image in lightbox
1200 × 1200 mm
Jochen Zeitz Collection

ELLEN GALLAGHER
Bird in Hand 2006
Oil, ink, paper, salt and gold leaf
on canvas
2380 × 3070 mm
Tate. Presented anonymously 2007

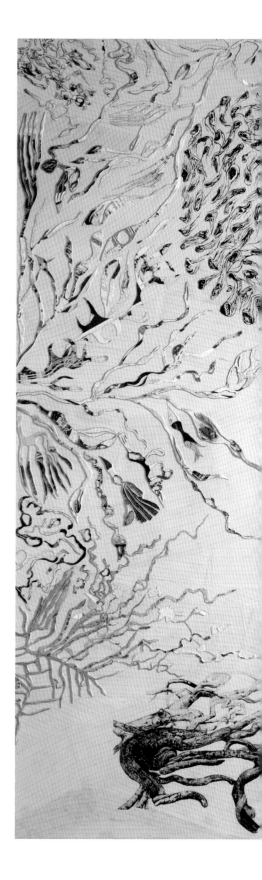

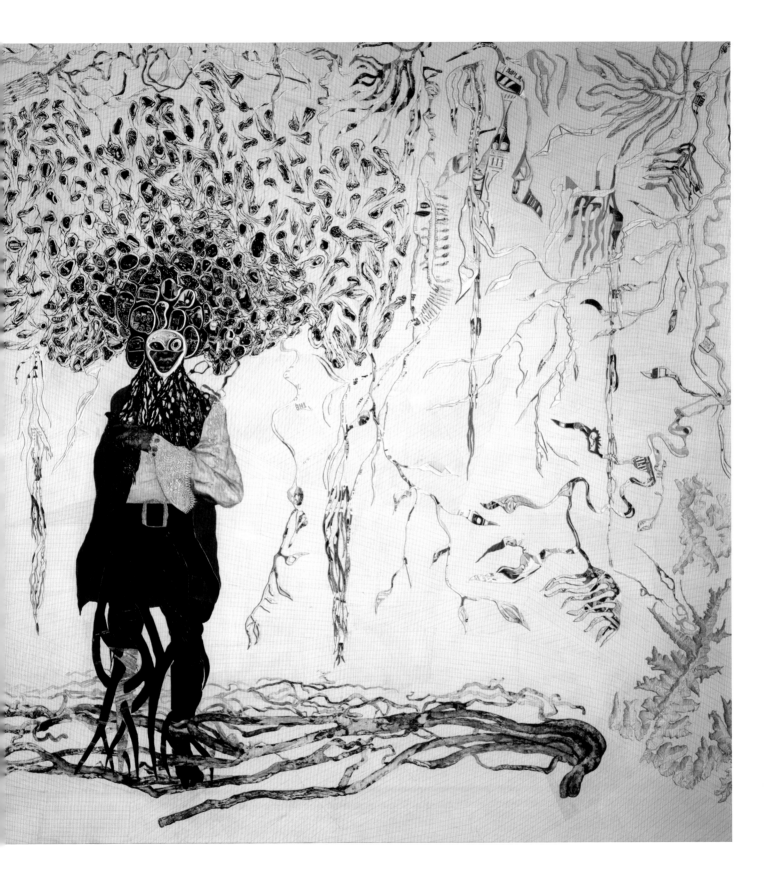

CHRISTOPHER COZIER
Tropical Night 2006 – present
Ink, graphite and stamps on paper
Each 229 × 178 mm
Installation of drawings of
an ongoing series
Dimensions variable
Courtesy of the artist

148

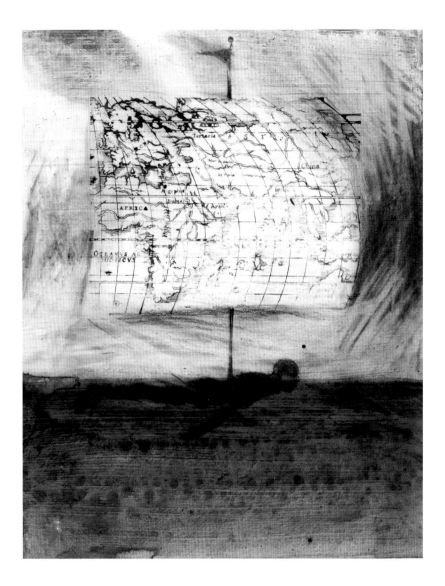

CHRISTOPHER COZIER
The Castaway from **Tropical Night**
2006 – present
Ink, graphite and stamps on paper
229 × 178 mm
Courtesy of the artist

RENÉE COX
River Queen from **Queen Nanny**
of the Maroons 2004
Digital ink jet print on
watercolour paper
1118 × 1118 mm
Courtesy of the artist

MARIA MAGDALENA CAMPOS-PONS
Of Two Waters 2007
Colour photograph on paper
12 parts, each 610 × 508 mm
Collection of Mark D Pescovitz,
Indianapolis
Courtesy of Julie Saul Gallery,
New York

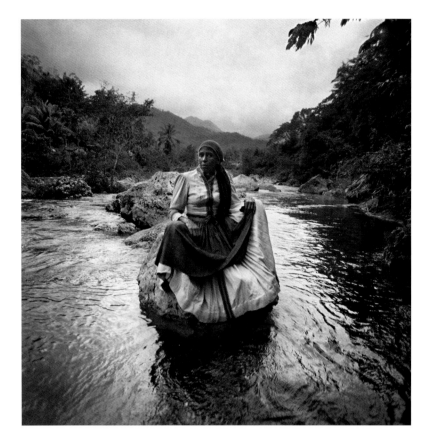

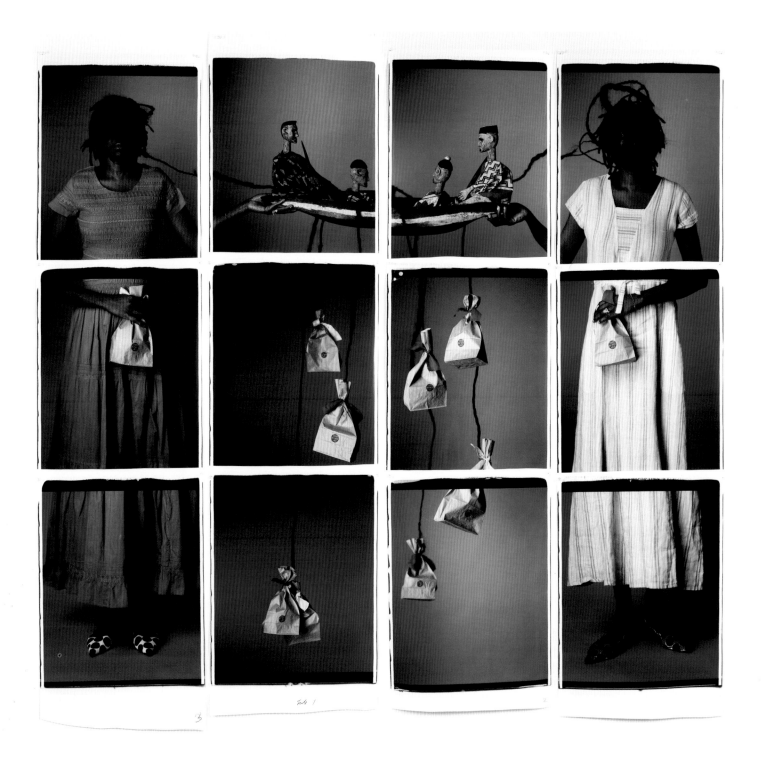

TRACEY ROSE
Venus Baartman 2001
Colour photograph on paper
1200 × 1200 mm
Courtesy of the artist and
The Project, New York

EXHIBITING BODIES: RACISM, RATIONALISM AND PSEUDO-SCIENCE

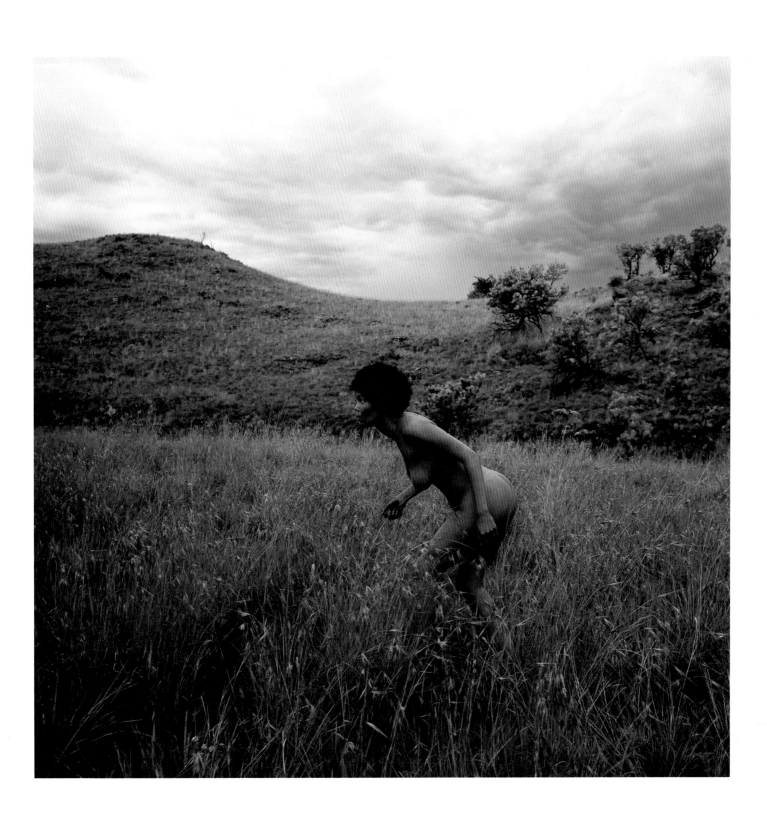

SONIA BOYCE
**From Tarzan to Rambo: English Born
'Native' Considers her Relationship
to the Constructed/Self Image and
her Roots in Reconstruction** 1987
Photograph and mixed media on paper
1240 × 3590 mm
Tate. Purchased 1987

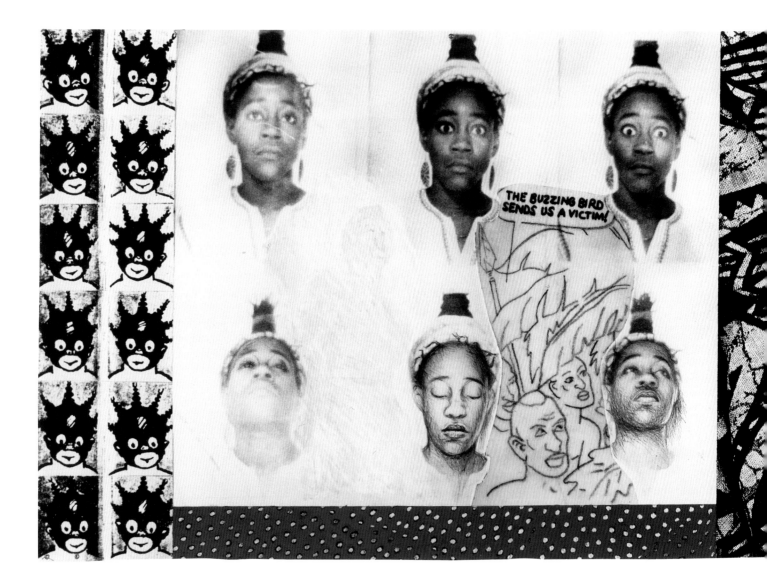

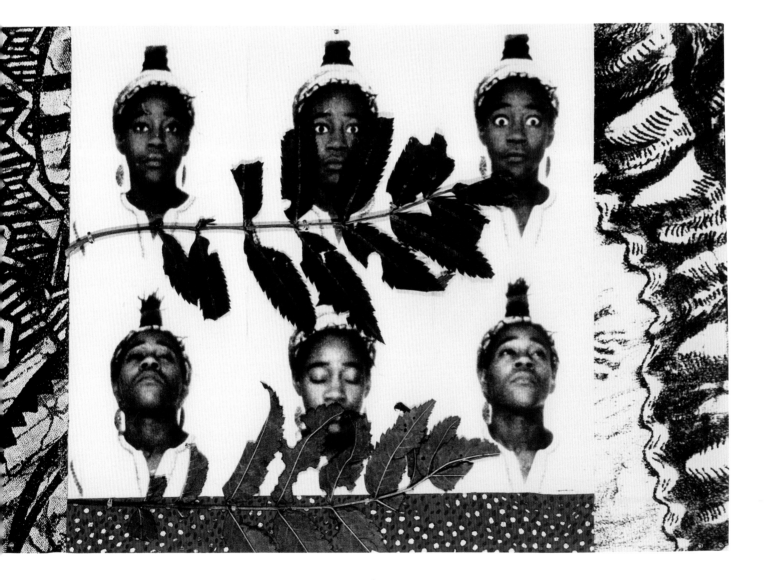

CARRIE MAE WEEMS
**A Negroid Type / You Became
a Scientific Profile / An
Anthropological Debate /
& A Photographic Subject**
1995–1996
Colour photograph on paper
4 parts, each 673 × 578 mm
Courtesy of the artist and
Jack Shainman Gallery, New York

CANDICE BREITZ
Ghost Series #4 1994–6
Chromogenic print on paper
1015 × 685 mm
Courtesy of the artist and
White Cube/Jay Jopling

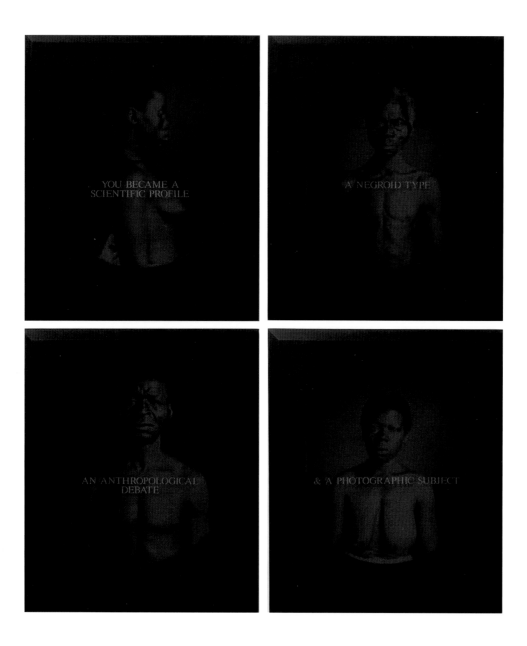

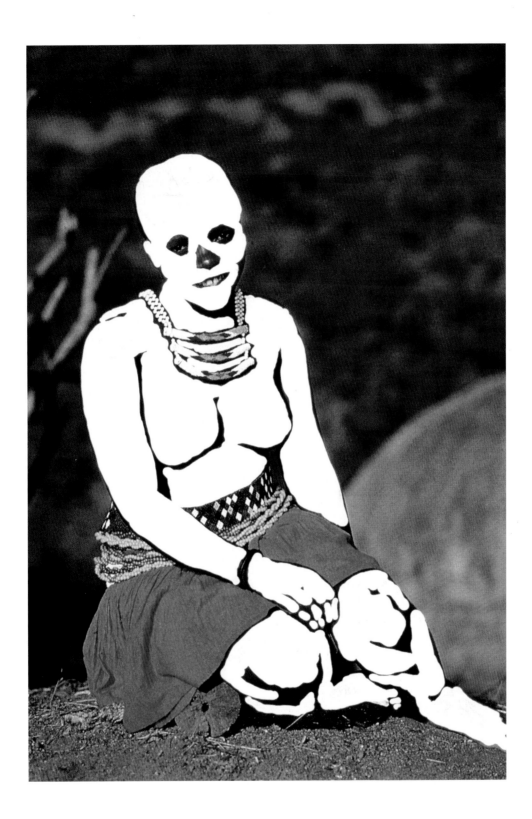

COCO FUSCO AND
GUILLERMO GOMEZ-PEÑA
Two Undiscovered Amerindians
Visit Madrid 1992
Performance
Photo: Nancy Lytle

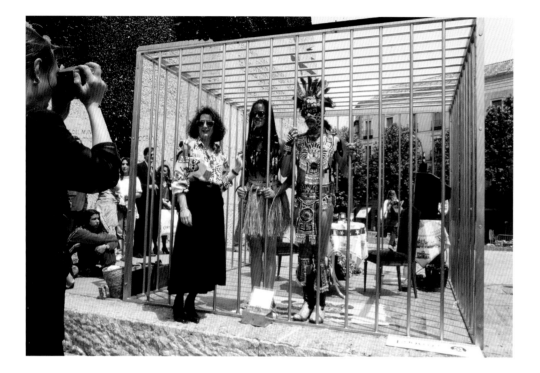

WANGECHI MUTU
Bird Flew 2008
Mixed media, ink and collage on Mylar
1067 × 1575 mm
Collection of Charlotte and Bill Ford

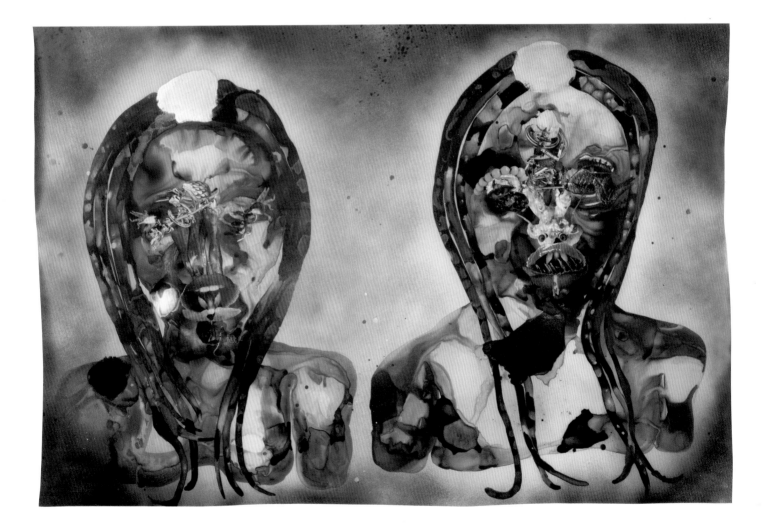

MARTA MARÍA PÉREZ BRAVO
It's in Your Hands 1994
(printed 2009)
Gelatin silver print
500 × 400 mm
Courtesy of the artist

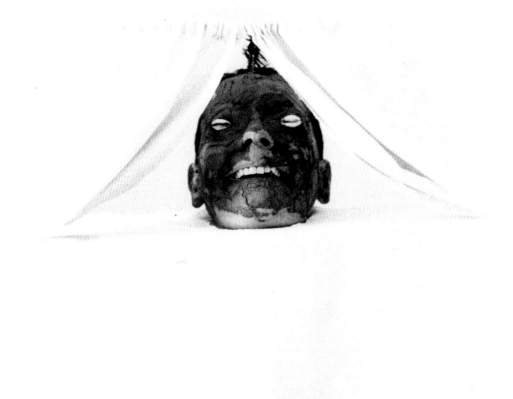

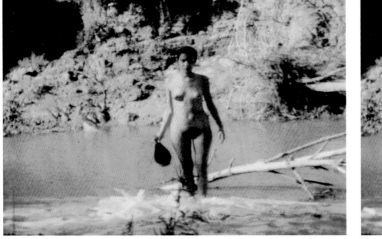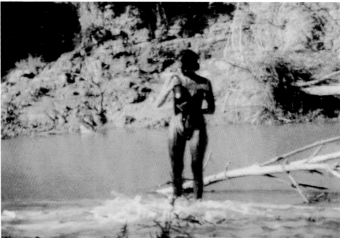

ANA MENDIETA
Untitled (Blood and Feathers #2)
1974
Super-8 film transferred to DVD,
colour, silent, 3:30 minutes
Tate. Presented by the Estate of
Ana Mendieta Collection and
an anonymous donor 2009

FROM POST-MODERN TO POST-BLACK: APPROPRIATION, BLACK HUMOUR AND DOUBLE NEGATIVES

CHRIS OFILI
**Double Captain Shit and the
Legend of the Black Stars** 1997
Mixed media on canvas
2440 × 1830 mm
Tate. Purchased with assistance
from Evelyn, Lady Downshire's
Trust Fund 1997

GLENN LIGON
Gold Nobody Knew Me #1 2007
Acrylic and oil stick on canvas
813 × 813 mm
Rubell Family Collection, Miami

GLENN LIGON
Malcolm X (version 2) #1 2000
Vinyl paint, oil based printed ink
on canvas
1224 × 915 × 36 mm
Tate. Purchased with funds provided
by the American Fund for the
Tate Gallery 2007

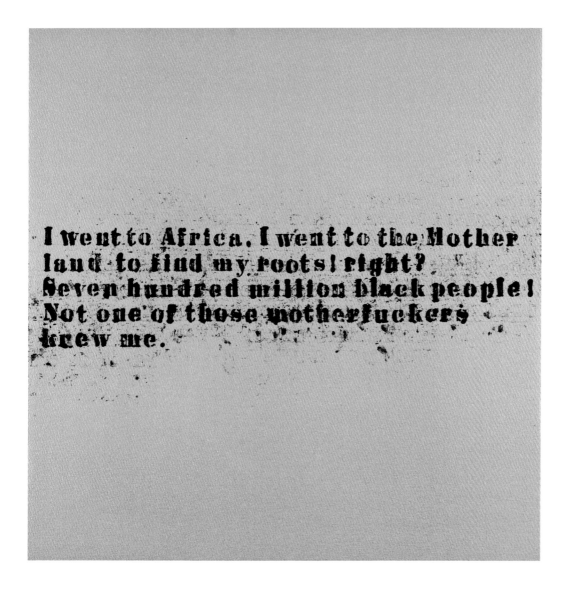

Malcolm X

ADAM PENDLETON
Black Dada (BK/AD) 2008
Silkscreen on canvas
1930 × 1219 mm
Courtesy of the artist and
Haunch of Venison, London

ADLER GUERRIER
Untitled (BLCK–We Wear the Mask)
2008
Mixed media with video
Dimensions variable
Courtesy of the artist and
Newman Popiashvili Gallery, New York

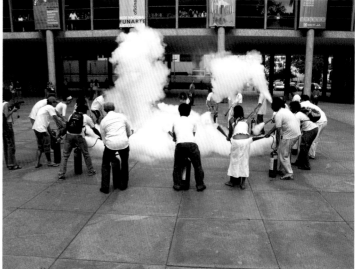

RONALD DUARTE
Nimbo/Oxalá 2004
Video transferred to DVD,
colour, sound, 3:09 minutes
Courtesy of the artist

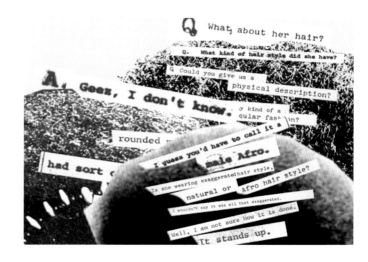

COCO FUSCO
a/k/a Mrs. George Gilbert 2004
Video transferred to DVD, colour,
sound, 31 minutes
Courtesy of the artist

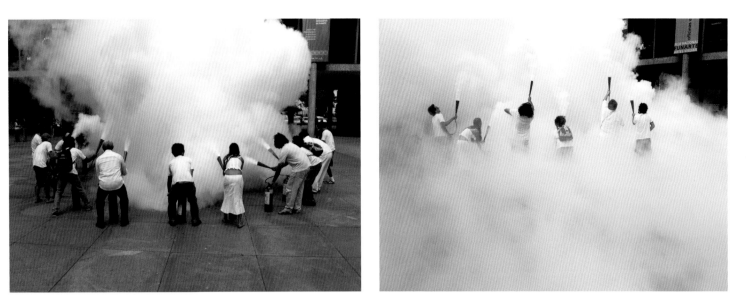

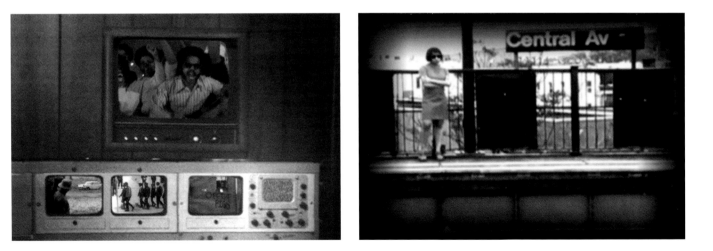

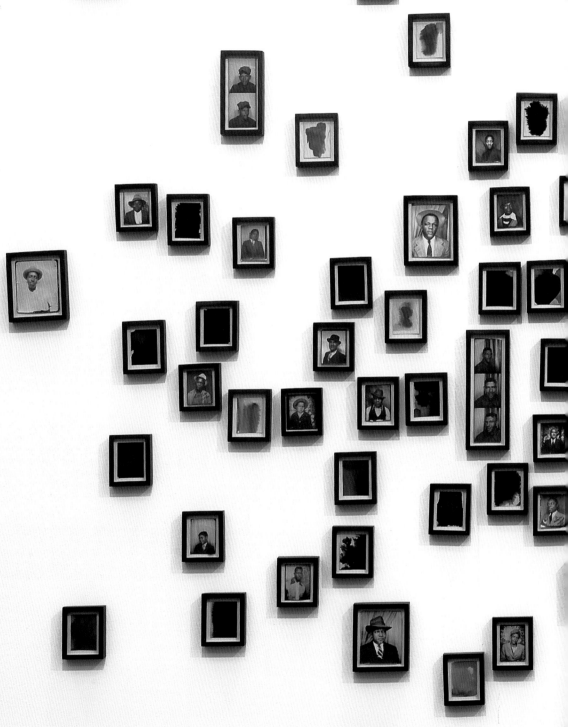

LORNA SIMPSON
Photo Booth 2008
50 found photo booth portraits
and 50 ink drawings on paper
Dimensions variable
Tate Purchased using funds provided
by the 2008 Outset / Frieze Art Fair
Fund to benefit the Tate Collection
2009

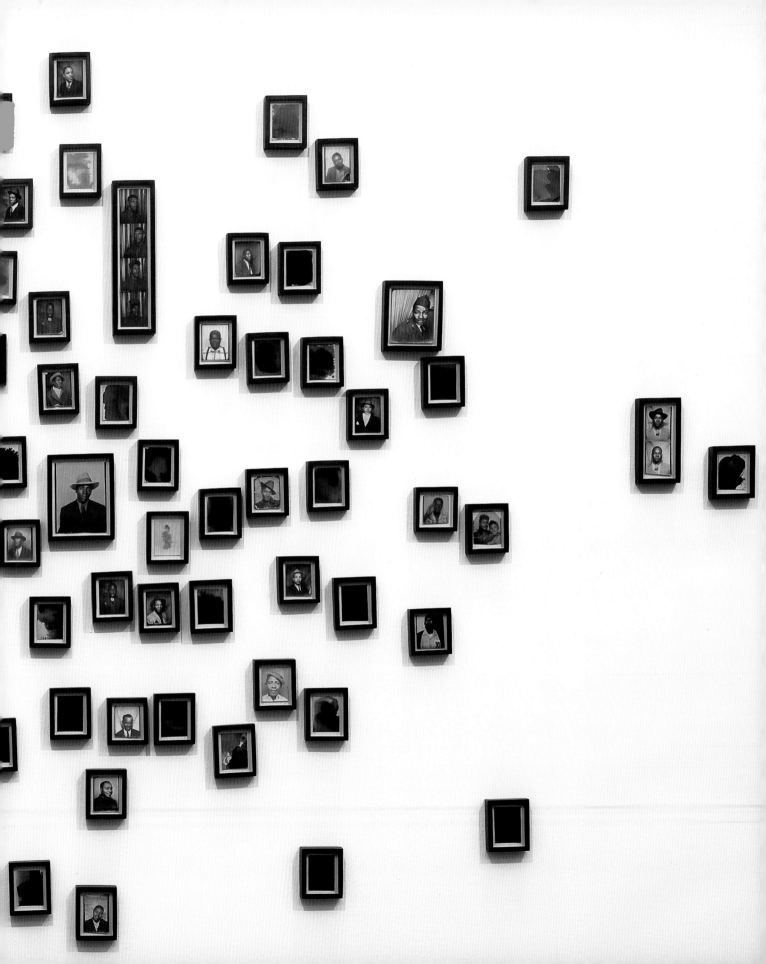

ELLEN GALLAGHER

DeLuxe 2004–5
Portfolio of 60 etchings with photogravure,
engraving, spitbite, silkscreen, lithography,
cutting and collage
Each 330 × 265 mm
Overall display dimensions 2153 × 4470 mm
Tate. Purchased 2006

KARA WALKER
8 Possible Beginnings Or:
The Creation of African-America,
a Moving Picture by Kara E. Walker
2005
16mm film and video transferred
to DVD, black and white, sound,
15:57 minutes, single-screen projection
Tate. Lent by the American Fund for
the Tate Gallery, courtesy of the
American Acquisitions Committee
2007

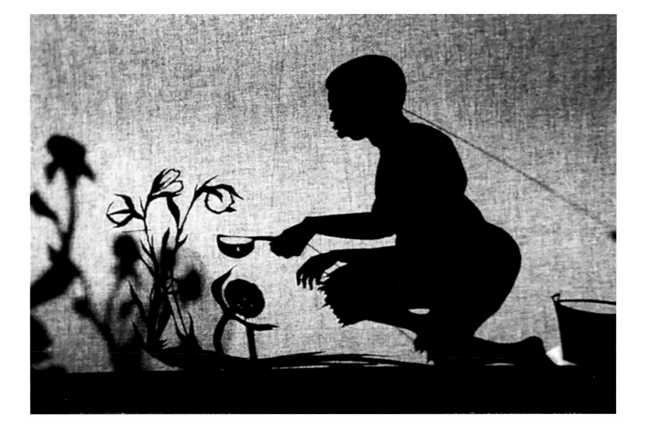

APPENDIX

GLOSSARY

CHRONOLOGY

BIBLIOGRAPHY

LIST OF WORKS

CONTRIBUTORS

NOTE BY THE EDITORS

On occasion of the exhibition *Afro Modern: Journeys through the Black Atlantic*, Tate Liverpool and University of Liverpool's School of History have jointly initiated an online resource on the Black Atlantic, available at www.liv.ac.uk/csis/blackatlantic.

The bibliography in this book focuses on visual art of the African diaspora and is based on the holdings of the Tate Library. In addition, it includes important publications from the Iniva Library in London, as well as key documents related to Black Atlantic theory.

GLOSSARY

Abolitionism

A movement originating in the late eighteenth century which sought the abolition of slave trading and the emancipation of slaves in Europe and the New World. Criticised by some religious groups and condemned by Enlightenment thinkers as a violation of the rights of man, the slave trade (specifically the enforced transportation of African slaves) was made illegal in Britain in 1807, in large part due to the efforts of politician William Wilberforce. Slavery itself was abolished throughout the British Empire in 1833. In the United States political tensions between slavers and abolitionists resulted in the American Civil War (1861–65) and the ultimate abolition of slavery in 1865. In the Caribbean, the abolition of slavery occurred at different times through the nineteenth century: Haiti (1804), Trinidad (1834), Jamaica (1834), Martinique (1848) and Cuba (1886). Brazil did not abolish slavery until 1888, making it the last nation in the Western hemisphere to do so.

Afro-modernism

A broad term referring to those strands of twentieth-century transnational black art and literature affiliated to global modernism and composed of disparate strains of African tradition and experience. Afro-modernism embraces the networks of hybridity evident across Africa and its diaspora and rejects the exoticising tendencies of modernist 'Primitivism'.

Afropolitan

A conflation of 'African' and 'cosmopolitan', the term refers to an emergent, internationally mobile group of people of African origin able to exert cultural and economic influence on the world. It has also been used to describe a community of artists originating from Africa but living in alternative locations, and thus part of a more recent and mobile diaspora.

Antillanité

A political and cultural movement arising in the early 1960s, developed by Édouard Glissant (b. 1928), which sought to celebrate and assert a distinct Caribbean identity, Antillanité was a reaction to the idea of a single African identity shared across the diaspora proposed by the earlier Négritude movement, of which Glissant has been the principal critic. Antillanité espoused the convergence of a multiplicity of ethnic and cultural elements, including African ones, in the creation of a syncretic Caribbean identity.

Antropofagia

A Brazilian artistic and cultural movement heralded by the poet Oswald de Andrade (1890–1954) in 1928, Antropofagia was a response to the cultural legacies imparted by European colonialism and aimed to assert the distinctively hybrid aspects of Brazilian art and literature. The term 'antropofagia' translates literally as people-eating, therefore meaning cannibalism, and Andrade's usage refers to the idea of Brazilians devouring or appropriating foreign cultural influences rather than being colonised by them. Tarsila do Amaral (1886–1973) was the artist most closely related to the movement and her paintings *Abaporu* 1928 and *Antropofagia* 1929 explore this theme.

Archipelago

A geographical term used to describe a chain or cluster of islands, or a sea containing a large number of scattered islands, such as the Caribbean.

Black Atlantic

A term defined in Paul Gilroy's book *The Black Atlantic: Modernity and Double Consciousness* (1993), describing an alternative space for cultural and intellectual interchange and experience with specific regard to the African diaspora. Emphasising the hybridity and transnationalism of African diasporic experience the term challenges the legitimacy of cultural nationalism and racial essentialism, and questions notions of regional intellectual autonomy. A key motif in the book is the idea of the Atlantic Ocean as a 'continent in negative', a network of cultures spanning Africa, North and South America, the Caribbean and Europe.

Black Orpheus

Referring to the myth of Orpheus, the title of philosopher Jean-Paul Sartre's 1948 essay analysing Négritude that introduced a volume of francophone poetry called *Anthologie de la nouvelle poésie nègre et malgache*, compiled by Léopold Senghor, was 'Orphée Noir' (Black Orpheus). From 1957, in its English form 'Black Orpheus', it was used as the title of a literary and artistic journal published by the Mbari club in Ibadan, Nigeria; it featured the work of African, Caribbean and African-American writers and artists. In 1959, *Orfeu Negro* (Black Orpheus) became the title of a film made in Brazil by the French director Marcel Camus which updated the myth of Orpheus and set it in the *favela* (shanty-town) communities and carnival of Rio de Janeiro. Thus, the term links the different continents around the Atlantic, through the context of different manifestations of Négritude and the negotiation of modernism and cultural hybridity.

Black Power

A political movement originating in the USA in the 1960s and greatly influenced by Malcolm X (1925–65), Black Power was developed into a coherent ideology by Stokely Carmichael (1941–98) and Charles Hamilton. It called upon African-Americans to take pride in their culture and their descent. By exhibiting a sense of solidarity, they could create a distinctively Black

economic and political base to further their claim for full equality in US society. As these goals were seen to be unfulfilled, Black Power adopted an increasingly confrontational approach. The most prominent of the Black Power groups became the Black Panther Party (1966–c.1976), which, as well as adopting a community-oriented stance, also advocated the establishment of paramilitary self-defence units. Some adherents believed in Black autonomy, nationalism and separatism. Its actions resulted in a significant increase in cultural awareness among many young African-Americans, manifested in political activity, slogans such as 'Black is Beautiful', and in movements such as the Black Arts Movement.

Candomblé

An African-Brazilian folk religion practised chiefly in Brazil, but also found in other areas of South and North America and Europe. Candomblé originated in the region of Bahia, the capital of which, Salvador, boasts the the country's largest Afro-Brazilian population. The religion is based on a form of animism (the belief that within every animal, plant, and inanimate object there dwells a spirit or soul capable of governing its existence and influencing human affairs). Candomblé arose from the rituals practised by peoples of the African diaspora, principally inspired by the Yoruba veneration of orishas. It also refers to the customs and rituals associated with the religion.

Chronotope

A concept arising from the study of language (linguistics) and developed by Russian literary theorist Mikhail Bakhtin (1895–1975). The term refers to the idea that narrative is defined by the interdependent and indivisible temporal and spatial conditions in which it is formed. Bakhtin defines a chronotope as the intersection and fusing of given spatial and temporal coordinates. For example, a specific point in time within an inhabited landscape can be seen as a chronotope. Time is able to take physical form and become visible for human contemplation. Furthermore, space itself is shaped by a chronological element, as well as by the distinctive mental and moral character of its inhabitants. In this way a chronotope can be regarded as a symbol of community itself. Gilroy applies the term to ships, as spatially and temporally defined units.

Creolisation

Closely identified with hybridity, creolisation describes the appropriation and reinterpretation of non-native cultural elements into a single creole, or multi-ethnic society. 'Creole' also describes a form of language evolved from sustained contact with a range of vernaculars and traditions, whose increased usage means that it becomes the mother tongue of a speech community. Creole languages have had difficulty in being recognised as independent languages in their own right or as written languages, something the Négritude and Antillanité movements sought to address. Striking similarities have been noted in the structure of all such languages, suggesting that what is common to creoles in widely scattered communities may also underpin the acquisition of languages everywhere.

Créolité

A literary movement originated in 1989 by Patrick Chamoiseau, Jean Bernabé and Raphaël Confiant on the French Caribbean island of Martinique. It was a response to the ideology proposed by the writers of the earlier Négritude movement who, rejecting the dominating influence of French colonialism, defined themselves in terms of their cultural, racial and historical ties to the African continent. Créolité regarded this as a form of 'fake universality', instead proposing that Caribbean identity be defined by plurality and hybridity informed by indigenous peoples, and other diasporic communities, as well as by the heritage of ex-slave and European colonialists. As such, Créolité shares the concerns of Antillanité regarding what it considers to be the falsehood of the assertion that a single shared cultural tradition exists across all elements of the African diaspora.

Diaspora

The term refers to a permanently displaced or relocated population with a shared ethnic identity, originally arising in relation to Jewish exile from Israel in 607 BC and successive subsequent expulsions in diverse times and contexts. Diaspora describes the process of forced emigration as well as voluntary relocation on a large scale. The African diaspora in particular refers to descendants of black Africans who were forcibly enslaved and dispersed as a result of the Atlantic slave trade. It is estimated that at least 12 million Africans were transported across the Atlantic Ocean between the sixteenth and nineteenth centuries, though some believe the true figure to be much higher.

Double consciousness

Developed by African-American activist, historian and sociologist W.E.B. Du Bois (1868–1963), double consciousness is a concept describing the felt contradiction between social values and daily experience for black people in the United States. It refers to the state of belonging to a culture but being simultaneously outside it, denied access or ignored within it. For Du Bois being black meant being deprived of a 'true self-consciousness' insofar as black Americans' perception of themselves is framed by a generalised contempt on the part of white America. To be black and American thus implied a range of contradictions between American social ideals, which blacks shared, and the experience of exclusion from American life. The term was later used in cultural studies to describe conflicting and/or overlapping forms of identification, for instance in Paul Gilroy's work on Atlantic culture.

Enlightenment

A European intellectual movement of the late seventeenth and eighteenth centuries, it refers to a period of political, philosophical and cultural life during which Reason was seen as being the key source of human knowledge and, crucially, underpinned the belief in progress. It challenged hitherto accepted social, political and religious traditions. With its inherent criticism of government and Church, the ideas of the Enlightenment are associated with revolution and political upheaval, including the American War of Independence (1775–83), the French Revolution (1789) and the Haitian Revolution (1791–1804).

Ethnography

A branch of the social sciences arising in France in the early twentieth century concerned with studying human societies and individual cultures, thus closely related to anthropology and sociology. In the UK it is often called social anthropology. While not prescribing any particular research method, ethnographers rely principally on direct first-hand observation and social engagement as methods of research and understanding. Ethnography is underpinned by the idea that humanity is best understood through the study and acknowledgment of its fullest possible context.

Garveyism

A term encompassing the work and philosophy of Marcus Garvey (1887–1940), a prominent black nationalist and Pan-Africanist who founded the UNIA-ACL (Universal Negro Improvement Association and African Communities League). It defined a movement of 'African Redemption'. Garveyism can be regarded as a movement towards the realisation of a transnational African identity with the ultimate aim of political and social union among all those of African descent. It also called for all European colonial powers to leave Africa. It inspired later figures such as Malcolm X (1925–65) and movements and organisations such as the Nation of Islam.

Harlem Renaissance

A cultural, literary, artistic and intellectual movement originating in New York during the 1920s, the Harlem Renaissance was an early manifestation of black consciousness in the United States. It was through this movement that black writers and artists expressed and asserted their sense of modernity. It was a celebration and exploration of African-American history, identity and expression and exerted influence until the 1930s, though many of its ideas resonated long afterwards. Profoundly influencing the cultures of the African diaspora in Europe and the Caribbean, the movement questioned the cultural authority of the Western canon and challenged white paternalism and societal racism. Writers such as the poet Langston Hughes (1902–67) became icons of this movement.

Hybridity

In post-colonial terminology hybridity alludes to racial and/or cultural mixing, usually with reference to the legacy of imperialism. Theorist Homi K. Bhabha noted that the concept of hybridity undermined the strict opposition of coloniser and colonised and challenged the legitimacy of imperial authority, while raising issues around race and multiculturalism and the construction of identity.

Lucumi

An Afro-Cuban religion practised in Cuba by people of African ancestry. When African slaves were transported to Cuba, they brought with them their religious beliefs and evolved groups or associations depending on their respective African backgrounds (e.g. Bantu, Arara, Yesa). The Yoruba people of South-West Nigeria left Africa from a slave port named Lucumi, which subsequently became the name of their African-Cuban religion.

Lwa

Lwa (also loa or l'wha) are spirits central to Haitian folk religion (the most well-known form of which is called voodoo, vodou or vodun), derived from a combination of West African and Catholic beliefs. In the practice of voodoo, they function as the spiritual intermediaries between religious devotees and a supreme divinity. There are many lwa, for instance protective spirits of African tribes, or deified ancestors. Lwa are grouped into families, or 'nations'.

Macumba

Although a variety of meanings for the word exist, primarily macumba refers to a range of syncretic religions or rituals of African (Bantu) origin commonly practised in Brazil, including Candomblé, Umbanda, Quimbanda and Omoloko. The word is also deployed pejoratively to connote black magic or witchcraft, though among macumba practitioners it is not interpreted in a negative sense.

Maroon

Derived from the Spanish for fugitive or runaway, 'maroon' was the name given to escaped slaves, and their descendants, in South, Central and North America and the Caribbean. The maroons established independent communities, or maroon republics, sometimes joined with indigenous populations, but separate from the principal colonial settlements. These communities were often the source of attacks on plantations and of slave rebellions, particularly in Haiti, Jamaica, Suriname and Brazil. Over time, they developed their own specific cultures and creole languages. Many maroon communities continue to exist, notably the Jamaican Maroons, remaining virtually autonomous and independent from mainstream society and culture.

Mestizaje/mestizo

Originating in the context of Spanish and Portuguese colonial contacts, the term denotes a person of mixed racial heritage. The term is distinct from 'mulatto' (referring to a person of African-European parentage) in that it refers to Latin Americans of mixed European and American Indian descent. The term can be used much more broadly, however, to describe many different variations of racial and cultural mixing.

Middle Passage

The transatlantic route upon which African slaves were transported to New World plantations, the Middle Passage refers to the central portion of the triangular trade between Europe, Africa and the Americas. The triangle operated thus: commercial and manufactured goods from Europe were imported into the African market where they were bartered or sold for slaves. The slaves were then transported across the Atlantic and sold onto plantations. The raw materials produced by these plantations (sugar and tobacco among others) were in turn exported to Europe. The Middle Passage was therefore the scene of appalling conditions of confinement, death and terror, and involved barbaric acts such as throwing sick or unruly slaves overboard. It was also the means by which African slaves became violently separated from their families, culture, religions and history, resulting in conflicted states of belonging and identity.

NAACP

The National Association for the Advancement of Colored People is a major Civil Rights group founded in 1909 as a result of

race riots in Illinois. In the first half of the twentieth century the NAACP was instrumental in enfranchising African-Americans and the passing of anti-lynching laws. Its mission continues to focus on political, educational, and economic equality for all and on the eradication of racial hatred and discrimination.

Natural Synthesis
Devised by the artist and theorist Uche Okeke (b. 1933) following the independence of Nigeria in 1960, Natural Synthesis was intended as an artistic manifesto for a nation reborn. For Okeke any revival of traditional art was regressive. Acknowledging a break from this past, he envisioned a Nigerian art which celebrated the heterogeneity of its cultural traditions while simultaneously confronting the immediate philosophical and artistic landscape in which it dwelt.

Négritude
A cultural and political movement founded during the 1930s by a group that included Martinican poet Aimé Césaire (1913–2008), French Guyanese poet Léon Damas (1912–78), and the future Senegalese President Léopold Sédar Senghor (1906–2001), Négritude, which affirmed consciousness of the value of blackness and African culture and identity, was influenced by Surrealism in Paris and the Harlem Renaissance in New York. The movement celebrated a rediscovered African identity, culture and expression, challenging the inherent racism of colonialism. It was underpinned by the belief that the shared heritage of members of the African diaspora was the best tool for combating colonial and cultural hegemony.

Negrophilia
A tendency in 1920s Paris through which avant-garde artists celebrated black culture, primarily as a means of reacting against what they deemed to be bourgeois sensibilities and rejuvenating European culture in the aftermath of World War I. It found manifestation in art, literature, music, fashion, dance and design and was styled as a craze or epidemic. The emphasis and fetishisation by white artists of the so-called 'primitive' often created a stereotyped image of black culture. Prominent personalities associated with

Negrophilia include Josephine Baker (1906–75) and Nancy Cunard (1896–1965).

New Negro
A term associated with the Harlem Renaissance, though used in African-American race-conscious discourse since the late nineteenth century. In 1917, Hubert Harrison (1883–1927) founded the Liberty League and *The Voice*, respectively the first organisation and the first newspaper of the New Negro movement. Alain Locke's (1885–1954) anthology of art and literature, *The New Negro* (1925), contrasted the Old Negro with the New Negro, who was associated with a newfound assertiveness, racial pride and self-confidence in the years following World War I.

Orisha/orixa
In the Yoruba tradition *orishas* (*orixas* in Brazil) are spiritual manifestations of a supreme divinity. In the syncretic religions of African origin (such as Candomblé and Santería) dedication to *orishas* has been conflated with the Catholic veneration of saints; individual *orishas* thus include characteristics of their Catholic counterparts. Orishas are broadly synonymous with the *lwa* of Lucumi people.

Pan-Africanism
A sociopolitical philosophy which strives to recognise the shared ethnicity, cultural and historical traditions of all the indigenous inhabitants of Africa and its diaspora with the ultimate aim of social and political unification. Pan-Africanist ideas originated in the eighteenth century, and can be seen as a product of the international slave trade rather than as a position that arose within Africa itself. Edward Wilmot Blyden (1832–1912) and W.E.B. Du Bois (1868–1963) have both been called the father of Pan-Africanism. It was Marcus Garvey (1887–1940), however, who played the most prominent role in advancing and disseminating a Pan-African philosophy and a Back-to-Africa movement, embodied in his Black Star Line shipping company.

Pau-Brasil
Pau-Brasil was a literary manifesto of 1925 by Oswald de Andrade which anticipated elements of his *Antropofagia* manifesto of

1928. Pau Brasil demanded the rejection of what Andrade regarded as the dominating influence of Portuguese cultural and literary tradition. Extending the theories of European modernism, Andrade championed the primitive spontaneity of Brazil's indigenous cultural traditions as the basis of renegotiating and recreating the nation's identity and expression in the modern world.

Phrenology
Phrenology was developed as a techique based on the belief that the personality and mental attributes of a subject can be deduced from the study of the shape of the skull. Founded in Germany and common among nineteenth century anthropologists and ethnographers formulating theories of racial difference and national character, phrenology had been largely discredited by the beginning of the twentieth century. It is now viewed as one of the methods by which Western powers sought to justify colonialism and racism through what appeared to be science and rationalism, though was in fact a kind of pseudo-science.

Post-black
A term coined in the 1990s, it refers to the social position and self-definition of black peoples, though it has largely been applied in an African-American context. Post-black art refers to a genre of contemporary art created by a young generation of African-American and diasporic artists. While post-black art may incorporate a concern with black culture and identity and the assertion of a black presence within what proponents deem to be the racially exclusive territory of Western art-historical discourse, these themes and concerns are often dealt with implicitly rather than in the explicit manner in which many artists of the previous generation had addressed them. It is, therefore, a self-consciously paradoxical genre in that it aims to address racism, even while evading an overly explicit concern with racial identity. The strategy of avoiding culturally and ethnically loaded classifications such as Black Art aims to challenge the legitimacy of categorising art in racial terms.

Post-colonialism

A critical theory dealing with the social, political and cultural consequences of colonialism, post-colonialism examines the after-effects of colonisation (and is thus concerned with the entire colonial period), as well as the concerns of formerly colonised peoples, particularly with regard to national identity, culture and history in the wake of independence. It examines the means by which power is justified and exercised between coloniser and colonised, and the inevitable processes of hybridity and cultural transfer which occur. It has more recently been extended to embrace examinations of the nature and effects of globalisation.

Primitivism

A term used to describe the appropriation by early modern European artists within their work of what was then called 'primitive' art. This included tribal art from Africa, the South Pacific and Indonesia, as well as prehistoric and ancient European art, European folk art and pre-Columbian art. The discovery of African tribal art by Picasso was a major factor in his move towards Cubism. Primitivism can also be interpreted as the search for a simpler way of life away from Western urban sophistication and social restrictions, and in this sense was also important for Expressionism. Curator William Rubin's controversial exhibition *Primitivism in Modern Art*, at the Museum of Modern Art New York in 1984, served as a catalyst for a re-examination of this genre and the use of the term 'primitive' itself. Thus, the term is now generally avoided unless qualified by inverted commas. Furthermore, some scholars have transformed the term 'primitivist' into 'primitivising', to highlight the transformation of the object by the attitude of the person regarding it.

Racial essentialism

The belief that every given race has a set of characteristics or traits which makes it what it is. From the standpoint of racial essentialism, every ethnic group can be described and defined in terms of fixed traits, discounting variations among individuals or over time. While racial essentialism has been used to support racist ideology, in the sense that it suggests a fundamental difference between races, the emphasis on distinctiveness or uniqueness has also been used strategically to further the objectives of groups engaged in identity politics.

Rationalism

A mode of philosophical and intellectual outlook and inquiry, originating in Enlightenment thought during the eighteenth century, in which reason and deduction, as opposed to experience or spiritual revelation, are held to be the principal means of attaining knowledge and defining truth.

Rhizome

A term central to the philosophical method and theory of knowledge developed by Gilles Deleuze and Félix Guattari in *A Thousand Plateaus* (1980). Deleuze and Guattari propose a multiple, non-hierarchical and de-centralised approach to research and understanding, modelled on the rhizome, in opposition to the binarism, dualism and totalising principles, which they termed 'arborescent'. The rhizomatic approach can be seen as a reaction against dialectical research and understanding.

Santería

The word can be loosely translated from Spanish as the 'Way of the Saints'. It refers to a hybrid and pantheistic Afro-Cuban religion developed from the beliefs of the West African Yoruba people, but which also contains elements of Catholicism.

Transnational

This term refers to an action or activity that involves the crossing of national borders. It is constructed in direct opposition to and challenges the apparent unity of the nation state and all those things belonging to or synonymous with it, such as national identity. Thus it can also refer to a state of being (transnationality) that encompasses and describes associated terms such as diaspora, exile or nomadism, as well as pointing to instances of cultural hybridity.

CHRONOLOGY

EDITED BY

Tanya Barson and Dmitri Van Den Bersselaar

POLITICAL BACKGROUND			1775–83 American War of Independence	1789–99 French Revolution	1806–25 Wars for independence in South America	1811 Chile gains independence
KEY POLITICAL EVENTS AND PEOPLE	Fifteenth century Portuguese bring African captives to Europe as slaves c. 1518 First African captives shipped directly from Africa to America 1640s Start of large-scale slave trading by British slavers and sugar cultivation in British Caribbean	1665–1740 Jamaica's First Maroon War c. 1745 Olaudah Equiano born in what is now Nigeria (West Africa) 1757 Ottobah Cugoano born near Ajumako, modern Ghana	1787 Freed black settlers from England, Nova Scotia and Jamaica arrive in Sierra Leone	1791–1804 Haitian Revolution 1804 1 January, Haiti declared a free republic 1807 25 March, Act for the Abolition of the Slave Trade declares the slave trade illegal in the British Empire	1808 Sierra Leone becomes a British colony, in which Christian missionaries settle and educate slaves rescued from slave ships	1817 or 1818 14 February, Frederick Douglass born (as slave) 1820–99 About 8000 Afro-Brazilian former slaves return to West Africa to settle
ATLANTIC THOUGHT			1787 Ottobah Cugoano publishes *Thoughts and Sentiments on the Evil of Slavery and Commerce of the Human Species*	1789 Olaudah Equiano publishes *The Interesting Narrative of the Life of Olaudah Equiano, or Gustavus Vassa the African*		
ART AND LITERARY EVENTS						
ART MOVEMENTS						

1821–22 Liberia founded as a colony by the African Colonization Society as a settlement for freed American slaves	1822 Brazil, Bolivia and Ecuador gain independence		1861 British annexation of Lagos	1880–1914 'Scramble for Africa' (European colonial conquest)	1884–85 Berlin Conference establishes rules for European colonisation of Africa
			1861–65 American Civil War		
	1833 Slavery Abolition Act abolishes slavery throughout most of the British Empire	1840s Rise of Yoruba *orisha* worship in Trinidad and Guyana	1863 Emancipation Proclamation issued by Abraham Lincoln	1875 Martiniano Eliseu do Bonfim travels to Lagos, Nigeria for education, and is initiated as a *babalawo* (Ifa diviner)	1887 17 August, Marcus Garvey born in St Anne's Bay, Jamaica
	1835 Major uprising of Muslim slaves in Bahia, Brazil	1848 Abolition of slavery in France and all its colonies	1865 13th Amendment to the US Constitution prohibits slavery throughout the USA	1877 Wallace D. Fard Muhammad born	1888 Martiniano Eliseu do Bonfim returns to Brazil and promotes Yoruba culture there. Abolition of slavery in Brazil
	1838 Frederick Douglass successfully escapes from his owner Mr Freeman	1859 Martiano Eliseu do Bonfim born in Bahia, Brazil	1868 William Edward Burghardt Du Bois born	1885 W.E.B. Du Bois attends Fisk University, Nashville, Tennessee	
					1887 Edward Wilmot Blyden publishes *Christianity, Islam and the Negro Race*
		1845 Frederick Douglass publishes his autobiography, *Narrative of the Life of Frederick Douglass, an American Slave.*		1870s Fisk University Jubilee Singers tour the UK and offer black music as popular culture	

POLITICAL BACKGROUND		1897 British 'punitive expedition' against Benin, during which artworks (the Benin bronzes) are stolen		1912 African National Congress founded in South Africa	1914–18 World War I	1915–34 United States' occupation of Haiti
KEY POLITICAL EVENTS AND PEOPLE	1889–91 Frederick Douglass minister-resident and consul-general to the Republic of Haiti 1890 Oswald de Andrade born. One in seven Lagosians has lived in Cuba or Brazil 1895 20 February, Frederick Douglass dies	1897 Elijah Muhammad born. W.E.B. Du Bois helps found the American Negro Academy 1899 26 May, Aaron Douglas born	1900 Henry Sylvester Williams organises first Pan-African Conference in London. Ronald Moody born in Jamaica 1902 Norman Lewis born. Wifredo Lam born 1906 Josephine Baker born	1910–12 Marcus Garvey travels in South and Central America, and London; returns to Jamaica 1911 Romare Bearden born 1914 Marcus Garvey founds Universal Negro Improvement Association (UNIA)	1916 Marcus Garvey moves to Harlem, New York City 1917 Jacob Lawrence born	1919 W.E.B. Du Bois organises the First Pan-African Congress in Paris with delegates from America, the Caribbean, Europe and Africa. Marcus Garvey founds the Black Star Line to aid transportation and the return from America to African homeland
ATLANTIC THOUGHT			1903 W.E.B. Du Bois publishes *The Souls of Black Folk*.			
ART AND LITERARY EVENTS			1907 Picasso paints *Les Demoiselles d'Avignon*			
ART MOVEMENTS						1919–35 Harlem Renaissance

1920
August, First International Convention of the Negro Peoples of the World, organised by UNIA and Marcus Garvey, Harlem

1921
Second Pan-African Congress in London, Brussels and Paris

1922
Marcus Garvey arrested for fraud in connection with the failed Black Star Line; is sent to prison and later deported to Jamaica

1923
Third Pan-African Congress, Lisbon

1925
Malcolm X born. Frantz Fanon born. Josephine Baker first arrives in Paris and opens at the Théatre des Champs-Élysées

1926
W.E.B. Du Bois travels to the Soviet Union

1920
W.E.B. Du Bois publishes a collection of essays and fiction, *Darkwater: Voices from within the Veil*, and a monthly magazine for black children, *The Brownies' Book*

1921
Exhibition by Negro artists, 135th Street Branch of the New York Public Library

1922
Exhibition of visual arts and literature by Negroes, Boston Public Library. August Savage makes a bust of Marcus Garvey

1924
James Van Der Zee starts photographic series of Marcus Garvey and UNIA activities

1925
Special issue of US publication *Survey Graphic* entitled *Harlem: Mecca of the New Negro*. Alain Locke publishes *The New Negro: An Interpretation*, collection of essays, short stories, and photographs, including an essay by W.E.B. Du Bois; partly illustrated and designed by Aaron Douglas

1926
Aaron Douglas, Wallace Thurman, Zora Neale Hurston, John P. Davis, Richard Bruce Nugent, Gwendolyn Bennett and Langston Hughes produce *FIRE!! A Quarterly Journal Devoted to the Younger Negro Artists*; Douglas designs cover

1927
Paul Colin creates *Le Tumulte Noir*, portfolio about Josephine Baker and jazz movement in Paris. Jacob Epstein arrives in New York for three months; meets Carl Van Vechten, Albert Barnes, Frank Crowninshield and Paul Robeson (who sits for portrait bust). Josephine Baker's performance at Folies Bergère is filmed

1928
'Manifesto Antropófago' (Cannibal Manifesto), by Oswald de Andrade, published in the first issue of the *Revista de Antropofagia* (São Paulo)

POLITICAL BACKGROUND	1929 Wall Street Crash in New York, start of Great Depression	1930 Coup d'état in Brazil. Beginning of the so-called Second Republic; Getúlio Vargas in power	1931 The Commonwealth founded	1935–44 Italian occupation of Ethiopia		
KEY POLITICAL EVENTS AND PEOPLE	1929 Martin Luther King, Jr, born 1930 Nation of Islam founded by Wallace D. Fard Muhammad, Detroit, Michigan		1931 Jacob Lawrence moves to Harlem, New York. September, Aaron Douglas sails to Paris; studies at L'Académie Scandinave. May (to February 1933), Dakar-Djibouti expedition, led by Marcel Griaule 1933 11 May, Minister Louis Farrakhan born	1934 Wallace D. Fard Muhammad dies 1935 Riot in Harlem following protest against employer discrimination by white-owned stores. Marcus Garvey moves to London	1936 W.E.B. Du Bois travels through Poland, the Soviet Union, Manchuria, China and Japan 1937 Josephine Baker returns to Paris and becomes French citizen. Loïs Mailou Jones travels to Paris and studies for a year at L'Académie Julian	1938 Aaron Douglas returns to Fisk to take up position of Professor of Art Education; travels to Haiti and the Virgin Islands to paint. Fela Kuti born in Abeokuta, Nigeria
ATLANTIC THOUGHT					1937 Négritude movement founded by Senegalese President Léopold Sédar Senghor, Martinican poet Aimé Césaire, and the Guianan Léon Damas	1938 C.L.R. James publishes *The Black Jacobins*
ART AND LITERARY EVENTS		1930 Aaron Douglas starts working on murals at Fisk University as an artist-in-residence 1931 Exposition Coloniale Internationale, Paris. Museum of African and Oceanic Arts opens at the same time	1933 Dakar-Djibouti exhibition, Trocadéro, Paris 1934 *Zou Zou*, starring Josephine Baker (directed by Marc Allegret), released in France. Publication of *Negro: An Anthology*, collected and edited by Nancy Cunard	1935 *African Negro Art* exhibition, Museum of Modern Art, New York (477 works photographed by Walker Evans, commissioned by James Johnson Sweeney) 1936 Ronald Moody exhibits at the Walker Art Gallery, Liverpool	1937 Cedric Dover publishes *Half-Caste*, 'a study tracing the cultural contributions of mixed-race peoples (including African-Americans)'	1938 Ronald Moody exhibits his sculptures at the Van Lier Gallery, Amsterdam, then at the Salon des Tuileries and L'Equipe in Paris. Jacob Lawrence has first solo exhibition, Harlem YMCA. Completes Toussaint L'Ouverture series
ART MOVEMENTS						

1939–45
World War II

1954
Algerian War of Independence begins, led by the Front Libération Nationale (FLN)

1940
10 June, Marcus Garvey dies

1943
David Hammons born

1944
Angela Davis born

1945
15–21 October, Fifth Pan-African Congress, Manchester, England. W.E.B. Du Bois attends. United call for an independent Africa

1947
In Paris, Alioune Diop establishes Présence Africaine, a publishing house and journal promoting African culture. W.E.B. Du Bois travels through Grenada, Jamaica, Trinidad, and Cuba

1948
22 June, arrival of the *Empire Windrush* in Tilbury, UK, from the Caribbean

1952
24 August, Linton Kwesi Johnson born in Jamaica

1953
W.E.B. Du Bois awarded International Peace Prize by the World Peace Council

1954
Oswald de Andrade dies

1939
Aimé Césaire publishes poem *Cahier d'un Retour au Pays Natal* (*Notebook of a Return to the Native Land*)

1944
Historian Eric Williams publishes *Capitalism and Slavery*

1946
Caribbean Voices broadcast weekly by the BBC, focusing on literary works from the Caribbean region

1950
Aimé Césaire publishes *Discourse on Colonialism*

1946
Léopold Sédar Senghor publishes *Chants d'Ombre* in Paris

1947
Historian John Hope Franklin publishes *From Slavery to Freedom*

1948
Léopold Sédar Senghor edits first anthology of Negritude poetry, *Anthologie de la nouvelle poésie nègre et malgache*, with introduction by Jean-Paul Sartre. Founding of the Museu de Arte Moderna (MAM) in São Paulo, Brazil

1951
First Bienal Internacional de Artes Plásticas in São Paulo, Brazil

1952
Frantz Fanon publishes *Peau noire, masques blancs* (trans. *Black Skin, White Masks*)

1953
First Exposição Nacional de Arte Abstrata, Brazil

POLITICAL BACKGROUND	**1957** 6 March, Ghana gains independence (first African colony to do so)	**1960** Seventeen African countries gain independence, including Nigeria, Senegal, Mali, Belgian Congo, French	Congo, and Ivory Coast. Insurrection in Algeria by French population against de Gaulle's government	**1961** Establishment of the parliamentary system in Brazil

| | | | |
|---|---|---|
| **KEY POLITICAL EVENTS AND PEOPLE** | **1956**
W.E.B. Du Bois refused passport to attend the First International Congress of Black Writers and Artists sponsored by Présence Africaine, Paris. Aaron Douglas spends part of summer in Europe and West Africa (including London, Lisbon, Madrid, Barcelona, Florence, Rome, and African ports of Dakar, Accra, and Lagos) | **1958**
20 August, Michael Jackson born | **1960**
Jean-Michel Basquiat born. Glenn Ligon born. Lorna Simpson born. Isaac Julien born. Coco Fusco born. W.E.B. Du Bois travels to Ghana and Nigeria

1961
6 December, Frantz Fanon dies in Washington, DC |

ATLANTIC THOUGHT

ART AND LITERARY EVENTS	**1956** Congrès des écrivains et artistes noirs (First International Congress of Black Writers and Artists), organised by Alioune Diop and Aimé Césaire, held in Sorbonne, Paris (attended by Frantz Fanon, Léopold Sédar Senghor, Langston Hughes, Richard Wright, Ben Enwonwu, and Cheik Anta Diop)	**1957** Launch of *Black Orpheus*, review of literature and arts, Ibadan, Nigeria	**1959** Second Congrès des écrivains et artistes noirs (International Congress of Black Writers and Artists), held in Rome	**1961** Frantz Fanon publishes *The Wretched of the Earth*. School of Fine Arts established at University of Nigeria, Nsukka

ART MOVEMENTS	**1958** Zaria Arts Society inaugurated at the Nigerian College of Arts, Science and Technology, under	directorship of Uche Okeke, also called the 'Zaria Rebels'. Their society develops theory of 'Natural Synthesis'.

1963
Restoration of the presidential system in Brazil

1966
15 January and 29 July, military coups d'état in Nigeria; Eastern Nigerians living in Northern Nigeria massacred

1967–70
Nigerian Civil War (Biafra War)

1962
W.E.B. Du Bois renounces his American citizenship, joins the Communist Party, and becomes citizen of Ghana at age of 95

1963
27 August, W.E.B. Du Bois dies in Accra

1965
Malcolm X visits London but is refused entry to France. On 21 February, he is assassinated in New York

1967
Eastern Nigerian artists leave Lagos and join war effort

1968
Leaders of the Tropicália movement, Caetano Veloso and Gilberto Gil, are arrested because seen as political threat (ending the movement). 4 April, Martin Luther King, Jr assassinated. 16 October, Mexico City: African-American athletes Tommie Smith and John Carlos are pictured controversially raising their fists in a salute of Black Power as they collect their Olympic medals. Chris Ofili born

1969
Kara Walker born. Fela Kuti visits North America and is introduced to Black Panther ideology by Sandra Smith

1975
Josephine Baker dies. Elijah Muhammad dies

1962
Opening of Mbari Mbayo Club in Oshogbo, Nigeria; workshops conducted by many artists including Jacob Lawrence and Georgina Beier

1965
First Notting Hill Carnival procession, London. *The Battle of Algiers*, film, directed by Gillo Pontevorco

1966
World Festival of Black Arts, Dakar, Senegal

1968
Festival of the Arts, University of Ife, Ile-Ife, Nigeria. The Caribbean Artists' Movement (CAM) controversially exhibit at the House of Commons, London

1969
First exhibition in Britain of contemporary African art at the Camden Arts Centre (including work by Uzo Egonu)

1971
Nathan Huggins publishes *Harlem Renaissance. Caribbean Artists in England* exhibition organised by CAM, Commonwealth Art Gallery

1963
Brazilian art movement Tropicália initiated, influenced by Antropofagia

1964
Members of Zaria Arts Society form the Society of Nigerian Artists (SNA). Centre for Contemporary Cultural Studies, Birmingham (UK) is established by Richard Hoggart

1966
Caribbean Artists' Movement (CAM) is founded by writers Edward Kamau Brathwaite, John La Rose and Andrew Salkey

POLITICAL BACKGROUND	1979 Margaret Thatcher becomes Britain's first female Prime Minister. Start of Thatcherite Conservatism	1980 End of white minority rule in Zimbabwe		1985 Live Aid charity pop concert raises £40 million for famine relief in East Africa		
KEY POLITICAL EVENTS AND PEOPLE	1978 Riots break out when Fela Kuti performs 'Zombie' in Accra, Ghana; he is banned from returning to Ghana 1979 Aaron Douglas dies. Norman Lewis dies	1981 Bob Marley dies 1982 Wifredo Lam dies. Ronald Moody dies				
ATLANTIC THOUGHT						
ART AND LITERARY EVENTS	1976 Ladislas Bugner et al. edit and publish *The Image of the Black in Western Art*, 4 volumes 1977 *Festac 77* – The Second Festival of Black and African Arts and Culture, held in Nigeria. Fela Kuti and the Afrika 70 release *Zombie*	1978 Rasheed Araeen, 'Preliminary Notes for a Black Manifesto', published in the first issue of *Black Phoenix*	1980 Bob Marley performs at the independence ceremony for Zimbabwe 1981 David Hammons is arrested for performing *Pissed Off*, urinating in public on a Richard Serra sculpture, New York City	1984 *Primitivism in Twentieth Century Art: Affinity of the Tribal and the Modern*, exhibition, Museum of Modern Art, New York. Rasheed Araeen publishes *Making Myself Visible (MMV): Rasheed Araeen*, with an introduction by Guy Brett	1985 An archive for black British artists is established in St Martins School of Art library, now part of the Chelsea School of Art (Liz Ward, librarian). 'Black Art/White Institutions' conference, Riverside Studios, London	1986 Eddie Chambers founds and becomes director of African and Asian Visual Artists Archive (AAVAA) (Bristol). *Handsworth Songs* by Black Audio Film Collective (61 mins), directed by John Akomfrah
ART MOVEMENTS		1981 Black Cultural Archives (BCA) established, 378 Coldharbour Lane, Brixton	1982 Eddie Chambers and Keith Piper form the Pan-Afrikan Connection	1982–88 Black Audio Film Collective, founded by John Akomfrah, Reece Auguiste, Edward	George, Lina Gopaul, Avril Johnson, David Lawson and Trevor Mathison, in Hackney, London	

1990
Nelson Mandela is released after 27 years in prison, returns as head of the African National Congress.

British Prime Minister Margaret Thatcher is forced out of office

1991
Official end of Apartheid in South Africa

1988
Jean-Michel Basquiat dies.
Romare Bearden dies

1991
Isaac Julien is a founding member of Normal Films, London

1992
Kwame Anthony Appiah publishes *In my Father's House: Africa in the Philosophy of Culture*

1987
Paul Gilroy publishes *There Ain't No Black in the Union Jack: The Cultural Politics of Race and Nation. Harlem Renaissance: Art of Black America* exhibition, Studio Museum in Harlem. Publication of first issue of *Third Text: Critical Perspectives on Contemporary Art and Culture*

1988
Autograph: Association of Black Photographers (ABP) established by Mark Sealy. *Black Art: Plotting the Course* exhibition, Oldham Art Gallery (travels to Bluecoat Gallery, Liverpool, 1989), curated by Eddie Chambers

1989
Looking For Langston by Isaac Julien, 16 mm black and white film with sound. *Magiciens de la Terre* exhibition, Centre Georges Pompidou, Paris. *The Other Story: Afro-Asian Artists in Post-War Britain*, Hayward Gallery, London, curated by Rasheed Araeen

1990
Contemporary African Artists: Changing Tradition, Studio Museum in Harlem, New York. African artists also shown at the Venice Biennale

1991
Michael Jackson's single 'Black or White' released from his album *Dangerous. Africa Hoy*, curated by André Magnin, opens at Centro Atlantico de Arte Moderno, Las Palmas de Gran Canaria; travels to the Saatchi Gallery, London under the title *Out of Africa*

1992
DAK'ART, The Dakar Biennial for Contemporary International Art, is founded

1983–92
Sankofa Film and Video Collective, founded by Isaac Julien in London

193

POLITICAL BACKGROUND

1994
First multi-racial elections in 350 years, South Africa; Nelson Mandela inaugurated as President

1999
Peace treaty signed in Lome, Togo, ending the civil war in Sierra Leone

KEY POLITICAL EVENTS AND PEOPLE

1993
Stephen Lawrence is murdered in London in a racial attack by white youths; all four men sentenced to jail for murder

1997
Chris Ofili included in the Young British Artists' exhibition *Sensation*, Royal Academy of Arts, London

1998
Okwui Enwezor is artistic director of *Documenta XI*. Chris Ofili wins the prestigious Turner Prize, and is chosen to represent Britain at the Venice Biennale

2000
Jacob Lawrence dies

2001
Isaac Julien is nominated for the Turner Prize for his film *The Long Road to Mazatián* (1999)

ATLANTIC THOUGHT

1993
Paul Gilroy publishes *The Black Atlantic: Modernity and Double Consciousness*

1994
Kobena Mercer publishes *Welcome to the Jungle: New Positions in Black Cultural Studies*

2001
Okwui Enwezor, Stuart Hall and others publish *Democracy Unrealized: Documenta 11 – Platform 1*

ART AND LITERARY EVENTS

1993
London's Electric Cinema, Portobello Road (1910) is the first cinema in London to screen films relating exclusively to black culture. Second International Symposium on Nigerian Art, Lagos. Haile Gerima's *Sankofa* is released

1994
Black Male: Representations of Masculinity in Contemporary American Art, Whitney Museum of American Art, New York, curated by Thelma Golden. Institute of International Visual Arts (InIVA) is established (merging Third Text and OVA), London. *Nka: Journal of Contemporary African Art* founded by Okwui Enwezor, New York

1995
Africa '95 festival of art, England. Related shows include *Seven Stories about Modern Art in Africa*, Whitechapel Art Gallery, London; *Self Evident*, Ikon Gallery, Birmingham; *Africa: The Art of a Continent*, Royal Academy of Arts, London; *Mirage: Enigma of Race, Difference and Desire*, ICA, London. The Black Women Artists study group is established, London

1996
Picturing Blackness in British Art 1700s–1900s, Tate Gallery, London, curated by Paul Gilroy. *In/Sight: African Photography, 1940 to the Present*, exhibition at the Solomon R. Guggenheim Museum, New York. Isaac Julien, *Frantz Fanon: Black Skin, White Mask* broadcast on BBC television

1997
Rhapsodies in Black exhibition, Hayward Gallery, London

2001
Freestyle exhibition, Studio Museum in Harlem, New York

2002
Black Romantic: The Figurative Impulse in Contemporary African-American Art, Studio Museum in Harlem. *The Upper Room* by Chris Ofili exhibited as part of *Freedom One Day* at the Victoria Miro Gallery, London

ART MOVEMENTS

2005
Hurricane Katrina destroys huge areas of New Orleans, United States, in August. The city's reconstruction programme is criticised for racial discrimination against black residents, who make up the majority of the population

2005
Chris Ofili launches the music project Freeness, in which he finds contemporary alternatives to, and tries to subvert the meaning of, 'urban music'

2007
Bicentenary of the Abolition Act, 1807. Museum in Docklands opens the first permanent display in London relating to the transatlantic slave trade, *London, Sugar, Slavery*. International Slavery Museum opens in Liverpool, England

2009
Barack Obama is inaugurated as the 44th, and first African-American, President of the United States

2003
Coco Fusco and Brian Wallis edit and publish *Only Skin Deep: Changing Visions of the American Self*, with an essay by Nicholas Mirzoeff

2005
Africa '05 Festival, London. *Africa Remix: Contemporary Art of a Continent*, Hayward Gallery. David A. Bailey, Ian Baucom and Sonia Boyce edit and publish *Shades of Black: Assembling Black Arts in 1980s' Britain*. Exhibition *Back to Black: Art, Cinema and the Racial Imaginary*, Whitechapel Gallery, London, curated by Richard J. Powell, David A. Bailey and Petrine Archer-Straw

2006
Frequency, Studio Museum in Harlem, New York. *David Hammons: The Unauthorised Retrospective*, controversial exhibition at Triple Candie, Harlem, curated by Shelly Bancroft and Peter Nesbett, features photocopies and print-outs in place of the artist's actual works in protest against five years of unsuccessful campaigning for a Hammons exhibition

2007
Opening of Rivington Place (Autograph ABP). First purpose-built cultural centre since Hayward Gallery in 1968, London. Lorna Simpson, 20-year survey of the artist's work, Whitney Museum of American Art, New York

2008
Kara Walker: My Complement, My Enemy, My Oppressor, My Love, Whitney Museum of American Art, New York. *Flow*, Studio Museum in Harlem, New York

2010
Archive for Culturally Diverse Photography opens at Autograph ABP, Rivington Place

2011
Black Cultural Archives will move to Raleigh Hall, Brixton

2012
Ryerson Photography Gallery and Research Centre, Gould St, Toronto, Canada to open. It will house the Black Star Historical Black & White Photography Collection

BIBLIOGRAPHY

* unseen items

COMPILED BY

Fiona Baker and Melanie Grant

I. BOOKS

1787
*Cugoano, Ottobah: Thoughts and sentiments on the evil of slavery and commerce of the human species. London: 1787; 148p.

1789
*Equiano, Olaudah: The interesting narrative of the life of Olaudah Equiano, or Gustavus Vassa, the African. London: 1789; 2 vol.

1845
*Douglass, Frederick: Narrative of the life of Frederick Douglass, an American Slave. Boston: Anti-slavery Office, 1845; 125p.

1887
*Blyden, Edward Wilmot: Christianity, Islam and the Negro race. London: W.B. Whittingham, 1887; 423p.

1903
*Du Bois, William Edward Burghardt: The souls of black folk. Chicago: A.C. McClurg & Co., 1903; 264p.

1920
*Du Bois, William Edward Burghardt: Darkwater: voices from within the veil. New York: Harcourt, Brace and Howe, 1920; 276p.

1925
*Locke, Alain: The new Negro: an interpretation. New York: Boni, 1925; 452p.; includes an essay by W.E.B Du Bois, partly illustrated and designed by Aaron Douglas.

1927
*Colin, Paul: Le tumulte noir. [Paris: Editions d'Art, Success, 1927]; [52]p., col. illus.; includes essay by Josephine Baker.

1934
*Cunard, Nancy: Negro: an anthology. London: Nancy Cunard at Wishart & Co., 1934; 854p.

1937
*Dover, Cedric: Half-caste. London: M Secker and Warburg, 1937; 324p.; bibl. pp.291–314.

1938
Goldwater, Robert J.: Primitivism in modern painting. New York; London: Harper, 1938; 210p., illus.; bibl. pp.195–210.

*James, C.L.R.: The black Jacobins: Toussaint L'Ouverture and the San Domingo revolution. New York: The Dial Press, 1938; 328p., illus.; bibl. pp.317–322.

1939
*Césaire, Aimé: Cahier d'un retour au pays natal. Paris: Volontes, [1939?]; 29p.

1943
Porter, James A.: Modern Negro art. New York: Dryden Press, 1943; 272p., illus. (85 plates); bibl. pp.183–192.

*Senghor, Léopold Sédar: Chants d'ombre. Paris: Editions du Seuil, 1945; 78p., illus.

1944
*Williams, Eric Eustace: Capitalism and slavery. New York: Russell & Russell, [1944]; 285p.

1947
*Franklin, John Hope: From slavery to freedom: a history of American Negroes. New York: A.A. Knopf, 1947; 622p.

1948
*Senghor, Léopold Sédar: Anthologie de la nouvelle poesie nègre et malgache de langue francaise. Paris: Presses Universitaires de France, 1948; 227p.; introd. by Jean-Paul Sartre.

1950
*Césaire, Aimé: Discours sur le colonialisme. Paris: Réclame, 1950; 60p.

1952
*Fanon, Frantz: Peau noire, masques blanc. Editions de Seuil, 1952; 237p. See English edition, published in 1986.

1956
The 1st international congress of black writers and artists: Paris, Sorbonne, 19–22 Sept. 1956: full account. Paris: 1958; 414p.; includes contributions by Frantz Fanon, Léopold Sédar Senghor and Langston Hughes amongst others.

1960
Apollinaire, Guillaume: Chroniques d'art (1902–1918). Paris: Gallimard, 1960; 524p.

1961
*Fanon, Frantz: Les damnés de la terre. Paris: F Maspero, 1961; 242p.; preface by Jean-Paul Sartre.

1967
Franco, Jean: The modern culture of Latin America: society and the artist. London: Pall Mall Press, 1967; see 1970 ed.

1968
Laude, Jean: La Peinture française [1905–1914] et "l'art nègre": contribution à l'étude des sources du fauvisme et du cubisme. Paris: Klincksieck, 1968; 2 vol. (574p, [96]p.) 90 illus. in vol. 2; bibl. vol. 1 pp.545–560.

1970
Franco, Jean: The modern culture of Latin America: society and the artist. London: Pelican Books, 1970; 380p.; rev. ed., 1st published 1967.

1971
Bihalji-Merin, Oto: Modern primitives: naïve painting from the late seventeenth century until the present day. London: Thames and Hudson; 1971; 304p., 389 illus. (204 col.); bibl. p.301, biogs. pp.289–300.

Pierre, José: La sculpture de Cárdenas. Brussels: La Connaissance, 1971; 143p., illus.; biogs., exhibs.

1973
Jager, E.J.: Contemporary African art in South Africa. Cape Town: C. Struik, 1973; 31p., illus.

Mount, Marshall Ward: African art: the years since 1920. Newton Abbot: David and Charles, 1973; 236p., illus. (some col.); bibl. pp.204–10. Originally published: Bloomington: Indiana University Press, 1973.

1974
Berman, Esmé: Art and artists of South Africa: an illustrated biographical dictionary and historical survey of painters and graphic artists since 1875. Rotterdam; Cape Town: A.A. Balkema, 1974; 368p., illus. (some col.); bibl. pp.353–355.

*Wentinck, Charles: Moderne und Primitive Kunst. Freiburg im Breisgau, Basel, Vienna: Herder, 1974; 31 p: col. illus.

1975
Christensen, Eleanor Ingalls: The art of Haiti. South Brunswick and New York: A.S. Barnes and Company; London: Thomas Yoseloff Ltd., 1975; 76p., illus. (some col.).

1976

Bugnar, Ladislas (ed.): The image of the black in western art. Houston; Menil Foundation: Cambridge, Mass.: distributed by Harvard University Press, 1976–1989; 4 vol., illus. (some col.)

Lewis, Samella S and Waddy, Ruth G: Black artists on art. Los Angeles: Contemporary Crafts, 1976; Vol. 1, revised ed.; 141 p., illus. (some col.); biogs. pp.137–41.

1977

*Baker, Josephine and Bouillon, Jo: Josephine. New York: Harper & Row, 1977; 302p., illus.; translated from the French by Mariana Fitzpatrick.

Fax, Elton C: Black artists of the new generation. New York: Dodd Mead, c1977; 370p., illus.

1978

*Lewis, Samella: Art: African American. New York: Harcourt, Brace, Jovanovich, 1978; 246p. See 1990 and 2003 editions entitled African American art and artists.

Wentinck, Charles: Modern and primitive art. Oxford: Phaidon, 1978; 30 p., col. [79]p. of plates, col. illus.; translated by Hilary Davies from 1974 German edition.

1979

Locke, Alain (ed.): The Negro in art: a pictorial record of the Negro artist and of the Negro theme in art. New York: Hacker Art Books, 1979; 224p., illus.; bibl. p.224. First published in 1940.

1984

Samaltanos, Katia: Apollinaire: catalyst for primitivism, Picabia, and Duchamp. From the series Studies in the fine arts: the Avant-Garde, No. 45. Ann Arbor: UMIResearch Press, 1984; 228p., illus.; bibl. pp.213–7; revision of 1981 thesis.

Thompson, Robert Farris: Flash of the spirit: African and Afro-American art and philosophy. New York: Vintage Books, 1984, c1983; 317 p., illus.; bibl. notes pp.271–[302].

1986

Fanon, Frantz: Black skin, white masks. London: Pluto Press, 1986; 232p.; translated by Charles Lam Markmann. Originally published in French as "Peau noire, masques blanc", 1952.

Goldwater, Robert: Primitivism in modern art. Cambridge, Mass; London: Belknap Press of Harvard University Press, 1986; 339 p., illus.; bibl. 'Publications of Robert Goldwater (1907–1973)' pp.[320]–8. First published in 1938.

1987

Baker, Houston A. Jr.: Modernism and the Harlem Renaissance. Chicago; London: University of Chicago Press, 1987; 122p., illus.

Gilroy, Paul: "There ain't no black in the Union Jack": the cultural politics of race and nation. London: Routledge, 1987; 271p., illus.; bibl. pp.251–66.

1988

Chambers, Eddie and Lamba, Juginda: The Artpack: a history of black artists in Britain. [London]: Haringey Arts Council, 1988; 31p., illus. (chiefly col.).

Clifford, James: The predicament of culture: twentieth-century ethnography, literature and art. Cambridge, Mass.; London: Harvard University Press, 1988; 381p., illus.; bibl. pp.349–70.

Fusco, Coco: Young British and black: the work of Sankofa and Black Audio Film Collective. Buffalo: Hallwalls/Contemporary Arts Center, 1988; 65p., illus.

Kobena Mercer (ed.): ICA documents 7: Black film, British cinema. London: ICA, 1988; 62p.; includes essays by Coco Fusco and Paul Gilroy, et al., and an interview with the Black Audio Film Collective and Sankofa Film Collective.

Owusu, Kwesi (ed.): Storms of the heart: an anthology of black arts and culture. London: Camden Press; 1988; 308p., illus.; includes essays by Keith Piper and Donald Rodney, and Sonia Boyce amongst others.

1989

Baddeley, Oriana and Fraser, Valerie: Drawing the line: art and cultural identity in contemporary Latin America. London and New York, Verso, 1989; 164p., illus.

*Barnes, Sandra T (ed.): Africa's Ogun: old world and new. 1989; see 1997 ed.

1990

Archer-Straw, Petrine and Robinson, Kim: Jamaican art: an overview – with a focus on fifty artists. Kingston: Kingston Publishers Ltd., 1990; 167p., col. illus.; biogs. pp.159–67.

Ferguson, Russell et al. (ed.): Out there: marginalization and contemporary cultures. New York: New Museum of Contemporary Art, 1990; 446p., illus.

Hiller, Susan (ed.): The Myth of primitivism: perspectives on art. London; New York: Routledge, 1991; 355p., illus.; biogs. pp.345–8; based on seminars held at the Slade School of Art, University of London 1985–1986.

Lewis, Samella: African American art and artists. Berkeley; London: University of California Press, 1990; 2nd rev. ed.; 302p., illus. (some col.). See 1978 edition, Art: African American, 1978; and 2003 expanded edition.

Lippard, Lucy R.: Mixed blessings: new art in a multicultural America. New York: Pantheon Books, 1990; 278p., illus. (some col.); bibl. pp.260–70.

Schwartzman, Myron: Romare Bearden: his life and art. New York: Harry N. Abrams, 1990; 320p., illus. (some col.); bibl. pp.243–51.

1991

Gaudibert, Pierre: L'art Africain contemporain. Paris: Editions Cercle d'Art, 1991; 175p., illus. (some col.); bibl. pp.160–74.

1992

Giraudon, Colette: Paul Guillaume: et les peintres du XXe siècle: de l'art nègre à l'avant-garde. Paris: La Bibiothèque des Arts, 1993; 147p., illus. (some col.); bibl. pp.135–139.

Kennedy, Jean: New currents, ancient rivers: contemporary African artists in a generation of change. Washington and London: Smithsonian Institution Press, 1992; 204p., illus. (some col.); bibl. pp.194–9.

Leyten, Harrie and Damen, Bibi (eds.): Art, anthropology and the modes of re-presentation: museums and contemporary non-Western art. Amsterdam: Royal Tropical Institute, 1993; 78p., illus. (some col.); bibl. pp.73–5.

McEvilley, Thomas: Art & otherness: crisis in cultural identity. New York: McPherson and Co., 1992; 174p.

Wallace, Michele: Black popular culture. Seattle: Bay Press, 1992; 373p., illus.; bibl. pp.347–68; ed. by Gina Dent; includes essays by Paul Gilroy, Isaac Julien, Coco Fusco et al.

Walmsley, Anne: The Caribbean Artists Movement 1966–1972: a literary & cultural history. Discussions in contemporary culture, no. 8. London; Port of Spain: New Beacon Books, 1992; 356p., illus. (some col.); bibl. pp.347–68;

1993

Baker, Jean-Claude and Chase, Chris: Josephine Baker: the hungry heart. New York: Random House, 1993; 592p., illus.

Gilroy, Paul: Small acts: thoughts on the politics of black cultures. London: Serpent's Tail, 1993; 257p., illus.

Gilroy, Paul: The black Atlantic: modernity and double consciousness. London: Verso, 1993; 261p.

Lucie-Smith, Edward: Latin American art of the 20th century. London: Thames & Hudson, 1993; 216p., illus. (some col.); bibl. pp.208–10. See 2004 revised and expanded edition.

McEvilley, Thomas: Fusion: West African artists at the Venice Biennale. New York: Museum for African Art; Munich: Prestel, 1993; 96p., col. illus.

Sealy, Mark (ed.): Vanley Burke: a retrospective. London: Lawrence & Wishart, 1993; 88p., illus.

1994
Baykam, Bedri: Monkey's right to paint: and the post-Duchamp crisis: the fight of a cultural guerilla for the rights of non-western artists and the empty world of the neo-ready mades. Istanbul: Literatur, 1994; 319p., illus.

Fisher, Jean (ed.): Global visions: towards a new internationalism in the visual arts. London: Kala Press in association with the Institute of International Visual Arts, 1994; 175p., illus.; papers delivered at the conference entitled "A new internationalism", the first conference of the Institute of International Visual Arts, held at the Tate Gallery in London on 27 and 28 April 1994.

Lucie-Smith, Edward: Race, sex and gender in contemporary art: the rise of minority culture. London: Art Books International, 1994; 224p., illus. (some col.); bibl. pp.212–217.

Martínez, Juan A.: Cuban art and national identity: the Vanguardia Painters. Gainsville: University Press of Florida, 1994; 189p., illus. (some col.); bibl. pp.175–83.

Mercer, Kobena: Welcome to the jungle: new positions in black cultural studies. New York and London: Routledge, 1994; 339p., illus.

Berger, Maurice (ed.): Modern art and society: an anthology of social and multicultural readings. New York: IconEditions an imprint of HarperCopllins Publishers, 1994; 310p., illus.

Rhodes, Colin: Primitivism and modern art. London: Thames and Hudson, 1994; 216p., illus. (some col.).

Williams, Patrick and Chrisman, Laura (eds.): Colonial discourse and post-colonial theory: a reader. Hemel Hempstead: Harvester Wheatsheaf, 1993; 570p; includes essays by Léopold Sédar Senghor, Frantz Fanon, Aimé Césaire and Paul Gilroy.

1995
Connelly, Frances S: The sleep of reason: primitivism in modern European art and aesthetics: 1725–1907. University Park, Pa.: Pennsylvania State University Press, 1995; 154p., illus.; bibl. pp.133–49.

Fusco, Coco: English is broken here: notes on cultural fusion in the Americas. New York: The New Press, 1995; 214p., illus.

Hooks, Bell: Art on my mind: visual politics. New York: New Press, 1995; 224p., illus. (some col.)

Kirschke, Amy Helene: Aaron Douglas: Art, race and the Harlem Renaissance, 1995; 166p., illus.; bibl. pp.149–58.

Mosquera, Gerado: Beyond the fantastic: contemporary art criticism from Latin America. London: Institute of International Visual Arts, 1995; 343p., col. illus.

Picton, John: El Anatsui: a sculpted history of Africa. London: Saffron Books, 1995; 96p., illus. (some col.); bibl. pp.93–94, biogs., colls., exhibs.

Watson, Steven: The Harlem Renaissance: hub of African-American culture, 1920–1930. New York: Pantheon Books, 1995; 224p.

1996
Baker, Jr. Houston A.; Diawara, Manthia; Lindeborg, Ruth H. (eds.): Black cultural studies: a reader. Chicago and London: The University of Chicago Press, 1996; 340p., illus.; bibl. pp.314–22.

Deepwell, Katy (ed.): Art criticism and Africa. London: Saffron Books, [c.1996–1998]; 125p., illus. (some col.); bibl. pp.113–8; essays developed from papers delivered at a conference organised by AICA (International Association of Art Critics) November 1996.

Magnin, André (ed.): Contemporary art of Africa. London: Thames and Hudson, 1996; 192p., illus., (some col.); bibl. pp.185–6.

Papastergiadis, Nikos (ed.): Mixed belongings and unspecified destinations. Annotations series. London: Institute of International Visual Arts, 1996; 80p., illus.; published in conjunction with a conference held at John Hansard Gallery, University of Southampton, May 1996.

Peltier, Philippe: "Primitivisme" et art moderne. Actualité des arts plastiques, no.82. Paris: CNDP, 1996; 77p., illus.; bibl. p.67. 1st published 1991.

Read, Alan: The Fact of blackness: Frantz Fanon and visual representation. London: Institute of Contemporary Arts; Seattle: Bay Press, 1996, in collaboration with the Institute of International Visual Arts; 211p., illus.; biogs. pp.206–9.

Richardson, Michael: Refusal of the shadow: surrealism and the Caribbean. London: Verso, 1996; 287p.; bibl. pp.281–3.

Stovall, Tyler: Paris noir: African Americans in the city of light. Boston, New York: Houghton Mifflin Company, 1996; 366p., illus.; bibl. pp.342–7.

Williamson, Sue and Jamal, Ashraf: Art in South Africa: the future present. Cape Town; Johannesburg: David Philip, 1996; 159p., col. illus.

1997
Barnes, Sandra T (ed.): Africa's Ogun: old world and new. Bloomington and Indianapolis: Indiana University Press, 1997. 2nd exp. ed.; 389p., illus. See 1989 ed.

Gibson, Ann Eden: Abstract expressionism: other politics. New Haven; London: Yale University Press, 1997; 248p., illus. (some col.)

Levering-Lewis, David: When Harlem was in vogue. New York Penguin Books, 1989; 381p., illus.

Maurer, Evan Maclyn: In quest of the myth: an investigation of the relationships between surrealism and primitivism. Ann Arbour: UMI Dissertation Services, 1997; 539p., illus.; bibl. pp.xxix–lxiv; facsimile of thesis (PhD), University of Pennsylvania, 1974.

Powell, Richard J.: Black art and culture in the 20th century. London: Thames and Hudson, 1997. 256p., illus. (some col.); bibl. pp.237–46; biogs. pp.226–36. See 2002 ed. Black art: a cultural history.

Riggs, Thomas (ed.): St. James guide to black artists. Detroit; New York; Toronto; London: St. James Press in association with the Schomburg Center for Research in Black Culture, 1997; 625p., illus.; biogs.

Shohat, Ella (ed.): Talking visions: multicultural feminism in a transnational age. New York: New Museum of Contemporary Art; Cambridge, Mass.: MIT Press, 1998; 574p., illus.; bibl. pp.533–545.

Tawadros, Gilane: Sonia Boyce: speaking in tongues. London: Kala Press, 1997; 96p., illus. (some col.); biog. pp.93–5.

1998
Boxer, David and Poupeye, Veerle: Modern Jamaican Art. Kingston: Ian Randle and University of West Indies, 1998; 192p., illus. (some col.); bibl. pp.176–7, biogs. pp.178–90.

*Gates, Henry Louis., Dalton, Karen C.C.: Josephine Baker and La Revue negre: Paul Colin's lithographs of Le tumulte noir in Paris, 1927; New York: Harry N. Abrams, 1998; 64p.

Keim, Curtis A. and Schildkrout, Enid: The scramble for art in Central Africa. Cambridge: Cambridge University Press, 1998; 257p., illus.; bibl. pp.236–251.

Lemke, Sieglinde: Primitivist modernism: black culture and the origins of transatlantic modernism. Oxford; New York: Oxford University Press, 1998; 183p., illus.; bibl. pp.165–74.

Martis, Adi and Rijnders, Mieke (eds.): Expressionisme en primitivisme in de beeldende kunst van de twintigste eeuw. Heerlen: Open Universiteit Faculteit Cultuurwetenschappen, 1998, 1998; 334p., illus. (some col.); bibl. pp.300–15.

Mirzoeff, Nicholas (ed.): The Visual culture reader. London: Routledge, 1998; 530p., illus; see Part four: 'Race and identity in colonial and postcolonial culture', includes essays by Paul Gilroy, Adrian Piper and Coco Fusco et al.

Moody, Cynthia: The works of Ronald Moody: catalogue raisonné. [Bristol: Cynthia Moody, 1998]. Unpublished catalogue raisonné; 2 vol. (70, 70p.), illus.

Tawadros, Gilane (ed.): Steve Ouditt: Creole in-site: annotations 4. London: Institute of International Visual Arts, 1998; 72p., illus. (some col.); bibl. p.66.

Patton, Sharon F.: African-American art. Oxford: Oxford University Press, 1998; 319p., illus. (some col.); bibl. pp.283–299.

Poupeye, Veerle: Caribbean Art. London and New York: Thames and Hudson, 1998; 224p., illus. (some col.).

Shohat, Ella (ed.): Talking visions: multicultural feminism in a transnational age. New York: New Museum of Contemporary Art; Cambridge, Mass.: MIT Press, 1998; 574p., illus.; bibl. pp.533–545.

Kester, Grant H.: Art, activism and oppositionality: essays from "Afterimage". Durham, N.C.; London: Duke University Press, 1998; 318p., illus.

1999
Anthology of African and Indian Ocean photography. Paris: Revue Noire, 1999; 1st English ed.; 432p., illus. (some col.); biogs. pp.426–9, bibl. pp.430–1.

Blake, Jody: Le tumulte noir: modernist art and popular entertainment in jazz-age Paris, 1900–1930. University Park, Pa.: Pennsylvania State University Press, 1999; 207p., illus. (some col.); bibl. pp.191–202.

Cummins, Alissandra: Art in Barbados: what kind of mirror image? Kingston: Ian Randle Publishers; 1999; 270p., col. illus.

Doy, Gen: Black visual culture: modernity and post-modernity. London and New York: I.B. Tauris, 2000 (i.e. 1999); 258p., illus.; bibl. pp.248–254.

Farris, Phoebe: (ed.): Women artists of color: a bio-critical sourcebook of 20th century artists in the Americas. Westport, Conn.; London: Greenwood Press, 1999; 496p., illus.

Heyd, Milly: Mutual reflections: Jews and blacks in American art. New Brunswick, N.J.: Rutgers University Press, 1999; 245p., illus.

Kasfir, Sidney Littlefield: Contemporary African Art. London: Thames and Hudson, 1999; 224p., illus. (some col.); bibl. pp.214–7.

King, Catherine (ed.): Views of difference: different views of art. New Haven and London: Yale University Press in association with The Open University, 1999; 272p., illus. (some col.); bibl. pp.261–2.

Klotman, Phyllis R. and Cutler, Janet K. (eds.): Struggles for representation: African American documentary film and video. Bloomington and Indianapolis: Indiana University Press, 1999; 483p., illus.; bibl. pp.457–470.

Oguibe, Olu and Enwezor, Okwui (eds.): Reading the contemporary: African art from theory to the marketplace. London: Institute of International Visual Arts, 1999; 432p., illus. (some col.).

Tawadros, Gilane and Clarke, Victoria (eds.): Run through the jungle: selected writings by Eddie Chambers: annotations 5. London: Institute of International visual arts, 1999; 140p., illus.; bibl. pp.135–139.

2000
Archer-Straw, Petrine: Negrophilia: Avant-Garde Paris and black culture in the 1920's. London: Thames & Hudson, 2000; 200p. illus.

Erickson, Peter and Hulse, Clark (eds.): Early modern visual culture: representation, race, and empire in Renaissance England. Philadelphia: University of Pennsylvania Press, 2000; 403p., illus.

Mirzoeff, Nicholas (ed): Diaspora and visual culture: representing Africans and Jews. London: Routledge, 2000; 264p., illus.

Nesbett, Peter T. and Dubois, Michelle (eds.): The complete Jacob Lawrence: Over the line: the art and life of Jacob Lawrence; Jacob Lawrence: paintings, drawings, and murals (1935–1999): a catalogue raisonné. Seattle and London: University of Washington Press in association with Jacob Lawrence Catalogue Raisonné Project, 2000; 343p., 285p. illus. (some col.); bibl. 'Jacob Lawrence' pp.321–43; 'Over the line' pp.270–8; see P.J. Karlstrom 'Modernism, Race, and Community' in 'Jacob Lawrence' pp.229–245. 'Over the line' republished as an exhibition catalogue in 2001.

Owusu, Kwesi (ed.): Black British culture and society: a text reader. London and New York: Routledge, 2000; 561p., illus.; includes essays by Paul Gilroy et al.

Visonà, Monica Blackmun et al.: A history of art in Africa. London: Thames & Hudson, 2000; 544p., illus. (some col.); bibl. pp.529–36; See 2008 edition.

Walvin, James: Making the Black Atlantic: Britain and the African diaspora. London; New York: Cassell, 2000; 180p.

2001
Abraham, John Kirby: In search of Josephine Baker. London: Pen Press Publishers Ltd., 2001 227p., illus.; bibl. pp.219–20.

*Aranda-Alvarado's: Rocio: "New World Primitivism in Harlem and Havana: constructing modern identities in the Americas, 1925–1945"; Doctoral dissertation, City University of New York, 2001.

*Baker, Jean-Claude: Josephine Baker: The Hungry Heart. Cooper Square Press, 2001; 592p.

Bennett, Michael and Dickerson, Vanessa D (eds.): Recovering the black female body: self-representations by African American women; New Brunswick, N.J.: Rutgers University Press, 2001; 331p.

Block, Holly (ed.): Art Cuba: the new generation. New York: Harry N. Abrams, 2001; 174p., col. illus.; bibl. p.168.

Hall, Stuart and Maharaj, Sarat: Modernity and difference: annotations 6. London: Institute of International Visual Arts, 2001; 64p., illus. (some col.); bibl. p.59; foreword by Gilane Tawadros; edited by Sarah Campbell and Gilane Tawadros; published in conjunction with a talk organised by Iniva at the Lux Centre, Hoxton, London, 25 Oct. 2000.

Hassan, Salah M. and Oguibe Olu: Authentic/ex-centric: conceptualism in contemporary African art. Ithaca, N.Y.: Forum for African Arts, 2001; 263p., col. illus.; bibl. pp.230–232, biogs. pp.238–249, colls., exhibs.; includes essays on the work of Maria Magdalena Campos-Pons and Yinka Shonibare. Published on the occasion of an exhibition held as part of the 49th Venice Biennale, as a project of the Forum for African Arts.

Leininger-Miller, Theresa: New Negro artists in Paris: African American painters and sculptors in the city of light, 1922–1934. New Brunswick, N.J. and London: Rutgers University Press, 2001; 320p., illus. (some col.); bibl. pp.289–305.

Mercer, Kobena and Darke, Chris: Isaac Julien. London: Ellipsis, 2001; 88p., illus. (some col.); biog., exhibs. bibl. pp.85–87.

Pan, David: Primitive renaissance: rethinking German expressionism. Lincoln; London: University of Nebraska Press, 2001; 239p., illus.

*Walker, Sheila S.: African roots/American cultures: Africa in the creation of the Americas. Rowman & Littlefield Publishers Inc., 2001; 464p.

2002
Ackermann, Marion et al.: Kara Walker. Frankfurt am Main: Deutsche Bank, 2002; 83p., illus.; biog. p.79, exhibs. p.81.

Araeen, Rasheed; Cubitt, Sean; Sardar, Ziauddin (eds.): The third text reader: on art, culture, and theory. London; New York: Continuum, 2002; 392p., illus.

Fall, N'Goné and Loup Pivin, Jean (eds): An Anthology of African art: the twentieth century. English ed. New York: D.A.P.; Paris: Revue Noire Éditions, African Contemporary Art, 2002; 407p., illus. (some col.); bibl. pp.402–4.

Jones, Kellie; Golden, Thelma and Iles, Chrissie: Lorna Simpson. London and New York: Phaidon, 2002; 160p., illus. (some col.); bibl. pp.158–9, colls., exhibs.

Powell, Richard J.: Black art: a cultural history. London: Thames & Hudson, 2002; rev. and expanded ed.; 272p., illus. (some col.); biogs. pp.242–52, bibl. pp.252–61. See 1st ed. Black art and culture in the 20th century, 1997.

Sims, Lowery Stokes: Wifredo Lam and the international Avant-Garde, 1923–1982. Austin: University of Texas Press, 2002; 281p., illus. (some col.); bibl. pp.261–7.

Willet, Frank: African art. London: Thames and Hudson, 2002; 272p., illus. (some col.); bibl. pp.262–7.

2003
Edwards, Brent Hayes: The practice of diaspora: literature, translation, and the rise of black internationalism. London, 2003; 397p., illus.

Eulisse, Eriberto: Afriche, diaspore, ibridi: il concettualismo come strategia dell'arte Africana contemporanea. San Marino: AIEP editore, 2003; 175p., illus. (some col.).

Flam, Jack and Deutch, Mirium (eds.): Primitivism and twentieth century art: a documentary history. Berkeley and London: University of California Press, 2003; 491p., illus.; bibl. pp.453–67.

Harris, Michael D.: Colored pictures: race and visual representation. Chapel Hill; London: University of North Carolina Press, 2003; 281p., col. illus.

Koser, Khalid: New African diasporas. London and New York: Taylor and Francis, 2003; 163p.

Lewis, Samella: African American art and artists. Berkeley and London: University of California Press, 2003; 3rd rev. and expanded ed.; 340p., illus. (some col.); bibl. pp.331–338. See 2nd ed. 1990, and 1st ed. 1978, published under the title Art: African American.

Lovejoy, Paul E. and Trotman, David V. (eds.): Trans-Atlantic dimensions of ethnicity in the African diaspora. London: Continuum, 2003; 289p., illus.; bibl. pp.265–84.

McConnell, William S. (ed.): Harlem Renaissance. San Diego, Calif.; London: Greenhaven Press, 2003; 224p.; bibl. pp.214–6.

Shipp, Steve: Latin American and Caribbean artists of the modern era: a biographical dictionary of more than 12,700 persons. Jeffrsion, N.C., McFarland & Company, 2003; 864p., illus. (some col.), exhibs. pp.804–28, bibl. pp.857–64, biogs.

Tythacott, Louise: Surrealism and the exotic. London: Routledge, 2003; 260p., illus.; bibl. pp.242–52.

Viard, Emile: Haitian Art in the diaspora: a directory of Haitian artists living abroad. [Miami]: Vie et Arts Collections, c.2003; 109p., col. illus.; biogs.

2004
Looker, Benjamin: B.A.G.: point from which creation begins: the Black Artists' Group of St. Louis. St. Louis: Missouri Historical Society, 2004; 316p., illus.; bibl. pp.308–311.

Lucie-Smith, Edward: Latin American art of the 20th century. London: Thames & Hudson, 2004; rev. and expanded ed.; 224p., illus. (some col.); bibl. pp.216–8. See 1st ed. published 1993.

*Wintz, C D and Finkelman, P (eds.): Encyclopedia of the Harlem Renaissance. New York: Routledge, 2004; 2 vol.

2005
Bailey, David A., Baucom, Ian and Boyce, Sonia (eds.): Shades of black: assembling black arts in 1980s Britain. Durham: London: Duke University Press in collaboration with the Institute of International Visual Arts and the African and Asian Visual Artists' Archive (Aavaa), 2005; 340p., illus. (some col.); biogs. pp.319–25, bibl. pp.309–18.

Challiss, Laura Charlotte: African art of the diaspora; the emergence of the opportunity for a new international discourse. Dissertation for Surrey Institute of Art and Design University College, 2005; 53p.; bibl. pp.47–51.

Keen, Melanie and Daly, Eileen (eds.): Necessary journeys. London: Arts Council England; BFI Blackworld, 2005; 96p., col. illus.

Farrington, Lisa E.: Creating their own image: the history of African-American women artists. Oxford; New York: Oxford University Press, 2005; 354p., illus. (some col.)

Mercer, Kobena: Cosmopolitan modernisms. London: Institute of International Visual Arts; Cambridge, Mass.: MIT Press, 2005; 208p., illus. (some col.); bibl. pp.192–203.

Smethurst, James Edward: The Black Arts Movement: literary nationalism in the 1960s and 1970s. Chapel Hill, N.C.; London: University of North Carolina Press, 2005; 471p.; bibl. pp.[429]–458.

2006
Collins, Lisa Gail and Crawford, Margo Natalie (eds.): New thoughts on the Black Arts movement. New Brunswick, N.J. and London: Rutgers University Press, 2006; 390p., illus.

Gobel, Walker and Schabio, Saskia (eds.): Beyond the Black Atlantic: relocating modernization and technology. London: Routledge, 2006; 210p; bibls.

*Lahs-Gonzales, Olivia: Josephine Baker: image and icon. Reedy Press, 2006; 116p.

Lázaro, Wilson; Araújo, Emanoel; Bispo do Rosario, Arthur; Museu Bispo do Rosário.; et al.: Arthur Bispo do Rosario. [Rio de Janeiro, Brazil]: Prefeitura da Cidade do Rio de Janeiro: IMAS Juliano Moreira: Museu Bispo do Rosário Arte Contemporânea, [2006?]; 303p., col. illus.; bibl. pp.100–1, biog., exhibs.

Mandri, Flora Gonzalez: Guarding cultural memory: Afro-Cuban women in literature and the arts. Charlottesville and London: University of Virginia Press, 2006; 232p., illus.; ed. by A. James Arnold; includes works by María Magdalena Compos-Pons and others.

Nuttall, Sarah (ed.): Beautiful ugly: African and diaspora aesthetics. Durham: Duke University Press; The Hague: Prince Claus Fund Library, 2006. 416p., illus. (chiefly col.).

Price, Sally and Price, Richard: Romare Bearden: the Caribbean dimension. Philadelphia: University of Pennsylvania Press, 2006; 189p., illus. (some col.); bibl. pp.188–9.

Twa, Lyndsey Jean: Troubling island: The imagining and imaging of Haiti by African-American artists, 1915–1940. Unpublished thesis, Chapel Hill, 2006; 359p., illus. (some col.).

2007
Calo, Mary Ann: Distinction and denial: race, nation, and the critical construction of the African American artist, 1920–40. Ann Arbor: University of Michigan Press, c2007; 264p.; bibl. pp.243–251.

Carroll, Anne Elizabeth: Word, image and the new Negro: representation and identity in the Harlem Renaissance. Bloomington and Indianapolis: Indiana University Press, 2007, c.2005; 275p., illus.; bibl. pp.247–63.

Conduru, Roberto: Arte afro-brasileira. Belo Horizonte: Editora C/Arte, 2007; 126p., col. illus.; bibl. pp.[125]–126.

English, Darby: *How to see a work of art in total darkness*. Cambridge, Mass.; London: MIT Press, 2007; 356p., illus. (some col.)

Gilroy, Paul: *Black Britain: a photographic history*. London: Saqi in association with Getty Images, 2007; 320p., illus.; preface by Stuart Hall.

Jules-Rosette, Bennetta: *Josephine Baker in art and life: the icon and the image*. Urbana and Chicago: University of Illinois Press, 2007; 392p., illus.

Machado, Arlindo: *Made in Brasil: três décadas do vídeo brasileiro = three decades of Brazilian video*. São Paulo, Illuminuras, 2007; 443p.; bibl. pp.241–249; text in Portuguese with English translations.

Sansi, Roger: *Fetishes and Monuments: Afro-Brazilian Art and Culture in the 20th Century*. New York; Oxford: Berghahn Books, 2007; 176p., illus.; bibl. pp.195–205.

Tidwell, John Edgar and Ragar, Cheryl R. (eds.): *Montage of a Dream: The Art and Life of Langston Hughes*. Columbia, 2007; 351p.; bibl. pp.319–34.

2008

González, Jennifer A.: *Subject to display: reframing race in contemporary installation art*. Cambridge, Mass.: MIT Press, 2008; 297p., col. illus.

Mercer, Kobena (ed.): *Exiles, diasporas and strangers*. London: Institute of International Visual Arts; Cambridge, Mass.; London: MIT Press, 2008; 224p., illus. (some col.); bibl. pp.216–8; includes essays on Aaron Douglas, Jacob Lawrence, Jean-Michel Basquiat and Adrian Piper.

Oboe, Annalisa and Scacchi, Anna (eds.): *Recharting the Black Atlantic: modern cultures, local communities, global connections*. New York; London: Routledge, 2008; 423p.; bibl. pp.379–406.

Spring, Chris: *Angaza Afrika: African art now*. London: Laurence King, 2008; 336p., col. illus.

Visonà, Monica Blackmu; Poynor, Robin; Cole, Herbert M: *A history of art in Africa*. Upper Saddle River, N.J.: Pearson/Prentice Hall, c2008; 560p., illus. (some col.); bibl. pp.544–551. See 1st ed. published in 2000.

2009

Lock, Graham, and Murray, David (eds.): *The hearing eye: jazz & blues influences in African American visual art*. Oxford and New York: Oxford University Press, c2009; 366p., col. illus.

Fusco, Coco: *The bodies that were not ours: and other writings*. London: Routledge published in collaboration with Institute of International Visual Arts, 2001; 252p., illus., (some col.); biog, bibl. p.245–6.

2. SECTIONS OF BOOKS

Scharf, Aaron: 'Return to Nature', Unit 5 in *A new beginning: primitivism and science in Post-Impressionist art; Return to nature*. Milton Keynes: Open University Press, 1976; Unit 4 and 5; 79p., 43 illus. (15 col.)

Perry Gill: 'Primitivism and the modern' in Charles Harrison, Francis Frascina and Gill Perry: *Primitivism, Cubism, abstraction: the early twentieth century*. New Haven; London: Yale University Press in association with the Open University, 1993; Part 1 pp.3–85, illus. (some col.)

Hooks, Bell: 'An aesthetic of blackness: strange and oppositional' in Diane Apostolos-Cappadona and Lucinda Ebersole (eds.): *Women, creativity and the arts: critical and autobiographical perspectives*. New York: Continuum, 1995; pp.75–86.

Chadwick, Whitney: 'Masking race matters: fetishizing fashion/fetishizing culture: Man Ray's Noire et Blanche' in Naomi Sawelson-Gorse (ed.): *Women in Dada: essays on sex, gender and identity*. Cambridge, Mass.; London: MIT Press, 1998; 686p., illus.; pp.294–329.

Julien, Isaac: 'Isaac Julien: on film-making and black cultural musics' in Cynthia Rose: *Trade secrets: young British talents talk business*. London: Thames & Hudson, 1999; pp.47–50.

Rose, Cynthia: 'Black punks re-write history: ragamuffins walk on the dark side' in Cynthia Rose: *Trade secrets: young British talents talk business*. London: Thames & Hudson, 1999; pp.38–47.

*Stephens, J.L.: 'The Harlem Renaissance and the New Negro Movement' in B. Murphy (ed.): *The Cambridge companion to: American women playwrights*. Cambridge, 1999.

Fisher, Jean: 'The syncretic turn: cross-cultural practices in the age of multiculturalism', in Zoya Kocur and Simon Leung (eds.): *Theory in contemporary art since 1985*. Malden (Mass.); Oxford; Victoria: Blackwell Publishing, 2005; pp.233–41.

Oguibe, Olu: 'In the "Heart of Darkness" in Zoya Kocur and Simon Leung (eds.): *Theory in contemporary art since 1985*. Malden (Mass.); Oxford; Victoria: Blackwell Publishing, 2005; pp.226–31.

*Gilroy, Paul: "Respeaking Othello in Fred Wilson's Speak of Me as I Am," in *Citing Shakespeare: The Reinterpretation of Race in Contemporary Literature and Art*. New York: Palgrave, 2007; pp.119–50.

Mercer, Kobena: 'Tropes of the grotesque in the black Avant-Garde" in Kobena Mercer (ed.): *Pop art and vernacular cultures: Annotating art's histories. Cross-cultural perspectives in the visual arts*, 3. London: Institute of International Visual Arts; Cambridge, Mass.: MIT Press, c2007; pp.136–59.

3. BIBLIOGRAPHIES

Holmes, Oakley N. Jr.: *The complete annotated resource guide to Black American art*. Spring Valley, N.Y.: Maogowan Enterprises, 1978; 275p.

Black art in Britain: a bibliography of material held in the Library, Chelsea School of Art, Manresa Road, London SW3. [London: Chelsea School of Art, 1986]; [14]p. typescript.

Literature of the Black Atlantic: a select bibliography of reference sources. New Haven, Sterling Memorial Library, Yale University, 1995, 1998; <http://www.library.yale.edu/humanities/blackan.pdf>

Keen, Melanie and Ward, Elizabeth: *Recordings: a select bibliography of contemporary African, Afro-Caribbean and Asian British art*. London: Institute of International Visual Arts and Chelsea College of Art and Design, 1996; 133p.; biogs. pp.42–113, exhibs.

Kemble, Jean: *The Harlem Renaissance: a guide to materials in the British Library*. London, British Library, 1997; 81p.

Black Atlantic Library. Berlin, Haus der Kulturen der Welt, 2004; <http://www.blackatlantic.com/library/ >

Brown, Sterling et al.: *Literary History: Harlem Renaissance 1919–1940*. 2009. <http://www.literary-history.com/20thC/HarlemRen.htm>

4. GROUP EXHIBITION CATALOGUES

1931

Exposition coloniale internationale: à Paris en 1931: guide officiel. Paris, 1931; illus. (some col.); text in French.

1935

African Negro art. Museum of Modern Art, New York 1935; 58p., illus.

1948

Exhibition of contemporary South African paintings, drawings and sculpture: with a prelude of historical paintings. Tate Gallery, London, 1948–9; 32p., illus. (some col.); introd. by Geoffrey Long; colls.

40,000 years of modern art: a comparison of primitive and modern. Institute of Contemporary Arts, London, 20 Dec. 1948 – 29 Jan. 1949; 54p., illus. (1 col.); essay by W.G. Archer and Robert Melville, preface by Herbert Read.

1966
*L'art négre sources, évolution, expansion: exposition organisée au Musée dynamique á Dakar par le Commissariat du [premier] Festival mondial des arts négres et au Grand palais á Paris, par la Réunion des musées nationaux. Musée dynamique, Dakar; Grand Palais, Paris, 1966; 176p., illus.; bibl.; text in French and English.

Nancy Sayles Day collection of modern Latin American art. Museum of Art, Rhode Island School of Design, Providence, Rhode Island, 23 Oct. – 24 Dec. 1966; [16]p., illus.; biogs.

1968
South African Breweries biennale art prize. Art Museum, Pretoria, 7 – 28 Aug. 1968; [20]p., illus.; biogs.

30 Contemporary Black Artists. Minneapolis Institute of Arts, Minneapolis, 17 Oct. – 24 Nov. 1968; 16p., illus.; biogs.

*The Ife festival of the arts, Ile-Ife. Institute of African Studies, University of Ife, Ife, 10 – 20 Dec. 1968; [20]p.

1969
Contemporary black artists. Museum of Art, Rhode Island School of Design, Providence, 1 – 36 July 1969; [39]p., illus.; biogs., colls.

Contemporary African art. Camden Arts Centre, London, 10 Aug. – 8 Sept. 1969; illus.; biogs.

New black artists. Brooklyn Museum, New York, 7 Oct. – 9 Nov. 1969; [56]p., illus.

1970
Afro-American artists: New York and Boston. Museum of the National Center of Afro-American Artists, Boston, 19 May – 23 June 1970; [92]p., illus.; biogs., colls., exhibs.; includes work by Romare Bearden, Jacob Lawrence.

1971
Caribbean artists in England. Commonwealth Art Gallery, London, 22 Jan. – 14 Feb. 1971; [17]p., illus.; biogs.

Some American history. Institute for the Arts, Rice University, Houston, Feb. 1971. [78]p., illus. (some col.).

Contemporary black artists in America. Whitney Museum of American Art, New York, 6 Apr. – 16 May 1971; 64p., illus. (some col.); bibl. pp.60–64.

Black artists: two generations. Newark Museum, Newark, N.J., 13 May – 6 Sept. 1971; illus.

1972
Los Angeles 1972: a panorama of black artists. Los Angeles County Museum of Art, Los Angeles. 8 Feb. – 19 Mar. 1972; 1 folded sheet, illus.; with essay by Carroll Greene, Jr.

1974
Directions in Afro-American art. Herbert F. Johnson Museum of Art, Ithaca, N.Y., 18 Sept. – 27 Oct. 1974; [100]p., illus.; bibl., biogs., colls., exhibs.

West Coast 74: black image. Crocker Art Gallery Association and E.B. Crocker Art Gallery, Sacramento, 13 Sept. – 13 Oct. 1974; [?]p., illus.; bibl., biogs., exhibs.

1976
Two centuries of black American art. Los Angeles County Museum of Art, Los Angeles, 30 Sept. – 21 Nov. 1976; 222p., illus. (some col.); bibl. pp.206–219, biogs.

Jubilee: Afro-American artists on Afro-America. Museum of Fine Arts, Boston, 14 Nov. 1975 – 4 Jan. 1976; 47p., illus. (some col); biogs. pp.36–47, colls., exhibs.

1977
* Festac '77 [the second world black and African festival of arts and culture]. Lagos, 15 Jan. – 12 Feb. 1977; 48p., illus.

1980
Aspects of the 70's: spiral – Afro-American art of the 70's. Museum of the National Center of Afro-American Arts, Roxbury, Mass., 17 May – 15 June 1980; 20p., illus.; biogs. pp.18–20, colls., exhibs.

Afro-American artists: North Carolina USA. North Carolina Museum of Art, Raleigh, 9 Nov. – 31 Dec. 1980; [89]p., illus.; biogs., colls., exhibs.

1981
Art from Africa. Commonwealth Institute, London, 13 Jan. – 5 April 1981; [26]p., illus.; bibl., biogs.

Forever free: art by Afro-American women 1862–1980. Center for the Visual Arts Gallery, Normal, Ill.; 30 Jan. – 22 Feb. 1981; 214p., illus. (some col.); bibl. pp.170–213., biogs. pp.53–151, colls., exhibs.

Black art an' done: an exhibition of work by young black artists. Wolverhampton Art Gallery, Wolverhampton, 9 – 27 June 1981; [6]p.; includes artists' statements, see Keith Piper.

1982
Black on black: [films by black film-makers]. Saint Louis Art Museum, Saint Louis, 1982; 40p., illus.; biogs.

"The Pan-Afrikan connection": an exhibition of work by young black artists. Africa Centre, London; 3 May – 4 June [1982]; [8]p.; includes statement by Keith Piper.

Ritual and myth: a survey of African American art. Studio Museum in Harlem, New York, 20 June – 1 Nov. 1982; 52p., illus. (some col.); bibl. pp.39–42; introd. by David Driskell.

"The Pan-Afrikan connection": an exhibition of work by young black artists. Ikon Gallery, Birmingham; 26 June – 17 July [1982]; [8]p.; includes statement by Keith Piper (different to that in the Africa Centre catalogue).

1983
The Pan-Afrikan connection: an exhibition of work by young black artists. Herbert Art Gallery and Museum, Coventry, 20 Feb. – 20 Mar. 1983; 8p., illus.; includes a statement by Keith Piper.

Creation for Liberation: the first open exhibition of contemporary black art in Britain. St. Matthews Meeting Place, London, 20 – 30 July 1983; 11p.; biogs. pp.8–10; includes 'Manifesto'.

1984
African-American art in Atlanta: public and corporate collections. High Museum of Art, Atlanta, 11 May – 17 June 1984; 16p., illus.; biogs.; introd. by Evelyn Mitchell.

Into the open: new paintings and sculpture by contemporary black artists. Mappin Art Gallery, Sheffield, 4 Aug. – 9 Sept. 1984; illus.; biogs.; includes work by Sonya Boyce, Keith Piper.

"Primitivism" in 20th century art: affinity of the tribal and the modern. Museum of Modern Art, New York, [24 Sept. 1984 – 15 Jan. 1985]; 2 v. (xiv, 689p. [343, 346]p.), illus. (some col.); ports.; introd. by William Rubin, biogs; includes work by Fernand Leger, Pablo Picasso.

1985
*Black skin, Bluecoat: Sonia Boyce, Eddie Chambers, Tom Joseph, Keith Piper. Bluecoat Gallery, Liverpool, 4 April – 4 May 1985; [6]p., illus.; biogs., exhibs.

"Primitivism" in 20th century art: affinity of the tribal and the modern. Museum of Modern Art, New York, [24 Sept. 1984 – 15 Jan. 1985]; 2 vol. 689p., illus. (some col.); bibl. vol. 1, pp.334–340; includes works by Pablo Picasso, Fernand Leger, Constantin Brancusi, Alberto Giacometti and Henry Moore amongst others.

1986
From two worlds. Whitechapel Art Gallery, London, 30 July – 7 Sept. 1986; 48p., illus. (16 col.); bibls., biogs., exhibs.; introd. by Gavin Jantjes and Nicholas Serota; see 'Keith Piper' p.44.

Brushes with the West: an exhibition of work by Jennifer M. Comrie, Shafique Uddin, Allan de Souza, Achar K. Burman. Wapping Sports Centre, London, 27 Aug. – 27 Sept. 1986; 8p., illus.

1987
Harlem Renaissance: art of Black America. Studio Museum in Harlem, New York, 1987; 200p., illus. (some col.); bibl. pp.188–91, biogs., exhibs.; includes bibl. of books and magazines illustrated by Aaron Douglas pp.192–3; introd. by Mary Schmidt Campbell.

Latin American artists in New York since 1970. Archer M. Huntington Art Gallery, Austin, 1987; 114p., illus. (some col.); biogs. pp.38–113; includes work by Helio Oiticica.

Race and representation: art/film/video. Hunter College Art Gallery, New York, 26 Jan. – 6 Mar. 1987; 39p., illus.; ports; bibl.

Black perspectives: an exhibition organised by Sojourner Truth Youth Association featuring works by black artists in Southwark. South London Art Gallery, London, 22 May – 11 June 1987; 16p., illus.; biogs.

The image employed: the use of narrative in Black art. Cornerhouse, Manchester, 13 June – 19 July 1987; [23]p., illus.; biogs., exhibs.; introd. by Keith Piper, Marlene Smith.; includes artists' statements, see Keith Piper, Sonia Boyce.

Creation for Liberation open exhibition: art by black artists. Brixton Village, London. 17 Oct. – 7 Nov. 1987; 16p., illus.; biogs. pp.6–12, exhibs.; includes essay by Eddie Chambers 'Black art exhibitions in Britain' pp.13–6.

1988
Massachusetts masters: Afro-American artists. Museum of Fine Arts, Boston, 16 Jan. – 6 Mar. 1988; 48p., illus. (some col.); biogs. pp.43–8, exhibs.

The essential Black Art. Chisenhale Gallery, London, 5 Feb. – 5 Mar. 1988; 48p., illus.; bibl. p.48, biogs. pp.29–35; exhibs.; text by Rasheed Araeen, Gavin Jantjes; includes work by Sonia Boyce, Keith Piper.

Black artists & images. Milwaukee Art Museum, 16 Feb. – 13 Mar. 1988; [8]p., illus.; biogs.; includes work by Jacob Lawrence.

Paris and South African artists 1850–1965. South African National Gallery, Cape Town, 14 Apr. – 29 May 1988; 111p., illus. (some col.); biogs.; introd. by Lucy Alexander.

Trading places: an art exchange exhibition. Artists Foundation, Boston, 19 Apr. – 21 May, 1988; 12p., illus.; biogs. p.12, exhibs.; includes work by David Hammons, Lorna Simpson.

Influences: the art of Sokari Douglas Camp, Keith Piper, Lubaina Himid, Simone Alexander, Joseph Olubo, Brenda Agard. South London Art Gallery, London, 9 – 29 Sept. 1988; 8p. folded card, illus.; see text selected by Keith Piper.

The Latin American spirit: art and artists in the United States, 1920–1970. Bronx Museum of the Arts, New York, 29 Sept. 1988 – 29 Jan. 1989; 343p., illus. (some col.); introd. by Luis R. Cancel, bibl. pp.333–8., biogs.; colls.; exhibs.

Black art: plotting the course. Oldham Art Gallery, 22 Oct. – 3 Dec. 1988; 32p., illus. (some col.); introd. by Eddie Chambers.

Art as a verb: the evolving continuum – installations, performances and videos by 13 African-American Artists. Maryland Institute, Baltimore, 21 Nov. 1988 – 8 Jan. 1989; [40]p, illus. (some col.); bibl. p.[13], biogs. pp.[14]–[39], exhibs.; introd. by Leslie King-Hammond, Lowery Stoke Sims; includes work by David Hammons, Adrian Piper.

The neglected tradition: towards a new history of South African art (1930–1988). Johannesburg Art Gallery, 23 Nov. 1988 – 8 Jan. 1989; 155p., illus. (some col.); bibl. pp.135–53, biogs. pp.97–134, colls., exhibs.; introd. by Steven Sack.

1989
Black history, black vision: the visionary image in Texas. Archer M. Huntington Gallery, University of Texas, Austin, 27 Jan. – 19 Mar. 1989; 93p., illus. (some col.); biogs. pp.18–85.

African-American artists 1880–1987: selections from the Evans-Tibbs Collection. [Hood Museum of Art. Hanover (N.H.) 21 Jan. – 12 Mar. 1989]; 125p., illus. (some col.); bibl. p.125, biogs. pp.115–24; exhibs.; introd. by David C. Driskell; includes work by Romare Bearden, James Van Der Zee, Aaron Douglas, Palmer Hayden, Sargent Johnson, Jacob Lawrence.

Introspectives: contemporary art by Americans and Brazilians of African descent. Californian Afro-American Museum, Los Angeles, 11 Feb. – 30 Sept. 1989; 100p., illus. (some col.); biogs. pp.35–83; introd. by Henry J. Drewal and David C. Driskell; includes works by Rubem Valentim.

Black printmakers and the W.P.A. Lehman College Art Gallery, New York, 23 Feb. – 6 June 1989; 35p., illus.; bibl. pp.34–5, biogs. pp.12–30; includes work by Sargent Johnson, Norman Lewis.

Magiciens de la terre. Centre Georges Pompidou, Paris, 18 May – 14 Aug. 1989; 272p., illus. (some col.); biogs. pp.71–269; introd. by Jean-Hubert Martin; essay by André Magnin '6°48' sud 38°39' est' pp.16–7.

Art in Latin America: the modern era, 1820–1980. Hayward Gallery, London, 18 May – 6 Aug. 1989; 361p., illus. (some col.); biogs. pp.338–59, bibl. p.360; colls.; text by Dawn Ades.

The blues aesthetic: black culture and modernism. Project for the Arts, Washington, 14 Sept. – 9 Dec. 1989; 104p., illus. (some col.); bibl. pp.97–8; includes work by Jean-Michel Basquiat, Romare Bearden, Paul Colin, Aaron Douglas, Jacob Lawrence, Norman Lewis.

US/UK photography exchange. Camerawork, London, 17 Nov. – 23 Dec. 1989; [10]p., illus.; biogs., exhibs.; includes essay by David Bailey.

The other story: Afro-Asian artists in post-war Britain. South Bank Centre, London, 29 Nov. 1989 – 4 Feb. 1990; 160p., illus. (some col.); biogs. pp.142–9, colls., exhibs.; includes work by Frank Bowling, Sonia Boyce, Ronald Moody, Keith Piper; text by Rasheed Araeen.

Black art: ancestral legacy: the African impulse in African-American art. Dallas Museum of Art, 3 Dec. 1989 – 25 Feb. 1990; 305p., illus. (some col.); introd. by David C. Driskell, bibl. pp.299–301, biogs. pp.260–98, colls., exhibs.; includes work by Aaron Douglas, Sargent Johnson.

1990
A stronger soul within a finer frame: portraying African-Americans in the Black Renaissance. University Art Museum, University of Minnesota, Minneapolis, 1990; 64p., illus.; introd. by Colleen Sheehy.

Against the odds: African-American artists and the Harmon Foundation. Newark Museum, New Jersey, 15 Jan. – 15 Apr. 1990; 298p., illus. (some col.); bibl. pp.290–1, biogs.; includes work by Sargent Johnson.

*Contemporary African artists: changing tradition. Studio Museum in Harlem, New York, 21 Jan. – 6 May 1990; 148p., illus. (some col.); bibl.

Transcontinental: nine Latin American artists. Ikon Gallery, Birmingham, 24 Mar. – 28 Apr. 1990; 112p., illus.; biogs. p.109.

1991
Africa explores: 20th century African art. The Center for African Art, New York, 1991; 294p., illus. (some col.); bibl. pp.288–94; introd. by Susan Vogel.

Interrogating identity. Grey Art Gallery and Study Centre, New York, 12 Mar. – 18 May 1991; 143p., col. illus.; biogs. pp.105–33; includes work by Rasheed Araeen, Glenn Ligon, Keith Piper; see 'Interrogating identity: a roundtable discussion – Paul Gilroy, Kass Banning, Adrian Piper, Hilton Als, Kellie Jones' pp.43–66.

Identity and consciousness: (re)presenting the self. Dunlop Art Gallery, Regina, 15 Jan. – 12 Feb. 1991; 24p., illus.; bibl. p.19, biogs. pp.21–3; includes interview with Homi Bhabha pp.12–7.

Africa hoy: obras de la contemporary African art collection. Centro Atlántico de Arte Moderno, Las Palmas 17 Sept. – 17 Nov. 1991; 221p., col. illus.; biogs. pp.217–21, exhibs.; text in Spanish.

Schwarze Kunst: Konzepte zu Politik und Identität: Hilton Als & Darryl Turner, Stan Douglas, Lyle Ashton Harris, Gary Simmons, Lorna Simpson, Carrie Mae Weems. RealismusStudio NGBK, Berlin, 14 Dec. 1991 – 26 Jan. 1992; 47p., illus.; biogs. pp.46–7, exhibs.; includes works by Lorna Simpson, Carrie Mae Weems.

1992
La rencontre des deux mondes vue par les peintres d'Haïti. Fondation Afrique en Creations, Paris, 1992; 291p., col. illus.; biogs. pp.274–82.

*Dakar 1992: biennale international des arts. Dakar, 1992; 65p., col. illus.; becomes known as DAK'ART, the Dakar biennial for contemporary international art.

The fortune teller: Karen Knorr, Lorna Simpson, Olivier Richon. Rochdale Art Gallery, 1992; 47p., col. illus.; introd. by Maud Sulter, bibl., biogs. pp.35–46, colls., exhibs.

Paris connections: African American artists in Paris. Bomani Gallery and Jernigan Wicker Fine Arts, San Francisco, 14 Jan. – 29 Feb. 1992; 95p., col. illus.; bibl. p.89, biogs. pp.60–72; exhibs.; includes work by Jean-Michel Basquiat, Romare Bearden.

Rastafari: Kunst aus Jamaika. Haus der Kulturen der Welt, Berlin, Feb.–Mar. 1992; 144p., illus. (some col.); bibl. pp.142–3.

Entre tropicos: artistas contemporaneous de los países miembros del Grupo de Río. Museo de Arte Contemporáneo Soféa Imber, April 1992; 119p., col. illus.; biogs. pp.20–111, colls., exhibs.

Crosscurrents of modernism: four Latin American pioneers; Diego Rivera, Joaquín Torres-Garcia, Wifredo Lam, Matta. Hirshhorn Museum and Sculpture Garden, Washington, D.C., 11 Jun. – 2 Sept. 1992; 295p., illus. (some col.); bibl. pp.292–4, biogs.; introd. by Valerie Fletcher; text in English and Spanish.

Trophies of empire. Merseyside Maritime Museum, Liverpool, 28 Aug. – 20 Sept. 1992; 72p., illus. (some col.); biogs. p.70.

Free within ourselves: African-American artists in the collection of the National Museum of American Art. Wadsworth Atheneum, Hartford, 18 Oct. 1992 – 10 Jan. 1993; 205p., illus. (some col.); bibl. pp.192–200, biogs. pp.23–191; introd. by Kinshasha Holman Conwill; includes work by Romare Bearden, Palmer Hayden, Sargent Johnson, Jacob Lawrence.

Important African & modern masterworks. Kent Gallery, New York, 24 Oct. – 4 Dec. 1992; 75p., illus. (some col.); bibls., biogs. pp.32–75, exhibs.; includes works by Fernand Léger, Pablo Picasso, Karl Schmidt-Rottluff.

Alone in a crowd: prints of the 1930s–40s by African-American artists from the Collection of Reba and Dave Williams. Newark Museum, New Jersey, 10 Dec. 1992 – 28 Feb. 1993; 2nd rcv. cd.; 59p., illus. (some col.); bibl. pp.39–41, biogs. pp.42–58; includes works by Aaron Douglas, Sargent Johnson, Norman Lewis.

1993
The theater of refusal: black art and mainstream criticism: artists Jean-Michel Basquiat... Fine Arts Gallery, University of California, Irvine, 8 Apr. – 12 May 1993; 91p., illus.; biogs. pp.83–92; includes work by Jean-Michel Basquiat, David Hammons, Adrian Piper, Carrie Mae Weems.

Latin American artists of the twentieth century. Museum of Modern Art, New York, 6 Jun. – 7 Sept. 1993; 424p., illus. (some col.); bibl. pp.399–412, biogs. pp.371–98, exhibs.; introd. by Waldo Rasmussen; includes work by Tarsila do Amaral, Wifredo Lam, Hélio Oiticica, Lasar Segall.

Dream singers, story tellers: an African-American presence. New Jersey State Museum, New Jersey, 7 Aug. 1993 – 20 Mar. 1994; 238p., illus. (some col.); biogs. pp.182–223, exhibs.; includes work by Jean-Michel Basquiat, Jacob Lawrence, Norman Lewis, Glenn Ligon, Adrian Piper, Lorna Simpson; text in English and Japanese.

African-American Art: 20th century masterworks [I]. Michael Rosenfeld Gallery, New York, 18 Nov. 1993 – 12 Feb. 1994; 32p., col. illus.; includes work by Romare Bearden, Aaron Douglas, Palmer Hayden, Jacob Lawrence, Norman Lewis; first of a four part exhibition series.

1994
Harlem Renaissance: art of black America. Studio Museum in Harlem, New York, 1994; 200p., illus. (some col.); bibl. pp.188–191, includes bibl. of books and magazines illustrated by Aaron Douglas pp.192–3; introd. by Mary Schmidt Campbell.

Western artists/African art. Museum of African Art, New York, 1994; 101p., illus. (some col.); bibl. p.98; introd. by Susan Vogel; includes work by Lorna Simpson.

The Harmon and Harriet Kelley collection of African American art. San Antonio Museum of Art, San Antonio, 3 Feb. – 3 Apr. 1994; 69p., illus. (some col.); bibl. pp.66–7; includes work by Jean-Michel Basquiat, Romare Bearden, Aaron Douglas, Palmer Hayden, Jacob Lawrence, Norman Lewis, James Van Der Zee.

Bienal Brasil: século XX. Fundação Bienal de São Paulo, 24 Apr. – 29 May 1994; 512p., col. illus.; bibls., biogs.

Equal rights & justice. High Museum of Art, Atlanta, 24 May – 28 Aug. 1994; 40p., illus.; biogs. pp.12–35; introd. by Cynthia Tucker; includes work by Radcliffe Bailey, Glenn Ligon, Carrie Mae Weems.

Black male: representations of masculinity in contemporary American art. Whitney Museum of American Art, New York, 10 Nov. 1994 – 5 Mar. 1995; 223p., illus. (some col.); bibl. pp.201–10; essay by Kobena Mercer and Isaac Julien 'True confessions' pp.191–200; includes work by Jean-Michel Basquiat, David Hammons, Glenn Ligon, Adrian Piper, Lorna Simpson, Carrie Mae Weems.

1995
Diaspora in context: connections in a fragmented world: Imants Tillers makes a painting by Georg Baselitz, Joseph Beuys, Bernhard Blume, Carlo Carra, Giorgio de Chirico, Mike Kelley, Vytautas Landsbergis, Colin McCahon, Arnulf Rainer, Nicholas Roerich and Isadore Tillers. Porin taidemuseo, Porin, 1995; 137p., illus. (some col.); biog. pp.130–2, colls. of Imants Tillers and his work, exhibs.

*Havana – Sao Paulo: Junge Kunst aus Lateinamerika. Haus der Kulturen der Welt (ed.) 1995; 160p., illus. (some col.).

Mirage: enigmas of race, difference and desire. Institute of Contemporary Arts/Institute of International Visual Arts, London, 12 May – 16 July 1995; 112p., illus. (some col.); biogs. pp.110–2; includes writing by Frantz Fanon and work by Sonia Boyce, Isaac Julien, Glenn Ligon, Kobena Mercer.

Self evident. Ikon Gallery, Birmingham, 12 Aug. – 6 Sept. 1995; [56]p., illus. (some col.); biogs., colls., exhibs.; introd. by Kobena Mercer.

Big city: artists from Africa. Serpentine Gallery, London, 21 Sept. – 5 Nov. 1995; [18]p., illus. (some col.); biogs., exhibs.

Africa: the art of a continent. Royal Academy of Arts, London, 4 Oct. 1995 – 21 Jan. 1996; 613p., illus. (some col.); bibl. pp.597–613; introd. by Tom Phillips.

Picturing blackness in British art, 1700s–1990s. Tate Gallery, London, 28 Nov. 1995 – 10 Mar. 1996; 1 folded sheet ([4]p.), illus.; essay by Paul Gilroy;

includes work by Sonia Boyce, Edward Burra, Benjamin Haydon, Ronald Moody.

Exultations: African-American Art – 20th century masterworks, II. Michael Rosenfeld Gallery, New York, 1 Feb. – 8 Apr. 1995; 48p., col. illus.; includes work by Romare Bearden, Aaron Douglas, Sargent Johnson, Jacob Lawrence, Norman Lewis, James Van Der Zee.

Latin American women artists: 1915 – 1999. Milwaukee Art Museum, 3 Mar. – 28 May 1995; 198p., col. illus.; bibl. pp.177–98, biogs. pp.97–167, exhibs.; includes work by Tarsila do Amaral, María Magdalena Campos-Pons.

Vital: three contemporary African artists. Tate Gallery Liverpool, Liverpool, 13 Sept. – 10 Dec. 1995; 47p., illus. (some col.); bibl., biogs., colls., exhibs.

New world imagery: contemporary Jamaican art. Arnofini, Bristol, 23 Sept. – 12 Nov. 1995; 72p., illus. (some col.); bibl. pp.41–2, biogs. pp.65–9, colls., exhibs.; see essay by Petrine Archer-Straw 'Many rivers crossed' pp.15–40.

Seven stories about modern art in Africa. Whitechapel Art Gallery, London, 27 Sept. – 26 Nov. 1995; 319p., illus. (some col.); bibl. pp.308–11.

1996
Explorations in the city of light: African-American artists in Paris, 1945–1965. The Studio Museum in Harlem, New York, 18 Jan. – 2 June 1996; 100p., illus. (some col.); bibl. p.98, biogs. pp.46–91; introd. by Kinshasha Holman Conwill; see essay by Catherine Bernard 'Confluence: Harlem Renaissance, modernism and negritude. Paris in the 1920s – 1930s' pp.21–8.

Imagined communities. Oldham Art Gallery, 27 Jan. – 24 Mar. 1996; col. illus.; biogs.; introd. by Richard Hylton.

A shared heritage: art by four African Americans. Indianapolis Museum of Art, 25 Feb. – 21 Apr. 1996; 195p., illus. (some col.); biogs. pp.167–81, exhibs.

Collectively speaking: African American art from area collections. Milwaukee Art Museum, 1 Mar. – 28 Apr. 1996; 30p., illus.; bibl. p.30; includes work by Radcliffe Bailey, Romare Bearden, Aaron Douglas, Jacob Lawrence, Glenn Ligon, Gordon Parks, James Van Der Zee, Carrie Mae Weems.

No doubt: African American art of the 90s. Aldrich Museum of Contemporary Art, Ridgefield, Conn., 19 May – 1 Sept. 1996; 28p., illus.; biogs. pp.22–5, exhibs.; includes work by Radcliffe Bailey, Kara Walker; Renée Cox is guest curator.

Transformations in Cleveland art 1796–1946: community and diversity in early modern America. Cleveland Museum of Art, [19 May – 21 July] 1996; 254p., illus. (some col.); bibl. pp.242–3, biogs. pp.221–41; see essay by Mark Cole '"I, too, am America": Karamu House and African-American artists in Cleveland' pp.147–61.

In/sight: African photographers, 1940 to the present. Solomon R. Guggenheim Museum, New York, 24 May – 29 Sept. 1996; 275p., illus. (some col.); biogs. pp.254–75; introd. by Claire Bell.

In the spirit of resistance: African-American modernists and the Mexican Muralist School = En el espíritu de la resistencia: los modernistas africanoamericanos y la la Escuela Muralista Mexicana. Studio Museum in Harlem, New York, 2 Oct. – 8 Dec. 1996; 191p., illus. (some col.); bibl. pp.188–9.

1997
African-American art: 20th century masterworks, IV. Michael Rosenfeld Gallery, New York, 24 Jan. – 26 Mar. 1997; 48p., col. illus.; biogs. pp.5–12; includes works by Romare Bearden, Palmer Hayden, Jacob Lawrence, Norman Lewis.

Bearing witness: contemporary works by African American women artists. Fort Wayne Museum of Art, Fort Wayne, Ind., 1 Feb. – 30 Mar. 1997; 176p., col. illus.; bibl. pp.165–71, biogs. pp.113–60; contributions by Maya Angelou; includes work by Lorna Simpson, Carrie Mae Weems.

Rhapsodies in black: art of the Harlem Renaissance. London. South Bank Centre, London, 19 June – 17 Aug. 1997; 182p., illus. (some col.); introd. by David A. Bailey; includes essay by Paul Gilroy 'Modern tones' pp.102–9.

Transforming the crown, African, Asian and Caribbean artists in Britain 1966–1996. Studio Museum in Harlem, New York, 14 Oct. – 15 Mar. 1997; 177p., illus. (some col.); bibl. pp.174–6, biogs. pp.119–48, exhibs.; see essay by Kobena Mercer 'Bodies of diaspora, vessels of desire: the erotic and the aesthetic' pp.53–7.

1998
The unmapped body: 3 black British artists. Yale University Art Gallery, New Haven, 13 Oct. 1998 – 3 Jan. 1999; 19p., illus. (some col.); includes work by Keith Piper, Sonia Boyce.

Narratives of African American art and identity: the David C. Driskell collection. The Art Gallery, College Park, Maryland, 22 Oct. – 17 Dec.; 192p., illus. (some col.); bibl. pp.179–82, biogs. pp.169–79, exhibs.; includes work by Romare Bearden, Aaaron Douglas, Jacob Lawrence, Norman Lewis, James Van Der Zee.

1999
African Americans in art: selections from the Art Institute of Chicago. Art Institute of Chicago, 1999; 136p., illus. (some col.); biogs. pp.53–83; includes work by Romare Bearden, Aaron Douglas, Jacob Lawrence, Norman Lewis, Adrian Piper, James Van Der Zee, Kara Walker.

African-American artists: (Bannister to Mitchell). Billy E. Hodges Gallery, New York, 6 Feb. – 3 Apr. 1999; 49p., illus. (chiefly col.); biogs. pp.4–49; includes work by Jacob Lawrence, Norman Lewis.

*Other narratives. Contemporary Arts Museum, Houston, 15 May – 4 July 1999; 96p., illus. (some col.); bibl. p.95, biogs., exhibs.; includes work by Jean-Michel Basquiat, Glenn Ligon, Lorna Simpson, Kara Walker, Carrie Mae Weems.

South meets west. Kunsthalle Bern, 9 Nov. 1999 – 26 June 2000; 122p., col. illus.; biogs. pp.111–9, colls.; includes work by Tracey Rose.

Transatlantic dialogue: contemporary art in and out of Africa. Ackland Art Museum, Chapel Hill, 19 Dec. 1999 – 26 Mar. 2000; 80p., illus. (some col.).

2000
Fresh. South African National Gallery, Cape Town, 2000–2002; 7 vol., illus. (some col.); bibl., biogs., exhibs.; includes volume on Tracy Rose.

Perfect documents: Walker Evans and African art, 1935. Metropolitan Museum of Art, New York, 1 Feb. – 3 Sept. 2000; 122p., illus.

Brasil +500: mostra do redescobrimento. Fundação Bienal de São Paulo, 23 Apr. – 10 Sept. 2000; 183p., col. illus.

Cross currents: contemporary art practice in South Africa: an exhibition in two parts. Atkinson Gallery, Street, 5 June – 29 July; 7 Aug. – 30 Sept. 2000; 120p., col. illus.; bibl. p.60, biogs. pp.61–118.

Brasil 1920–1950: de la antropofagia a Brasilia. IVAM Centre Julio González, Valencia, 26 Oct. 2000 – 16 Jan. 2001; 630p., illus. (some col.); bibl. pp.511–4; includes works by Tarsila do Amaral, Lasar Segall; text in Spanish with English translation.

Call and response: journeys of African art. Yale University Art Gallery, New Haven, 15 Dec. 2000 – 25 Mar. 2001; 124p., col. illus.; see essay by Lyneise Williams 'Traveling concepts' pp.55–78.

2001
Century city: art and culture in the modern metropolis. Tate Modern, London, 1 Feb. – 29 Apr. 2001; 295p., illus. (some col.).

Virgin territory: women, gender and history in contemporary Brazilian art. National Museum of Women in the Arts, Washington, 2001; 176p., col. illus.; biogs. pp.163–71, exhibs.

Committed to the image: contemporary black photographers. Brooklyn Museum of Art, New York, 16 Feb. – 29 Apr. 2001; 240p., col. illus.; biogs. pp.233–40; see essay by Deba P. Patnaik 'Diasporic double vision' pp.29–39.

Freestyle. Studio Museum in Harlem, New York, 28 Apr. – 24 June 2001; 88p., col. illus.; biogs. pp.76–9, colls., exhibs.

Made in USA: l'art américain, 1908–1947. Musée des Beaux-Arts de Bordeaux, 10 Oct. – 31 Dec. 2001; 254p., illus. (some col.); biogs. pp.243–53; text in French; includes works by Romare Bearden, Walker Evans, Jacob Lawrence, Man Ray, Gordon Parks.

2002
African-American artists – III. Billy E. Hodges Gallery, New York, 2002; 49p., illus. (chiefly col.); biogs. pp.4–45; includes work by Romare Bearden, Frank Bowling, Sargent Johnson, Jacob Lawrence, Norman Lewis.

Black romantic: the figurative impulse in contemporary African-American art. Studio Museum in Harlem, New York, 25 Apr. – 23 June 2002; 124p., col. illus.; ports.; biogs. pp.56–115, exhibs.

The age of jazz. Hazlitt, Gooden & Fox, London, 13 June – 12 July 2002; [57]p., col. illus.; biogs., colls., exhibs.; includes work by Paul Colin.

Atención México! Positionen der Gegenwart. Haus der Kulturen der Welt, Berlin, 15 Sept. – 1 Dec. 2002; 168p., col. illus.

20 million Mexicans can't be wrong: exhibition guide. South London Gallery, London, [18 Sept. – 17 Nov. 2002]; 12p., col. illus.; biogs. pp.10–1, exhibs.

2003
*Créolité and Creolization: Documenta 11. Platform 3, Kassel, 2003; see Isaac Julien, "Creolizing Vision," pp.149–55.

African-American artists 1929–1945: prints, drawings and paintings in the Metropolitan Museum of Art. Metropolitan Museum of Art, New York, 15 Jan. – 4 May 2003; 91p., illus. (some col.); biogs.; introd. by Lisa Mintz Messinger; includes work by Jacob Lawrence, Norman Lewis, Romare Bearden, Palmer Hayden.

Challenge of the modern: African-American artists, 1925–45, Vol. 1. Studio Museum Harlem, New York, 23 Jan. – 30 Mar. 2003; 125p., illus. (some col.); bibl.; text by Lowery Stokes Sims.

Black my story. Museum De Paviljoens, Almere, 12 Apr. – 17 Aug. 2003; 186p., illus. (some col.).

Ethiopian passages: contemporary art from the diaspora. National Museum of African Art, Washington, 2 May – 5 Oct. 2003; 128p., col. illus.; bibl. p.127, biogs. pp.56–97.

Next flag: the African sniper reader. Migros Museum für Gegenwartskunst, Zurich, 7 June 2003 – 11 Jan. 2004; 183p., illus. (chiefly col.); biogs.; exhibs.; includes work by Tracey Rose.

Fault lines: contemporary African art and shifting landscapes. La Biennale di Venezia, Venice, 15 June – 2 Nov. 2003; 272p., col. illus.; biogs. p.265, exhibs.; includes essay by Kobena Mercer 'Frank Bowling's map paintings' pp.139–49.

Intersecting circles: metaphors of Caribbean and Latin American transnationalism. Dominik Rostworowski Gallery, Krakow, 12 – 22 Sept. 2003; 35p., col. illus.; biogs. pp.32–5, exhibs.

True stories. Wolverhampton Art Gallery, Wolverhampton, 20 Sept. – 15 Nov. 2003; [44]p., illus. (some col.); biogs.

A fiction of authenticity: contemporary Africa abroad. New Contemporary Art Museum, St. Louis, 20 Sept. 2003 – 3 Jan. 2004; 200p., col. illus.; biogs. pp.130–43, exhibs.

Black belt. Studio Museum in Harlem, New York 15 Oct. – 4 Jan. 2004; 114p., col. illus.; bibl. p.113, biogs. pp.96–109, exhibs.; includes work by Ellen Gallagher, David Hammons.

Looking both ways: art of the contemporary African diaspora. Museum for African Art, New York, 14 Nov. 2003 – 1 Mar. 2004; 184p., col. illus.; bibl. pp.182–3, biogs. pp.179–80, exhibs.; includes work by Wangechi Mutu.

Only skin deep: changing visions of the American self. International Center of Photography, New York, 12 Dec. 2003 – 29 Feb. 2004; 416p., illus. (some col.); ports; bibl. pp.404–8; includes work by Romare Bearden, Maria Magdelena Compos-Pons, Walker Evans, Pirkle Jones, Isaac Julien, Glenn Ligon, Charles Moore, Wangechi Mutu, Adrian Piper, Man Ray, Lorna Simpson, James Van Der Zee, Andy Warhol, Carrie Mae Weems, Ernest Withers; with essays by Coco Fusco and Kobena Mercer.

2004
A century of African American art: the Paul R. Jones Collection. University Museum, University of Delaware, Newark, 2004; 259p., col. illus.; biogs. pp.215–48, exhibs.; includes work by Romare Bearden, Frank Bowling, Jacob Lawrence, James Van Der Zee, Carrie Mae Weems.

Bamako 03: fotografia Africana contemporània. Centre de Cultura Contemporània de Barcelona, Barcelona, 30 Jan. – 28 Mar. 2004; 143p., col. illus.; biogs.; text in Catalan and English.

Latin American & Caribbean art: MOMA at El Museo. El Museo del Barrio, New York, 4 Mar. – 25 July, 2004; 184p., col. illus.; bibl. pp.178–81; includes work by Wilfredo Lam, Hélio Oiticica.

Something to look forward to: an exhibition featuring abstract art by 22 distinguished Americans of African descent. Franklin & Marshall College, Lancaster, 26 Mar. – 27 June 2004; 60p., col. illus.; biog. pp.53–6, colls., exhibs.; introd. by Bill Hutson, includes work by Frank Bowling, David Hammons.

A decade of democracy: South African art 1994–2004 – from the permanent collection of Iziko: South African National Gallery. South African National Gallery, Cape Town, Apr. – Aug. 2004; 149p., col. illus.; see essay by Ashraf Jamal "The bearable lightness of Tracey Rose's 'The kiss'" pp.110–9.

Stranger than fiction. City Art Gallery, Leeds, 24 Apr. – 6 June 2004; 63 [1]p., col. illus.; biogs. pp.20–63, bibl. p.[64], exhibs.; includes work by Sonia Boyce, Isaac Julien, Keith Piper.

Dak'Art 2004: 6éme biennale de l'art Africain contemporain. Dakar, 5 May – 5 June 2006; 179p., col. illus.

Inverted utopias: avant-garde art in Latin America. Museum of Fine Arts, Houston, 20 June – 12 Sept. 2004; 586p., illus. (some col.); biogs. pp.559–76, exhibs.; introd. by Mari Carmen Ramírez; includes work by Hèlio Oiticica.

Chicago modern, 1893–1945: pursuit of the new. Terra Museum of American Art; Chicago, 17 July – 31 Oct. 2004; 175p., col illus.; bibl. p.173, biogs. p.79–161; includes a chapter on African American painters in Chicago.

Der black atlantic. Berlin: Haus der Kulturen der Welt, 17 Sept. – 14 Nov. 2004; 429p., col. illus.; refs. pp.427–8, bibl. pp.418–23, biogs. pp.424–6.

Racing the cultural interface: African diasporic identities in the digital age. Soil Digital Media Suite, Neutral Ground Artist-Run Centre, Regina, Oct. – Nov. 2004; 39p., col. illus.; biogs., exhibs.

2005
African American masters: highlights from the Smithsonian American Art Museum. Smithsonian American Art Museum, Washington, published to coincide with a US touring exhib. in 2005; 108p., col. illus.; biogs.; includes work by Romare Bearden, Palmer Hayden, Sargent Johnson, Jacob Lawrence, Norman Lewis, Gordon Parks, James Van Der Zee.

African American art by modern masters. Robert Henry Adams Fine Art, Chicago, 2005; 31p., col. illus.; includes work by Aaron Douglas, Sargent Johnson, Palmer Hayden.

Double consciousness: black conceptual art since 1970. Contemporary Arts Museum, Houston, 22 Jan. – 17 Apr. 2005; 111p., illus. (some col.); bibl. pp.103–7, biogs. pp.92–101, exhibs.; includes work by Ellen Gallagher, David Hammons, Glenn Ligon, Adrian Piper, Lorna Simpson.

African art now: masterpieces from the Jean Pigozzi Collection. Museum of Fine Arts, Houston, 29 Jan. – 8 May 2005; 224p., col. illus.; bibl. pp.214–7, biogs. pp.192–213; exhibs.; see essay by Thomas McEvilley 'How contemporary African Art comes to the west' pp.34–44.

Africa remix: contemporary art of a continent. Southbank Centre, London, 10 Feb. – 17 Apr. 2005; 224p., col. illus.; map; introd. by Roger Malbert, bibl. pp.215–6; includes work by Wangechi Mutu, Tracey Rose.

El fuego bajo las cenizas: (de Picasso a Basquiat) = Fire under the ashes: (from Picasso to Basquiat). IVAM Institut Valencià d'Art Modern, Valencia, 5 May – 28 Aug. 2005; 324p., col. illus.; see essay by Jaime Siles 'Paths of primitivism: its tradition and its variety' pp.78–99.

*Back to black: art, cinema & the racial imaginary. Whitechapel Art Gallery, London, 7 June – 4 Sept. 2005; 192p., illus. (some col.).

Arts of Africa: Jean Pigozzi's contemporary collection. Grimaldi Forum, Monaco, 16 July – 4 Sept. 2005; 365p., col. illus.; bibl. pp.364–5; text by Jean Pigozzi; essay by André Magnin.

Le feu sous les cendres: de Picasso à Basquiat. Fondation Dina Vierny–Musée Maillol, Paris, 8 Oct. 2005 – 13 Feb. 2006; 161p., col. illus.; bibl.; includes work by Jean-Michel Basquiat, Pablo Picasso.

Die Brücke und die Moderne 1904–1914. Bucerius Kunst Forum, Hamburg, 17 Oct. 2004 – 23 Jan. 2005; 207p., illus. (some col.); bibl. pp.[204]–7, biogs. pp.200–3; includes work by Karl Schmidt-Rottluff.

Tropicalia: a revolution in Brazilian culture. Museum of Contemporary Art, Chicago, 22 Oct. 2005 – 8 Jan. 2006, col. illus.; biogs. pp.321–42; includes work and essays by Hélio Oiticica.

Frequency. Studio Museum in Harlem, New York, 9 Nov. 2005 – 12 Mar. 2006; 118p., illus. (some col.); biogs. pp.100–4, colls., exhibs.

Syncopated rhythms: 20th-century African American art from the George and Joyce Wein collection. Boston University Art Gallery, Boston, 18 Nov. 2005 – 22 Jan. 2006; 103p., col. illus.; bibl. pp.100–1, biogs.

2006

African-American artists – IV. Bill Hodges Gallery, New York, 2006; 80p., col. illus.; biogs. pp.4–77; includes work by Romare Bearden, Jacob Lawrence, Norman Lewis, Glenn Ligon, Lorna Simpson, James Van Der Zee.

Building community: the African American scene. Michael Rosenfeld Gallery, New York, 13 Jan. – 11 Mar. 2006; 2p., col. illus.; includes works by Romare Bearden, Aaron Douglas, Palmer Hayden, Jacob Lawrence, Norman Lewis.

Olvida quién soy = Erase me from who I am. Centro Atlántico de Arte Moderno, Las Palmas de Gran Canaria, 23 Feb. – 30 Apr. 2006; 229p., col. illus.; biogs. pp.216–29, exhibs.; includes work by Tracey Rose.

Black Brown White: fotografie aus Südafrika = photography from South Africa. Kunsthalle Wien, Vienna, 24 Feb. – 18 June 2006; 239p., illus. (some col.); biogs. pp.225–30; text in German and English.

*Snap judgments: new positions in contemporary African photography. International Center of Photography, New York, 10 Mar. – 28 May 2006; 383p., col. illus.; bibl. pp.379–83, biogs., colls., exhibs.

Masquerade: representation and the self in contemporary art. Museum of Contemporary Art, Sydney, 23 Mar. – 21 May 2006; 128p., illus. (some col.); biogs. pp.115–27, exhibs.; includes work by Tracey Rose; see essay by Isolde Brielmaier 'I am not myself: a quick take on the photographs of Samuel Fosso and Tracey Rose' pp.29–33.

Energy experimentation: black artists and abstraction 1964–1980. Studio Museum in Harlem, New York, 5 Apr. – 2 July 2006; 147p., col. illus.; biogs. pp.127–43, colls., exhibs.

Montparnasse noir, 1906–1966: amours en contre-jour. Musée du Montparnasse, Paris, 15 June – 15 Oct. 2006; 173p., illus. (some col.); includes work on Josephine Baker.

TRANSactions: contemporary Latin American and Latino art. Museum of Contemporary Art San Diego, La Jolla, 17 Sept. 2006 – 13 May 2007; 167p., col. illus.; biogs.

A suitable distance: impressions of Trinidad by five artists: Rex Dixon, Peter Doig, Kofi Kayiga, Chris Ofili, Roberta Stoddart. Soft Box Studios, Port of Spain, Trinidad, 26 Sept. – 7 Oct. 2006; 32p., col. illus.; biogs. pp.29–30.

Heart of darkness: Kai Althoff, Ellen Gallagher and Edgar Cleijne, Thomas Hirschorn. Walker Art Centre, Minneapolis, 26 Oct. 2006 – 14 Jan. 2007; 128p., col. illus.; bibl., biogs., exhibs.

2007

Crossing the line: African American artists in the Jacqueline Bradley and Clarence Otis, Jr. Collection. Cornell Fine Arts Museum, Winter Park, 19 Jan. – 20 May 2007; 80p., col. illus.; includes work by Romare Bearden, Norman Lewis, Adrian Piper, Carrie Mae Weems; see essay by Franklin Sirmans 'Visual foresight' pp.13–8.

The ghosts of songs: the film art of the Black Audio Film Collective, 1982–1998. Foundation for Art & Creative Technology, Liverpool, 2 Feb. – 1 Apr. 2007; 239p., illus. (some col.); bibl. pp.228–31; edited by Kodwo Eshun and Anjalika Sagar.

Uncomfortable truths: the shadow of slave trading on contemporary art and design. Victoria and Albert Museum, London, 20 Feb. – 17 June 2007; [14]p., illus. (some col.); biogs.

Global feminisms: new directions in contemporary art. Brooklyn Museum of art, New York, 23 Mar. – 1 July 2007; 304p., col. illus.; biogs. pp.267–87, bibl. pp.288–97; includes work by Wangechi Mutu, Tracey Rose, Kara Walker.

Flava: Wedge curatorial projects (1997–2007). Wedge Gallery, Toronto, May – June 2007; 141p., col. illus.; introd. by Deborah Willis; includes work by James Van Der Zee.

Africa remix: contemporary art of a continent. Johannesburg Art Gallery, 24 June – 30 Sept. 2007; 260p., col. illus.; biogs.; includes work by Wangechi Mutu, Tracey Rose, Yinka Shonibare; adapted version of the German, French, and British catalogues, 2005.

Infinite island: contemporary Caribbean art. Brooklyn Museum, New York, 31 Aug. 2007 – 27 Jan. 2008; 223p., col. illus.; bibl. pp.222–3, biogs. pp.216–21, exhibs.

Crossing the waters. Cartwright Hall, Bradford, 1 Sept. – 2 Dec. 2007; 32p., col. illus; bibl. p.32, biogs. pp.8–31, exhibs., includes work by Sonia Boyce, Isaac Julien, Glenn Ligon, Chris Ofili, Keith Piper, Carrie Mae Weems.

Bamoko 2007: VII recontres Africaines de la photographie: dans la ville et au-dela. Rencontres Africaines de la Photographie, Bamako, 24 Nov. – 23 Dec. 2007; 269p, col. illus.; biogs. pp.247–65, exhibs.

2008

African American art: 200 years. Michael Rosenfeld Gallery, New York, 11 Jan. – 15 Mar. 2008; 153p., col. illus.

Tarsila: viajante = viajera. Pinacoteca do Estado de São Paulo, São Paulo, 19 Jan. – 16 Mar. 2008; 157p., col. illus.; biog. pp.130–37, exhibs.

Cuba: art and history, from 1869 to today. Montreal Museum of Fine Arts, 31 Jan. – 8 June 2008; 424p., illus. (some col.); bibl. pp.420–[3]., biogs. pp.360–[89].

2008 Biennial exhibition. Whitney Museum of American Art, New York, 6 Mar. – 1 June 2008; 269p., illus. (some col.); biogs. pp.88–251.

Black womanhood: images, icons, and ideologies of the African body. Hood Museum of Art, Dartmouth College, Hanover, 1 Apr. – 10 Aug. 2008; 374p., illus. (some col.); bibl. pp.361–8, biogs. pp.352–60; exhibs.

Flow. Studio Museum in Harlem, New York 2 Apr. – 29 June 2008; 127p., col. illus.; biogs. pp.106–13; colls.; exhibs.; see essay by Salah Hassan 'Flow: diaspora and Afro-cosmopolitanism' pp.26–31.

Home lands – land marks: contemporary art from South Africa. Haunch of Venison, London, 31 May – 5 July 2008; 167p., col. illus.; introd. by Tamar Garb and Ben Tufnell, bibl. p.167, biogs. pp.162–5, colls., exhibs.

Street art street life: from the 1950s to now. Bronx Museum of the Arts, New York, 14 Sept. 2008 – 25 Jan. 2009; essays by Katherine A Bussard, Frazer Ward and Lydia Yee; includes work by David Hammons, Adrian Piper, Peter Moore, Xaviera Simmons.

Travesía. Centro Atlántico De Arte Moderno CAAM, Las Palmas De Gran Canaria, 17 Oct. 2008 – 4 Jan. 2009; 165p., illus. (some col.); biogs.; text in Spanish and English.

5. SOLO CATALOGUES

1986

Jacob Lawrence: the Harriet Tubman series. Albright-Knox Art Gallery, New York, 18 Jan. – 2 Mar. 1986; [7]p., col. illus.; biog., exhibs.

Jacob Lawrence: American painter. Seattle Art Museum, Seattle, 10 July – 7 Sept. 1986; 235p., illus. (some col.); bibl. pp.225–31, biog., colls., exhibs.

1989

Norman Lewis: from the Harlem Renaissance to abstraction. Kenkeleba Gallery, New York, 10 May – 25 June 1989; 72p., illus. (some col.); biog., exhibs.

1990

David Hammons: rousing the rabble. Institute for Contemporary Art, P.S.1 Museum, New York, 16 Dec. 1990 – 10 Feb. 1991; Institute of Contemporary art, Philadelphia, 15 Mar. – 28 Apr. 1991; San Diego Museum of Contemporary Art, 17 Aug. – 10 Nov. 1991; 95p., illus.

1993

Wifredo Lam. Fundació Joan Miró, Barcelona, 21 Jan. – 21 Mar. 1993; 188p., col. illus.; biog. pp.186–8; text in Catalan.

Jacob Lawrence: the migration series. Phillips Collection, Washington, D.C., 23 Sept. 1993 – 9 Jan. 1994; Milwaukee Art Museum, 28 Jan. – 20 Mar. 1994, and around the U.S.A. ending at Museum of Modern Art, New York, Jan. – Apr. 1995; 172p., illus. (some col.).

1996

Pedro Figari en el Museo Nacional de Bellas Artes. Museo Nacional de Bellas Artes, Buenos Aires, 1996; 67p., col. illus.

1997

Relocating the remains: Keith Piper. Royal College of Art, London 18 July – 13 August 1997; 95p., illus. (some col.); bibl. p.92; includes CD-ROM.

Romare Bearden in black and white: photomontage projections 1964. Whitney Museum of American Art, New York, 17 Jan. – 20 Mar. 1997; 88p., illus.; bibl. pp.82–3, biog. pp.77–80.

1998

Aubrey Williams. Whitechapel Art Gallery, London, 12 June – 16 Aug. 1998; 110p., illus. (some col.); bibl. pp.106–10, colls., exhibs.

Glenn Ligon: un/becoming. Institute of Contemporary Art, Philadelphia, 17 Jan. – 8 Mar. 1998; 63p., illus.; bibl. pp.60–2; introd. by Judith Tannenbaum.

Norman Lewis: black paintings, 1946–1977. Studio Museum Harlem, New York, 1 Apr. – 20 Sept. 1998; 124p. illus. (some col.); biog. pp.118–9, exhibs.; introd. by Kinshasha Holman Conwill.

Norman Lewis 1909–1979: 25 highly important paintings: an exhibition. Bill Hodges Gallery, New York, 23 May – 11 July 1998; 59p., illus.; biog.

2000

Coloring: new work by Glenn Ligon. Walker Art Center, Minneapolis, 22 Oct. 2000 – 11 Mar. 2001; 36p., illus. (some col.); bibl. p.35, biog. pp.34–5, exhibs.

2001

Glenn Ligon: stranger. The Studio Museum in Harlem, New York, 31 Jan. – 1 Apr. 2001; 37p. illus.; bibl. p.35, biog. pp.33–5, exhibs.

Over the line: the art of Jacob Lawrence. Phillips Collection, Washington 27 May – 19 Aug. 2001; Whitney Museum of American Art, New York, 8 Nov. 2001 – 3 Feb. 2002; Detroit Institute of Arts, Detroit, 24 Feb. – 19 May 2001; Los Angeles County Museum of Art, Los Angeles, 16 June – 8 Sept. 2002; Museum of Fine Arts, Houston, 5 Oct. 2002 – 5 Jan. 2003; 336p., col. illus.; bibl. pp.270–8, biog. pp.25–65. See original edition published as part of a 2 vol. catalogue raisonné.

2002

Lasar Segall: un expresionista brasileño. Museo de Arte Moderno, Conaculta, 6 Mar. – 2 June 2002; 318p., col. illus.; bibl. p.313, biog. pp.292–312; exhibs.

Chris Ofili: the upper room. Victoria Miro Gallery, London, 25 June – 3 Aug. 2002; [59]p., col. illus.

2003

The art of Romare Bearden. National Gallery of Art, Washington, 14 Sept. 2003 – 4 Jan. 2004; 334p., col. illus.; bibl. pp.270–315, biog. pp.212–46.

2004

Glenn Ligon: text paintings 1990–2004. Regen Projects, Los Angeles, Sept. 2004; [20]p., col. illus.

2006

*David Hammons: the unauthorized retrospective. Triple Candie, Harlem, New York, 8 Jan. – 12 Feb. 2006; illus.

David Hammons: selected works. Zwirner & Wirth, New York, 21 Feb. – 1 Apr. 2006; [44]p., col. illus.; text by Franklin Sirmans.

Lorna Simpson. Museum of Contemporary Art, Los Angeles, 16 Apr. – 10 Jul. 2006; 158p., illus. (some col.); bibl. pp.152–3; includes interview with the artist.

Romare Bearden: fractured tales: intimate collages. Michael Rosenfeld Gallery, LLC, New York, 8 Sept. – 28 Oct. 2006; 48p., col. illus.; bibl. p.42.

2007

María Magdalena Campos-Pons: everything is separated by water. Indianapolis Museum of Art, 25 Feb. – 3 June 2007; 183p., col. illus.; bibl. pp.176–81, biog. pp.167–75, colls., exhibs.; ed. by Lisa D. Freiman; see essay by Enwezor, Okwui: "The Diasporic Imagination: The Memory Works of Maria Magdalena Campos-Pons," pp.64–89.

Ellen Gallagher: coral cities. Tate Liverpool, Liverpool, 21 Apr. – 27 Aug. 2007; 114p., col. illus.; biog. pp.111–3, exhibs.

Wangechi Mutu: the Cinderella curse. A.C.A. Gallery of Savannah College of Art and Design, Atlanta, 9 May – 22 July 2007; [20]p., col. illus.; biog., exhibs.

*Aaron Douglas: African American modernist. Spencer Museum of Art, University of Kansas, Lawrence (Kansas), 8 Sept. – 2 Dec. 2007; 253p., col. illus.; bibl. pp.235–7, biog., exhibs.

6. ARTICLES AND JOURNALS

1926

*Fire!!: devoted to younger Negro artists. 1926

Barnes, Albert C.: 'Negro art, past and present', in Opportunity: journal of Negro life, May 1926, vol. 4 no. 41, pp.148, 169.

Munro, Thomas: 'Primitive Negro sculpture', in Opportunity: journal of Negro life, May 1926, vol. 4 no. 41, pp.150–2.

Guillaume, Paul: 'The triumph of ancient Negro art' in Opportunity: journal of Negro life, May 1926, vol. 4 no. 41, pp.146–7.

1928

*Andrade, Oswald de. 'Manifesto Antropófago' in Revista de Antropofagia, 1928, issue 1.

1957

Black Orpheus: a journal of African and Afro-American literature, [(no.1) 1957]–

1978

Araeen, Rasheed: 'Afro-Caribbean art: an analysis' in Black Phoenix, Summer 1978, no.2, pp30–2.

Araeen, Rasheed: 'Preliminary notes for a black manifesto' in Black Phoenix, Winter 1978, no.1, pp.3–12.

1987

Araeen, Rasheed: 'From primitivism to ethnic arts', in Third text, Autumn 1987, no. 1, pp.6–25.

Walmsley, Anne: 'The Caribbean Artist's Movement, 1967–1972' in Artrage, Winter 1987, no. 19, pp.35–8.

1988

Linsley, Robert: 'Wifredo Lam: painter of negritude', in Art History, Dec. 1988, vol. 11, pp.527–44.

1990

Gilroy, Paul: 'David A. Bailey: from Britain, Barbados or both', in Creative Camera, 1990, no. 2, pp.10–3.

1991

Conwill, Kinshasha Holman: 'In search of an "authentic" vision: decoding the appeal of the self-taught African-American artist', in American Art, Autumn 1991, vol. 5 no. 4, pp.2–9.

1994

Clifford, James: 'Diasporas', in Cultural Anthropology, Aug. 1994, vol. 9 no. 3, pp.302–38.

1995

Mercer, Kobena: 'Art that is ethnic in inverted commas', in Frieze, Nov.–Dec. 1995, issue 25, pp.38–41.

1997

Ratnam, Niru: 'A colouring book', in Frieze, Apr. 1997, issue 33, pp.39–40.

1998

*Eden Gibson, Ann: 'Diaspora and ritual: Norman Lewis's civil rights paintings', in Third Text, Winter 1989–99 – might be 98, vol. 13 issue 45, pp.29–44.

1999

Mercer, Kobena: 'Ethnicity and internationality: new British Art and diaspora based blackness', in Third Text, Winter 1999–2000, vol. 13 issue 49, pp.51–62.

2000

Roberts, Allen F.: 'Is "Africa" obsolete?', in African Arts, Spring 2000, vol. 33 no. 1, pp.1–9, 93–4.

Archer-Straw, Petrine: 'Black intentions', in Art Review, Nov. 2000, vol. 52, pp.46–7.

Juan Jr, E San: 'Aimé Césaire's poetics of fugitive intervention', in Third Text, Winter 2000–2001, vol. 14 issue 53, pp.3–17.

2001

Mosquera, Gerado: 'Good-bye identity, welcome difference: from Latin American art to art from Latin America', in Third Text, Autumn 2001, vol. 15 issue 56, pp.25–32.

2003

Kihm, Christophe: 'Paul Gilroy: l'atlantique noir', in Art Press, June 2003, no. 291, pp.56–9.

2004

Sims, John; Harris, Juliette (eds.): 'Rhythm of structure: MathArt in the African diaspora [Special Issue]': The International review of African American art, 2004, vol. 9 no. 3.

Bourne, Kay: 'Complex dialogue: art of Africa and the African diaspora', in Art New England, Aug./Sept. 2004, vol. 25 no. 5, pp.18–20.

Murray, Derek Conrad: 'Hip-hop vs. high art: notes on race as spectacle', in Art Journal, Summer 2004, vol. 63 no. 2, pp.4–19.

2005

Peffer, John: 'Africa's diasporas of images', in Third Text, July 2005, vol. 19 issue 4, pp.339–55.

Peffer, John: 'Notes on African art, history, and diasporas within', in African Arts, Winter 2005, vol. 38 no. 4, pp.70–7, 95.

2006

Ottenberg, Simon: 'African art and culture in Maine', in African Arts, Spring 2006, vol. 39 no. 1, pp.1,4,8,10,86–9,96.

Winkiel, Laura: 'Nancy Cunard's "Negro" and the transnational politics of race', in Modernism/Modernity, Sept. 2006, vol. 13 no. 3, pp.507–30.

2007

Thompson, Krista A.: 'Preoccupied with Haiti: the dream of diaspora in African American art, 1915–1942', in American Art, Fall 2007, vol. 21 no. 3, pp.74–97.

Murray, Derek Conrad: 'Post post-black: some politically incorrect thoughts on the reception and contemplation of African-American Art', in Art Journal, Winter 2007, vol. 66 no. 4, pp.112–4.

2008

Shelby, Tommie: 'Cosmopolitanism, blackness, and utopia: a conversation with Paul Gilroy', in Transition, 2008, Issue 98, pp.116–35.

Tawadros, Gilane: 'The revolution stripped bare...', in Nka, Spring/Summer 2008., no. 22/23, pp.60–79.

2009

Edmondson, Locksley: 'Aime Cesaire (1913–2008): Architect of Negritude' in Nka, 2009, no. 24, pp.92–7.

Erickson, P: 'The black atlantic in the twenty-first century: artistic passages, circulations, revisions', in Nka, 2009, no. 24, pp.56–70.

Bianchi, Paolo: '3—hot spot Karibik', in Kunstforum International, Jan./Mar. 2009, no. 195, p.85.

Melas, Natalie: 'Losing Cesaire' in Nka, 2009, no. 24, pp.102–7.

Bonami, Francesco: 'Now is forever... again', in Tate etc. Spring 2009, issue 15, pp.30–7.

Evans, Lucy: 'The Black Atlantic: exploring Gilroy's legacy', in Atlantic Studies, 6.2, Aug. 2009, pp.255–68.

7. AUDIOVISUAL

* Allegret, Marc: Zouzou. Paris, 1934; 85 min.; film starring Josephine Baker, screenplay by Pepito Abatino,

*Caribbean Voices. London: British Broadcasting Corporation, General Overseas Service, Broadcast weekly, 1943–58.

* Pontecorvo, Gillo: La battaglia di Algeri. Written by Gillo Pontecorvo and Franco Solinas, 1967; 125 min.

Gopaul, Lina; Akomfrah, John and Black Audio Film Collective: Handsworth songs. London: Black Audio Film Collective, 1986; videocassette.

Julien, Isaac: Looking for Langston. London: British Film Institute, 1989; b&w film; 42 min.

Robbins, Warren M: [Skowhegan lecture archive] 1991 [sound recording]. New York; Skowhegan, Me.: Skowhegan School of Painting and Sculpture, 1991. 2 sound discs: digital, audio; recording of lecture entitled "African Elements in 20th Century Art: Expanding the Concept of Appropriation in Art Beyond Western Culture."

*Julien, Isaac: Frantz Fanon: black skin, white mask. London: Normal Films production for BBC and the Arts Council of England in association with Illumina, 1995; videocassette; 50 min.

New histories. Boston: 1 video: col.; 35 mins; published on the occasion of an exhibition held at Institute of Contemporary Art, Boston 23 Oct. 1996 – 5 Jan. 1997; includes interviews with Isaac Julien, Zofia Kulik, Mariko Mori, Virginia Nimarkoh, Lorraine O'Grady, Adriana Varejão, Kara Walker and Fred Wilson.

Dialogues across the Black Atlantic. Institute of International Visual Arts, 1997. Recorded at Iniva, 18th June, 1997. Tape 1 & 2.

Open sesame: a Making Histories Visible project. Preston: Centre for Contemporary Art, University of Central Lancashire, 2005. DVD + 16p. booklet; 27 min.

Black British Art: The Revolt of the Artists. Tate Britain London, 17 May 2006; audio cassette.

Josephine Baker: the first black superstar. Documentary. BBC 2, 19 June 2006

LIST OF WORKS

BLACK ATLANTIC AVANT-GARDES

Tarsila do Amaral (1886–1973)

Hill of the Shantytown 1924
[Morro da favela]
Oil on canvas
640 × 760 mm
Hecilda and Sergio Fadel Collection

Cecil Beaton (1904–1980)

Nancy Cunard 1929
Vintage bromide print
237 × 220 mm
National Portrait Gallery, London
Given by executors of the Estate of Eileen Hose,
1991

Nancy Cunard 1929
Vintage bromide print
241 × 188 mm
National Portrait Gallery, London
Given by executors of the Estate of Eileen Hose,
1991

Constantin Brancusi (1876–1957)

Head circa 1919–23
[Tête]
Wood (oak)
292 × 194 × 210 mm
Tate. Purchased 1980

Studio view: The White Negress I (1923) 1923 (printed
2010)
[Vue d'atelier: La Négresse blanche I (1923)]
Exhibition print
circa 240 × 180 mm
Centre Pompidou, Paris
Musée national d'art moderne / Centre de création
industrielle

The Blonde Negress front view, polished bronze (1926)
1926
[La Négresse blonde vue de face, bronze poli (1926)]
Gelatin silver print
238 × 179 mm
Centre Pompidou, Paris
Musée national d'art moderne / Centre de création
industrielle

Portrait of Nancy Cunard, walnut (1925–1927) circa 1927
[Portrait de Nancy Cunard, noyer (1925–1927)]
Gelatin silver print
238 × 179 mm
Centre Pompidou, Paris
Musée national d'art moderne / Centre de
création industrielle

Studio view circa 1930
[Vue d'atelier]
Gelatin silver print
298 × 238 mm
Centre Pompidou, Paris
Musée national d'art moderne / Centre de
création industrielle

Edward Burra (1905–1976)

Harlem 1934
Brush, ink and gouache on paper
794 × 571 mm
Tate. Purchased 1939

Paul Colin (1892–1985)

Dancer in Pink on Piano, from Le Tumulte Noir 1927
Colour lithograph on paper
472 × 319 mm
Victoria and Albert Museum, London

Josephine Baker in Banana Skirt, from Le Tumulte Noir
1927
Lithograph with pochoir colouring on paper
470 × 319 mm
Victoria and Albert Museum, London

Josephine Baker in Palm Skirt, from Le Tumulte Noir
1927
Lithograph with pochoir colouring on paper
478 × 318 mm
Victoria and Albert Museum, London

Nude Dancer on Piano, from Le Tumulte Noir 1927
Colour lithograph on paper
479 × 319 mm
Victoria and Albert Museum, London

Woman Dancer Behind Bars, from Le Tumulte Noir
1927
Lithograph with pochoir colouring on paper
471 × 319 mm
Victoria and Albert Museum, London

Woman in White and Magenta, from Le Tumulte
Noir 1927
Lithograph with pochoir colouring on paper
470 × 319 mm
Victoria and Albert Museum, London

Aaron Douglas (1899–1979)

Aspects of Negro Life: The Negro in an
African Setting 1934
Oil on canvas
1835 × 1994 mm
Art & Artefacts Division, Schomburg Center for
Research in Black Culture, The New York Public
Library, Astor, Lenox and Tilden Foundations

Aspiration 1936
Oil on canvas
1524 × 1524 mm
Fine Arts Museums of San Francisco, Museum
purchase, the estate of Thurlow E. Tibbs Jr., the
Museum Society Auxiliary, American Art Trust
Fund, Unrestricted Art Trust Fund, partial gift of
Dr. Ernest A. Bates, Sharon Bell, Jo-Ann Beverly,
Barbara Carleton, Dr. And Mrs. Arthur H. Coleman,
Dr. and Mrs. Coyness Ennix, Jr., Nicole Y. Ennix,
Mr. and Mrs. Gary Francois, Dennis L. Franklin,
Mr. and Mrs. Maxwell C. Gillette, Mr. and Mrs.
Richard Goodyear, Zuretti L. Goosby, Marion E.
Greene, Mrs. Vivian S. W. Hambrick, Laurie Gibbs
Harris, Arlene Hollis, Louis A. and Letha Jeanpierre,
Daniel and Jackie Johnson, Jr., Stephen L. Johnson,
Mr. and Mrs. Arthur Lathan, Lewis & Ribbs
Mortuary Garden Chapel, Mr. and Mrs. Gary Love,
Glenn R. Nance, Mr. and Mrs. Harry S. Parker III,
Mr. and Mrs. Carr T. Preston, Fannie Preston,
Pamela R. Ransom, Dr. and Mrs. Benjamin F. Reed,
San Francisco Black Chamber of Commerce, San
Francisco Chapter of Links, Inc., San Francisco
Chapter of the N.A.A.C.P., Sigma Pi Phi Fraternity,
Dr. Ella Mae Simmons, Mr. Calvin R. Swinson,
Joseph B. Williams, Mr. and Mrs. Alfred S. Wilsey,
and the people of the Bay Area, 1997.84

Self-portrait 1954
Charcoal and Conté crayon
634 × 480 mm
Spencer Museum of Art, The University of Kansas:
Peter T. Bohan Art Acquisition Fund

Aaron Douglas (1899–1979)
Langston Hughes (1902–1967)

Cover, Opportunity Art Folio 1926
Relief print
500 × 335 mm
Spencer Museum of Art, The University of Kansas:
The Helen Foresman Spencer Art Acquisition
Fund, the Office of the Chancellor, and the Lucy
Shaw Schultz Fund

Weary As I Can Be, from Opportunity Art Folio 1926
Relief print, letterpress
406 × 292 mm
Spencer Museum of Art, The University of Kansas:
The Helen Foresman Spencer Art Acquisition
Fund, the Office of the Chancellor, and the Lucy
Shaw Schultz Fund

On De No'thern Road, from Opportunity Art Folio 1926
Relief print, letterpress
406 × 292 mm
Spencer Museum of Art, The University of Kansas:
The Helen Foresman Spencer Art Acquisition
Fund, the Office of the Chancellor, and the Lucy
Shaw Schultz Fund

Ma Bad Luck Card, from Opportunity Art Folio 1926
Relief print, letterpress
406 × 292 mm
Spencer Museum of Art, The University of Kansas:
The Helen Foresman Spencer Art Acquisition
Fund, the Office of the Chancellor, and the Lucy
Shaw Schultz Fund

Play De Blues, from Opportunity Art Folio 1926
Relief print, letterpress
406 × 292 mm
Spencer Museum of Art, The University of Kansas:
The Helen Foresman Spencer Art Acquisition
Fund, the Office of the Chancellor, and the Lucy
Shaw Schultz Fund

I Needs a Dime for Beer, from Opportunity Art Folio
1926
Relief print, letterpress
406 × 292 mm
Spencer Museum of Art, The University of Kansas:
The Helen Foresman Spencer Art Acquisition
Fund, the Office of the Chancellor, and the Lucy
Shaw Schultz Fund

Untitled, from Opportunity Art Folio 1926
Halftone reproduction, letterpress
406 × 292 mm
Spencer Museum of Art, The University of Kansas:
The Helen Foresman Spencer Art Acquisition
Fund, the Office of the Chancellor, and the Lucy
Shaw Schultz Fund

Walker Evans (1903–1975)

Ancestral Figure, Sudan, Senufo, Plate 4 from African
Negro Art 1935
Silver gelatin print
235 × 118 mm
Victoria and Albert Museum, London

Mask, Liberia, Plate 55 from African Negro Art 1935
Gelatin silver print
239 × 174 mm
Victoria and Albert Museum, London

Mask, Ivory Coast, Plate 98 from African Negro Art
1935
Gelatin silver print
240 × 172 mm
Victoria and Albert Museum, London

Mask, Ivory Coast, Guro, Plate 119 from African
Negro Art 1935
Gelatin silver print
236 × 157 mm
Victoria and Albert Museum, London

Two Bobbins, Ivory Coast, Plate 133 from African
Negro Art 1935
Gelatin silver print
186 × 224 mm
Victoria and Albert Museum, London

Ancestral figure, Head, Gabun, Pahouin (Fan), Plate 321
from African Negro Art 1935
Gelatin silver print
236 × 144 mm
Victoria and Albert Museum, London

Figure stuck with Nails, Congo, Plate 376 from African
Negro Art 1935
Gelatin silver print
232 × 112 mm
Victoria and Albert Museum, London

Head rest, Congo, Urua, Plate 384 from Exhibition of
African Negro Art 1935
Gelatin silver print
199 × 162 mm
Victoria and Albert Museum, London

Pedro Figari (1861–1938)

Candombe 1921
Oil on canvas
730 × 1040 mm
Museo de Arte Latinoamericano de Buenos Aires –
Malba – Fundación Costantini

Palmer Hayden (1890–1973)

Midsummer Night in Harlem 1936
Oil on canvas
635 × 762 mm
Museum of African American Art, Los Angeles

Sargent Johnson (1888–1967)

Forever Free 1933
Wood with lacquer on cloth
914 × 292 × 241 mm
San Francisco Museum of Modern Art.
Gift of Mrs. E. D. Lederman

Mask 1933
Copper
276 × 200 × 60 mm
San Francisco Museum of Modern Art.
Albert M. Bender Collection,
Gift of Albert M. Bender

Fernand Léger (1881–1973)

Mise-en-scéne for the ballet of 'The Creation of
the World' 1922
Pencil on paper
210 × 270 mm
The Museum of Modern Art, New York. Gift of
John Pratt, 1949

Norman Lewis (1909–1979)

Dan Mask 1935
Pastel on sandpaper
459 × 317 mm
Courtesy of Michael Rosenfeld Gallery,
New York

Guru Head (handle) 1935
Pastel on sandpaper
356 × 222 mm
Courtesy of Michael Rosenfeld Gallery,
New York

Man Ray (1890–1976)

Noire et Blanche 1926 (copy 1982)
Gelatine silver print
219 × 294 mm
Museo Nacional Centro de Arte Reina Sofia,
Madrid

Amedeo Modigliani (1884–1920)

Caryatid circa 1913–4
[Cariatide]
Drawing on paper
549 × 448 mm
Tate. Purchased 1957

Ronald Moody (1900–1984)

Johanaan 1936
Wood (elm)
1550 × 725 × 388 mm
Tate. Purchased 1992

Midonz 1937
Wood (elm)
720 × 380 × 445 mm
Ronald Moody Estate

Pablo Picasso (1881–1973)

Bust of a Woman 1909
[Buste de femme]
Oil on canvas
727 × 600 mm
Tate. Purchased 1949

Karl Schmidt-Rottluff (1884–1976)

Male Head 1917
[Männlicher Kopf]
Wood
343 × 133 × 165 mm
Tate. Presented by the executors of Dr Rosa
Shapire, 1954

Lasar Segall (1891–1957)

Banana Plantation 1927
[Bananal]
Oil on canvas
870 × 1270 mm
Collection of the Pinacoteca do Estado de
São Paulo/Brazil. Acquisition by the
Government of the State of São Paulo, 1928

James Van Der Zee (1886–1983)

The Van Der Zee Men, Lenox, Massachusetts, from
Eighteen Photographs portfolio 1908 (printed 1974)
Modern gelatin silver print
381 × 318 mm
The Minneapolis Institute of Arts, The Stanley
Hawks Memorial Fund

Garveyite Family, Harlem, from Eighteen Photographs
portfolio 1924 (printed 1974)
Gelatin silver print
379 × 318 mm
The Minneapolis Institute of Arts, The Stanley
Hawks Memorial Fund

Marcus Garvey and Garvey Militia, Harlem, from
Eighteen Photographs portfolio 1924 (printed 1974)
Gelatin silver print
381 × 316 mm
The Minneapolis Institute of Arts, The Stanley
Hawks Memorial Fund

Black Jews, Harlem, from Eighteen Photographs
portfolio 1929 (printed 1974)
Gelatin silver print
318 × 379 mm
The Minneapolis Institute of Arts, The Stanley
Hawks Memorial Fund

Couple, Harlem, from Eighteen Photographs portfolio
1932 (printed 1974)
Gelatin silver print
318 × 381 mm
The Minneapolis Institute of Arts, The Stanley
Hawks Memorial Fund

UNIA Musical Detachment 1926
Gelatin silver print
203 × 257 mm
The Minneapolis Institute of Arts, Gift of
Mr. and Mrs. Paul N. Rifkin

Cuban Men's Group 1926 (printed later)
Gelatin silver print
305 × 254 mm
Donna Van Der Zee and Howard Greenberg
Gallery, New York

Harlem Trade School 1927
Vintage gelatin silver print
241 × 191 mm
Donna Van Der Zee and Howard Greenberg
Gallery, New York

Carl van Vechten (1880–1964)

McCleary Stinnett with African Sculpture 1933
Black and white photograph
226 × 169 mm
Tate

McCleary Stinnett 1933
Black and white photograph
227 × 169 mm
Tate

Anthony Wysard (1907–1984)

Probably Henry Crowder; Nancy Cunard 1928
Watercolour on paper
267 × 211 mm
National Portrait Gallery, London.
Purchased 1990

MAYA DEREN: THE LIVING GODS OF HAITI

Maya Deren (1917–1961)

Divine Horsemen: The Living Gods of Haiti 1947–1951
(1977)
16mm film transferred to DVD, black and white,
sound, 55 minutes
Courtesy of Tavia Ito and Pip Chodorov, Re:Voir

BLACK ORPHEUS: NEGRITUDE, CREOLIZATION, NATURAL SYNTHESIS

Adebisi Akanji (born circa 1935)

Untitled (Two Screens) circa 1966
Cement and metal
1575 × 1010 mm and 1556 × 1029 mm
National Museum of African Art, Smithsonian
Institution, Gift of Mr. and Mrs. Waldemar
A. Nielsen

Marc Bernheim and Evelyne Bernheim

New Art of Africa: Cement sculpture bas-relief by
Felix Idubor, decorates the side facade of the new 25-story
Independence House, In Lagos, Nigeria circa 1960–1965
Gelatin silver print
336 × 242 mm
The Minneapolis Institute of Arts, Gift of
Lora and Martin G. Weinstein

Agustín Cárdenas (1927–2001)

Untitled circa 1960
[Sans titre]
Wood
3200 mm (h)
Private Collection, France
Courtesy of JGM Galerie, Paris

Wifredo Lam (1902–1982)

Light in the Forest, The Large Jungle 1942
[Lumière dans la forêt, La Grande Jungle]
Gouache on paper mounted on canvas
1920 × 1235 mm
Centre Pompidou, Paris
Musée national d'art moderne / Centre de
création industrielle

The Murmur 1943
[Le bruit]
Oil on paper mounted on canvas
1050 × 840 mm
Centre Pompidou, Paris
Musée national d'art moderne / Centre de
création industrielle

Jacob Lawrence (1917–2000)

Street to Mbari 1964
Tempera, gouache and graphite on paper
565 × 784 mm
National Gallery of Art, Washington DC,
Gift of Mr. and Mrs. James T. Dyke

Agnaldo Manoel dos Santos (1926–1962)

Nun circa 1950s–1960s
[Monja]
Pau Brazil wood
1270 × 400 × 360 mm
Collection of Vilma Eid

Uche Okeke (born 1933)

Ana Mmuo 1961
Oil on board
910 × 1219 mm
National Museum of African Art, Smithsonian
Institution, Gift of Joanne B. Eicher and
Cynthia, Carolyn Ngozi, and Diana Eicher

Rubem Valentim (1922–1991)

Untitled circa 1960s
[Sem titulo]
Oil on canvas
1000 × 730 mm
Courtesy of Galeria Berenice Arvani, São Paulo

Composition 1961
[Composição]
Oil on canvas
400 × 300 mm
Courtesy of Galeria Berenice Arvani, São Paulo

Painting no.11 Rome 1965
[Pintura n.11 Roma]
Egg tempera on canvas
1000 × 740 mm
Ricard Akagawa Collection

Painting no.12 Rome 1965
[Pintura n.12 Roma]
Egg tempera on canvas
1000 × 735 mm
Ricard Akagawa Collection

DISSIDENT IDENTITIES: RADICALISM, RESISTANCE AND MARGINALITY

Jean-Michel Basquiat (1960–1988)

Native Carrying Some Guns, Bibles, Amorites on Safari
1982
Acrylic and oil on paper, mounted on canvas,
and exposed wood
1828 × 1828 mm
Collection Hermes Art Trust
Courtesy of Francesco Pellizzi

Romare Bearden (1911–1988)

Watching the Good Train Go by: Cotton 1964
Photomechanical reproductions, watercolour,
gouache and pencil on paperboard
283 × 356 mm
Hirshhorn Museum and Sculpture Garden,
Smithsonian Institution, Washington DC,
Gift of Joseph H. Hirshhorn, 1966

The Prevalence of Ritual: Baptism 1964
Photomechanical reproductions, paint and
graphite on board
232 × 305 mm
Hirshhorn Museum and Sculpture Garden,
Smithsonian Institution, Washington DC,
Gift of Joseph H. Hirshhorn, 1966

Sermons: The Walls of Jericho 1964
Photomechanical reproductions, pencil, brush,
ink and watercolour on paper
300 × 237 mm
Hirshhorn Museum and Sculpture Garden,
Smithsonian Institution, Washington DC,
Gift of Joseph H. Hirshhorn, 1966

Fish Fry 1967
Paper collage on board
762 × 1016 mm
Courtesy of Michael Rosenfeld Gallery,
New York

Flights and Fantasy 1970
Mixed media collage with synthetic polymer
paint on Masonite
222 × 298 mm
Courtesy of Michael Rosenfeld Gallery,
New York

Blue Shade 1972
Mixed media collage on Masonite
241 × 356 mm
Courtesy of Michael Rosenfeld Gallery,
New York

Arthur Bispo do Rosario (1909–1989)

Exu's Cape n.d.
[Capa de Exu]
Cloth, thread, acetate, wool and glass
1500 × 950 × 50 mm
Collection of the Museu Arthur Bispo do Rosário
Arte Contemporânea / Prefeitura da Cidade do
Rio de Janeiro

Macumba n.d.
Wood, metal, cloth, plastic, thread, nylon, glass,
iron, gesso and paper
1930 × 750 × 150 mm
Collection of the Museu Arthur Bispo do Rosário
Arte Contemporânea / Prefeitura da Cidade do
Rio de Janeiro

Warships n.d.
[Navios de Guerra]
Wood, cloth, metal, thread and plastic
1390 × 1260 × 40 mm
Collection of the Museu Arthur Bispo do Rosário
Arte Contemporânea / Prefeitura da Cidade do
Rio de Janeiro

Frank Bowling (born 1936)

Who's Afraid of Barney Newman? 1968
Oil on canvas
2364 × 1295 × 27 mm
Tate. Presented by Rachel Scott 2006

Ivan Cardoso (born 1952)

H.O. 1979
35mm film transferred to DVD, colour, sound,
13 minutes
Courtesy of Ivan Cardoso

David Hammons (born 1943)

The Door (Admissions Office) 1969
Wood, acrylic sheet and pigment
2007 × 1219 × 381 mm
California African American Foundation

Pirkle Jones (1914–2009)

Plate glass window of the Black Panthers Party National
Headquarters the morning it was shattered by the bullets
of two Oakland policemen September 10, 1968
Gelatin silver print
298 × 278 mm
International Center of Photography with funds
provided by the ICP Acquisitions Committee, 2003

Norman Lewis (1909–1979)

American Totem 1960
Oil on canvas
1880 × 1143 × 50 mm
Collection of Ouida B. Lewis

Redneck Birth 1961
Oil on canvas
1308 × 1829 mm
Collection of Billy E. Hodges

Charles Moore (born 1931)

Martin Luther King, Montgomery 1960
(printed later)
Gelatin silver print
356 × 279 mm
Charles Moore and Howard Greenberg Gallery,
New York

Birmingham, Alabama (police dogs attack
demonstrators) 1963 (printed later)
Gelatin silver print
279 × 356 mm
Charles Moore and Howard Greenberg Gallery,
New York

Peter Moore (1932–1993)

Untitled (Jean-Michel Basquiat/SAMO Graffiti,
New York City) 4/29/78 – B4 1978
Gelatin silver print
203 × 254 mm
Paula Cooper Gallery and Barbara Moore

Untitled (Jean-Michel Basquiat/SAMO Graffiti,
New York City) 6/2/79 – B31 1979
Gelatin silver print
254 × 203 mm
Paula Cooper Gallery and Barbara Moore

Untitled (Jean-Michel Basquiat/SAMO Graffiti,
New York City) 6/2/79 – B1 1979
Gelatin Silver Print
203 × 254 mm
Paula Cooper Gallery and Barbara Moore

Untitled (Jean-Michel Basquiat/SAMO Graffiti,
New York City) 6/2/79 – B15a 1979
Gelatin silver print
203 × 254 mm
Paula Cooper Gallery and Barbara Moore

Untitled (Jean-Michel Basquiat/SAMO Graffiti,
New York City) 4/15/79 – D11 1979
Gelatin silver print
203 × 254 mm
Paula Cooper Gallery and Barbara Moore

Hélio Oiticica (1937–1980)

P 11 Parangolé Cape 07 "Sex and Violence is what
pleases me" 1966
[P 11 Parangolé capa 07 "Sexo e Violência eis o
que me agrada"]
Paint, cotton fabric, resin-coated vinyl plastic
1060 × 798 × 200 mm
Private Collection, London

Gordon Parks (1912–2006)

American Gothic, Washington, DC 1942
(printed later)
Gelatin silver print
356 × 279 mm
Gordon Park Foundation and Howard Greenberg
Gallery, New York

Emerging Man, Harlem 1952
Gelatin silver print
305 × 457 mm
International Center of Photography with funds
provided by the ICP Acquisitions Committee, 2003

[Man outside Apollo Theater smoking a cigarette, part of
re-enactment of Ralph Ellison's "Invisible Man", Harlem]
1952
Gelatin silver print
227 × 270 mm
International Center of Photography, The LIFE
Magazine Collection, 2005

[Liberty or Death] 1960s
Gelatin silver print
321 × 460 mm
International Center of Photography, International
Fund for concerned Photography Purchase 1974

[Steps of Lincoln Memorial littered with debris after
March in Washington] August 28, 1963
Gelatin silver print
203 × 276 mm
International Center of Photography, The LIFE
Magazine Collection, 2005

L.A. Courtroom, Malcolm X displaying picture of
Muslim Ronald Stokes, killed by police a year earlier 1963
Gelatin silver print
330 × 483 mm
International Center of Photography, with funds
provided by the ICP Acquisitions Committee, 2003

Stokely Carmichael 1967
Gelatin silver print
343 × 232 mm
International Center of Photography, International
Fund for concerned Photography Purchase 1974

Adrian Piper (born 1948)

Food for the Spirit 1971
Gelatin silver prints
14 parts, each 368 × 381 mm
Collection of Thomas Erben, New York

I Embody Everything You Most Hate and Fear 1975
Oil crayon on black and white photograph
178 × 254 mm
Collection of Thomas Erben, New York

Andy Warhol (1928–1987)

Birmingham Race Riot from Ten Works by Ten Painters
1964
Screenprint on paper
510 × 610 mm
Tate. Purchased 1996

RECONSTRUCTING THE MIDDLE PASSAGE: DISAPORA AND MEMORY

Radcliffe Bailey (born 1968)

Garvey's Ghost 2008
Model ship and black glitter
762 × 476 × 121 mm
Courtesy of the artist and Jack Shainman Gallery,
New York

Maria Magdalena Campos-Pons (born 1959)

Of Two Waters 2007
[De Las Dos Aguas]
Colour photograph on paper
12 parts, each 610 × 508 mm
Collection of Mark D Pescovitz, Indianapolis
Courtesy of Julie Saul Gallery, New York

Renée Cox (born 1960)

Banana Road from Queen Nanny of the Maroons 2004
Digital ink jet print on watercolour paper
1118 × 1118 mm
Courtesy of the artist

Cleanse from Queen Nanny of the Maroons 2004
Digital ink jet print on watercolour paper
1118 × 864 mm
Courtesy of the artist

Nanny Warrior from Queen Nanny of the Maroons
2004
Digital ink jet print on watercolour paper
1118 × 1118 mm
Courtesy of the artist

River Queen from Queen Nanny of the Maroons 2004
Digital ink jet print on watercolour paper
1118 × 1118 mm
Courtesy of the artist

Christopher Cozier (born 1959)

Tropical Night 2006 – present
Ink, graphite and stamps on paper
Each 229 × 178 mm
Installation of drawings of an ongoing series
Dimensions variable
Courtesy of the artist

Ellen Gallagher (born 1965)

Bird in Hand 2006
Oil, ink, paper, salt and gold leaf
on canvas
2380 × 3070 mm
Tate. Presented anonymously 2007

Isaac Julien (born 1960)

Western Union Series No. 1 (Cast No Shadow) 2007
Duratrans image in lightbox
1200 × 1200 mm
Jochen Zeitz Collection

Keith Piper (born 1960)

Go West Young Man 1987
Photograph on paper mounted on board
14 parts, each 840 × 560 mm
Tate. Purchased 2008

EXHIBITING BODIES: RACISM, RATIONALISM AND PSEUDO-SCIENCE

Sonia Boyce (born 1962)

From Tarzan to Rambo: English Born 'Native'
Considers her Relationship to the Constructed/Self
Image and her Roots in Reconstruction 1987
Photograph and mixed media on paper
1240 × 3590 mm
Tate. Purchased 1987

Candice Breitz (born 1972)

Ghost Series #1, 1994–6
Chromogenic print on paper
1015 × 685 mm
Courtesy of the artist and White Cube/Jay Jopling

Ghost Series #4, 1994–6
Chromogenic print on paper
1015 × 685 mm
Courtesy of the artist and White Cube/Jay Jopling

Ghost Series #6, 1994–6
Chromogenic print on paper
1015 × 685 mm
Courtesy of the artist and White Cube/Jay Jopling

Coco Fusco and Guillermo Gomez-Peña (born 1960, born 1955)

The Couple in the Cage: Guatianaui Odyssey 1993
Video transferred to DVD, colour, sound,
31 minutes
Courtesy of the artist and Video Data Bank,
Chicago

Ana Mendieta (1948–1985)

Untitled (Chicken Piece) 1972
Super-8 film transferred to DVD, colour, silent,
6:20 minutes
Courtesy of Galerie Lelong, New York

Untitled (Ocean Bird Wash-Up) 1974
Super-8 film transferred to DVD, colour, silent,
4:30 minutes
Courtesy of Galerie Lelong, New York

Untitled (Blood and Feathers #2) 1974
Super-8 film transferred to DVD, colour, silent,
3:30 minutes
Tate. Presented by the Estate of Ana Mendieta
Collection and an anonymous donor 2009

Wangechi Mutu (born 1972)

You were always on my mind 2007
Ink, paint, mixed media, plant materials,
plastic pearls on Mylar
1418 × 935 mm
Tate. Presented 2008

Bird Flew 2008
Mixed media, ink and collage on Mylar
1067 × 1575 mm
Collection of Charlotte and Bill Ford

Highland Woman Afar Girl Hamar Woman Surma
Woman 2009
Mixed media collage
341 × 786 × 45 mm
Courtesy of the artist and Victoria Miro Gallery,
London

Marta María Pérez Bravo (born 1959)

Protection 1990 (printed 2009)
[Proteccion]
Gelatin silver print
500 × 400 mm
Courtesy of the artist

It's in Your Hands 1994 (printed 2009)
[Esta en tus manos]
Gelatin silver print
500 × 400 mm
Courtesy of the artist

Talisman 1992 (printed 2009)
[Macuto]
Gelatin silver print
400 × 500 mm
Courtesy of the artist

Pathways 1990 (printed 2009)
[Caminos]
Gelatin silver print
500 × 400 mm
Courtesy of the artist

Ilekes 1998 (printed 2009)
Gelatin silver print
500 × 400 mm
Courtesy of the artist

Tracey Rose (born 1974)

Venus Baartman 2001
Colour photograph on paper
1200 × 1200 mm
Courtesy of the artist and The Project,
New York

Carrie Mae Weems (born 1953)

A Negroid Type / You Became a Scientific Profile /
An Anthropological Debate / & A Photographic Subject
1995–1996
Colour photograph on paper
4 parts, each 673 × 578 mm
Courtesy of the artist and Jack Shainman Gallery,
New York

FROM POST-MODERN TO POST-BLACK: APPROPRIATION, BLACK HUMOUR AND DOUBLE NEGATIVES

Ronald Duarte (born 1963)

Nimbo/Oxalá 2004
Video transferred to DVD, colour, sound,
3:09 minutes
Courtesy of the artist

Coco Fusco (born 1960)

a/k/a Mrs. George Gilbert 2004
Video transferred to DVD, colour, sound,
31 minutes
Courtesy of the artist

Sightings 3 2004
Photograph on paper
330 × 914 mm
Courtesy of the artist

Sightings 4 2004
Photograph on paper
330 × 914 mm
Courtesy of the artist

Ellen Gallagher (born 1965)

DeLuxe 2004–5
Portfolio of 60 etchings with photogravure,
engraving, spitbite, silkscreen, lithography,
cutting and collage
Each 330 × 265 mm
Overall display dimensions 2153 × 4470 mm
Tate. Purchased 2006

Adler Guerrier (born 1975)

Untitled (BLCK – We Wear the Mask) 2008
Mixed media with video
Overall dimensions variable
Courtesy of the artist and Newman Popiashvili
Gallery, New York

David Hammons (born 1943)

African-American Flag 1990
Dyed cotton
1500 × 2325 mm
Monsoon Art Collection

Glenn Ligon (born 1960)

Malcolm X (version 2) #1 2000
Vinyl paint, oil based printed ink on canvas
1224 × 915 × 36 mm
Tate. Purchased with funds provided by the
American Fund for the Tate Gallery 2007

Gold Nobody Knew Me #1 2007
Acrylic and oil stick on canvas
813 × 813 mm
Rubell Family Collection, Miami

Gold When Black Wasn't Beautiful #1 2007
Acrylic and oil stick on canvas
813 × 813 mm
Rubell Family Collection, Miami

Chris Ofili (born 1968)

Double Captain Shit and the Legend of the Black Stars
1997
Mixed media on canvas
2440 × 1830 mm
Tate. Purchased with assistance from Evelyn, Lady
Downshire's Trust Fund 1997

Adam Pendleton (born 1980)

Black Dada (BK/AD) 2008
Silkscreen on canvas
1930 × 1219 mm
Courtesy of the artist and Haunch of Venison,
London

Black Dada (LCK/D) 2008
Silkscreen on canvas
1930 × 1219 mm
Courtesy of the artist and Haunch of Venison,
London

System of Display, EIAL (Theatrical/Documenta 1, 1955,
Museum Fridericianum, Artworks by Pablo Picasso)
2008–2009
Silkscreen on glass and mirror
248 × 248 × 76 mm
Courtesy of the artist and Haunch of Venison,
London

System of Display, ODAS (Foundations/International
Photo Studio, Couple, Calabar, Nigeria, 1953)
2008–2009
Silkscreen on glass and mirror
248 × 248 × 76 mm
Courtesy of the artist and Haunch of Venison,
London

System of Display, ODIY (Modernity/Dada Dancers,
Zurich, 1918)
2008–2009
Silkscreen on glass and mirror
248 × 248 × 76 mm
Courtesy of the artist and Haunch of Venison,
London

System of Display, PP (Perception/Gold Coast
Governor Sir Charles Arden Clarke (left) visiting ballot
counting office for Accra Central Constituency, 1956)
2008–2009
Silkscreen on glass and mirror
248 × 248 × 76 mm
Courtesy of the artist and Haunch of Venison,
London

Lorna Simpson (born 1960)

Photo Booth 2008
50 found photo booth portraits and 50 ink
drawings on paper
Dimensions variable
Tate. Purchased using funds provided by the 2008
Outset / Frieze Art Fair Fund to benefit the Tate
Collection 2009

Kara Walker (born 1969)

8 Possible Beginnings Or: The Creation of African-
America, a Moving Picture by Kara E. Walker 2005
16mm film and video transferred to DVD, black
and white, sound, 15:57 minutes, single-screen
projection
Tate. Lent by the American Fund for the
Tate Gallery, courtesy of the American
Acquisitions Committee 2007

CONTRIBUTORS

PETRINE ARCHER

is an art historian and curator living between Kingston, Jamaica, and London. An advocate of Caribbean art, she has been a visiting curator and member of the Board of Directors at the National Gallery of Jamaica since 2000. At The National Art Gallery of the Bahamas she spearheaded the development of their curatorial practices and policies, and at the School of Visual Arts in Jamaica she designed their first degree programme in Art History. Archer has published and edited numerous books including *Negrophilia: Avant-Garde Paris and Black Culture in the 1920s* (2000) and a number of articles focusing on the field of Negrophilia including "Negrophilia: A Double Edged Infatuation" published in *The Guardian* newspaper (23 September 2000). She is a Visiting Associate Professor at Cornell University, her lectures covering aspects of the Black Diaspora.

TANYA BARSON

joined Tate in 1997. In 2001 she co-curated the Turner Prize exhibition. Recent exhibitions she has curated include *Making History: Art and Documentary in Britain from 1929 to Now* (2006); *Jake and Dinos Chapman: Bad Art for Bad People* (2006); *Ellen Gallagher: Coral Cities* (2006) at Tate Liverpool, and *Frida Kahlo* (2005) (with co-curator Emma Dexter) and *Oiticica* in London (with Guy Brett) in 2007 at Tate Modern. She is currently Curator of International Art at Tate Modern.

ROBERTO CONDURU

is an art historian and writer based in Rio de Janeiro whose work focuses on the art and architecture of Brazil. He has authored monographs on Vital Brazil, Willys de Castro, and Jorge Guinle and has published numerous essays. Conduru teaches at Universidade do Estado do Rio de Janeiro and is interested in the cultural, artistic and diasporic exchange between Brazil and Africa.

HUEY COPELAND

is Assistant Professor of Art History at Northwestern University in Illinois. His research, criticism, and curatorial projects focus on modern and contemporary art with an emphasis on articulations of blackness in the visual field. His published writings include "The Blackness of Blackness" (*Artforum*, October 2008), "A Family Resemblance" (*Kori Newkirk: 1997–2007*, 2007), and "'Bye, Bye Black Girl': Lorna Simpson's Figurative Retreat" (*Art Journal*, Summer 2005). He is currently at work on a book that examines the aesthetic and political significance of slavery for postmodern artists.

MANTHIA DIAWARA

is a Malian art historian and filmmaker. His academic career critically examines contemporary Black American and African cinema studies. In addition to publishing widely in journals, his books include *In Search of Africa* (1988) and *African Cinema* (1985). He has edited several publications such as *Black American Cinema* (1993) and *Black British Cultural Studies: A Reader* (1996). Diawara is University Professor and Director of the Institute of Afro-American Affairs at New York University. He is editor-in-chief of *Black Renaissance Noire*, an interdisciplinary journal, serves on the advisory board of *October*, and is also part of the editorial collective of *Public Culture*, a cultural studies journal. Diawara lives in New York.

ÉDOUARD GLISSANT

is a writer, poet and literary critic, widely recognised as being one of the most influential figures in Caribbean and negritude studies. Glissant received his PhD in Paris in 1946, studying ethnography at the Musée de l'Homme and history and philosophy at the Sorbonne. Active in politics, he helped to establish Antillo-Guyanais pour l'Autonomie in 1959, a radical left-wing group, the result of which left Glissant blacklisted for four years. Returning to his birthplace of Martinique in 1965, he founded the Institut martiniquais d'études, as well as Acoma, a social sciences publication. Glissant divides his time between Martinique, Paris and New York, where he has been visiting professor of French Literature at CUNY since 1995. Glissant was shortlisted for the Nobel Prize in 1992. He is also a member of the advisory board of several art journals.

THELMA GOLDEN

is Director and Chief Curator of The Studio Museum in Harlem. Golden began her career at the Studio Museum in 1987 before joining the Whitney Museum of American Art in 1988. In a decade at the Whitney, she organized numerous ground-breaking exhibitions and served as Director of the Whitney Museum at Phillip Morris. She returned to the Studio Museum in 2000 as Deputy Director for Exhibitions and Programs, and was named Director and Chief Curator in 2005. At SMH, Golden has organized many notable exhibitions including Chris Ofili: Afro Muses 1995-2005, Black Romantic, Freestyle, Frequency, Glenn Ligon: Stranger, Martin Puryear: The Cane Project and Isaac Julien: Vagabondia. Golden holds a B.A. in Art History and African-American Studies from Smith College and honorary doctorates from the City College of New York (2009), San Francisco Art Institute (2008), Smith College (2004), and Moore College of Art and Design (2003). She is an active guest lecturer, curator, and panelist.

GLENN LIGON

is a conceptual artist currently working in New York. He works in a range of media, including painting, video, photography. Ligon has had solo shows at the Hirshhorn Museum and Sculpture Garden in Washington, D.C., Brooklyn Museum of Art and The Studio Museum in Harlem amongst other venues. He has received grants and fellowships from the National Endowment for the Arts in 1982, 1989, and 1991, Art Matters (1990), the Joan Mitchell Foundation (1997), and the John Simon Guggenheim Memorial Foundation (2003).

COURTNEY J. MARTIN

is an art historian and curator. She has curated numerous exhibitions, including C-Series: Artists' Books and Collective Action at the Nathan Cummings Foundation, New York, which travelled to the Baltic Centre for Contemporary Art, Gateshead, England in 2005. She collaborated on several artists' projects, including, I Wish it Were True (2006) at the Jamaica Center for Arts and Learning, New York. Her writings have been published in numerous volumes, exhibition catalogues and magazines, including Flash Art and Frieze. Martin is a regular contributor to Artforum.com. She has recently completed a doctorate on late twentieth century British art at Yale University and is a Chancellor's Post-doctoral fellow at the University of California, Berkeley.

KOBENA MERCER

was formerly Reader in Art History and Diaspora Studies at Middlesex University, London and previously taught at New York University and University of California, Santa Cruz. His work critically examines sexuality, black identity and African diasporic culture and his essays are featured in several anthologies including Frantz Fanon: Critical Perspectives (1999) and Black British Cultural Studies (1996). He is the author of Welcome to the Jungle: New Positions in Black Cultural Studies (1994) and editor of Exiles, Diasporas and Strangers (2008), Pop Art and Vernacular Cultures (2007), Discrepant Abstraction (2006), and Cosmopolitan Modernisms (2005). In 2006 Mercer was the inaugural recipient of the Clark Prize for Excellence in Arts Writing, presented by the Sterling and Francine Clark Art Institute.

SPONSORS AND DONORS 2009

The Art Fund
Arts and Business
BT
Business in the Arts: North West
DLA Piper
The Embassy of the United States in London
European Regional Development Fund
Horace W Goldsmith Foundation
The Granada Foundation
KPMG Foundation
Liverpool City Council
Liverpool Primary Care Trust
Museums, Libraries and Archives Council
Neil Sheppard
North West Business Leadership Team
North West Regional Development Agency
Peter Cruddas Foundation
Pro Helvetia, Swiss Arts Council
The Romanian Cultural Institute in London
Tate International Council
Tate Liverpool Members
Tate Members
Unilever UK
Vony Gwillim

CORPORATE PARTNERS

Accenture (UK) Ltd
David M Robinson (Jewellery) Ltd
DLA Piper
DWF
Ethel Austin Property Group
Hill Dickinson
HSBC Bank Plc
Laureate Online Education
Liverpool Hope University
Liverpool John Moores University
The University of Liverpool
Unilever UK

CORPORATE MEMBERS

Andrew Collinge Ltd
Alder Hey Imagine Appeal, supported by Assura Group
Barlows Plc
Betafence Ltd
British Waterways
Bruntwood
Cheetham Bell JWT
Deutsche Bank Private Wealth Management
Dr Foster Ltd
Fraser Wealth Management
Grant Thornton
Individual Restaurant Company
J.W Lees & Co (Brewers) Ltd.
KPMG
Lime Pictures
Midas Capital Partners Ltd
Pannone LLP
Novartis Vaccines & Diagnostics Ltd
Royal Bank of Scotland

PATRONS

Diana Barbour
David Bell
Tom Bloxham MBE
Peter Bullivant
Jim Davies
Olwen McLaughlin
Barry Owen
Ross Warburton

COPYRIGHT CREDITS BY ARTIST

Adebisi Akanji:
© 2010 reserved, p.118

Tarsila do Amaral:
© RMPI, São Paolo, pp.13, 108

Malcolm Bailey:
© The artist, p.29

Radcliffe Bailey:
© The artist and Jack Shainman Gallery, p.144

Jean-Michel Basquiat:
© ADAGP, Paris and DACS, London 2010, p.139

Romare Bearden:
© Romare Bearden Foundation / VAGA, New York and DACS, London 2010, pp.132, 133

Cecil Beaton:
© Cecil Beaton Studio Archive at Sotheby's, p.94

Marc and Evelyne Bernheim:
© 2010 reserved, p.119

Arthur Bispo do Rosario:
© Coleção Museu Bispo do Rosário Arte Contemporânea / Prefeitura da Cidade do Rio de Janeiro, p.140

Frank Bowling:
© The artist, pp.48, 52, 127

Sonia Boyce:
© The artist, pp.154/155

Constantin Brancusi:
© ADAGP, Paris and DACS, London 2010, pp.90, 91

Candice Breitz:
© The artist, courtesy of White Cube/Jay Jopling, p.157

Edward Burra:
© Tate, p.107

Maria Magdalena Campos-Pons:
© The artist, p.151

Agustín Cárdenas:
© The Estate of Agustin Cárdenas, courtesy of JGM Galerie, Paris, p.116

Paul Colin:
© ADAGP, Paris and DACS, London 2010, p.88

Renée Cox:
© The artist, pp.36/37, p.150

Christopher Cozier:
© The artist, pp.148, 149

Maya Deren:
© Tavia Ito, Estate of Maya Deren, courtesy of Lux, London, p.45
© Tavia Ito, Estate of Maya Deren, courtesy of Pip Chodorov, Re:Voir, pp.112, 113

Agnaldo Manoel dos Santos:
© 2010 reserved, p.121

Aaron Douglas:
© The Aaron and Alta Sawyer Douglas Foundation, pp.11, 85, 87

Ronald Duarte:
© The artist, pp.170/171 (top)

Walker Evans:
© Walker Evans Archive, The Metropolitan Museum of Art, p.100

Rotimi Fani-Kayode:
© The Estate of Rotimi Fani-Kayode, p.38

Pedro Figari:
© The Estate of Pedro Figari, courtesy of Mr. Fernando Saavedra Faget, p.111

Frente 3 de Fevereiro:
© The artists, p.70

Coco Fusco and Guillermo Gomez-Peña:
© The artists, p.158

Coco Fusco:
© The artist, pp.170/171 (bottom)

Ellen Gallagher:
© The artist, pp.146/147, 174

Anna Bella Geiger:
© The artist, p.66

Adler Guerrier:
© The artist and Newman Popiashvili Gallery, p.169

David Hammons:
© The artist, pp.135, 163

Palmer Hayden:
© 2010 reserved, pp.34, 106

Ayrson Heráclito:
© The artist, p.71

Sargent Johnson:
© 2010 reserved, p.89

Isaac Julien:
© The artist, p.145

Pirkle Jones:
© 2009 Survivors Trust FBO Pirkle Jones, p.129

Wifredo Lam:
© ADAGP, Paris and DACS, London 2010, p.115

Jacob Lawrence:
© ARS, NY and DACS, London 2010, pp.43, 120

Fernand Léger:
© ADAGP, Paris and DACS, London 2010, p.99

Norman Lewis:
© Ouida B. Lewis, p.101, 125

Glenn Ligon:
© The artist, pp.166, 167

Milton Machado:
© The artist, p.64

Man Ray:
© Man Ray Trust / ADAGP, Paris and DACS, London 2010, pp.32, 93

Marepe:
© The artist, p.68

Ana Mendieta:
© The Estate of Ana Mendieta Collection, p.161

Amedeo Modigliani:
© ADAGP Paris and DACS, London 2010, p.96

Ronald Moody:
© Ronald Moody Estate, p.103

Charles Moore:
© The artist, p.131

Peter Moore:
© The Estate of Peter Moore/ VAGA, NYC, p.137

Wangechi Mutu:
© The artist, cover, pp.82, 159

Chris Ofili:
© The artist, p.165

Hélio Oiticica:
© César Oiticica Filho, courtesy of Projeto Hélio Oiticica, pp.17, 19, 141

Uche Okeke:
© 2010 reserved, p.117

Gordon Parks:
© The Gordon Parks Foundation, p.128

Adam Pendleton:
© The artist, pp.23, 168

Marta María Pérez Bravo:
© The artist, p.160

Pablo Picasso:
© ADAGP Paris and DACS London 2010 © Succession Picasso – Gestion droits d'auteur, p.97

Adrian Piper:
© The artist, p.136

Keith Piper:
© The artist, p.143

Tracey Rose:
© The artist, p.153

Karl Schmidt-Rottluff:
© DACS London, 2010, p.102

Lasar Segall:
© Museu Lasar Segall, p.109

Lorna Simpson:
© The artist, courtesy Salon 94, New York, pp.172/173

Rubem Valentim:
© Rubem Valentim Estate, courtesy of Roberto Bicca di Alencastro, pp.122. 123

James Van Der Zee:
© 2010 reserved, p.105

Alexandre Vogler:
© The artists, p.73

Kara Walker:
© The artists, p.175

Andy Warhol:
© ADAGP, Paris and DACS, London 2010, p.130

Carrie Mae Weems:
© The artists, p.156

Fred Wilson:
© The artist, courtesy of PaceWildenstein, New York, p. 55

Anthony Wysard:
© 2010 reserved, p.95

PHOTOGRAPHIC CREDITS BY ARTIST

Adebisi Akanji:
Courtesy of the National Museum of African Art, Smithsonian Institution, p.118

Tarsila do Amaral:
© Romulo Fialdini, p.13

Malcolm Bailey:
© 2009 Image copyright The Metropolitan Museum of Art / Art Resource / Scala, Florence, p.29

Radcliffe Bailey:
Courtesy of the artist and Jack Shainman Gallery, New York, p.144

Jean-Michel Basquiat:
© Hickey-Robertson, Houston, p.139

Romare Bearden:
© Hirshhorn Museum and Sculpture Garden, Smithsonian Institution, Washington DC, Gift of Joseph H. Hirschorn, p.132
Courtesy of Michael Rosenfeld Gallery, New York, p.133

Cecil Beaton:
© Cecil Beaton Studio Archive at Sotheby's, p.94

Marc and Evelyne Bernheim:
Courtesy of The Minneapolis Institute of Arts, p.119

Arthur Bispo do Rosario
© Rodrigo Lopes, p.140

Frank Bowling:
Courtesy of the artist and ROLLO Contemporary Art, p.48
© Spencer A Richards, p.52
© Tate, 2010, p.127

Sonia Boyce:
© Tate, 2010, pp.154/155

Constantin Brancusi:
© Collection Centre Pompidou, Dist RMN / Philippe Migeat, p.90
© Tate, 2010, p.91

Candice Breitz:
Courtesy of the artist and White Cube/Jay Jopling, p.157

Edward Burra:
© Tate, 2010, p.107

Maria Magdalena Campos-Pons:
Courtesy of the artist and Julie Saul Gallery, New York, p.151

Agustín Cárdenas:
© Bertrand Huet, p.116

Paul Colin:
© V&A Images/ Victoria and Albert Museum, London, p.88

Renée Cox:
Courtesy of the artist, pp.36/37, 150

Christopher Cozier:
Courtesy of the artist and The Brooklyn Museum, NY, p.148
Courtesy of the artist, p.149

Maya Deren:
Courtesy of Lux, London, p.45
Courtesy of Pip Chodorov, Re:Voir , p.113

Agnaldo Manoel dos Santos:
© Vilma Eid / Galeria Estação, p.121

Aaron Douglas:
Courtesy of the Arts and Artifacts Division, Schomburg Center for Research in Black Culture, The New York Public Library, Astor, Lenox and Tilden Foundations, p.87
Courtesy of the Corcoran Gallery of Art, Washington, DC, Museum Purchase and partial gift from Thurlow Evans Tibbs, Jr., The Evans-Tibbs Collection, p.11
Courtesy of the Fine Arts Museums of San Francisco, p.85

Ronald Duarte:
© Wilton Montenegro, pp.170/171 (top)

Walker Evans:
© V&A Images/Victoria and Albert Museum, London, p.100

Rotimi Fani-Kayode:
© Estate of Rotimi Fani-Kayode, courtesy of Autograph ABP, p.38

Pedro Figari:
Courtesy of Museo de Arte Latinoamericano de Buenos Aires – Malba – Fundación Costantini, p.111

Frente 3 de Fevereiro:
© Frente 3 de Fevereiro, p.70 (top, middle)
© Peetssa, p.70 (bottom)

Coco Fusco and Guillermo Gomez-Peña:
© Nancy Lytle, Courtesy of the artists, p.158

Coco Fusco:
Courtesy of the artist, pp.170/171 (bottom)

Ellen Gallagher:
© Mike Bruce, courtesy of the artist and Hauser & Wirth, pp.146/147
Courtesy the artist, Two Palms Press, New York and Hauser & Wirth, p.174

Adler Guerrier:
© Newman Popiashvili Gallery, New York, p.169

David Hammons:
© California African American Foundation, p.135
© 2009 Digital image, The Museum of Modern Art, New York / Scala, Florence, p.163

Palmer Hayden:
Courtesy of The Museum of African American Art, Los Angeles, p.106
© 2009 The Metropolitan Museum of Art / Art Resource / Scala, Florence, p.34

Sargent Johnson:
© San Francisco Museum of Modern Art, p.89

Isaac Julien:
Courtesy of the artist and Jochen Zeitz Collection, p.145

Pirkle Jones:
Courtesy of International Center of Photography, Purchase, with funds provided by the ICP Acquisitions Committee, 2003, p.129

Wifredo Lam:
© Collection Centre Pompidou, Dist. RMN / rights reserved, p.115

Jacob Lawrence:
Courtesy of the Board of Trustees, National Gallery of Art, Washington, p.120
© Aaron Douglas Collection, The Amistad Research Center, Tulane University, New Orleans, LA 70118, p.43

Fernand Léger:
© 2009 Digital image, The Museum of Modern Art, New York / SCALA, Florence, p.99

Norman Lewis:
Courtesy of Michael Rosenfeld Gallery, New York, p.101
Courtesy of Ouida B. Lewis and Bill Hodges Gallery, New York, p.125

Glenn Ligon:
Courtesy of Regen Projects, LA, and Thomas Dane Gallery, London, p.167 Courtesy of Rubell Family Collection, Miami, p.166

Man Ray:
© Man Ray Trust, p.32
Courtesy of Museo Nacional Centro de Arte Reine Sofia, Madrid, p.93

Marepe:
Courtesy of Galeria Luisa Strina, p.68